77152

Chautauqua

The University of
Chicago Press

Chicago and London

Drawings by Jane E. Nelson

Theodore Morrison

Chautauqua

A Center for Education, Religion,
and the Arts in America

THEODORE MORRISON is professor
emeritus of English at Harvard
University. He is the author of
several novels and books of verse,
including *The Whole Creation* and
The Dream of Alcestis.
[1974]

The University of Chicago Press, Chicago 60637
The University of Chicago Press, Ltd., London

© 1974 by The University of Chicago
All rights reserved. Published 1974
Printed in the United States of America
International Standard Book Number: 0–226–54062–6
Library of Congress Catalog Card Number: 74–75614

Contents

Foreword vii

1. Origins and Early Development

1. Scene with Backdrop 3
2. The Founders 17
3. Chautauqua Begins 31
4. From Sunday School Assembly to University 41
5. Home Reading 53
6. Successors in Leadership: William Rainey Harper and George Edgar Vincent 73

2. World War, Economic Crisis, and Social Transformation

7. The Presidency of Arthur E. Bestor 87
8. Chautauqua as Music Center 119
9. Ventures in Other Arts 149
10. Tents and Tabernacles 161

3. Continuity in a World of Upheaval

11. Chautauqua since World War II 195
12. Tradition and Evolution—A Trial Balance 231

Epilogue
The Future, by President Oscar E. Remick 243

4. Chautauqua in Photographs

Chautauqua through Time 259
The Arts 279
Education 293
Personalities 305
Architecture 313
Leisure 331

Acknowledgments and Sources 337

Index 343

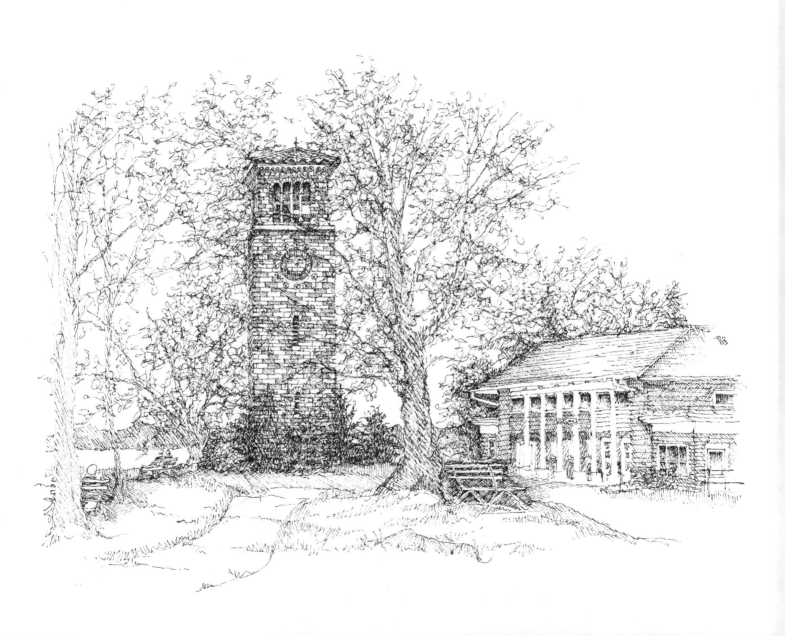

Foreword

Chautauqua as a name properly designates a county, a lake, and an institution. The county occupies the extreme southwestern corner of New York State, between Lake Erie and the Pennsylvania border. The lake is a chief feature of the county. The institution, which began its life as a Sunday school assembly, has become a summer center for a bewildering variety of activities in education, religion, discussion of public issues, music, art, theater, sports, hobbies, and clubs. With its grounds, halls, and dormitories, its municipal services such as fire and police protection and water filtration, with its hotels, cottages, churches, and its capacious public arena, the Amphitheater, it suggests a little city-state providing the instruments of civilization for a summer populace. The name Chautauqua, in a restricted sense, applies to this institution and the lake its grounds adjoin. But the use of the name has not been so restricted. Other enterprises, some closely, some at best remotely related, have called themselves Chautauqas. These enterprises fall into two main divisions. Imitative assemblies quickly sprang up in fixed localities in all parts of the country, and Chautauqua as parent cordially shared its name with them and gave them its support. By contrast, the travelling tent companies that brought circuit programs by rail or truck or automobile to thousands of American towns and villages during the early decades of the twentieth century, simply appropriated the title of Chautauquas. To literally millions of Americans, "Chautauqua" has meant these circuit companies rather than the institution in New York. Many who still retain memories of the circuits, with vague if any knowledge of the assembly whose title they adopted, ask what Chautauqua was, how it started, and whether it still exists.

It does, and this book tries to trace the history of its first hundred years. The book is principally concerned with Chautauqua Institution, but at least pays the tribute of a chapter to the local imitators and the circuits. All belong to American cultural history and are interfused with it in multiple ways.

Not the least fascinating strand in the Chautauqua story is the almost

wildly diverse roster of men and women who have contributed to it. A small-scale but widely representative Dictionary of American Biography could be compiled from the list. It would include presidents—Grant, McKinley, Garfield, Harding, both Roosevelts. It would include political figures of radical or controversial renown—William Jennings Bryan, Governor Al Smith, Socialist candidate Norman Thomas, Senator Robert F. Kennedy. Among women of sundry causes it would give due place to Frances E. Willard, Carrie Chapman Catt, Jane Addams, Ida Tarbell; among inventors and industrialists, Thomas A. Edison and Henry Ford; it would pay its bow to the sympathetic but critical William James, to physicians such as Karl Menninger or Paul Dudley White; to explorers and aviators such as Admiral Byrd and Amelia Earhart; to preachers, reformers, musicians, artists, scientists, scholars, magicians, counsellors on fashion and cooking. The range of talent and the diversity of biography seem almost without limit.

This book tries to tell the Chautauqua story for readers not already acquainted with it, hoping at the same time not to exclude the interest of those who know the place and its work from long familiarity. In preparing it the writer has been given complete independence by a cordially cooperative Chautauqua administration. No attempt has been made to influence his judgment, no document or item of information withheld that he had the wit to ask for. His only restriction has been one of time. Chautauqua history is rich enough to warrant a good decade of research, but the commission for this work was first discussed toward the end of 1971, leaving scarcely two full years for both research and the production of the text. The writer has at least been fortunate in the materials readily available or placed in his hands, and in the help of historically informed correspondents whose generosity is acknowledged elsewhere in the volume.

Origins and Early Development

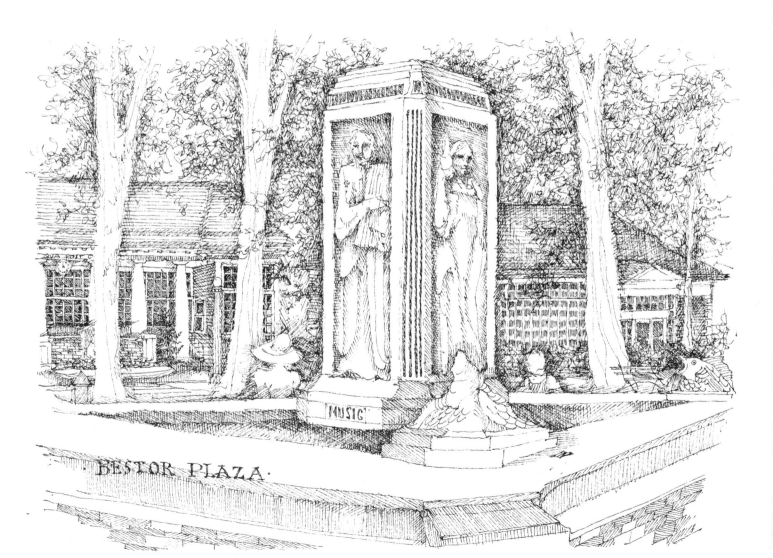
BESTOR PLAZA.

MUSIC

Scene with Backdrop

1

Those who have known Chautauqua for many seasons, often as far back as childhood, may well have forgotten or in effect never experienced what it was like to see it for the first time. A newcomer has the privilege of an initial impression, and may well need a brief period of grace to sort out the sights and sounds he encounters. At first look, Chautauqua can give an effect of crowded sprawl, but it is compact enough so that its contours and characteristic features become familiar quickly enough. Today the customary approach is by road, on Route 17-J between Mayville and Jamestown, New York. An extensive, roofed-over gate-building gives entrance to the fenced grounds. A great many visitors buy their gate-tickets only for a day or a single event, an opera, symphony concert, play, lecture, symposium, or entertainment, but if the newcomer has planned a longer sojourn and wants to learn something of the institution as a whole, he can encompass most of the grounds inside the fence by a couple of not at all arduous walks, and on the way at least begin to satisfy his curiosity. Going straight ahead from the entrance, on a brick-paved stretch of the narrow street called Vincent Avenue, he will find himself after three short blocks at the Bestor Plaza, a central open quadrangle faced on the west by the four-story wooden-frame St. Elmo Hotel, on the north by the colonnade with its shops and administrative offices, on the east by the post office, where he will find a well-stocked bookstore in the basement, and on the south by the Smith Library, plentifully supplied with Chautauqua memorabilia and files as well as books for general reading. If it is daytime and the weather is in good humor, the plaza will be well populated. Thousands of people occupy the grounds on any given day, and may well make a first impression somewhat confusing. Children will be scampering on the walks and grass, young people standing or sprawling in couples or groups, elders sitting on benches and reading or merely sunning. Newsboys will be crying the *Chautauquan Daily* in competitive slogans or balancing stacks of them on bicycle racks for delivery. Shoppers will be toting packages from the drugstore, the fashion shop,

the grocery. Automobiles of employees, cottage owners, or hotel guests will be nudging gingerly around the quad. On a corner of grass a contented elderly gentleman, or it may be a young aspirant, will have set up an easel and will be at work with brush and palette, unconcerned by the flow of crowd that eddies within touching distance.

Thus far the progress from the entrance gate to the plaza has taken the newcomer over pretty much level ground, but beyond the plaza a mare's nest of narrow streets winds and crisscrosses steeply down hill to the waterfront. These streets are crowded with cottages and boarding houses elbowing each other in close formation, though they are interspersed here and there by small shaded parks that open vistas between their tree trunks to the lake. The cottages and other buildings are wooden frame structures, running to balconies, sometimes three or four on top of one another, and to gingerbread ornamentation ranging from the most innocently simple to the most intricately ambitious. Among them are appealing period pieces that attract the notice of architects and photographers interested in native American building styles. By slanting across the plaza and turning right at the library end, the newcomer on his way down to the lakeshore will come to the Amphitheater, encircled by its iron fence. He can look down through the open sides, over the tiers of bench seats that accommodate variously estimated thousands of listeners, to the wide stage and the pipes of the organ. In the Amphitheater, depending on the hour and the day of the week, the choir may be practicing hymns for a Sunday service, or a lecturer may be talking or a preacher preaching, or the symphony or the student orchestra may be rehearsing for a concert, or a jazz ensemble or a military band may be gratifying its crowd of fans. Rounding the Amphitheater and still heading downhill, the visitor will find himself confronting the Athenaeum Hotel, an impressively large, wooden frame hostelry that proclaims itself a period piece at first sight. Its chandeliered, high-ceilinged Victorian ballroom-drawing room is handsomely proportioned as well as spacious, and its cuisine is not likely to disappoint either appetite or refinement of taste. The slope of lawn below the Athenaeum opens directly on the lakefront, a little south of Miller Park, which extends out into the lake on Fair Point, where the tents of the original Sunday School Assembly were dispersed among the trees. Miller Bell Tower is the most familiar visual symbol of Chautauqua, a tile-roofed campanile of aging brick with a prominent clock and a peal of bells that trolls out hymns and keeps Westminster count of the hours and the quarters.

Instead of angling past the Amphitheater and the Athenaeum and so

reaching the lakeshore by an only mildly devious route, a visitor on reaching the plaza could turn directly right or left and so begin a circuit of the grounds which would bring him to the lake by a longer course. If he turned right or southward, he could wind his way among more gingerbread cottages and lodging houses, past the quarters of various religious denominations, past the Hall of Philosophy and the Hall of Christ, until he came to the Ravine, a tract of natural woods with a steep gulley and a brook running through it. A wooden-floored bridge that ripples pleasantly under human tread crosses the gulley, and beyond the street on the far side is a development of more substantial if somewhat suburban-looking houses. The street slopes down toward the sports field with its baseball diamond and bleachers, and thence the visitor can turn left up South Lake Drive between the Boys' Club and the Girls' Club, past the dance studio and swimming beach, past the white-pillared facade of the Women's Club, and so on back to Miller Park below the Athenaeum. Alternatively, from his original position on the plaza, the visitor could turn left or northward. In this direction he would pass the Hurlbut Memorial Church and Norton Hall, home of opera and theater. By some veering and tacking, he would pass the little village of shack studios for piano practice and make his way through the Arts and Crafts Quadrangle. Eventually, by turning east and downhill, he would come out on North Lake Drive. Here he would find what Chautauquans call their Gold Coast. Instead of blocks of cheek-by-jowl cottages with their wooden filigree and almost-touching porch-balconies, he would find himself among ranch-houses with picture windows looking out over the lake from lawns or terraces of comfortable extent, their privacy further protected by plantings of yew clipped in a style that has reminded more than one observer of the Boboli Gardens in Florence. Passing the Gold Coast, the visitor will come back along North Lake Drive to where it meets end-to-end with South Lake Drive at Miller Park.

The lakeside scene gives an impression of activity pursued at leisure. It is unusual to see anyone in a rush at Chautauqua. On Miller Park, near the Miller bell tower, the children have a playground where they can crawl through the cavities in grotesquely sculptured shapes or dabble in the sand. In the elbow of Fair Point, the tots have a protected bathing or wading beach. A troop of listeners may be following a guide over the hummocks of Palestine Park, an approximate scale model of the Holy Land which uses a stretch of lakefront as a substitute for the Mediterranean. A file of docks thrusts its parallel catwalks out over the water, and small, brightly striped triangles of sail move slim hulls

through the ripples, piloted by youngsters who take a ducking now and then as a cat's-paw catches them unprepared. Fishing boats dot the surface of the lake, their occupants trolling for small-mouthed or large-mouthed bass, walleyed pike, or the prize of fighting fishes, for which Chautauqua is famous, the muskellunge. Statistics for 1970 record that over six thousand muskellunge were legally taken from the lake, their average weight 9.8 pounds each. Twenty-two percent of the licensed fishermen landed one or more, spending, again on the average, twenty-eight hours per fish. The trollers sit quietly in their scattered craft. Only the speed boats, bouncing along on their own for the sheer sake of velocity or towing water skiers behind them, create a din and a sense of motion in a hurry.

Especially as the afternoon begins to wane, shuffleboard disks will begin to whisper across the cement lanes of the court near the Sports Club, where elderly ladies and gentlemen propel their counters back and forth with practiced deliberation. If dusk has fallen, a visitor strolling by the water or viewing the scene from a balcony chair may notice that he is not being pestered by mosquitoes as he might expect. If a bat "with short shrill shriek flits by on leathern wing," as Collins puts it in his "Ode to Evening," the visitor will see the reason for his freedom from mosquito bites. If he looks into the subject, he will learn that the bat is a female left behind to raise young while the males travel on to spend the summer farther north. Chautauqua values its bat population and tries not only to protect but also to encourage it. By word of mouth, by notices in the *Chautauquan Daily* and in cottage rooms, the apprehensive are assured that bats will not get in women's hair, and that fear of a bite from a rabid bat is wasted worry. If a bat gets into a room, the occupant is urged not to molest it but to throw a towel over it and release it safely outside. Bats provide a mosquito control better and cheaper than poisoning the grounds and the lake with insecticide.

Chautauquans feel a strong attachment not only to their Institution but to its lakeside setting. They have compared their lake to Lake Como or one or another of the English lakes. Such comparisons are ambitious and depend not a little on the eye and the allegiance of the beholder. Lake Chautauqua does not have the advantage of a neighboring mountain range or shoreline of unusually striking contour. Its surrounding slopes rise more gently than ruggedly, and while their meadows and patches of woods look pleasantly pastoral from across the water, they hardly offer the excitement of the spectacular. But of course it is no longer possible to see the lake as the first Chautauquans saw it, still less the first white settlers of the county who moved in after the Ameri-

can Revolution when the region was still unexploited wilderness. Towns, resorts, motor roads, and sports traffic on the water itself have obscured the historic and even prehistoric backdrop that lies behind a scene of busy summer retreat.

Yet whatever its position in some scenic hierarchy, Chautauqua is an unusual lake, and some sense of how geological and human history has dealt with it adds an imaginative dimension to the Institution on its western shore. Tiny in comparison to the Great Lakes, small by the side of such a lake as Champlain, it is still a waterway of substantial extent. It stretches some eighteen miles in length on an axis from northwest to southeast, varying in width from a quarter of a mile to two miles. Its basin lies atop a ridge, some 1,300 feet above sea level and more than 700 feet above Lake Erie, eight miles away to the north. This seems a curious situation for such a body of water, and one might at least expect Chautauqua to drain down into its lower lying neighbor, Lake Erie, and so out through Lake Ontario and the St. Lawrence to the Atlantic. But the Chautauqua terrain as it is now was sculptured, we are told, by the long-vanished ice cap in its journey down the continent. Scrapings heaved up by the glacier blocked the natural northward drainage of the region, so that Chautauqua's outlet, the Chadakoin (one of many alternative spellings of Chautauqua before the name was stabilized), flows southward into the Conewango, Allegheny, and Ohio rivers and so contributes ultimately to the Mississippi in its descent to the Gulf of Mexico. Chautauqua has only brooks or creeks to spare for Lake Erie, and in its elevated basin is itself fed not by an inlet river but by springs, brooks, and run-off.

Before European eyes looked out across the lake, it was plied by Indian canoes, and the wilderness in which it lay was broken only by Indian villages and trails or by animal runs. County histories—one by Obed Edson published in 1894, another published in 1921 by the American Historical Society under the editorship of John P. Downs and Fenwick Y. Hedley, and still a third by Helen G. McMahon in 1958— record that the tribe of the Eries populated the region until the mid-seventeenth century, when the Senecas of the Iroquois Federation destroyed the Eries in a savage attack. From then until the period of white settlement by pioneers of the Holland Land Company, after the American Revolution, the region was Seneca territory. The French, long before the English, discovered the convenience of Lake Chautauqua as a waterway. Champlain's interpreter, Étienne Brulé, may possibly have seen it as early as 1615, before the Pilgrims landed at Plymouth. By a stronger probability, the chief of all French explorers in America, La

Salle, much later in the century, may well have reached the headwaters of the Ohio River by portage from Lake Erie to Lake Chautauqua and down its outlet. Another Frenchman, his name variously given as Céloron de Blainville, or de Bienville, or Bienville de Céloron, used the route for certain in 1749. This was the year in which the English had chartered the Ohio Land Company to encourage trade and settlement among the Indians of the Ohio Valley. To counter this threat to territory the French regarded as their own, Céloron was sent from Canada with a mixed force of French and Indians to reassert and solidify the French claims. His expedition, some two hundred and fifty strong, needed six days to make the uphill forest portage from Lake Erie to Lake Chautauqua. Paddling down the lake, they followed the river chain to the Ohio, Céloron burying at chosen points plates of lead on which formal French claims to the territory were inscribed. One of these plates fell into English hands, perhaps by the guile of a Seneca uncertain which side to choose. On it the word "Tchadakoin" was engraved, so that it was evidently intended for burial by the lake.

To reach its present form, the name Chautauqua has had to struggle through a dozen or more variants, French and English, from Tjadakoin (French) to Jadaghqua (English), all representing efforts at phonetic spelling of a word of Seneca origin. After the county had been settled, the spelling Chautauque persisted until 1859, when a resolution by the county supervisors fixed it in its present form. Not only the attempt to spell the name but the interpretation of its meaning has given rise to differences. A legend has it that an Indian girl ate a thirst-provoking root by the lakeshore, bent to drink, and was never seen again. Hence the name has been taken to mean "place of easy death." By another interpretation, it signifies "pack tied in the middle," or "two moccasins tied together," a sense that gains at least topographical support from the division of the lake at its narrowest point into upper and lower basins. By another story, a party of Senecas caught a fish in the lake of a kind unknown to them. They tossed it in a canoe and found it still alive when they made their way back to Lake Erie, where they threw it overboard, and after a time, by an unexplained biological feat, fish of the same species began to appear there plentifully. An explanation in keeping with this story holds that "chautauqua" is compounded of two Seneca words meaning "fish" and "taken out," an etymology that one could reduce to plain "Fish Lake."

Some four years after the expedition of Céloron de Blainville, the French built a road over the portage route from Lake Erie to Lake Chautauqua, watched the while by a British scouting party to see what

they were up to. A witness quoted in Obed Edson's history says that this road was plainly visible at points and could be tracked for most of its length in 1827, and that traces of it could still be detected in 1890 when Chautauqua Institution was sixteen years old. But not only the French by their road and the Indians by their bones, their artifacts, and the relics of their fortifications left their memorials in the region. In the mild climate that prevailed after the retreat of the ice cap, long-extinct mammals, the mastodon and the North American elephant, made it their habitat and left teeth and other skeletal fragments. Bones of a mastodon were found a mile from Jamestown in 1871. Buffalo, elk, and reindeer, according to Edson, survived in the county into the historical period.

Pioneer settlers found the local fauna both a source of plunder and of menace. Helen McMahon says that flocks of passenger pigeons "several miles long" were in evidence as late as 1850. People netted them in great numbers or, if they only wanted a few, set up poles against which the birds killed themselves in flight. Wolves so threatened sheep that the state, the county, and most towns united to offer bounties for each full-grown specimen. Wolves could hardly sustain themselves against such cooperative hostility. McMahon gives an account of a wolf hunt in 1824 in which two hundred and sixty-odd men formed a hollow square a mile and a half on a side and closed in around Cassadaga Swamp, netting only two wolves, but a miscellaneous catch of one bear, several deer, and many rabbits.

Trees, of course, were another object of conquest and profit to early settlers. They had to rape the valleys and ridges of their pristine growth, pine and hemlock in the lower-lying areas, hardwoods such as maple, oak, chestnut, beech, and cherry on the higher slopes, in order to open the land for farming. Obed Edson gives an account, a sort of postmortem biography of a particular tree, that suggests the stature to which the original forests could attain. It concerns a black walnut that blew down on April 22, 1822. The butt was hollow, and a twelve-foot log was cut from it and scooped out to make a rough cylinder, which had a circumference of thirty-one feet. A man was said to have ridden through it on horseback while it lay flat, and this would have been quite possible, as anyone can verify by working out the simple arithmetic of pi. Raised upright, the log served as a parlor for a ladies' tea party. It made its way to a museum in New York, where it became a museum in itself, fitted up as a drawing room garnished, among other items, with a letter in the hand of George Washington. From New York the log went to London, where its arrival was noticed in the *Literary Gazette* in 1828,

and where it eventually perished by fire. A regional equal to this particular tree does not seem to have reached the annals, but it was not without good company, such as an oak six feet in diameter at the stump and only a foot less than that sixty feet above the ground. It supplied the wood from which eight hundred firkins with their heads were made. No such trees exist now, in the cut-over forests of the East, to be burned for potash or bunched into rafts and shipped down the river chain into the Mississippi, yet good reminders of them still rise in the parks on the Chautauqua grounds, especially the fine hard maples, of stout girth, whose straight, rough-barked trunks climb cleanly to an impressive height before branching out.

By 1824, according to Helen McMahon, so much merchandise and household furniture was passing through Jamestown at the southern end of the lake that a certain Elisha Allen experimented with a novel kind of transportation. He built a horse-boat, a scow with a passenger cabin on one side and a stable for eight horses on the other. Four horses at a time turned a drive-wheel geared to port and starboard paddle-wheels. The contraption was an example of ingenuity rather than success. It took ten hours with a favoring wind to reach Mayville, the next town up the lake, and sometimes a week for the round trip. In 1827 Jamestown saw the beginning of a more efficient means of transport, which was to serve for many years as the principal mode of ferrying passengers and baggage to the Chautauqua grounds. This was the first of the lake steamers. To celebrate its launching a cannon was mounted on one of Jamestown's hills. A lady broke a bottle of currant wine across the ship's bow and proclaimed, "I name thee 'Chautauqua.' " As the duly christened vessel moved down the ways, and again when it struck water, the cannon fired, to the satisfaction of a crowd that had assembled from miles around. As figurehead the craft bore what was described as "A magnificent figure of a female head and bust" This was the forerunner of a fleet such as carried President Grant to one of the earliest Chautauqua sessions. The steamers represented an advance in transportation, but they were not immune to mishap. A number of them burned up, and the boiler of a successor to the vessel proudly launched at Jamestown, the "Chautauqua No. 2," exploded while the ship was taking on wood at a landing, killing eight people, injuring others, and leaving a rubble of wreckage as memorial to a major disaster. Rival captains added excitement and sometimes danger to lake travel by racing their craft in true Mississippi style, and rival crews indulged in fist fights in their competition to capture waiting passengers. It used to be said that Chautauqua was the highest navigable lake

in the world. A more cautious statement in Downs's and Hedley's county history is that at the time of the first lake steamers it was the highest known to be navigated by that particular means.

A visitor to Chautauqua today, if he drives from the outskirts of Buffalo to the town of Westfield and on up the grade to Mayville, will notice that he is driving through a grape belt, the most conspicuous horticultural feature of the region. He will go by acres of vines trained on wires that are strung on posts two or three feet high. As far back as 1818, according to Obed Edson, Deacon Elijah Fay tried to transplant native grapes from New England, and failing in this venture, made further efforts with Isabellas and Catawbas from Long Island. His son, in the 1850s, introduced the Concord grape, and a contest sprang up between this and other varieties, in which the Concord won by surviving the winter of 1873, a year before Chautauqua began. At first grapes were considered useful only for wine, and the progress of grape culture was slow, but momentum picked up until the amount of fruit shipped or made into wine at home increased from a few thousand baskets in 1867 to 13,000 tons in 1891. An article in the *Chautauquan Daily* for August 21, 1969, celebrates another step in the growth of the local grape industry. Just a hundred years earlier Dr. Thomas B. Welch had made his first batch of "Dr. Welch's Unfermented Wine". Dr. Welch, a communion steward of his church who disapproved of wine, applied Pasteur's principles to the Concord grape to prevent fermentation. It was his son who named the product "Welch's Grape Juice" and made it a component of what became a multimillion-dollar business. Unfortunately for visitors who come from a distance, grapes are harvested after the close of the Chautauqua season, so that they miss the opportunity of tasting New York State Concords fresh from the vine.

Chautauqua made itself famous in its early decades by its pioneering educational ventures. A common assumption, against which the founders of Chautauqua resolutely set themselves, was that education, so far from being a lifetime enterprise, came to an end with the end of traditional schooling. Helen McMahon describes the early nineteenth century as "the heyday of the tuition academy." Public high schools were not available, and if children wanted to go beyond elementary study, their parents had to supply them with money for tuition and board at an academy or "subscription" school. Her account of Fredonia Academy, founded in 1826 in the town of that name not far from Chautauqua, is illustrative. The "subscription" by which Fredonia was built, according to the account McMahon quotes from Obed Edson, included, in addition to a modest sum of cash, "every form of material for build-

ing . . . besides cattle, rye, corn, chairs, cabinet work, shoes, and hay. Solomon Hinckley gave $30 in pork, 10 bushels of corn and 10 of rye and 300 pounds of beef. . . . Lyman Ross subscribed 20 gallons of whiskey." The upper story of the building "was reserved perpetually for the Presbyterian church for a place of worship." Both young ladies and young gentlemen, as they were known at the time, attended such academies. Fredonia, in the forty years before it was absorbed into a high school, attracted students from all the existing states except South Carolina. According to McMahon, tuition cost four dollars a term, with an extra fee for music and drawing. Board and room, with washing included, ran from a dollar to a dollar and a half a week. One of the co-founders of Chautauqua, Lewis Miller, studied during his early years at a subscription school in Ohio.

Chautauqua itself was born into the age of bitterness and stumbling reconciliation, the age of industrial and social strife and expansion, that followed the Civil War. It was the Gilded Age, to give it the name it acquired from the title of the novel by Mark Twain and Charles Dudley Warner, published in 1873, a year before Chautauqua began. Federal troops still occupied some of the Southern states, not to be finally withdrawn until the disputed election of 1876 by which Rutherford B. Hayes obtained the presidency instead of Samuel Tilden. The last attempts by the Republican radicals at Congressional reconstruction, as distinguished from the wound-healing policy of Lincoln, were coming to an end, as well as the last spasms of "Bloody Shirt" oratory. The Ku Klux Klan had been formally disbanded in 1869, but the South found other means of maintaining white supremacy, not excluding lynching and murder. A climate of scandal and corruption lingered from the break-up of the Tweed Ring, which had milked the city of New York of millions of dollars, and from such exposures of chicanery under the administrations of Grant as the Credit Mobilier, by which Union Pacific Railroad magnates had put blocks of stock in the hands of congressmen and senators and even Grant's vice-president. During the first Chautauqua decades, the foundations of great American fortunes were built up, the the fortune of Andrew Carnegie in steel, of John D. Rockefeller in oil, of railroad builders and speculators such as James J. Hill and Leland Stanford. Ruthlessness toward competitors, arrogance toward the public, and bribery of legislative bodies marked the activities of the Robber Barons. But if to be constructive meant to transform America into a complex and immensely powerful industrial society, a transformation greatly accelerated by the Civil War itself, then the ruthlessness and corruption had their constructive side. The railroads were built, the steel

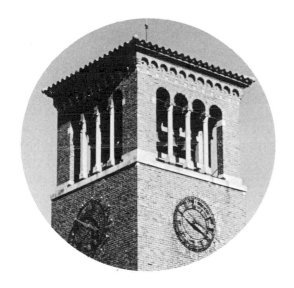

produced, the oil pumped and refined, and the financial organizations required by the scale of such activities were created.

All this could scarcely be accomplished without rural unrest and without attempts by labor to organize itself against financial and industrial forces that operated on the principle of laissez-faire and were often supported by courts that had imbibed the social Darwinism of Herbert Spencer. Farmers took out their resentment against middlemen and the rate-setting powers of the railroads through the Granger movement and the Greenback party. The Grange had originally been designed as a cultural and educational organization, but with the panic of 1873 the farmers turned it to economic ends and launched the first notable cooperative movement in the nation. The Greenback party in 1876 sought redemption of the national debt in paper currency rather than gold, a measure that would have favored debtors as against creditors. Lewis Miller, one of the two "pilgrim fathers" of Chautauqua, ran unsuccessfully for Congress as a candidate of the Greenback party. Labor's problem of organizing effectively was complicated by increasing immigration and by a shift in the balance of its traditional sources, British and Irish, to various European stocks. In 1887 agitation against Chinese labor in San Francisco led to serious race riots that had their part in bringing about Asiatic exclusion as an immigration policy. In the same year unorganized railroad employees struck against the second wage cut since the panic of 1873. Pitched battles between militia and the strikers, with their supporters among the unemployed, occurred in such cities as Pittsburgh and Chicago until order was restored by federal troops. By 1884, the Order of the Knights of Labor won a railroad strike, compelling the financial baron Jay Gould to treat with their leaders and grant their demands. Anarchism and socialism played their part in the evolution of labor as an organized force. In 1886, during a period of prosperity, a strike of mixed elements in Chicago led to the Haymarket Square riot in which, after a bomb had been thrown, eight police were killed and over sixty wounded. Four of eight anarchists were hanged, though the man who threw the bomb was never identified. Of the four not hanged, Governor Altgeld later pardoned three who were still alive in jail, and thereby sacrificed his political future. By the late 1880s, Samuel Gompers had emerged as leader of the American Federation of Labor, which became, in Samuel Eliot Morison's words, "the fighting spearhead of the American labor movement."

All this abrasive evolution in a country exerting its energies in every direction after a still recent and bitterly divisive war forms more than a backdrop for the early years of Chautauqua's growth, for the social

forces and contentions by which Chautauqua was surrounded rapidly found diverse and uninhibited reflection on its "open platform." The immediate goal of the Sunday School Assembly that became Chautauqua as it is now known was the improvement of religious education among the established Protestant sects, but the minds of the founders were too capacious to be limited to Sunday school pedagogy, as the history of the institution they created quickly began to show.

THE LEWIS MILLER COTTAGE

The Founders

Chautauqua has reflected and influenced the cultural history of America in more ways than one can easily keep in mind—in education, in religion, in concern for reform, in discussion of issues, in the arts, especially music, and in entertainment. Piety and idealism strongly marked its beginnings, yet it did not spring from the motives that gave rise to the Utopian societies of the earlier nineteenth century. Its people were largely middle-class, and came not to withdraw from the world, to set up a countersociety, to the existing America, or to form a new sect. They came for a summer day or a week or the whole season, to study, to enjoy idyllic surroundings, to be fortified and instructed in their Protestant faith (Catholic, Jewish and Christian Science worship received welcome in due course), or to be innocently amused, and when the visit or the season was over, they went back to their homes and occupations in the milieu to which they were accustomed. Chautauqua had what may seem a prosaic and even improbable origin, though the improbability fades as the story unfolds. Chautauqua began in the minds of two Methodists, stout-hearted, imaginative, and intellectually flexible, one of whom eventually became resident bishop of his church in Europe, with headquarters in Zurich, the other an inventor and manufacturer whose business success enabled him to become an important benefactor not only to Chautauqua but to other institutions as well. Both acquired an early interest, amounting to a passion, in education, strengthened by the fact that each had to forego, or felt called on to forego, the higher education he would have liked to complete.

John Heyl Vincent, the future bishop, was born in the South, at Tuscaloosa, Alabama, in 1832. His father had moved to Alabama for business reasons and there met his wife, by birth a Philadelphia girl. John Vincent wrote much later in life: "I have always felt a measure of pride in the fact that I was born in the South." Although he had no opportunity to become well acquainted with Southerners until after the Civil War, he was sympathetic toward them and anxious to see the country healed and unified after its bitter division. The South has always

been well represented at Chautauqua, and the Institution may claim to have made a modest contribution toward damping down sectional antagonism by its hospitality and sympathy.

Vincent's predilection for preaching made an early appearance. His nephew and biographer, Leon Vincent, records that as a small child he played at exhorting a group of black children, and quotes a reminiscence from him in later life: "My little hymnbook in one hand and a rod in the other, I was fully prepared to keep order and impart instruction." His mother wrote in a letter: "I wish you could now see John; he is standing beside me with his Bible and hymnbook before him, his hands spread out, preaching. He says he is preaching in Greek."

John's father moved the family to Northumberland County in Pennsylvania in about 1837. There, while not in school, John worked in his father's country store in Chillisquaque. He absorbed what was available in nearby schools and could report that he had mastered English grammar thoroughly enough to be able to parse glibly. "I spent months in thus dissecting Milton's *Paradise Lost*," he wrote, "and I nevertheless still revere the poem and its author." He worked at Latin grammar and Caesar and studied elementary textbooks in astronomy, physics, and chemistry. In his father's library he could find the *Encyclopedia Americana*, Pitkin's *History of the United States*, Gibbon, Plutarch, Shakespeare, the *Spectator* papers, and poems by James Thomson. The family was given to singing, and could call not only on the *Southern Harp* but airs from Mozart and Haydn and American favorites of the time. Eventually a piano made its appearance in the house. With Caesar, Gibbon, Shakespeare, elementary science, and the unperturbed admiration of a pious Methodist family for Joseph Priestley, the English Unitarian who had settled in Northumberland County in 1794, the young Vincent did not lack for intellectual fare. This early range of exposure is symptomatic of the enthusiasm he could show for comprehensive education while remaining untroubled in his Methodist belief.

Vincent followed an established pattern in passing immediately from his early schooling to teaching in his own right. From a man named Pelton he learned an art known as "Singing Geography" and went about in neighboring villages teaching it. Later he put it to use in the "Palestine classes" which he founded in connection with Sunday school work and which eventually led to the establishment of Palestine Park as a feature that still remains at Chautauqua. But the passion for education that never left him was inseparable from his sense of a vocation to the ministry. In 1850, in his eighteenth year, he was licensed to "exhort," in a document of pleasantly erratic spelling: "This is to Authorize John

H. Vincent, Jun. to exhort in the Methodist E. Church so long as his Doctrine, Sperit, and Practice corrispond with the word of God, and the Disciplin of said Church." He was assigned to the Luzerne circuit, a large one, which it took him four weeks to cover in its entirety. Happily, as his biographer comments: "He had excellent health, ambition, and a good horse." Jogging on the road, he could read Dante in translation, study articles on Comte's positivism in the *Methodist Review,* and memorize pages of Campbell's *The Pleasures of Hope.*

Vincent's religious sensibility at this time betrays one of the more damaging effects from which children of fundamentalist upbringing have suffered more than their elders could imagine. The prevailing impression of his life is one of cheerfulness and vigor, but in his boyhood, millennial excitement reached a pitch of intensity. The Millerites (William Miller and his disciples) were anticipating, to the day, the second coming of Christ to judge the quick and the dead. Some of this emotionalism coincided with the appearance of a comet in the sky, and even men of ordinary stability were afflicted with metaphysical apprehension. Vincent, viewing his boyhood, considered that he had too early been impressed by the morbid strain in the religion in which he had been brought up. "I used to be filled," he confessed, "with an anxiety which no 'consolations of religion' that I knew anything about were able to alleviate." He did not express resentment, but wrote that it was through the influence of his mother that he had been "saved from permanent morbidness, and from the reaction which often comes to a man when the religious instruction of his youth has been a discipline of legality without love."

The death of John's mother in 1852 broke up the Chillisquaque home. John and his father moved in different directions. John was given charge of the City Mission in Newark, New Jersey, where he took occasion to enroll at the Newark Wesleyan Institute. A complete college education still lured him with temptation and hope, but he eventually rejected it, at least partly because the need for pastoral work was urged on him as a superior claim. For a decade he was actively at work ministering to churches, first in New Jersey, then in the Rock River Conference in Illinois, where he served in Joliet, Galena, Rockford, and Chicago. At Galena he found Ulysses S. Grant among his congregation, and began a friendship with him that lasted through Grant's death. When Grant left Galena with the Jo Daviess County Guards in April of 1861, a first step toward Appomattox, John Vincent addressed the departing group from the top of a freight car. During his years in Illinois, in 1858, John courted and married Elizabeth Dusenbury. She appears to have

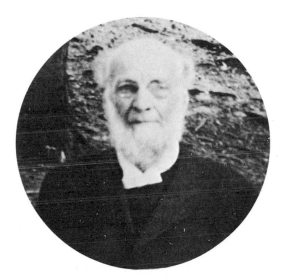

Bishop John Heyl Vincent

been an avid reader from girlhood who had ploughed her way through Carlyle's *Frederick the Great* and who, during his boyhood, read to her later very eminent son, George Edgar Vincent, from Scott, Dickens, Thackeray, and George Eliot.

During his pastorates in New Jersey, John had already conceived two educational ideas which were later to bear fruit through Chautauqua. One was a scheme for theological study by prospective ministers who were not formally enrolled in a seminary or college. It consisted of a balance of public lectures and planned private reading, in which the germ of the Chautauqua reading circles is visible. The other was his plan for "Palestine Classes," to make Sunday school students thoroughly familiar with the geography of the Holy Land and with general history as reflected in the Bible, including Oriental manners and mores. In the words of Jesse Lyman Hurlbut, "Near the church he staked out a map of Palestine . . . and led his teachers and older scholars on pilgrimages from Dan to Beersheba, pausing at each of the sacred places while a member of the class told its story." In keeping with his predilection for ceremonies, titles, and tangible forms of recognition, the successive grades who met the Palestine Class requirements were known as Pilgrim, Resident in Palestine, Dweller in Jerusalem, Explorer of other Bible Lands, "and after a final and searching examination, Templar, wearing a gold medal." In the Palestine Classes his earlier apprenticeship to "Singing Geography" played a part as a mnemonic device for assimilating biblical place names.

An important enlargement of his experience took place in 1862, when he was sent as a delegate to the General Sunday-School Convention in London. His journey not only introduced him to England, but also Ireland and Scotland and then Europe, where he did the accustomed sights in Paris, worked to improve his French, went on to Florence and Rome, and managed finally to satisfy his eager desire to visit Egypt and Palestine. Thereafter, as one who had seen the Nile, the Dead Sea, and the Jordan, and had carried out in person the journey from Jerusalem to Damascus, he was able to make a special impression on biblical students.

On his return to Illinois, he was assigned to Trinity Church, Chicago, where he became one of the leaders among a group of men, not all Methodists, who were concerned to improve the work of the Sunday schools. Vincent was anxious that such schools should make use of all the best pedagogy available. The notion was abroad of a concerted effort by all Sunday school teachers, regardless of denomination, to raise the standard of their work. Vincent proposed, at a teacher's meeting at

Freeport, Illinois, in 1861, the formation of a Union Sunday School Institute for the Northwest, which would issue its own publication to provide lessons and appropriate articles. The institute and its journal, under various names and formats, took root, and eventually Vincent became editor of the Sunday School Journal and corresponding secretary of the Sunday School Union, posts that moved him to Plainfield, New Jersey, and superseded his pastoral commitments. One of his beliefs from the start was that Sunday school lessons should be made uniform, not left to the hazards of sect or local and untrained teaching. Overcoming denominational jealousies, skepticism, and contentions of rival publishers, the idea prevailed. The scheme was nationalized, and finally internationalized, the sects agreeing to study the uniform lessons, but each left free to supply its own interpretive notes.

Thus Vincent became immersed in the Sunday school work that was to lead him into collaboration with the other and equally indispensable founder of Chautauqua. But the convulsive bloodletting of the Civil War had to subside before that particular collaboration could take place. Vincent served in 1865 with the Christian Commission as a delegate among ministers and laymen of all denominations. He visited and helped men who had been wounded. He preached to congregations that included Confederate prisoners, saw two deserters shot at City Point, Virginia, walked from Meade Station to Petersburg across the scene of recent fighting, and recorded meeting a young woman "bristling with secession quills." He called at Grant's headquarters and there talked not only with his former parishioner but with President Lincoln. When General Grant was welcomed at Galena on his return from the war, Vincent made for him the speech of thanks that the reticent Grant declined to make for himself.

The war over, at Akron, Ohio, in 1868, Vincent met Lewis Miller, the co-founder of Chautauqua, and an equally remarkable and interesting man. Lewis's grandfather, Abraham, who wrote the name as Müller, came to Baltimore from Germany in time to enlist in the Continental Army and spend a memorable winter at Washington's camp at Valley Forge. Eventually he took his family to northern Ohio, pioneer country, where he had to clear land for farming and build a log cabin for living quarters. Lewis's father, John, built his own log cabin, supplanting it later by a brick house at Greentown, in Stark County. Lewis's mother died shortly after his birth in 1829, when she was still a girl of twenty-two. Next year Lewis's father married a widow, Elizabeth Aultman, whom Lewis regarded as his mother. The energy and stability of his life suggest that she satisfied the boy's needs, though she brought to

the household two children by her first husband and added six more Millers to a family circle already containing Lewis and two siblings.

In an autobiographical fragment set down late in his life, Lewis wrote: "My father was a farmer who had made his home in the virgin woods. He wrested his fields from the forest with his axe, and by the help of that simple implement he had also built the house in which we lived. Though built of logs it was roomy and comfortable. . . . My parents were industrious, thrifty, and well-to-do . . . if our home lacked the luxuries of modern life, the essentials were always present in abundance." Lewis grew up in a family atmosphere of piety, but his father did not hesitate, on the visit of a circuit-riding preacher, to offer his guest a stiff whisky toddy. The guest in turn offered Lewis, then aged three, a sip for himself, and Lewis liked it so well that he was allowed all he would take, with the result that he became reeling drunk, to the less than tender amusement of his seniors. In Greentown in 1850, says Lewis's biographer, his father had a cabinetmaker's shop, a large farm, and a small whisky distillery. Lewis in later life continued to drink a toddy with his father until his church became politically active in the temperance movement, when he turned teetotaller. Possibly with as much nostalgia as truth, he confessed that he might even have become too fond of alcohol. Lewis's stepmother, who seems to have been a woman of notable vigor in managing her household tasks and bringing up its numerous children, liked to relax with her pipe at the end of the day.

Greentown, where the family had settled, lacked a public school but did contain a subscription school where Lewis studied and showed himself an omnivorous reader. His intense desire for education and his intense interest in its methods and philosophy began early. He followed a similar course to John Heyl Vincent's by beginning to teach a rural school at the age of sixteen. He either studied or taught every winter until he reached twenty-one. Many stories record the ingenuities of country schoolmasters in outwitting their pupils, and Lewis Miller made his contribution to the endless contest. It was customary to hold a school session on Christmas day, when the teacher was expected to provide candy as a compensation. Miller came supplied with candy but found that his class had gone into the school building and locked him out, proposing not to admit him until the candy had been distributed. He got a plank from the woodshed, climbed up on the roof, put the plank over the chimney, and smoked the class out, giving them the candy on his terms, not theirs.

In later life a notably practical and successful man, Miller none the less responded intensely to the natural surroundings in which he was

brought up. When in late years he was persuaded to set down an auto-biographical record, he seems not to have got beyond a few nostalgic pages largely recalling scenes and impressions of his boyhood. He speaks of a marsh near the Miller home, "the wave of bird songs that arose from [its] thickets in the spring, the hum of its invisible orchestra of insects in the summer days, the great chorus of its frogs at night." And he dwells on the vehicles that he watched on their way past, the stages, the freight-carrying Conestoga wagons, their drivers armed with black-snake whips. "Often and often," he writes, "do I entrap myself, even now, wandering back in reverie to those jaunty four-in-hand stages, and the slow-trailing freight-wagons with the big watch-dog marching along under the front axle, and the black tarbucket swinging from the tail of the reach."

Despite such sensory responses, persisting in memory through a life-time, Miller early took an antipathy to farming. He saw the farmer, in the classic phrase, buying in a retail and selling in a wholesale market, and between the two being exploited by the railroads and an array of middlemen. He was to contribute important labor-saving machinery to the agricultural economy of his day, but his sympathies with the farmer went beyond successful manufacture. They led him into a position of political radicalism unusual for a highly prosperous inventor and man of business. Unsuccessfully, he ran for Congress on the Greenback ticket. The two lasting absorptions of his life were education and the improvement of agricultural machinery by invention, adaptation, and skilful plant management.

In his distaste for farming, Lewis Miller had learned the plasterer's trade. His emergence, with no apparent previous experience, as a me-chanic, inventor, and manager seems to represent one of those cases in which an unrevealed talent is brought to light by the luck of circum-stance. Lewis was drawn into the production and improvement of farm machinery through the marriages of his step-sister and step-brother, Cornelius Aultman, which involved him in a firm that operated a ma-chine shop in Greentown. Lewis's mechanical improvements and de-velopments budded off from a prototype of the cutter-bar patented by Obed Hussey of Baltimore. Hussey's invention was an all-important step in the development of labor-saving mowers and reapers, but it had defects that gave Miller his first opportunity to show his inventive tal-ents. Miller devised a way of attaching the cutter-bar to the frame of the mower by a double-hinged joint, which allowed the bar to follow the contour of the ground. He also invented a device that allowed the driver to raise the bar at various angles, so that the driver could lift it over

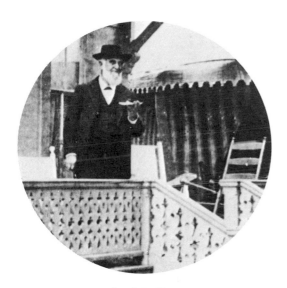

Lewis Miller

rocks without stopping, backing, and veering. He worked out a two-wheel drive that evened the pull on the horses, and he shifted the cutter-bar to a position in advance of the driver, so that if the driver were pitched off he would fall behind the knives and not in front of them. So began the Buckeye Mower and Reaper, which in 1857 was awarded a medal for its utility.

In the course of developing his inventive and manufacturing talents, Lewis found himself in Plainfield, Illinois, on a mission to open western territory for labor-saving farm machines. There he studied at Plainfield Academy during the winter of 1849, and fell in love with Mary Valinda Alexander, daughter of a well-to-do farming family. Letters between them, full of the quaint formality, the reserves and decorums of Victorian America, recount their extended engagement. Lewis seems to have felt a tug between the claims of further education and the claims of marriage. It was not until he had returned to Greentown and acquired an interest in the firm of Ball, Aultman and Company that he finally made his way back to Plainfield in 1852 for his marriage, forgetting to pack his wedding trousers so that his bride and her mother had to collaborate in making him a pair. Mary Valinda was known as a frail child, but she bore eleven children and lived past her eightieth year.

By 1863 the firms in which Miller shared an interest had become two branches, Aultman, Miller and Company, transferred to Akron partly in the hope of more favorable freight rates, and C. Aultman and Company in Canton. In 1864 the combined Akron and Canton works produced eight thousand Buckeye Mowers and five hundred threshing machines. The Canton business had already made all the partners rich. One business misjudgment deprived the enterprise of considerable profits. The Aultman and Miller binding machines used wire for binding wheat sheaves. When D. F. Appleby devised a binder that used twine, a contest arose between the two materials. Twine won, and by declining to acquire Appleby's patent on his terms at the start, Aultman and Miller eventually had to pay a great deal more to hold their competitive position. Miller finally worked out a lighter and more compact machine than others on the market. Speaking of it, Henry Ford said to one of Miller's daughters: "The first job I ever had was setting up your father's low-down binders in the field. I never see one that I do not want to go and pat it. There never was a better machine made."

The move to Akron, according to his biographer, brought a change in Miller's life-style. He acquired a large house, Oak Place, on a rise above the town, enriched his property with exotic trees and landscape gardening, and became a prominent citizen and a man of the world without

ceasing, as he put it, to be "as good a Methodist as I can be." He liked good horseflesh and enjoyed family high-jinks. He omitted the custom of family prayers, not, it seems, from any slackening of piety, but from suspicion of devotions that might be hurried or merely ceremonial. At the same time his passion for education continued in full force. He was a member of the Akron Board of Education and served as its president for several terms. In 1865 he joined and later became president of the Board of Trustees of Mount Union College, said to be the first in America to give full educational privileges to women as well as men, and the first to include electives instead of limiting the students to a rigidly prescribed curriculum. At Miller's urging, Mount Union also became the first college to adopt the four-term academic year, giving students who came mostly from farm families the opportunity to use any of the terms for study or for work, as circumstances made it seem best. The four-term year was still a novelty when William Rainey Harper, after leaving Yale and Chautauqua, installed it at the University of Chicago. Miller also urged making the scientific faculty as broad as possible and commended the value of soil chemistry, surveying, and other practical applications of science for the clientele of the college. Besides his services as trustee, Miller and his brothers became considerable benefactors to Mount Union as well.

As with John Vincent, Sunday school improvement held a strong place in Miller's educational concerns. Already, in his twenties at Canton, he had served as Sunday school superintendent, had introduced graded classes instead of allowing pupils of different ages to be lumped together, and had recruited teaching staff from the secular schools. One of his Canton teachers was Helen McKinley, sister of the future president. His Sunday school concerns brought out still another latent talent in a character of many resources. He had architectural as well as mechanical imagination, and at Akron, together with the architect Jacob Snyder, he worked out the design of a Sunday school building which was imitated the country over. The notion came to him at an Akron Sunday school picnic where the company "were seated for . . . public exercises in a sort of natural recess in a grove; the ground on three sides sloping toward a common centre." The topography of the scene suggested to him a semicircular assembly room surmounted by balconies, with separate classrooms extending outward from the main room and given privacy by movable partitions. Thus each graded class could enjoy its own protected meeting place, but the partitions could be withdrawn to bring the whole company together for general exercises.

Miller's building proved highly successful, but to improve Sunday

school teaching meant to improve the training of teachers. Miller instituted conferences with his teaching staff on Sunday evenings to prepare the next week's lesson, and a Normal class program corresponding to the last two years of high school. He continued to draft teachers from the public schools and included the study of science and nature in his program, especially for older pupils. Conceiving of Sunday school as an occasion of enjoyment and enthusiasm, he gave importance to music. Anyone who could tootle acceptably on an instrument or draw a bow competently across a string was welcome to join the band. Miller's own enthusiasm was infectious, as he came early to Sunday sessions with his arms full of flowers from Oak Place.

When some six years after their first meeting in Akron, Lewis Miller and John Vincent joined to launch their Chautauqua venture, they had strong bonds of common interest and shared important traits of character, but in certain ways they stood in marked contrast to each other. Vincent was thoroughly a cleric of his church; Miller was a layman, a highly successful inventor and man of business. Vincent had natural platform presence and eloquence, and used it extensively; Miller would not be teased to a platform, and remained self-effacingly in the background as custodian of practical affairs, benefactor, and manager. One of two ladies who had originally recommended Fair Point as an idyllic site for the Chautauqua enterprise relates in a letter that Miller was absent from the final meeting of the first Assembly and could not be found. He was eventually discovered lying exhausted on a sofa. A water pump had broken down, and lacking help he had gone to repair it with his own hands. No one had mentioned him from the platform, but when the ladies deplored this omission as a scandalous oversight, he said, 'What difference does it make who gets the praise if only the thing itself is a success."

The two men seem to have been in nearly perfect sympathy in their educational ideas, though they reached their collaboration by different roads. Miller's son-in-law, the more famous inventor Thomas A. Edison, wrote of him that "he seemed to be eternally making money in his factory in order to enable him to better carry on his schemes for education." Vincent's road was through the channels of advancement in his church. Both men were entirely hospitable to science and general knowledge, including music and the arts, as proper studies in a world made by a universal creator. Both possessed independence and curiosity of mind, and would not be deterred from carrying out their educational ambitions by narrowness of piety or contentions of sect. They had that freedom from intellectual intimidation that can accompany a strong

central faith when it is in fact faith and not a predetermined adherence to vulnerable tenets. Neither was by temperament a theologian, but rather concerned with the improvement of the human condition and the use of fundamental Christian piety and ethics as an instrument to that end. This equable liberality of mind is illustrated by some words of Vincent, when, as bishop, he visited South America. At Buenos Aires, he wrote, "The theological school is doing excellent work. Some stir was caused by rumors concerning the teaching of what is called the 'higher criticism,' and a few of the younger students, looking through smoked glass for the first time, made more of the spots on the sun than was necessary, and gave the impression that the principal thing taught in the institution was the scientific theories concerning spots. And some good people were afraid that the School of Theology had damaged the sun, and that it might go out entirely."

The words are imperturbable enough, and suggest another trait credited to both Vincent and Miller, a sense of humor. Humor is a highly perishable commodity, and difficult to retrieve in its original effect from records of the past. But another anecdote may show that Vincent's presence did nothing to discourage sallies that hit the mark. At a church congress at Chautauqua, Vincent was entertaining at his hotel table two visiting speakers, one the pastor of a Fifth Avenue church in New York, apparently Johnsonian in speech and not lacking in clerical unction, the other the famous Georgia-born evangelist, Sam P. Jones. Vincent asked the Fifth Avenue visitor, "What are your methods in dealing with young and immature minds?" "Ah," came the answer, "in the effort to establish relations of sympathetic receptivity. . . . I try to employ language that is essentially simple. . . ." and so on. Vincent then put the question to his other guest. "Mr. Jones, what are your methods?" "Oh," said Jones, "I put the fodder on the ground, where anything from a jackass to a giraffe can get at it."

One episode is told of Miller that has no counterpart in the recorded life of Vincent. Miller was not a quarrelsome character, though he could be persistent in the use of his powers of persuasion. Yet on one occasion he proved himself capable of using muscular Christianity in what he considered a good cause. An Akron citizen known as the "Oatmeal King" wanted a spur railroad line built to his mill. The spur was to be sunk below street level with a bridge-crossing for school children and pedestrians, or so Miller believed. When he discovered a foreman with a gang of Italians laying a grade crossing at the foot of the hill on which Oak Place and other residences stood, he took measures. Known for his adroitness in his relations with his work force, Miller issued a call to

his factory hands and led them in person, Buckeyes against Oatmeals, in a free-for-all that would have made a stirring episode in an Alec Guinness film.

These were the men who founded Chautauqua. They could not have brought their enterprise to such success if their association had not represented a friendship on a higher than common plane, a friendship it is still pleasant to contemplate. In what was to prove the last year of Miller's life, they signed a paper in which they said: "The question of personal pre-eminence or priority as to the original elements and plans for Chautauqua is forever dismissed. The two claim joint ownership and fellowship; and no recognition of the one shall by our permission be acknowledged without the recognition of the other." This expression of solidarity is obviously touched with no small pride as well as with renunciation of rivalry. Yet when he spoke at Miller's funeral, Vincent admitted the inevitable differences with which they had had to contend. "No great enterprise," he said, "can be developed by an association of men without divergence of view and conflict of policies. The more intense the devotion of such men to the cause they love the more likely they are to grow warm in advocacy and debate. And good men are not always perfectly well poised, and few men can look back on intimate association in business and not find grounds of regret." Having said as much, Vincent added a sentence more directly expressing his sense of loss: "They covet one more chance for an exchange of opinion, one more hand-grasp for the sealing of friendship."

After the money panic of 1893, Miller suffered business reverses that cost him a considerable portion of his means and a collapse of his health. In 1898 he lost a son, Theodore, who had enlisted a year after graduating from Yale in Roosevelt's Rough Riders and was killed in the battle of San Juan Hill. When his body was brought home from Cuba, John Vincent spoke at the commemorative services for Miller and three other Akron soldiers. The burden of his extended address is suggested by a paragraph:

A soldier is more than an individual, more than a man!
You cannot think of him or estimate him as one citizen, as son,
brother, father. When you look into his closed eyes you see
constitutions, history, laws, rights, prerogatives, powers. When
you touch his cold body you touch a sacred thing, and you
hear drumbeat and bugle call and the thunder of armies!

The bishop's son, George E. Vincent, wrote an account of young Miller's life which was privately published, together with his diary of

military service, under the title: *Theodore W. Miller, Rough Rider.* Not long after the death of his son, Lewis Miller also lost a daughter. He himself died in 1899. His friend and co-founder John Vincent survived him by two decades. As his duties and travels as bishop multiplied, Vincent had to relinquish his intimate, firsthand management of Chautauqua, but his pride in it and his active concern lasted until near the end of his own long career in 1920.

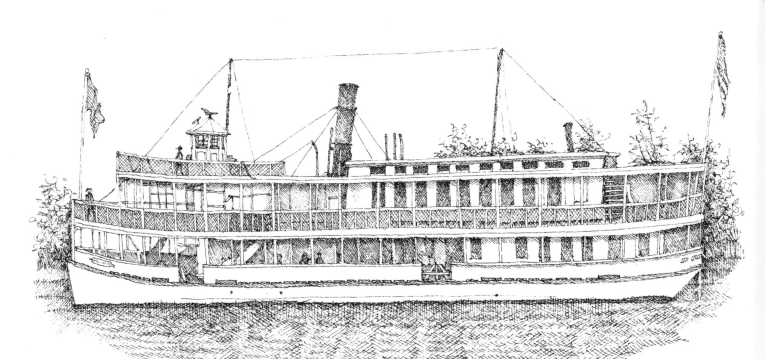

CITY OF CINCINNATI

Chautauqua Begins

When Miller and Vincent joined forces to found the Fair Point Sunday School Assembly, later to become Chautauqua Institution, each had been thinking for some time of an annual meeting, if possible national in scope, which would emphasize training for teachers and the application of the best pedagogical methods to Sunday school work. The idea took form in Miller's mind in 1872, while he was attending a session of the Ohio State Camp Meeting for "The Promotion of Holiness." With him were two women—ladies, they would have been called at the time — who had taught in his Canton Sunday school. They sat at some distance from the crowd, since none of them had a taste for revivalism. The ladies were surprised when Miller asked, "Girls, why wouldn't it be a good idea to have a Sunday School Camp Meeting?" They questioned the proposal, but Miller explained that what he had in mind would not be a camp meeting in the familiar evangelistic sense, but would devote itself to Bible study, teacher-training classes, musical entertainment, lectures, and recreation as well as devotional exercises. The ladies were persuaded more rapidly than Miller was able to persuade John Vincent.

Vincent had also been thinking of an annual national institute, but he wanted it to take place in the winter, in a series of cities, beginning with Akron where it could use Miller's widely known Sunday school building. Miller cited the advantages of summer, when public school teachers could attend, but Vincent resisted for a considerable time, fearing that the plan would be thought of as merely another camp meeting with its emotional extravagances. Miller finally persuaded his friend during a carriage drive they made together from Akron to the commencement exercises at Mount Union College.

As it happened, a Methodist camp meeting had already been established at Fair Point on Chautauqua Lake. One of the ladies who had been surprised at Miller's original proposal had tented there, was delighted with the surroundings, and praised the site to Miller. He became interested in the Fair Point Camp Meeting and was made a trustee of its governing association. As the idea matured for the new kind of meet-

ing he and Vincent were planning, he thought of Fair Point as the appropriate setting for their venture.

In August of 1873, after the camp meeting had closed for the season, Miller and Vincent, on a lake steamer, disembarked at Fair Point. With them came John Vincent's nine-year-old son, George Edgar, who later claimed to be the first Chautauquan because he jumped from boat to shore ahead of his elders. The three had supper at what was called the hotel, and George Vincent later told a Chautauqua audience: "Some of you who complain of the hotels and boarding houses of Chautauqua ought to have had that supper." During the evening, George Vincent recorded, his father and Lewis Miller inspected the grounds and talked excitedly of their idea. They returned to the hotel "and were stowed away under the roof. They were lulled to sleep by the rustling of the corn husks—in the mattresses. All thoughts of the Chautauqua Idea were at that time abandoned. The noble Pilgrim Fathers gave themselves to the abuse of the Hotel."

Despite their privations, they found the place suitable for their designs. Thanks to the camp meeting which had occupied it for three years, it offered a covered platform for speakers, bench seats for an audience, a few cottages, and cleared spaces for tents. They decided to lease the grounds for the following August and convene their Sunday School Institute. Their proposal was approved by the Methodist Sunday School Union. Miller was elected president and Vincent superintendent of instruction. In due course the first session of the Sunday School Teachers' Assembly was ready to open on August 4, 1874.

Their venture prepared, they meant it to be a success, and did not leave to providence what human practicality might help to accomplish. Vincent undertook an extensive publicity campaign. In his book *The Chautauqua Movement,* he is candid about his promotional efforts. As editor of the Sunday school publications of the Methodist Book Concern and corresponding secretary of the Sunday School Union, he says that he was "justified in making a free use of the periodicals under his control. And this he did." The *Sunday-School Journal,* which had a circulation of over 100,000 monthly, added its weight to announcements in the religious and secular press generally, with the result that plans were more than adequately publicized. The daily and weekly press reported the doings of the assembly at length; later a secretary recorded its proceedings in a pamphlet running to three hundred pages. Some of the advance notice the assembly received may well have proved disconcerting to the founders. The flamboyant DeWitt Talmage, for example, editor of *The Christian at Work* and later of *The Christian*

Herald, and once tried and acquitted by the Brooklyn Presbytery on charges of "falsehood . . . and using improper methods of preaching, which tend to bring religion into contempt," wrote his own forecast of the Fair Point meeting: "Soon the Methodists will be shaking out their tents and packing their lunch-baskets. . . . Rev. Dr. J. H. Vincent, the silver-tongued trumpet of Sabbath Schoolism, is marshaling a meeting for the banks of Chautauqua Lake which will probably be the grandest religious picnic ever held since the five thousand sat down on the grass and had a surplus of provisions to take home to those who were too stupid to go."

If a picnic was not precisely what the founders were aiming at, the very success of their publicity may have enhanced another problem they encountered. From the first, Vincent was staunch in his efforts to distinguish "assembly" from "camp meeting," but he could not defeat all the expectations that exuberant Christians brought with them to the grounds. Rebecca Richmond, in her book *Chautauqua, An American Place,* says that many who attended the first session "were indignant when they learned that exhortation and a call to sinners to repent had no place on the program and that voluntary and spontaneous gatherings were not permitted." Only scheduled speakers were allowed to sit on the platform. When once an itinerant evangelist gathered a group in the auditorium, handed out songbooks, and got a revival going, John Vincent himself intervened and informed the enthusiasts that no meeting could take place without his permission. Jesse Lyman Hurlbut, an associate of Vincent's in Sunday school work, who joined the Chautauqua forces during the second session in 1875 and returned for over fifty consecutive summers, recalls that he met "a prominent Sunday School talker . . . gripsack in hand, leaving the ground," who said, "This is no place for me. They have a cut-and-dried program, and a fellow can't get a word in anywhere. I'm going home. Give me the convention where a man can speak if he wants to." Vincent summed up his position by saying that the assembly was not a camp meeting in any sense except that most people who attended lived in tents. Few sermons were preached, he declared, and no evangelistic services were held; "the Assembly was totally unlike the camp-meeting. We did our best to make it so."

Whatever the hopes or fears of the founders after their preparatory campaign, the result may well have exceeded all reasonable expectation. The gateway to Chautauqua, during its early sessions, was a pier served by steamers from towns at railheads about the lake. These steamers became a legend in themselves. Jesse Hurlbut describes the disgruntle-

ment of their captains, who owned their ships and depended on their take in passenger fares, at the stringent Sabbath ruling that in early years closed the gates from Saturday night until Monday morning, preventing the Sunday delivery of willing pilgrims. Chautauquans of long-standing still remember the sinking of one of the steamers at the pier and the clothing spread out to dry on the grass when trunks were recovered from total immersion. Among the fleet that plied the lake, the *Jamestown* was notable, a four-decker with a pair of stern paddles that became known as Vincent and Miller. Since railroads from New York, Pittsburgh, or Cincinnati ran on different times, much confusion of schedule and baggage resulted. Steamers would neglect their own posted schedules and pile up at points where a train was due. Such were the means by which those who came to the first assembly reached Chautauqua, and they came in numbers. From Jamestown or other points on the lake participants arrived from twenty-five states, including Maine, Louisiana, and California, and from the British Isles and India. A retrospective estimate put the daily average attendance at four thousand, and the total present at one time or another at twenty-five thousand. The core of earnest seekers, as opposed to sightseers and curiosity hunters, consisted of ministers and Sunday school superintendents and teachers, and from the beginning they represented other denominations besides the Methodist. Presbyterians, Baptists, and Congregationalists spoke from the platform. DeWitt Talmage, present himself, was moved to proclaim: "The Trumpet of the gospel has been so well blown that the walls of bigotry have all come down. . . . Why not have all our churches and denominations take a Summer airing? The breath of the pinewoods or a wrestle with the waters would put an end to everything like a morbid religion. One reason why the apostles had such a healthy theology was that they went a-fishing."

Chautauquans, in their early seasons, had to put up with a good deal of the primitive. Eating was not among the easiest problems. As Jesse Hurlbut describes the scene, "Everybody, except such as did their own cooking, ate their meals at the dining hall, which was a long tabernacle of rough, unpainted boards, with a leaky roof, and backless benches where the feeders sat around tables covered with oilcloth. . . . Sometimes it rained, and D.D.'s, LL.D.'s, professors, and plain people held up umbrellas with one hand and tried to cut tough steaks with the other." Tent living, with its separation of family sleeping units by curtains, was hardly free from embarrassments, though tents rapidly gave way to more ambitious cottages. The cottages themselves were at first crudely and hastily built. Ida M. Tarbell, who during her early years spent parts

of numerous summers at Chautauqua with her family from Titusville, Pennsylvania, some fifty miles away, recorded in her autobiography that "the sound of hammers nailing together . . . flimsy cottages was never still." She was reminded of Mark Twain's reference, speaking of another summer colony, to "partitions so thin you can hear the women changing their minds." She took notice of a distinctive piece of Chautauqua furniture, a bench with a high back made from the headboard of an old four-poster bed. The context was one in which a curfew bell and such rules as "No giggling after ten o'clock—no chopping of wood before six" made sense.

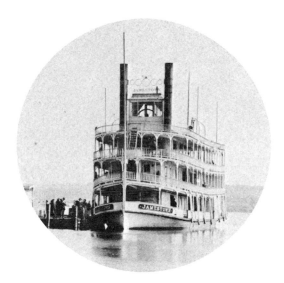

Among the features which the first Chautauquans encountered for their diversion and instruction was a scale model of Palestine, for which a stretch of the lake front, with east and west reversed, served as the Mediterranean Sea. This was an obvious outgrowth of Vincent's early Palestine Classes. With its miniature Dead Sea and trickle representing the Jordan River, its tiny models of Holy Land towns and cities, it still endures and is the subject of guided lecture tours. "Palestine Park" has had to be reconstructed from time to time because of the presence at Chautauqua of children in considerable numbers. "Originally the models of the cities," writes Rebecca Richmond, "were made of plaster and were light enough to permit mischievous youngsters to take unholy liberty with Palestinian geography." Children filled two capacities at Chautauqua. They would be the ultimate beneficiaries of improved Sunday school teaching, and in this capacity they were given their "Children's Day," the first Saturday of the session, and duly addressed and instructed from the platform. On the following Sunday morning a large-scale Sunday school session took place before the regular service. But in their second capacity the children were simply children. Looking back on her own early Chautauqua summers, Ida Tarbell recalled: "The worst mischief in which I personally assisted was playing tag up and down the relief model of Palestine . . . one rule of our game was that you could not be tagged if you straddled Jerusalem. The most serious vandalism was stealing Damascus or Nazareth or Tyre and carrying it away bodily." A granddaughter of John Vincent remembers whiling away a stretch of a Sabbath afternoon by throwing stones in the lake. The bishop himself happening by, he suggested that there were better occupations for a small girl on Sunday, whereupon she amused herself by climbing a model mountain in the Holy Land.

Another feature of the original Chautauqua scene was a tent-housed museum designed to illustrate biblical and oriental geography, costumes, and manners, and to furnish at least introductory materials for

study. Its casts, books, clothing, dried flora, agricultural and domestic implements included items representing Assyria and Egypt as well as Palestine. A mummy was present, lent by Mount Union College. After it was returned, the *Assembly Herald* commented: "He was a quiet old fellow, who never talked after the ten o'clock bell."

If Miller and Vincent took pains to avoid revivalism in their assembly, the first note struck was none the less devotional and left a lasting impression on those who took part. Vincent conducted a vesper "covenant service," in an auditorium consisting of benches among the trees in the present Miller Park. The platform was decorated with lanterns, transparencies, and flags, says Rebecca Richmond, and wood fires burned on platforms protected by earth. On a Tuesday in August an "Old First Night" ceremony is still annually repeated, the only occasion when gifts to the institution are directly solicited from the general attendance. Two years after the first covenant service of hymns and scripture readings, Chautauqua was able to claim a hymn of its own, but one which has become virtually universal, at least among Protestant congregations. This was the hymn "Day is Dying in the West," its words by Mary A. Lathbury, its music by William F. Sherwin, Chautauqua's first music director.

Other devotional exercises took place in the following days, naturally including sermons. DeWitt Talmage outscored other well-known clergymen in the size of his audience, which was estimated, perhaps with benevolent excess of enthusiasm, at ten thousand listeners. But as H. J. Thornton puts it, "In spite of the large emphasis on devotional expression, the leaders . . . resisted every temptation . . . to permit the enterprise to become simply a camp meeting under restraint." They turned to their purposed work of improving the techniques of Sunday school teaching and administration. Eight sermons during the session were outnumbered, according to Vincent's count, by twenty-two lectures on the theory and practice of Sunday school work, and seven lectures on such topics as Biblical history and geography. Among this extensive list of discourses, "Language and Illustration in Teaching" and "Helps of Science in Religious Teaching" illustrate the range of pedagogical concerns that found a place in the program. The teachers and church officials who made up the students in the Normal classes were counselled in the preparation of lessons, record-keeping, grading and promotion of pupils, and an opportunity was provided for practice teaching under supervision.

Vincent and Miller had included recreation in their thinking from the start, and it did not lack during the first assembly. Through its early

seasons the Chautauqua audience relished the illustrative work of Frank Beard, who did not suppress his comic sense even in providing illustrations for a Bible lesson. This celebrated cartoonist had begun submitting sketches to well-known periodicals before reaching the age of twelve. During the Civil War he was commissioned by *Leslie's Weekly* and *Harper's Weekly* to serve as cartoonist for the Army of the Potomac. Later he developed his "Chalk Talks," popular lectures with illustrations served up on the spot. In 1877 he published *The Blackboard in the Sunday School*, and much of his best work is said to have resulted from his association with Sunday schools and with Chautauqua. He made himself valued not only on the platform but as a personal figure, known for his congeniality and his quickness of repartee. Besides chalk, music played its part in diverting the first assembly. It could hardly have attained to the later standards of excellence that Chautauqua music was to bring to its own audience and to thousands of radio listeners, but any lack of sophistication did not dampen the enthusiasm for the chorus singing across the water from a boat on the lake or for F. A. Goodwin's cornet. The director of the department of recreation provided fireworks, including rockets and balloons from a lake steamer. Those more given to nature or athletics invaded the woods for ferns and flowers, or swam or boated or trolled for pickerel.

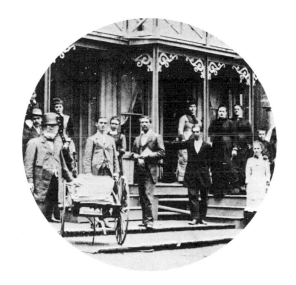

The first assembly ended on a sterner than recreational note. In a large tent some two hundred people gathered to answer fifty questions in writing on their Bible and Normal study. They made a diverse gathering, with women in the majority, but they included, according to the account by a reporter for *The Western Christian Advocate*, a well-known lawyer who took off his hat, coat, collar, and cuffs the better to grapple with his test, and a boy from Iowa who made a table out of a log and heaped dry beech leaves together to keep his kneecaps from rubbing sore while he knelt to his task. Some twenty candidates quit; some worked at the examination for nearly five hours. One hundred and fifty-two received diplomas after their papers had been graded.

When the first session reached its end and disbanded, it appeared that despite the extraordinary attendance the assembly had not made ends meet financially. The burden fell on Lewis Miller, the organizing genius of the enterprise. It was he who had arranged for sleeping quarters, food, water, and sanitation. He had also devised a system of gate fees, which had the advantage that visitors did not have to be pressed for collections on the grounds, though even this foresighted plan met with some resentment. Jesse Hurlbut recalls that ministers especially did not understand "why *they* should buy a ticket . . . to the holy ground," and he says

that some insistent applicants for free admission came close to putting up a physical fight. Lewis Miller made up the initial deficit from his own pocket, though he did induce wealthy friends to help finance the on-going institution. By the third year it had stabilized itself financially, though it continued to need gifts and fund-raising campaigns in times of stringency.

Deficit or not, Miller and Vincent felt gratified by their experiment and confident of its future. They set about thinking how to solidify and improve it. Any lurking doubt on Vincent's part sank to rest, influenced by tangible and perhaps some less tangible considerations. Practically, Chautauqua was very favorably situated for its purposes, midway between New York and Chicago and on the route of travel between Pittsburgh and Buffalo. If the assembly stayed at Fair Point, it could develop its own plant and buildings and fix in the public imagination its existence at a particular place known for its natural beauty. And despite his original preference for a winter conference, meeting in a sequence of cities, Vincent was far from insensitive to natural surroundings. He left one expression of his feeling which may come as something of a surprise in its romantic, in a loose sense almost mystical, sensibility, though it should hardly be surprising in view of his acceptance of Swedenborg's "correspondences" as at least one way of looking at a world "full of harmonies." At any rate, speaking of Chautauqua, he wrote that "the stars, the night winds, the thunder, the clouds piled up like towers at the sunset . . . took hold upon me, filling me with unrest and longing, that grew at times into a sort of torture." It does not sound like a Methodist voice talking; but if the founders were Methodists, they were something more, or Methodists of no common variety. The Chautauqua they inaugurated in the primitive circumstances of the first assembly went on, and its expansion, diversification, and growth in sophistication proceeded rapidly.

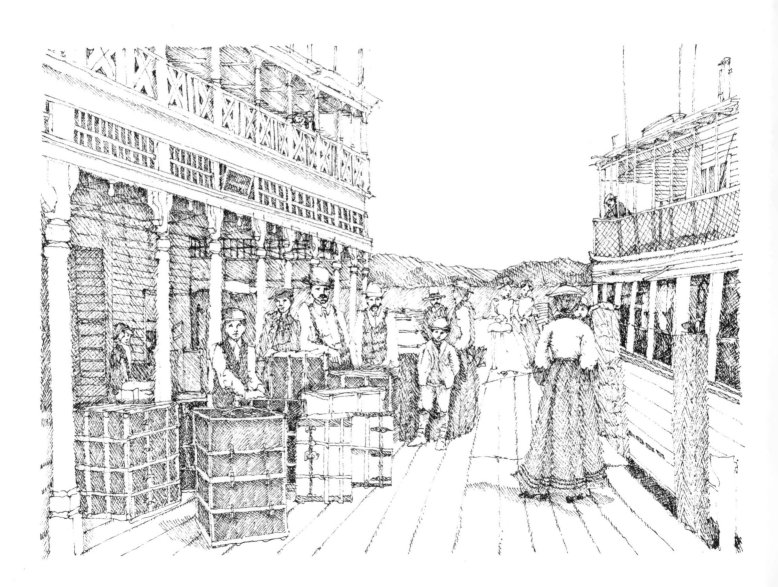

From Sunday School Assembly
to University

The first assembly so exceeded expectation that it left in some minds the question whether Chautauqua could do it again. But the confidence of Miller and Vincent did not fail. Again they prepared the way by vigorous publicity, including the caution that while tents and furniture could within limits be rented on the grounds, prospective campers should provide themselves with bed linen, towels, shawls, waterproofs, rubbers, and umbrellas. The lake steamers delivered pilgrims in such numbers, whether singly or in families or groups, that the overflow had to be housed in surrounding villages. Enough of them were repeaters so that the second assembly took on an aspect of reunion. Mary A. Lathbury provided a new hymn of greeting: "And now beside the shore again / We gather at the Master's feet." Indeed an alumni association was formed, consisting of members who had passed their examination in Sunday school methodology in the previous season. The association must have set something of a record for an institution only a year old. New equipment and new studies expanded the program. Classroom tents were ready with platforms, maps, and blackboards, and classes were offered in blackboard sketching and lettering and in map-drawing. The study of Hebrew was added to the curriculum. Jesse Lyman Hurlbut took charge of the Normal Class. Evening concerts on the lake continued, fortified by a chorus of one hundred and fifty voices brought from Akron by Lewis Miller.

With his turn for practical showmanship as well as piety, John Vincent felt the need for a star visitor who would bolster the second assembly by attracting national attention. Henry Ward Beecher was considered, but he was under a cloud as a result of the accusation brought against him by the husband of one of his parishioners. Vincent bethought himself of a former member of his own congregation at Galena, Ulysses S. Grant, now president of the United States, and he invited Grant to visit Chautauqua. The negotiations, complete with telegraphed code names for the president, were conducted through an intermediary, Theodore L. Flood, who later edited Chautauqua pub-

lications. Grant accepted, and on a Saturday, August 15, 1875, he duly arrived on the *Josie Bell,* one of a flotilla of gaily trimmed lake steamers bringing part of a crowd that was estimated in toto at thirty thousand. Miller and Vincent escorted him to the auditorium, where he received a vociferous welcome. Mary Lathbury had written a new song for the occasion. He was regaled with no less than three addresses; the grounds were illuminated in the evening, and like a good Chautauquan he went to church on Sunday. He was presented with two Bibles, which he apparently received in respectful silence.

Grant was the first of seven United States presidents, including both Roosevelts, who visited Chautauqua before, after, or during their administrations. His stay, reported by the Associated Press and prominent newspapers, gave an important boost to the still infant assembly in its critical second year. The scandals that had reached into Grant's administrative circle did not deter Vincent from persisting in his admiration for his friend. At Chautauqua, in 1909, on National Army Day, with both Union and Confederate veterans present, Vincent declared: "Ulysses S. Grant was the embodiment of resolution and persistence, sound in judgment, devoted to his family. His domestic life was stainless. He was absolutely pure in speech and thought, magnanimous to those whom he had defeated, patient in suffering." At Galena, in 1911, on the anniversary of Grant's birthday, with twelve survivors of the Jo Daviess Guards among his listeners, Vincent hinted one cautious reservation, saying that if Grant was "not always the wisest judge of men in private life"—one might have expected "public life"—"he did know men as by intuition when his powers of judgment were stimulated by any present emergency." And he added to his praise by saying that Grant was "silent under abuse . . . honoring the day of God and the house of God." Words of a bishop, but also of a friend.

If the season of '75 confirmed Chautauqua as a going concern, the season of '76 brought remarkable extensions of its program. Again Miller and Vincent had to contend with suggestions that it might be the part of wisdom to forego the session. It was the year of the Haynes-Tilden presidential campaign, and some feared that national politicking would cut down enrollment. Moreover, the lingering effects of the panic of 1873 might well restrict travel and curtail vacations. Most of all the prospective Centennial Exhibition at Philadelphia threatened ominous competition for attendance. But once more Miller and Vincent were not to be deterred. They decided to set up a rival attraction, a Scientific Congress, and they promised that Chautauqua would be "a centennial exhibition in itself." Yet science was not the only matter to occupy a

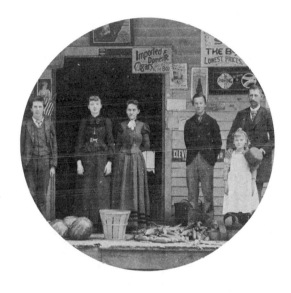

special place in the session. A Temperance Convention was also held, addressed by the notable temperance champion Frances E. Willard. Miss Willard, according to her biographer Mary Earhart, wanted to use the occasion to come out for women's suffrage, believing that the vote for women would strengthen their influence in causes they valued; but aware through discussion with John Vincent of his lack of enthusiasm for such an announcement, she stuck to her temperance guns. Two years earlier she had been elected president of the Chicago Woman's Christian Temperance Union, which itself had resulted from discussions by a number of women during the first session of the Assembly, and later she became president of the World's WCTU. She seems to have broken the ice as the first woman to speak at Chautauqua on other than a Sunday school subject. If Vincent was queasy about platform appearances by women, and needed nudging from Miller to be persuaded, Frances Willard completed the persuasion. In urging her to return to Chautauqua subsequently, Vincent wrote: "I do not care for women speakers generally. . . . You are one of my magnificent exceptions."

The Scientific Congress was a strenuous exercise, and for its day represented a truly advanced attempt in popular education in physical and biological phenomena. Naturally, in the intellectual and religious atmosphere of the time, the strictly scientific lectures and demonstrations were interlarded with others on such topics as "Bible Miracles and Modern Science," "Latest Results of Scientific Investigation, and Their Bearing upon the Bible Idea of Heaven," "Alleged Discrepancies between Science and the Bible," and "The Importance of Science to the Religious Thinker." What most memorably impressed the audiences at the congress was a series of lecture-demonstrations by Professor R. Ogden Doremus, who brought with him from New York some three tons of illustrative apparatus. With him, as an assistant, came his son Charles, who left an account of his father's performances. "For one of his most striking experiments," wrote the younger Doremus,

a globe of oil was placed in the centre of a mixture of alcohol and water of the same density. The whole was then rotated and, as this was done, the . . . oil first flattened at the poles, and later broke up into very small globules each revolving about the central point of its own axis. This represented a miniature celestial constellation, and typified the solar and other systems.

From this and other experiments, together with the observations of astronomers, it was argued that the various types of heavenly bodies, including the earth,—except those still in a gaseous state—were once in a molten condition. The cooling of any one of

these and the gradual change to the present condition of the earth was next considered.

Dr. Lyman Abbott was present, and he then and there declared that "This lecture makes an evolutionist of me!"

Other experiments dealt with heat, light, and electricity. "The latest known forms of artificial illumination were explained," says Charles Doremus. "So also was the spectroscope and the discoveries made by its use in regard to the constitution of the sun and the stars; the recognition of hydrogen, iron, calcium, and many other elements contained in them—all of which were unknown until the middle of the XIX Century." A further experiment dealt with the relation of electric currents to animal tissue, and must have produced a climax, if not of scientific illumination, then at least of dramatic effect. "To show the stimulating effects of currents on tissue that is almost living, a bullock was slaughtered near-by, and the head brought immediately to the lecture-table. Then one pole was placed in contact with the spinal cord, and whenever the other pole was touched to the surface of the skin, there resulted the most lifelike muscular contractions; the eyelids winked, the nostrils contracted, and the lips and tongues moved. Imagine what a sensation this produced!" The predominantly female Chautauqua audience might well have been startled by being winked at by an "almost living" bullock's head. But Charles Doremus was no doubt right in saying of still other experiments, "When we consider that this date, 1876, was quite ahead of the general use of liquefied gases," the demonstration to the Chautauqua audience "of liquefied nitrous oxide or laughing gas, and of liquefied and solid carbon dioxide by means of which mercury was easily frozen," meant that Chautauquans were witnessing "remarkable and early demonstrations of Man's control of heat."

Science kept its prominence in the session of the following year, 1877. Professor Doremus lectured again, and other academic and scientific figures spoke on such topics as "Nature's Mechanics," "The Postulates of Scientific Knowledge," and "The Literature of Science." Professor S. A. Lattimore of Rochester University daily demonstrated the microscope, assisted by "his cultivated and amiable daughters Miss Rose and Miss Lida," who directed a "Department of Microscopy" for the next two seasons. It must have been these ladies who gave the young Ida Tarbell a brush-off when she asked to use their "magnificent" instrument. Perhaps their amiability reached its limits, or in youthful diffidence Miss Tarbell may not have let them know that in her early ambition to become a biologist she had saved money to buy a more modest

microscope for home use, and that their instrument would have been safe in her hands.

Science was not the only direction in which Chautauqua pushed out and expanded its activities. A council of reforms made its appearance, and led, in the fourth session of 1877, to a pair of performances that reflected the moral climate of the times. One was given by the celebrated Anthony Comstock, secretary of the Society for the Suppression of Vice. He took as his target obscene and corrupting publications and their dissemination among the young. He was reported as saying, in view of the composition of his audience, especially the children present, that there were "many parts of this work . . . that I cannot even touch upon; scarcely refer to or hint at." A later generation might think his method an ideal way to whet curiosity, but the Assembly's *Daily Herald* reported that he had been to the forces of corruption what "the fires of heaven's wrath were to Sodom and Gomorrah." Again it is amusing to think of Ida Tarbell, a Chautauqua figure from girlhood, who in her early years filched copies of the *Police Gazette* from workers in her father's business who boarded at the prosperous family house in Titusville, combing them over no doubt with the baffled protection of innocence, but at least not becoming corrupted.

The excitement generated by Comstock still vibrated in the air when Chautauquans were treated to another round of reform oratory, this time by John B. Gough, apostle of temperance. Introduced by an ex-barkeep, Francis Murphy, as "one of God's noblest Christian gentlemen," Gough proclaimed: "We wage war against drink wherever we find it, whether at the sideboard of the wealthy, in the social circle, or in the grog-shop . . . our principle is total abstinence from all that can intoxicate." He described a member of an audience he had once addressed in Scotland, a virago pointed out to him as "the most abandoned woman in the city of Dundee." She was, Gough was informed, "a strong, muscular woman, and hits right and left, and sometimes it will take three men" to arrest her "with the blood streaming down her face; and the power of her tongue in blasphemy is so awful that men who can stand any amount of it will run away." But as Gough spoke, "she waved her naked arm and hand to the audience, and she said it was all true," winding up by signing the pledge and becoming "a godly woman." In view of the demonstrations of Professor Doremus and the addition of Hebrew to the language curriculum, one's eye is arrested by Gough's declaration: "I am not a learned man . . . I do not understand Hebrew or Greek. . . . But I say to you temperance men who are not learned or scientific, I have found this by my experience: if a man is right by the

exercise of the little common sense God has given him, he can stand his ground against all the learning and science in the universe." Climax! It seems a pity that Gough rather took the edge off it by adding: "if he does not go out of his depth." Alfreda L. Irwin, in her account of Chautauqua, *Three Taps of the Gavel,* quotes a report from the *Daily Herald* showing that Gough was given a chance to do more than utter full-flowing diatribes against drink. "Dr. Vincent," the report begins, "stated to the vast congregation that one of our keen-eyed, strong-handed policemen captured Saturday night a couple of young men who had brought to Fair Point a large square box filled with bottles of whiskey." The young men were sent packing, the whisky seized. Gough and Francis Murphy were appointed to dispose of it. In shirtsleeves on the platform Murphy demolished the bottles with a shovel, and the broken glass was buried after a mock funeral sermon from Gough. The account suggests that the obsequies were regarded as an unalloyed triumph for righteousness, no mourner wiping his eyes or his lips.

These are only examples, and perhaps unduly highlighted ones, of the expansion and diversification of program that began in the first Chautauqua years. They do illustrate a polarity that has persisted in an institution of strongly Protestant heritage, a polarity between the popular, inspirational, moralistic if not outright evangelistic performance, and the more strenuously intellectual and advanced educational efforts of a Doremus. Devotional exercises, Sunday school work, language and other studies, and recreation continued to hold their central place. None the less a shift in focus began to show itself early, and it could only be in the direction of giving greater range to secular study and interest. The perception arose of a large potential general audience rather than one consisting mainly of Sunday school workers. John Vincent credited to Lewis Miller "the original suggestion" for "the improvement of the camp-meeting by the presentation on the platform of scientific as well as theological subjects." Vincent seems to have supported the suggestion wholeheartedly. He is candid in admitting a financial motive in the attempt to attract a general audience. "The large population within easy reach of the Chautauqua gates and dock needed some other attraction" than Sunday school or Bible studies "to bring them to our Assembly. And we required for our more radical work their financial support; while they needed, more than they desired, the quickening and awakening which come from great ideas."

So Vincent wrote in 1886 in *The Chautauqua Movement.* He had already conceded in the previous year that concentration on Sunday school pedagogy could reach a limit of usefulness. "Sunday School

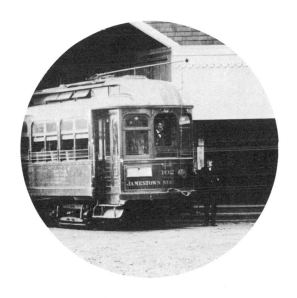

workers," he granted, "could not content themselves, year after year, with the discussion of the same old practical questions of organization, administration, and method." Enterprising religious workers "detest ruts. They want radical ideas, and new applications of them to everyday service. But the compass of pedagogical and governmental philosophy as applied to the Sunday-Schools is not wide; and thoughtful, earnest souls loathe husks and platitudes and repetitions." He admitted that "it is possible to insist upon too many hours of Bible study each day. Even a good thing can be carried to excess." Nor was he afraid of the word "secular." "Things secular are under God's governance and are full of divine meanings," he wrote, in a tone suggestive of the quite un-Methodistical Emerson. "All things are sublime. . . . Flowers, fossils, microscopic dust, foul soil, things that crawl and things that soar . . . all are divine in origin and nature." Meanwhile Lewis Miller, sharing the sympathies of his superintendent of instruction, went on taking care of leases, road-and-cottage-building, parks, amphitheater, and the full range of executive problems.

As the seasons merged into decades and programs expanded, organization proliferated to keep pace, until a point came at which it had to be consolidated and simplified. Some of the principal steps, both of educational innovation and administrative structure, take the assembly down to the turn of the century. Some are so important as to demand separate treatment, but a skeleton map at this point of the main advances may provide a helpful basis for later examination in greater detail.

The first assembly occupied a term of fifteen days, but Chautauqua could not expand its activities to meet the ambitions of its founders without expanding its calendar. By 1879 the term had increased to forty-three days, and by 1899 it had lengthened to sixty days, about the total summer time practically available to teachers and vacationers. Since then the seasons have stabilized at about eight weeks, give or take a few days. The territorial expansion has been even greater. By 1895 the original fifty acres had grown to one hundred eighty-five, and the increase continued until now Chautauqua spreads over seven hundred acres. With physical growth and lengthening terms came the acquisition of new buildings and facilities and the progressive decline of tent life. "Long may tent life at chautauqua draw the weary multitudes from their monotonous daily toil," proclaimed the *Assembly Daily* at the end of the 70s, but not many seasons later it was congratulating its readers that "the few rude cottages and tents in the woods with their unkept and undressed grounds" had become "a large village of beautiful summer homes." The *New York Tribune Monthly* reported that "tenters

are becoming rarer and rarer at Chautauqua. People are getting tired of throwing their silhouettes on the canvas wall by lamplight for the delectation of irreverent beholders."

Meanwhile vigorous academic growth and innovation were taking place. In 1879, a School of Languages was organized, offering, in addition to the already established Hebrew, courses in Greek, Latin, French, German, and Oriental languages, and later Anglo-Saxon. The teaching was in competent academic hands. Leon Vincent, John Vincent's nephew and biographer, says that the instructors were experts, accustomed to handling large groups. One professor in particular was said to have taught German without ever speaking "one word of English in his classes." John Vincent did not expect miracles of achievement, but he thought that by the "natural method" of teaching—conversation first and grammar afterward—a student could be prepared to continue his progress by his own efforts as long as his stamina held out. Despite the seriousness of this innovative program, and his respect for the teaching staff, Leon Vincent writes: "It was a droll sight, the spectacle of one of these classes in action, so good-humored were the pupils, so vociferous, and in such deadly earnest. They recited in concert—no other method was possible. Without doubt they picked up a good deal, and were set on the right track in the matter of pronunciation. Best of all, they learned how to use their textbooks."

With the School of Languages occurred another extension of Chautauqua's educational scope. This was the Teachers' Retreat, a scheme to recruit teachers from the secular schools to study pedagogical theory and practice at Chautauqua. The first two-weeks' retreat enlisted forty-five teacher-students, who listened to lectures ranging in historical sequence from Socrates to Pestalozzi and in geography from "The Public Schools of Boston" to "Teaching in the West." "Jesus as the Perfect Teacher" was not overlooked as a Sunday theme. By 1885 the retreat offered not only pedagogical study but also chemical laboratory practice, microscopy, clay-modelling, Shakespeare, elocution, stenography, and calisthenics.

In 1880 the National Education Association held its annual meeting at Chautauqua, and musical theory made its appearance in the curriculum, a foretaste of later growth that carried Chautauqua to its enduring distinction as a music center. In the next year a School of Theology was inaugurated, duly chartered by the State of New York. Its purpose was to train candidates for the ministry, but also to give clergymen in harness a chance for further study. Vincent announced that the work of the school would be carried on by correspondence for those who could not

come to Chautauqua in person, and the announcement represented, in effect, another innovation. America had seen only two previous attempts at correspondence teaching, one in Boston, the Society to Encourage Study at Home, the other at Illinois Wesleyan University. Outside Chautauqua, attempts at correspondence teaching did not come to much, says A. E. Bestor, Jr., until the International Correspondence Schools were established in Pennsylvania in 1891. Besides theology and homiletics, Vincent's plan of study included Greek, Hebrew, ecclesiastical Latin, and sociology "from the Christian point of view." Human nature was to be given its due by way of such texts as Shakespeare, Addison, Thackeray, Dickens, George Eliot, and Hawthorne. The School of Theology enjoyed only a relatively brief run. Often those who were enrolled, says Hurlbut, were among the most ill-paid in the ministry. They found the fees inconvenient and the studies hard, and the school came to an end for want of support.

Still another educational movement was promptly taken up by Chautauqua as soon as it reached America, delayed by the Civil War and some twenty years late in arriving. University extension work had largely been pioneered by Professor James Stuart of Cambridge, England. In 1887, a faculty member of Johns Hopkins University put forward a suggestion for such work in America, and Chautauqua took it up in the following summer. The Chautauqua extension program peaked about 1892, when it was able to offer 168 lecturers to interested local groups. The plan called for lectures in sequence developing single topics and supplemented by quizzes, syllabi, and questions to be answered at home and submitted to the lecturer for criticism.

Activities at Chautauqua proliferated so rapidly into so many units and departments that John Vincent was moved to compare the institution to a banyan tree, "with its bending boughs and forest of trunks, all from the original stock; and these, like the banyan-tree, have taken root as individual and yet as united . . . separate in name rather than in organization." He goes on to list no less than twenty trunks of the parent stock. Such fertility obviously called for consolidation, and led Chautauqua to take an ambitious unifying step. In 1883 it obtained a charter as Chautauqua University, complete with degree-granting powers, though it actually awarded only a small number of degrees, none honorary. Incorporation as a university was no doubt a helpful step in organization, allowing secular academic studies to be grouped under a College of Liberal Arts while studies in divinity could be separately administered. But as a summer institution, carrying on its post-season work by correspondence or extension, Chautauqua lacked both

the endowment and the calendar to function long as a true university. Throughout its history, moreover, Chautauqua has suffered a fate which was unavoidable but which has robbed it periodically of earned preeminence. As fast as it pioneered or took up and advanced new movements, it found its experimental projects adopted by established universities or other organizations better equipped to carry them on year-round. In 1892 it gave up its title of university, becoming the Chautauqua System of Education, and in 1898 it abandoned its power to grant degrees. By the century's end, it ceased offering correspondence work except as a part of another of its notable innovations, the famous home reading groups under the title of the Chautauqua Literary and Scientific Circle, still active today though on a greatly reduced scale.

The CLSC is important enough in American cultural history to demand treatment in its own right, but before coming to it this chronicle must indulge in a postlude to the present chapter, illustrating early Chautauquan piety at its exetreme. Chautauqua in its budding days had not only its hymnodist in Mary Lathbury but its novelist in "Pansy." Before fiction was admitted to the official booklists of the CLSC or the pages of its monthly journal, the *Chautauquan*, Mrs. G. R. (Isabella) Alden—"Pansy" by nom de plume—had begun the writing of what finally amounted, in a lifetime of eighty years, to one hundred and twenty books, some of them translated into French, Swedish, Japanese, and Armenian. She spent summers at Chautauqua from 1873 to 1895, beginning in her teens, lectured frequently, and once gave the commencement address to the graduating CLSC class. Her husband was a CLSC member. She seems to have made an unobtrusive but familiar and respected figure in the early Chautauqua community. She did not lack, in a minor way, some of the craft expected of a novelist. She had a degree of ingenuity in a Victorian kind of plotting, in which the right marriages solved important problems. She could understand and differentiate characters, she could carry on a scene and a dialogue, she was not without a kind of sprightliness and humor, all within the limits of the content with which she worked. This content, to judge by the two examples of her work this writer has examined, was Protestant fundamentalist concern for salvation and the Christian life. A contemporary reader without a tincture of this concern in his bringing up might well find it hard to believe that the emotions Pansy explores and the anxieties she plumbs were ever real (they were). *Four Girls at Chautauqua* (1876) and its sequel, *The Chautauqua Girls at Home,* will suffice as exhibits. Of the four girls, one is a lonely, self-supporting school teacher who at the start professes to be an "infidel." The others, though individualized

temperamentally, are more or less giddy-pated normalities who attend a fashionable city church where Christianity is politely professed without any further disturbing effects. The girls decide to visit Chautauqua, partly as a lark, a decision the pastor of the church regards as an "unfortunate freak." They come, and despite much byplay of incident, not all congenial, each in turn is smitten with the desire to become a Christian in earnest. One, not knowing how to take the first step, is aided by a coincidence made possible by the unavoidable intimacies of tent life. She overhears a young man with whom she has had an inconclusively probing conversation praying for her behind a neighboring canvas wall before he goes to bed. (Will he marry her in the sequel? He will.) At home again, the girls have first of all to persuade the city pastor of the genuineness of their new state, then to undergo the embarrassments of trying to carry Christianity into practice among Laodicean families and indifferent or skeptical friends. They discuss the propriety, for Christians, of cards, dancing, and the kind of parties they have been accustomed to, and decide against setting an example that might be an occasion of stumbling to the weak. One of the girls, who before her Chautauqua experience had entered into a less than passionate engagement with a young man regarded as an appropriate match, wants to lead him also to serious Christianity, but is afraid or unable to open the subject. When he suddenly dies without any apparent religious conviction, she feels an all but unbearable responsibility, and confesses to one of her friends, "I believe I have the blood of a lost soul clinging to my garments."

One wonders how much Pansy John Vincent read, and what he made of it. True enough, she admits nothing of camp-meeting hysteria in the story of the four girls, but Vincent does not seem to have conceived of Chautauqua as a machinery for conversion. No doubt he would have welcomed the result, but his ideas of popular education, emphasizing the secular as much as the sacred, are best seen in other directions, notably in his plan of home reading.

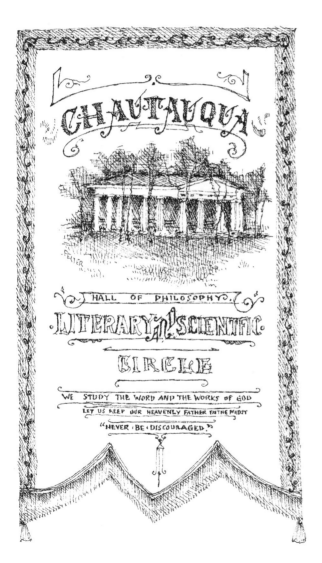

CHAUTAUQUA

HALL OF PHILOSOPHY

LITERARY AND SCIENTIFIC

CIRCLE

WE STUDY THE WORD AND THE WORKS OF GOD

LET US KEEP OUR HEAVENLY FATHER IN THE MIDST

"NEVER BE DISCOURAGED"

C·L·S·C

ORGANIZED

HOLY BIBLE

AUGUST

AD·1878

Home Reading

Of all the educational experiments launched by John Vincent, the Chautauqua Literary and Scientific Circle has been called the most influential. So writes Arthur E. Bestor, Jr., in his bibliographical survey *Chautauqua Publications,* and the judgment fits the record. Vincent's conception of the CLSC goes back to his early pastoral work in New Jersey, when he devised his scheme of study for "out of school" theological candidates, a scheme combining public lectures and private reading. As it came to fruition at Chautauqua, the CLSC embodied the principal educational beliefs and motives that Vincent cherished throughout his life. He insisted that education never ended till the grave, that it was for all men and women of every kind and station in life. For those who did not have the opportunity to undertake college or graduate training—an opportunity he had missed himself—he was convinced that a program of guided reading could at least initiate them into the "college outlook," give them a baseline from which to advance, and give their children the stimulation of a home where knowledge and educational ambition were respected.

Such was Vincent's passion for education that his praises of it reached the tone of rhapsody. The opening pages of *The Chautauqua Movement* bristle with quotable idealism on the subject. He recognized no area of life in which education could not solve or mitigate some problem. In 1880, Garfield, then a candidate for the presidency, visited Chautauqua, asked to see Palestine Park, and made a short speech to the pursuing crowd. Vincent quotes the "beloved Garfield" as saying, "It has been the struggle of the world to get more leisure, but it was left for Chautauqua to show how to use it." Education could enrich leisure, improve life in the home, in the professions, in the shop, and on the farm. Popular education, Vincent declared, "must increase the power of the people in politics, augmenting the independent vote which makes party leaders cautious." Education "must tend to a better understanding between the classes of society, causing the poor to honor wealth won by honest ways of work . . . to despise wealth . . . when greed and

trickery win the gold; to honor knowledge and a taste for knowledge, whether it be found clad in fine linen or in linsey-woolsey; to hate with resolute and righteous hatred all sham and shoddy . . . to avoid struggles between capital and labor, and to promote, in all possible ways, the glorious brotherhood of honesty, sympathy, and culture." Amen, though the vision may seem to hover at some distance above common earth.

Vincent invites his readers to "imagine the soliloquy of a woman" who says (he is putting the words in her mouth), "I am old,—that is, older than I once was . . . I am going to college! . . . Harvard? No, nor Yale, nor Boston, nor Middletown, nor Evanston, nor Wellesley. . . . I am going to college, my own college, in my own house, taking my own time; turning the years into a college term; turning my kitchen, sitting-room, and parlor into college-halls, recitation-rooms, and laboratory." And so on, for some three pages of type. "I am thoroughly convinced," Vincent writes on another page, "that there is a hunger of mind abroad in the land,—in the rural districts, in the villages, among the working-people, and the trades-people, the people that are not acquainted with school thought and school learning in the higher forms." The hunger was there, as in its heyday the nourishment Vincent offered in the form of the CLSC made irresistibly clear.

Although they are dated ten years later than the launching of the CLSC, two letters that Vincent received are appropriate in the home-reading context. They show that his enthusiasm for popular education was not universally shared and that he sought support for his views from diverse quarters. Evidently Vincent had encountered a "New York merchant" whom he doesn't name and who rejected the notion of "culture for the masses" on the ground that it led to discontent. The two letters give Vincent the desired support, but for amusingly contrasting reasons. The first:

My Dear Bishop:
 I differ entirely from the New York merchant who did not believe in culture for the masses. My experience has been that the more a man knew the more valuable the service he could render. The mechanic who reads and knows Shakespeare, Buckle, Spencer, Darwin and especially the literature bearing upon his calling is a much more valuable man to his employer than he who is ignorant. He is also a more contented man, and much easier to deal with as a servant, provided his employer wishes to deal fairly with him. I have found this in visiting the homes of our working men, that, wherever I saw a row or two of books upon his shelf and a

harmonium in his parlor, we had here one of our most valuable men. The improvements suggested by our workmen come invariably from the educated. The more highly educated the workers about you, either in house or in factory, the happier you are in the former and the more successful in the latter. The opposition to culture comes from the fact that the schools have hitherto paid attention to the dead languages of the past. As far as the classical literature of the colleges is concerned I agree with the New York merchant. It is not only useless, but injurious except to the few destined for Professional or Educational lives.

Very Truly Yours,
Andrew Carnegie

The second letter:

My dear Sir:

There is a great deal of truth in what your New York merchant said. Under present social conditions the great majority of people *are* destined to play a humble part in life, and education does make them dissatisfied with their condition; but this is a reason, not for refusing them opportunities for higher education, but for extending these opportunities as much as possible. The hope of reform is in the discontent of the masses with unjust conditions, and in so far as education tends to make that discontent intelligent instead of blind it is a most powerful agency of social reform. I am in favor of every possible extension of the opportunities for education, and I would like to take this occasion to express my appreciation of the great work you have done and still are doing in this line.

It is a great mistake to think that education ends when manhood begins; on the contrary the most important part of our education is received afterwards, and I do not believe that, if properly exercised, the intellectual powers decline until the limit of life is reached, if in reality then.

With best wishes for continued success in your good work

I am

Yours very truly
Henry George

A sense of something important to come marked the occasion when, on August 10, 1878, the CLSC was announced. Writing of Vincent's work at Chautauqua in general, Ida Tarbell said, "A man better fitted by experience, conviction, and personality to persuade a half-asleep, wholly satisfied community to accept a new order could not have been found in the America of the eighties . . . he was an orator, and orating at

Chautauqua made men tolerant even of heresy." She refers to his address announcing the CLSC as "the finest of what we call inspirational talks I ever heard." She takes note of other forces at work. "Women of that generation had had their natural desire for knowledge intensified by the Women's Rights movement. . . . The immediacy of their response was in a degree accounted for by their devotion to Dr. Vincent. I suppose most of the women who frequented Chautauqua were more or less in love with him." Touché! But the tide of response to the CLSC went far beyond the personal influence of Vincent. It swept through all parts of the country and abroad and took in practically all strands of the population.

Hurlbut reports that, during an evening of preliminary discussion, he told Vincent that home readers would give up after the spell of the Chautauqua season, and asked how untrained people could study science without teachers or laboratories. In return Vincent asked how many could be expected to carry on his plan. Perhaps a hundred, Hurlbut ventured. Vincent excitedly said a thousand. But when he made his public announcement, he cautiously lowered his figure. He would be satisfied for a start if ten candidates volunteered. As it turned out, membership in the first class of the four-year projected curriculum reached more than eight thousand.

Vincent had not gone ahead without other consultations. He had invited opinions from friends in the ministry and other professions. Few would probably have expressed anything more discouraging than benevolent skepticism, but in any case he had received welcome support. Two of his correspondents wrote from different areas of concern. From Lyman Abbott: "If you can lay out such plans of study, particularly . . . in practical science, as will fit our boys and young men . . . to become, in a true though not ambitious sense . . . scientific and intelligent miners, mechanics, and farmers, you will have done more to put down strikes and labor-riots than any army could." From the poet William Cullen Bryant, in a letter Vincent read from the platform: "There is an attempt to make science . . . an ally of the school which denies a separate spiritual existence and a future life; in short, to borrow of science weapons to be used against Christianity. The friends of religion, therefore, confident that one truth can never contradict another, are doing wisely when they seek to accustom the people at large to think and to weigh evidence as well as believe." Bryant also caught an essential point in Vincent's design, saying: "I perceive this important advantage in the proposed organization; namely, that those who engage in it will mutually encourage each other . . . that many who, if they stood alone, might soon grow

weary of the studies recommended to them, will be incited to perseverance by the interest which they see others taking in them." Bryant's cordiality led to the annual observance of a Bryant Day, and the Bryant Bell in the Miller Bell Tower annually is called on to ring in the start of the next reading year.

Vincent had not only fortified himself by outside encouragement before he attempted to launch the CLSC, but he came to his announcement meeting with a small nucleus of recruits already in hand, the first of them the Reverend L. H. Bugbee, President of Allegheny College. Thus he could define his plan with some tangible support for his hopes. As years passed, he went on clarifying, defending, and adding further incitements to his scheme. He had anticipated the charge that his four-year study course could be mocked as superficial, a criticism that has frequently been made, by the skeptical or the unimpressed, of cultural and educational Chautauqua in general. Vincent's answer was partly a *tu quoque*. College education itself is superficial, he said rightly enough, and the student who graduates without knowing as much has missed the point. But he remained unintimidated by Pope's warning that "A little knowledge is a dangerous thing," declaring that "superficiality is better than absolute ignorance." Admitting that popular education by home study could not hope to be the equivalent of college training, and saying that no one pretended it could, he invested it with an aura that verged at times on the extravagant and took away some of the force of his concession. Yet few will find reason to quarrel with his purposes as such. The CLSC, as he described it at one time, "aims to promote habits of reading and study in nature, art, science, and in secular and sacred literature . . . especially among those whose educational advantages have been limited . . . so as to secure to them the college student's general outlook upon the world and life, and to develop the habit of close, connected, persistent thinking. It encourages individual study in lines and by text-books which shall be indicated; by local circles for mutual help and encouragement in such studies; by summer courses or lectures and students' sessions at Chautauqua; and by written reports and examinations." The CLSC, he advised again, "is for busy people who left school years ago . . . for people who never entered high school or college, for merchants, mechanics, apprentices, mothers, busy housekeepers, farmer-boys, shop-girls, and for people of leisure and wealth who do not know what to do with their time." Despite his interest in the deprived, he was pleased to discover, as the scheme developed, that "many college graduates, ministers, lawyers, physicians, and accomplished ladies are pursuing the course."

From the first the four-year cycle of reading was expected to culminate, for those who persisted to the end, in a diploma and a form of graduation, at Chautauqua itself for those who could make the journey, or for those who could not at one or another of the local Chautauquas that imitated the parent assembly and took its name, or in a town or village reading circle, or even in solitude. John Vincent had observed the part played by "sentiment" or "college spirit" in providing incentives and arousing institutional loyalty. He had an inclination toward ceremonies, titles, and tangible badges of accomplishment, yet he was not unaware of the hazards they offered. He confessed, in relation to the CLSC, that "The appeal to sentiment was an experiment" and that if it failed with adults "it would prove both ridiculous and disastrous." Ritual at Chautauqua did arouse the risibilities of some assembly members from time to time, but it escaped disaster and no doubt contributed to the intense loyalty of confirmed Chautauquans and to the nostalgia they felt in the seasonal gap between sessions. One well-known Chautauqua ceremony sprang from an on-the-spot inspiration of Vincent's. In 1887 a deaf mute, S. L. Greene, occupied the platform, and using sign-language and pantomime, presented Bible stories so vividly that they were said to be completely intelligible to his spectators. Vincent reminded them that Greene could not hear their applause, and suggested that they wave their handkerchiefs to show their appreciation. So began the "Chautauqua Salute," which persisted as a form of special tribute on occasions of more than common enthusiasm, though only when called for by the head of Chautauqua in person.

The CLSC was promptly enveloped in ceremony and visible tokens of achievement. Vincent had chosen a place on the grounds which could serve as its center and which he called "St. Paul's Grove." Here he proposed to build a Hall of Philosophy, known as the "Hall in the Grove," and it was duly dedicated in August of 1879. Open-sided, roofed over on supporting pillars and beams, it has served through the years for courses of lectures and for the rites of annual classes of the reading circle. Each yearly class took its own distinctive name, and adopted its own motto, emblem, or flower. The first class to graduate, to take only one example, called itself the "Pioneers." Classes also created their own songs, banners, and badges, held reunions and vigils, and the circle celebrated "days" for sacred and profane personages ranging from St. Paul to Garfield. In addition to the standard quadrennial core of reading, special courses enabled students to go on as graduates and earn seals to be attached to their diplomas. Four seals brought membership in the Order of the White Seal, seven in the League of the Round Table, fourteen in

the Guild of the Seven Seals. Some persistent home-readers earned over a hundred seals. Eventually such emblematic proliferation had to be pruned, as George E. Vincent recognized when he succeeded his father in the leadership of Chautauqua, observing that "the CLSC is in danger of losing caste through pretentious titles."

The climax of ceremony occurred on "Recognition Day," when those who had stuck with the course and made the journey to Chautauqua received their diplomas. John Vincent regretted that many readers who undertook the CLSC program fell by the wayside. In 1891 he reported that no less than 180,000 had enrolled, but only about 12 percent had completed the work. Yet of the more than eight thousand members of the first graduating class, over eight hundred "Pioneers" turned up at Chautauqua for their recognition, surely a gratifying figure. This original commencement in 1882 has been substantially repeated at Chautauqua itself, or imitated in offshoot Chautauquas up and down the land, and has provided a model for a considerable number of generations. The goal of the ceremony was the Hall in the Grove, but it had to be approached with due formality. The diploma candidates, marching in column, paused before the Golden Gate, a large wooden portal erected only on Recognition Days, and the first of four arches celebrating Faith, Science, Literature, and Art. Meanwhile other files of officials and guests converged on the grove to music supplied by a band from Meadville, Pennsylvania. Before the candidates were admitted, the official procession entered the hall, where baskets of flowers hung between the pillars, and busts of Plato, Socrates, Homer, Virgil, Goethe, and Shakespeare were placed "looking inward." The candidates joined in a responsive reading from the twenty-eighth chapter of Job ("But where shall wisdom be found? And where is the place of understanding?"). At last, after a formal summons of welcome and congratulation, the gate opened and the candidates entered, preceded by the elaborate CLSC banner and by garlanded little girls in white carrying baskets and strewing flowers. Naturally, the whole assemblage listened later on to the equivalent of a commencement address.

Commencement addresses of far off years may well fail to exhilarate later generations, but at least a few of the early examples heard at Chautauqua speak both for the times and the Institution. In 1885, the speaker was Edward Everett Hale. The style of oratory admired in his day can be illustrated by a few of his sentences. "The American people, in the pride of wealth and power, mean to lead a larger life. . . . They have a glimpse of the treasures of history, a glimpse of the stores of philosophy, a glimpse of the possibilities of science. . . . Books

. . . are the food of mind and soul. . . . The American People see this, and do not choose to leave their treasures to any separate class of scholars. . . . For themselves this people mean to walk with Homer and Euripides. Virgil shall sing for them, and Dante. Chemists shall analyze, geologists shall explore, astronomers pierce infinity, and the people shall know what they find." Alice Freeman Palmer, former president of Wellesley College, was less grandiloquent and more to the point when she told CLSC graduates: "Not one of you could earn your bread because of what you have learned in your homes and in your books," but "every mouthful you eat ought to be sweeter because of the work you have done together." Harvard President Charles W. Eliot invited his listeners to consider "what characteristic contributions the American people have been making to the progress of civilization." He found five, and by an irony alike unaware of his own later advocacy of Wilson's League of Nations and of the massed military horrors of the twentieth century, he put foremost the move toward minimizing armaments and substituting arbitration for war. In 1905, Jane Addams, of Chicago's Hull House fame, spoke for greater understanding of the immigrant. She begged Chautauquans "to break out still further into the world about you till it includes the man who seems quite unlike ourselves. Although his real experiences are so like our own this man is forlorn because he does not realize there is any fellowship in this land to which he comes; who thinks that all we want is money and muscle. As our land is growing cosmopolitan in its people, let us meet it with a cosmopolitan culture." Such utterances show that the CLSC could command the respect of very different individuals of contemporary prestige and could evoke the special message each had to offer. They also illustrate the early-established tradition of free speech on important issues that characterized the Chautauqua platform in general.

As the program developed, much of the surrounding academic apparatus that John Vincent originally planned had to be dropped or absorbed into other Chautauqua departments. The correspondence he envisioned between remote readers and the local instructing staff was relegated to university extension while that lasted, and his too-elaborate scheme for monthly reports and final examinations was abandoned, though a voluntary competitive examination arranged by the Northern Illinois Chautauqua Union for a score of members of the class of 1888 was given in Chicago and won by a farm woman. The first heterogeneous lists of books and pamphlets gave way to more unified sequences, so that a representative course would consist of an English year, an American, a European, and a classical year. Variations are recorded, such as a

Russian year and a Chinese year, and readings on science found a regular place. Choice of books was originally committed to a group of counselors, churchmen chosen for denominational and geographical distribution as well as prestige, but the role of the Counselors faded out, as commonly with schemes of more or less remote control by committee. Theological readings were dropped from the requirements after 1894 because, as George E. Vincent noted, protests had accumulated against any theological prescription and because of the increasing diversity of the readership.

John Vincent himself announced the first book chosen for the first CLSC class, John Richard Green's *Short History of the English People.* An immediate rush to the bookstore followed, says Hurlbut, and a telegram to the publisher for more copies. The surprised publisher telegraphed in return to find out whether the substantial and totally unexpected order was genuine. The same occurred with subsequent choices, and when the hitherto untapped Chautauqua market was confirmed, both publishers and authors maneuvered for CLSC adoptions. Green's *Short History* met with some objection for its treatment of Methodism, but it stood its ground as a highly successful selection. Other titles on the opening list included Stopford Brooke's *English Literature,* a work entitled *The Word of God Opened,* Henry White Warren's *Recreations in Astronomy, with Directions for Practical Experiments and Telescopic Work,* and J. Dorman Steele's *Fourteen Weeks in Human Physiology.* Besides these volumes, four ten-cent pocket-sized booklets produced especially for the CLSC were prescribed. John Vincent himself wrote a variety of such little paperbacks as time passed, and others contributed similar manuals on topics ranging from Socrates, Pestalozzi, and Horace Mann, to *Good Manners: A Few Hints about Behaviour.* Such pamphlets disappeared as the reading course was consolidated into sets of four to six substantial volumes a year, though a considerable number of books continued to be written especially for CLSC use.

For the second year, the prescribed readings included Charles Merivale's *A General History of Rome,* J. H. Wythe's *The Science of Life, or Animal and Vegetable Biology,* John Clark Ridpath's *History of the United States* (the first work issued in a special edition for Chautauqua), besides an extensive array of other books and pamphlets. The third year's list was the first to admit a novel, Charles Kingsley's *Hypatia.* As the reading lists accumulated through the seasons down toward the First World War, they took in such titles as Richard T. Ely's *An Introduction to Political Economy;* the same writer's *The Strength and Weakness of Socialism* and *Studies in the Evolution of Industrial*

Society; James Bryce's *Social Institutions of the United States,* reprinted from *The American Commonwealth* with the author's special introduction for Chautauqua; Jane Addams's *Newer Ideals of Peace* and *Twenty Years at Hull House;* and *The Autobiography of Lincoln Steffens.* Even so sketchy a sampling shows that the choice of reading for the CLSC, at least at its best, represented a much more than respectable range of knowledge and level of intellectual standing. Among the special courses which were open to home readers and which led to additional diploma seals, a Chautauqua Book-a-Month Club enjoyed a limited term of life beginning half a century before the current club of similar name.

The mushrooming circle needed an organ of its own to keep in touch with its far-flung readers and to supply helps which to many of them would have been otherwise inaccessible. From the third term of the assembly, Chautauquans had read the local news in their own daily paper, originally under the title of *The Chautauqua Assembly Daily Herald,* later shortened to *The Chautauquan Daily.* This was a venture for private profit, approved by the Chautauqua management, under the editorship of the Reverend Theodore L. Flood. The new organ of the CLSC was again a profit enterprise undertaken by Flood in cooperation with the assembly authorities. It was called *The Chautauquan* and was published monthly at Meadville, Pennsylvania, except during the summer weeks, when Flood and his staff moved to Chautauqua to bring out the *Daily.* The monthly began by taking advantage of a shrewdly perceived business opportunity. Much of what it contained was designated required reading for the CLSC, with the result that from an initial printing of 15,000 copies in 1880, it reached a circulation of nearly 50,000 in five years. The first required item in the opening number of the new monthly was an article entitled "From the Creation to the Deluge," an installment of a "History of the World" by a writer who informed his readers that the Bible was "the only source that supplies knowledge of the early history of mankind." Besides required reading, *The Chautauquan,* as it went on, printed general articles on historical and current topics, news from local reading circles, study helps and questions, and it brought to its pages contributors of such varied claims to attention as George Rawlinson, James B. McMaster, Theodore Roosevelt, Woodrow Wilson, and Artemus Ward.

Since the magazine was not averse to profits, it was not averse to advertising. Thornton cites from the first number notices of "books and patent medicines," such as the advice that "a sallow complexion, a languid, spiritless state of mind, and an exhausted, debilitated condition of the body, is always remedied by taking Barosma, and Dandelion and

Mandrake Pills." An issue of 1898 carried almost forty pages of advertising, including such items as "Hall's Vegetable Sicilian Hair Renewer" and "Ferris's Good Sense Corset Waists. DO YOU KNOW," demanded Ferris, that "there is a Ferris Good Sense Corset Waist made to *fit you:* to give you absolute comfort, perfect ease, and graceful contour? . . . Yielding to every motion of the body, permitting healthful respiration, unrestrained comfort." At Chautauqua, mental culture and physical culture were encouraged to go hand in hand.

It was Theodore Flood, during a visit to the Tarbell home in Pennsylvania, who enlisted the young Ida Tarbell as his assistant on the burgeoning monthly. She was to help with study aids, annotations of required texts, and answers to readers who wrote despairingly asking how to pronounce an unfamiliar word, how to translate a foreign phrase, wanting to know the identity behind a name merely alluded to. Many of those in the Circle were without dictionaries, reference books, or access to libraries, although not all were, as Miss Tarbell discovered if an error turned up in print. She was soon doing more than annotating and offering study helps. She found ways of bringing greater order into the management of *The Chautauquan*. From the foreman of the printing office she acquired professional training in such matters as scheduling, printing, and makeup. She began to contribute articles to the monthly and editorials to the *Daily* when it transferred itself to Chautauqua for the summer, where John H. Finley, later editor of *The New York Times,* read copy and proof for several seasons, returning to Chautauqua in 1936 to give the Recognition Day address. Miss Tarbell records that her "particular editorial concern" with *The Chautauquan* came to be its treatment of problems and issues in the eighties, labor, slums, and temperance among them. Thus she gained invaluable preparation at Chautauqua for her later success as a journalist, as historian of the Standard Oil Company, and as biographer of Lincoln.

Like other publications of the Institution, *The Chautauquan* underwent changes of format, ownership, and management. As the century came to an end, decreasing circulation led to the elimination of private ownership and profit from the conduct of publications, which were reorganized under Chautauqua control. In a valedictory article of 1899, Flood said that one of his motives in giving up a pastorate and undertaking to edit *The Chautauquan* had been to promote John Vincent's "new movement." When he began his publishing ventures, Chautauqua was not meeting its expenses, Flood declares, and he summarizes forthrightly the services he considered his editorship to have rendered. "Chautauqua from the beginning has never been responsible for one

dollar in the publication of any of its periodicals. . . . I assumed and have continuously carried the financial responsibility for its daily paper at Chautauqua and its monthly magazine. Up to this time, 1899, . . . I have paid all the bills, secured the copyright . . . and I have paid as percentages into the treasury of Chautauqua during the years of my ownership of these periodicals and my interest in publishing Chautauqua books over two hundred and fifteen thousand dollars." He adds a little magniloquently, "I ask no loftier fame than to be known as the maker of this magazine." In this account Flood does not mention the partnership into which Jesse Hurlbut says he entered with George Vincent, son and successor to Bishop Vincent, for the publication of *The Chautauquan* and the CLSC books. It could not have been a barren association, for Flood and Vincent together, in 1890, presented the CLSC with a building of its own, later used as a bookstore with classrooms above. The CLSC building gave way in the nineteen twenties to the present congenial structure of the Smith Library.

Flood was succeeded as editor by Frank Chapin Bray, who continued in office until *The Chautauquan* merged with *The Independent* magazine at the outbreak of World War I. It was Bray who introduced fiction into the pages of *The Chautauquan*. For a time *The Independent* published the CLSC required readings and information, but by the early nineteen twenties this arrangement had come to an end and the connection with *The Independent* was severed. All outlines, questions, and suggestions for Circle readers were lumped in a *Round Table Handbook*, and complete sets of books and periodicals were offered with the *Handbook* as a unit at considerably less than the total list price.

In its rapid expansion, the CLSC needed not only an organ of its own, but an energetic managerial hand and a guiding spirit. It found both in the person of Kate Fisher Kimball, executive secretary of the home reading plan almost from its inception until her death in 1917. Intensely as John Vincent cared for the CLSC, it was not his only preoccupation, and as the months went on after his announcement of the project, he found himself swamped by the correspondence it evoked. When he complained of his difficulties, a friend recommended Kate Kimball as a possible assistant. She was a girl of eighteen who had just graduated from high school in Plainfield, New Jersey. Despite doubts about her youth, Vincent invited her to try herself out as a helper, and she proved to be one of those women possessed of a natural sense of order, a quick intelligence, an abundance of energy, and a gift of institutional loyalty who know how to keep wheels turning as only such women do. To her talent for management she added personal qualities that made her a

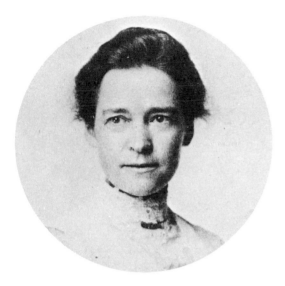

Kate Kimball,

desired visitor to reading groups up and down the land and an object of pilgrimage to men and women who might otherwise never have come to Chautauqua. She brought order to a correspondence that reached a total of fifty thousand letters a year, eventually directed an office staff of twenty, presided over the round tables of CLSC members at Chautauqua in the summer, wrote for *The Chautauquan,* and earned from Frank Chapin Bray the title of "mother superior of the CLSC."

The rapidity with which the CLSC bounded ahead in its first years can be measured in figures. In 1891 Vincent could report that 180,000 members had joined the program. By 1918 the total enrollment exceeded 300,000. A. E. Bestor, Jr., summarizing statistics given by John S. Noffsinger in a study entitled *Correspondence Schools, Lyceums, Chautauquas,* states that in the first two decades of the scheme 10,000 local reading circles sprang up, a quarter of them in villages of less than 500 population and a half in communities between 500 and 3,500. In many of these communities, says Bestor, "the CLSC was the only group organized for cultural purposes, and it formed the nucleus out of which developed a woman's club or other civic organization." And he sums up: "This permeation of American life through its smallest units is perhaps the most significant social fact about Chautauqua."

To understand the CLSC in its formative years, one must understand something of how the local circles were constituted, how they worked, and what their work amounted to. Members of the circles, to be sure, were not all village or grass-roots volunteers. College presidents, faculty members, degree-holders, and individuals of one or another kind of eminence pursued the program. Graduates of McGill, Wellesley, Cornell, Ohio Wesleyan, and CCNY applied for membership in the class of 1896. William Jennings Bryan belonged for a year to a circle in Nebraska. Thomas A. Edison and his wife, a daughter of Lewis Miller, were graduates. But "the permeation of American life through its smallest units" was accomplished by solitary individuals or by local groups. Those who worked alone often had to struggle against hardship and discouragement and felt the lack of fellow students with whom they could talk about their reading adventures and problems. A Winnipeg woman wrote to Kate Kimball's office to say that she received mail only three or four times a year, and another solitary reader said that his village lacked a preacher, a schoolteacher, a doctor, anyone with whom he could exchange ideas or questions.

Vincent wanted to offer whatever encouragement was possible to the solitaries in the Circle, but recognizing their problems he said, "The more local circles we can have the better." Chautauqua gave them every

incentive it could through its own publications, through advertising, through cooperation with other Chautauquas that took the parent name, and through its own summer programs and ceremonies, culminating in Recognition Day. Anyone could join by registering with the central office and paying the stipulated fee. Chautauqua imposed no uniform schedule or program for meetings of local groups, but offered suggestions and guidelines and printed reports of typical or unusual activities. Most local groups organized on their own initiative, but some sought the sponsorship of churches, schools, or of a YM or YWCA. Commonly, local groups met at the homes of members, but they also made use of church parlors, schools, and in time, as public libraries multiplied, of library rooms. They met ordinarily to review and discuss the material the members were supposed to have read privately, but some circles developed supplementary interests ranging from lemon culture to cookery. Some put more emphasis than others on science. At Lewiston, Maine, and again at Cambridgeport, Massachusetts, and Union City, Indiana, groups were able to carry their study of astronomy from text to telescope and to view such phenomena as the craters of the moon. The circle in Burlington, Iowa, studied chemistry under a local physician; at Storm Lake in the same state, members bought chemical apparatus which they later gave to the public schools, and reported that they had carried out all indicated experiments short of the danger point. A number of circles in the late 80s put on classical evenings in Greek or Roman costume, selecting members to impersonate the Muses or Caesar Augustus. Quaint doings, no doubt, but the Greco-Roman evening of the circle at Garrison, Iowa, served the laudable purpose of raising money for the high school library. An early circle in Cincinnati took the name of the German Literary Chautauqua Society. Some of its members could not readily read English, and books in German were allowed them instead. One of its programs includes a number of lieder, an address (*Anrede*) by a Fraulein, readings of poems, a paper (*Aufsatz*) by each of two members, and a reading entitled "Georg Washington und sein Kleines Handbeil."

The social and geographical spread of the CLSC reached out to every quarter of the country and may well seem to have taken in the whole span of American occupations and conditions. Summarizing from an early inspection of the records by Jesse Lyman Hurlbut, Thornton records a servant girl who later graduated from a normal school and became a teacher; a night watchman who did his required reading as he came within reach of the lights on his beat; a Mississippi River boat-captain who conned his lessons on the bridge of his ship; an army

officer's wife whose days on the western plains were so monotonous that she cried for pleasure when her books arrived. Military and naval posts supported a number of circles, as at Fort Spokane on the Spokane River and at Fort Wingate in New Mexico. A U.S. Naval Surgeon, beginning the course in St. Louis, submitted his final report from Shanghai, where he had kept on with graduate reading. Groups of working girls in Maine, in Pennsylvania, in Iowa, found means of following the program. A circle at Syracuse, New York, reported a membership of teachers, lawyers, druggists, bookkeepers, students, a newspaper reporter, a chemist, a potter, and an artist, adding that the religious composition of the group "represented Methodists, Presbyterians, Congregationalists, Episcopalians, Roman Catholics, and unbelievers." A Negro and a Creek Indian joined the CLSC in 1880, and three years later Indian Territory saw the creation of the Chickasaw Circle. On a stagecoach crossing the Rockies, one woman observed another reading Chautauqua books. They later joined forces to found a circle at Bozeman, Montana. A teacher in a caboose—a common conveyance for rural travellers—noticed the conductor doing his reading between stations. He said that some of his brakemen did the same, and a whole freight crew read away at their CLSC course while delayed on a siding. A dramatic company met as a circle in railroad stations, hotels, or theaters.

Kate Kimball in 1886 wrote that "readers of *The Chautauquan* are not likely to be surprised by any extension of the CLSC . . . but their expectations would naturally be arrested at prison doors." Yet solitary or circle readers were locked away at one time or another in almost a dozen prisons from Sing Sing in New York to Bismarck, North Dakota. At the State Penitentiary of Colorado a Dr. Humble, with the support of the warden and of Chautauqua, undertook to form a group, and of three hundred inmates forty men and one colored woman promised to finish the course in prison or out. In 1890 John Vincent sent a message to the fifty-seven members of the Look Forward Circle, addressing them as "My fellow students in the Nebraska Penitentiary." During the course of the year, the circle was addressed by William Jennings Bryan, listed as a member of one of the city circles in Lincoln, and next summer it received a visit from Kate Kimball, Jesse Hurlbut, and Frank Beard. They resolved that it should not wither, and the CLSC groups in the city provided a set of books for every three men. Still another group, the Pierian Circle, appeared in 1890 in the Minnesota State Prison at Stillwater. It set up a membership limit of thirty-six, with the result that it acquired a waiting list. It also drew up its own bylaws and established its own discipline. It heard an address from John Vincent, and received

"fraternal greetings" from the Round Table meeting at Chautauqua. The warden was so impressed by the work of the circle that he organized a primary school for illiterate prisoners and sought teachers among the prison population.

A stream of tribute and gratitude flowed in letters from CLSC readers to headquarters at Chautauqua. Some are extravagant. A German immigrant to Kate Kimball: "The Grecian schools of philosophy were as nothing compared to this system of educating the people. It is the grandest educational movement in the world." Some reflect the cramped lives and pinched opportunities of the writers and the importance to them of even the limited accomplishment that could be expected from the CLSC program. From a "busy mother": "The study of astronomy in last year's course started me on what has since been the greatest pleasure I have ever known. . . . I know the stars, and really greet them each night as dear, familiar friends." From a correspondent in Vermont: "The course of reading has taken me into broader fields, widened my field of vision, and altogether made me a better man." From a reader born and brought up in a log cabin on the Des Moines River, who could count only three years' schooling in his life: the Chautauqua course has "done much to extract the bitterness and envy out of my heart. I can say that it has been the one bright spot in a life of poverty and toil." From a late starter: "In 1881 I commenced the readings of the CLSC. I was then seventy-one years old, a very ignorant and unlettered old man. But I soon became interested in the studies and graduated in the class of '85. By continuous study I have added twenty-four seals to my diploma. I am . . . now in my eighty-seventh year. Do you ask, 'Have you learned anything . . . ?' Well, yes. From very narrow and circumscribed views my vision has been wonderfully enlarged. I have learned something of ancient and modern history, something of the sciences. . . . In all these, to me, new revelations I have enjoyed more of life in the last fifteen years than in all the years before."

In a sketch called "Katytown in the Eighties," in *Harper's Magazine* for August, 1928, the novelist Zona Gale gives a picture, fictionalized in method, of a CLSC group in action during an evening at the home of a member. The circle described, for the evening chosen at any rate, is operating on its own resources. No local doctor is present to guide experiments in chemistry, no sign appears that the members have access to a nearby microscope or telescope, no William Jennings Bryan lends prestige to the occasion. The membership of the CLSC as a whole was predominantly feminine. In the Katytown circle only a few husbands have been cajoled into attending, and among them heads nod. The

group is devoting itself to *The Preparatory Latin Course in English,* and the editorial prose quoted from this text is, to a more recent ear, nauseously turgid and unwittingly pretentious. None the less the circle is having a go at it, while two youngsters sit unseen on the stairs nearby and listen, suppressing giggles at the hesitations and embarrassments of the discussion.

A circle member says: "Think of 'cordial' being from the Latin word meaning heart. Oh, isn't it wonderful?"

Another: "You could take an English page and pick out the different words that came out of Latin!"

The circle sceptic: "What good'd that do you?"

Several: "Why, so to know!"

The hostess: ". . . it makes you feel as if Katytown isn't all there is to it."

Even so. The smallest crack has opened and let in a glimpse of light. "Weep for what little things could make them glad," says Robert Frost in his poem "Directive" of the playthings left by the children on the deserted farm. One could say weep for what tiny vistas can evoke the sense of horizon. But the knowledge that knowledge exists can be the beginning of knowledge, and can come as a revelation.

Riding on its initial momentum, the CLSC achieved a rate of growth that seemed to recognize no visible limit. Its cumulative total by 1940, as reported by Chautauqua President Arthur E. Bestor to the New York commission of education, had reached a membership of three quarters of a million, of whom 10 percent had graduated. Members and circles spanned not only the United States, but the continents and subcontinents from Labrador to Argentina, from Puerto Rico to Ceylon, from Russia to Korea. Europe was represented along with China, India, Turkey, Japan, South Africa. Yet in a nation and a world of rapid social stir and change, the initial growth could not continue unchecked. Beginning in the late 1890s, the CLSC entered on a history of fluctuation and eventual decline. New avenues to learning, new devices for entertainment and the use of time, brought formidable competition. In the 20s, the American Library Association pushed a scheme of reading that combined manuals issued at fifteen to forty cents with recommended books that could be borrowed without charge. The Library Committee of the General Federation of Woman's Clubs promoted home libraries with its own recommended book list. The Book of the Month Club, the Religious Books Club, the Literary Guild, and similar enterprises added further competition. Radio increasingly gobbled public attention. In the depression years, the number of CLSC readers fell below

two thousand. Julius King, then director of the program, sent the membership a questionnaire from the answers to which he was able to make recommendations to the Chautauqua trustees that brought a considerable increase in the entering class of 1939. His introduction defined a recurrent Chautauqua problem as it related specifically to the home reading plan: "we are supremely conscious of the fact that the CLSC is the mother of book clubs, and that her children have outgrown her." At its worst moments of crisis, confronted with shrinking membership and financial deficits, the CLSC was threatened with extinction, but it did not give up the ghost. Though it can no longer reach with its original impact villages that never heard a radio or thought of reading four or more solid volumes a year, though its membership has shrunk from thousands to hundreds, the CLSC, kept afloat by its lectures and "sidewalk" sessions at Chautauqua and its traditional graduation ceremonies, is still a regular activity of the institution and has even shown at least modest signs of increasing again.

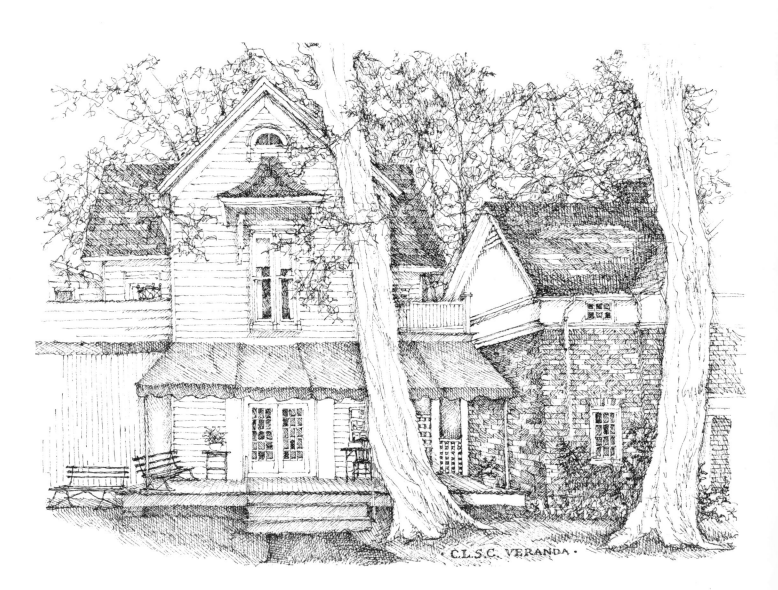

C.L.S.C. VERANDA.

Successors in Leadership
William Rainey Harper and
George Edgar Vincent

While the CLSC was still thrusting ahead in growth and influence, two new leaders began to make themselves felt in the affairs of the assembly. Chautauqua has drawn into its history a surprising number and variety of remarkable lives—preachers, teachers, musicians, executives, men and women of diverse talent and style. Two men of unusual distinction were especially influential in the years from the 1880s down to the verge of the First World War. The enlistment of the first represented another bit of shrewdness on the part of John H. Vincent. His sense of proprietorship in his growing institution was alarmed when a group of Baptists acquired a parcel of land across the lake from Fair Point, named it Point Chautauqua, and built on it a summer hotel and a lecture hall. The enterprise, as it turned out, did not prove stable. It ran into debt, and the lecture building, according to Hurlbut, became a dance hall, patronized by at least some of Chautauqua's younger set for whom dancing was taboo on the home grounds. But the possibility of an unwelcome renewal existed. Vincent said to his son, "The Baptists will find some bright, aggressive young minister of their denomination, put him in charge over there, and give him a free hand." He set out to forestall the menace by himself discovering a qualified Baptist and giving him a post at Chautauqua. The man he found was William Rainey Harper, though Harper was not an ordained minister and was a Baptist by circumstance rather than birth into a family of that faith.

Harper came from Scotch Covenanters both on his father's and his mother's side. His grandfather brought the family from County Down, near Belfast in Northern Ireland, to Pennsylvania, and thence the family moved to New Concord, in Muskingum County, Ohio, where Harper was born in a log house in 1856. His father kept store in a village of some six or eight hundred people, mostly United Presbyterians, and was a supporter of Muskingum College. Harper was something of an intellectual prodigy. He could read at the age of three, and at eight entered the preparatory school of Muskingum College. At ten he was admitted to the college itself. The small class to which he belonged elected to

study Hebrew, and Harper was chosen by lot to deliver at graduation a "salutatory" in that language, this at the august age of thirteen. His teacher observed that "it would have been impossible" for a boy of his years "to have written and delivered a lengthy oration in Hebrew with the proper use of nouns and verbs," but despite this pedagogical stricture his performance must have been a more than creditable feat.

Not surprisingly, young Harper was indifferent to sports, though his father gave him a pair of skates and insisted on his learning to use them. His two early passions were languages and music. He thought for a time of giving his life to music, and though other concerns won out, music did help to supply one significant link in his life. He not only took part in organizing a band, in which he played the cornet and for which he arranged concerts in various parts of the state, he also played the piano with the girl he later married, Ella Paul, daughter of President Paul of Muskingum College.

After college, if circumstances had allowed, he would have gone abroad for graduate study. Instead he continued to study languages locally, worked in his father's store, and did some Hebrew teaching of his own at the college. Then, in 1873, he entered Yale as a graduate student, finding himself less than ideally prepared and considerably younger than his classmates, but making up for both deficiencies by his gift for work and his mental endowments. It was said of him that he "could read a German grammar twice and take the whole thing in just like a sponge." On the verge of his nineteenth birthday, he took his Ph.D. degree, submitting as his thesis "A Comparative Study of the Prepositions in Latin, Greek, Sanskrit, and Gothic."

Leaving Yale as a newly certified Ph.D., Harper taught for two years, first at Masonic College, as it called itself, in Macon, Tennessee, where, lacking a class in Hebrew, he taught the language to his wife, and then at Denison University in Granville, Ohio, at that time a small Baptist college rather than a university. At Denison he unexpectedly appeared at a Baptist prayer meeting and announced, "I don't know what it is to be a Christian, but I know I am not a Christian and I want to be one." That he allied himself with the Baptists was probably due more to his associations with his Denison colleagues, and in particular to his life-long friendship with the considerably older President Andrews, than to a deliberate choice among rival denominations. At any rate, he was baptized by immersion and became a member of the faith. The step must have represented a significant turnabout in his life, for he later wrote, in the foreword to a book of talks to students, "For several years I studied the Bible . . . for the purpose of discovering that which would

enable me to convince others that it was only an ordinary book, and very ordinary at that." A period of skepticism or outright unbelief is implied. It must have been temporary, though as Harper's career advanced and his intellectual concerns enlarged, his orthodoxy and even his central belief were to come under attack and to involve him in privately painful controversy.

But a good deal was to happen in Harper's life before he became an exponent of the higher criticism and an object of suspicion to religious conservatism. One of the singularities of his character was its layers of talent that revealed themselves successively as his experiences and opportunities developed. From Denison, Harper went in 1879 to the Baptist Theological Seminary in Morgan Park, Illinois, as an instructor in Hebrew. Abundant testimony exists to his exciting gifts as a teacher. He seems to have been able to make the study of Hebrew, or of anything he undertook to teach, electric to his students. He drove them relentlessly, and they accepted from him what surely no student would have accepted from another. A colleague at Morgan Park, Eri Hulbert, wrote of him: "Think of a class of beginners in Hebrew reciting four hours a day, and five days in the week, and through a stretch of ten weeks. Think of the heavy discount on eating, sleeping, exercise, rest and recreation which this prolonged memory tug and this unremitting mental tension necessarily exacted. Think of the magnetic or hypnotic power of a teacher who could entice a crowd of greybeards and youth, of pastors and students, of parents and their children, of matrons and young girls, into such a class." Hypnotic and, one is tempted to add, fanatical. It is hardly surprising that such pedagogical zeal for language as language should have excluded wider preoccupations. In his year at Denison, Harper is said to have shown "not the slightest interest in the literature of any language as literature." Another account says that he showed little concern for "writing, speaking, theological controversy, general literature, or philosophy."

This was at Denison. At his next step, Morgan Park, where he stayed for some seven years, other capacities in his character began to come to the fore. One was a constant in his career, his zest for hard, vacationless work, which finally took its toll of his generally strong health. The other was his executive ability. At Morgan Park he set up a summer school of Hebrew, which grew into a system of schools at such widely separated points as Chautauqua and the University of Virginia. He had to acquire a building as headquarters, select and organize a staff, and he complicated his plan still further by instituting and supervising correspondence courses for those who could not attend in person. He wrote text-

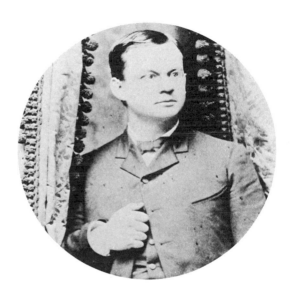

William Rainey Harper

books and founded two journals, one *The Hebrew Student*, the other and more advanced called, *Hebraica*, afterward renamed *The American Journal of Semitic Languages and Literatures*. He showed himself an American of his time and revealed a further entrepreneurial streak in his nature by hopefully setting up a stock company and offering shares at one hundred dollars each to try to finance his Hebraic enterprises.

It was in 1883 that Vincent found at Morgan Park the gifted young Baptist he was looking for and persuaded him to accept an instructorship at Chautauqua in the Hebrew language and literature. This was the year in which Chautauqua received its charter as a university with degree-granting power. Twenty-seven years old when he assumed the instructorship, Harper by successive steps became the administrative mainstay of the entire Chautauqua educational effort and even carried important responsibility for its general platform program. In 1887 he was made principal of the Chautauqua College of Liberal Arts, meanwhile keeping an active hand in his own summer schools of Hebrew and maintaining his extensive correspondence courses. When the title of university was abandoned in 1892, Harper became principal of the reorganized Chautauqua System of Education. As head of the Liberal Arts College, he had the responsibility, as described by Joseph E. Gould in *The Chautauqua Movement*, "for securing fifteen department heads and one hundred or more teachers, preparing sections for over two thousand students, planning a curriculum to include language and literature, mathematics and science, music, art, physical culture and practical art. He had the task of editing the catalogue, planning and supervising the publicity, and securing approximately three hundred 'events' (lectures, sermons, entertainment) for each session. He was expected to take an active part in helping to formulate the policies of the Institute itself, with Dr. Vincent" and others. Enough, one might think, to occupy the waking moments and even the dreams of a year, but Harper's Chautauqua burdens, his summer schools and his correspondence courses made up only a fraction of the total responsibility he carried.

In 1886, after he had served Chautauqua for three years, and not without strenuous efforts on the part of Morgan Park to dissuade him, Harper accepted a call to Yale as professor of Semitic languages. This new appointment did not prevent his carrying on his own educational ventures and his work for Chautauqua. At Yale his individual correspondence was said to have been larger at times than the entire official correspondence of the university. As the Chautauqua years and the Yale

years went on, another latent strand in his character came into prominence, an ultimate progression from the indifference to literature and general intellectual inquiry of his brief term at Denison. He became known as a biblical interpreter and critic who could not only galvanize language classes but capture audiences, younger and older, by contagion from the platform. At Yale he began to offer a course to undergraduates that dealt with Oriental literatures and cultures in broader than merely linguistic terms, and he gave public lectures on the English Bible to groups in Brooklyn, Vassar, Boston, and New Haven. At Chautauqua, in 1888, he set up a School of the English Bible which evoked some of the controversy he encountered from opponents of the "higher criticism." The controversy pained him, but he found a stout defender in John Vincent, who called him "a teacher of the Word . . . to the last degree reverent," and who praised his urbanity and freedom from dogmatism in debate. When dispute arose over the authorship of the Pentateuch, Vincent showed his confidence that faith could survive fair-minded study. "The issue raised," he wrote, "is whether Dr. Harper and others believe in Moses as an author. They declare that they do so believe; and it is replied that what they have written is fatal to the Mosaic authorship of the first five books of the Bible." Harper's critics, Vincent felt, had allowed the controversy to become personal, and he declared: "The day is gone for settling questions by calling names. A rationalist who denies all inspiration is a very different person in faith and works from the Christian Scholars who are quite sure Moses did not write the account of his own death." Harper himself explained his position to a *Herald Tribune* reporter by saying: "I believe in applying to the Bible the principles of literary criticism, to determine when its books were written, and the particular purpose for which they were written. . . . Inquiry does not imply a doubt in the divine origin of the Bible. It simply implies a desire for knowledge in relation to the human circumstances connected with that origin."

Despite the outward urbanity for which Vincent gave him credit, Harper was sensitive to the attacks he had received. His vulnerability showed in the next and final turn of his career. When munificent gifts by John D. Rockefeller made possible the revival of the university of Chicago as virtually a new institution, and the trustees chose Harper as its president, he went through a period of hesitation that marks a departure from his usually positive temperament. Some of his doubt sprang from uncertainty whether he was a suitable candidate to head an institution of Baptist sponsorship. Finally he allowed his ambition for large accomplishment to have its way. His success as President of

Chicago became a chapter in the history of American university building. At Chicago, Harper established three of the educational features he had witnessed and helped to develop at Chautauqua, thus perpetuating and extending some of the chief ideas of John Vincent and Lewis Miller. He insisted that the academic year be divided into four terms, including a term for summer study. He also installed university extension work and correspondence courses. With his stomach for work, he continued to serve as principal of the Chautauqua System of Education until 1895, delegating much of his administrative responsibility, but turning up faithfully for summer weekends at the lake. For years his energy seemed inexhaustible, but spells of illness followed by resumption of his frantic work-pace showed that a limit could be reached. At last surgery exposed the presence of cancer. Even when this was made clear to him he went on teaching and carrying the burden of the presidency until his death in 1906.

While Harper was carrying his multiple burden of responsibilities at Chautauqua and elsewhere, another remarkable man, who would ultimately become a figure of national and international distinction, was getting in his first licks at Chautauqua management. This was George Edgar Vincent, the son of John Vincent and the self-proclaimed first Chautauquan who jumped off the boat ahead of his father and Lewis Miller when they scouted the premises before the first assembly. George was eventually to become president of the Institution, but other Vincents also found places for themselves in the Chautauqua hierarchy. As Jesse Hurlbut puts it, "With one Vincent Founder and Chancellor, his son the President, one nephew [Leon H. Vincent, the bishop's biographer] a lecturer every year or two on literature, the other nephew [Henry] the organ and band master, and his mother the President of the Woman's Club for many years, the Vincent family had been worthily represented at Chautauqua." In another kind of institution such clan participation would have invited the charge of nepotism, but Chautauqua has undoubtedly profited by its strong tradition of personal and family loyalty among its officers and benefactors, Vincents, Millers, Masseys, Nortons, and others.

George Edgar Vincent was born in 1864, and was thus William Rainey Harper's junior by eight years. George was given the college education his father had missed, graduating from Yale in 1885. He put in a year at newspaper work and another traveling in Europe and the Orient, and in the summers began helping his father at Chautauqua. He followed Harper to Chicago in 1892, took his Ph.D. in sociology, and rose there through the usual academic ranks until he was made dean

of the Faculties of Arts, Literature, and Science. He did not become president of Chautauqua until 1907, but his intimate association with his father brought him into the center of activity much earlier. He met the speakers, popular, academic, and religious, who came to conduct sessions. He made use of his travels by conducting some of the simulated foreign tours that were a popular feature of the program. He was made literary editor of the Chautauqua Press. Kate Kimball shipped him off on a tour of CLSC groups, and he reported "an Irish comedy and a Baptist oyster supper" among rival attractions he encountered. But he proselytized for the CLSC "hot and heavy," as he put it, distributing circulars and exhorting people to join. When his father became Bishop Vincent, George was appointed vice-principal of instruction, and ten years later was made principal.

In 1885, two years after Harper's arrival, he made his first appearance in the Chautauqua amphitheater, where he began to preside when his father could not be present. Chautauquans quickly came under the spell of his platform facility, which he apparently developed not through debating clubs or speakers' societies at Yale but through exposure to Chautauqua itself. He gained a reputation for aptness and wit in his introductions of other speakers, and he expressed himself with a rapidity that according to one estimate reached two hundred and fifty words a minute. His daughter, Elizabeth Vincent Foster, recalls that on one occasion he knew that among his expected listeners a court reporter was to be present who boasted that he could keep pace with any rate of utterance. Vincent began slowly, at a pace calculated to lull the expert into overconfidence, and then poured it on with his customary fluency, taxing the professional pencil to the utmost. His preparation for speaking seems to have been mental. A few notes or jotted heads of what he meant to say were enough to keep him going. His daughter recalls that when he was once asked what kind of mental process it was that enabled him to develop his ideas in a virtually extemporaneous spate, he said in effect that it was like describing a view seen through a window. The suggestion is that he had a gift of externalizing his thoughts in visual images and translating them into language as he went along.

His proficiency as a speaker was not accompanied by equal facility as a writer. Apparently the act of writing obscured that view through the window which he could evoke to the wonder of his audience. His daughter says that when he attempted to set down his memoirs the effort came to nothing. Not only are his own memoirs lacking, but no biography of him by another hand exists. His daughter remembers that

James Gray, author of *The University of Minnesota,* the university of which George Vincent became president, wanted to write his life but was deterred by Mrs. Vincent. The loss seems a genuine one, for both George Vincent and Louise Palmer, whom he married, were a pair worthy of a detailed record.

A letter of September, 1892, from Bishop Vincent to "My dear George & Lou" while the couple were abroad shows the affection of the father for the son and his wife, and also that belief in a providence both solicitous and selective which an older generation of believers could accept. "The telegraphic news," the Bishop writes, "is not very reassuring: German ships coming in with cholera on board; ordered to quarantine; several deaths; men in N. Y. offering all sorts of inducements to the authorities to let their friends land, but in vain; Americans abroad paying fabulous sums to get home but steamers all full; cholera increasing etc. etc. etc. I am [underlined] sorry you started. . . . But I am trusting in your own good sense & caution & in an all-wise & all-loving Providence. Return on the best [doubly underlined] steamer. Don't think of German or French line. Never mind expense. Take a steamer that brings no emigrants. . . . Be very [doubly underlined] cautious. I love you both more than you know."

George Vincent's leadership at Chautauqua was a true filial succession, yet it seems clear that the son belonged to a later generation than the father in mores and beliefs as well as chronology. According to his daughter's recollections, George Vincent was not one to observe all the counsels of the bishop's *Better Not,* a small book of cautionary precepts for the young. Though stopping short of absolute prohibition, this treatise considered it "better not" to dance, play cards, go to the contemporary theater, or drink. Unlike his father, George had no ear for music and was bored by concerts, but he loved the theater, enjoyed nothing more than watching the curtain go up in London, and especially admired Mrs. Fiske as an actress. As a young man, he showed an amateurish but genuine knack for sketching scenes and people with a pen or pencil, sometimes adding a wash in color to vary the black and white. He took a girl to a prom at Yale, and while they sat it out together and did not actually dance, they were at least present. When George left Chautauqua to become president of the University of Minnesota, Mrs. Vincent, according to James Gray, maintained the ballroom which was part of the presidential house as a place where undergraduates could dance to the player piano. She was also capable of marshalling faculty wives for salutary exercise with a basketball. The Vincents together encouraged plays, games, parties, fairs, and "bouts

of public speaking," and Mrs. Vincent appeared as Queen Elizabeth in a "tremendous May fete."

Mrs. Foster reports that while her mother never put the point explicitly, she allowed her daughter to feel that Sunday school was not the most important observance in the world. For his part, George Vincent did not express any open difference with his father's beliefs. He was a frequent church-goer when occasion offered or demanded, and felt called on to question his wife's sense of timing when she could be seen driving the children off in a buggy to a Sunday picnic just when the devout were entering or leaving the sacred doors. But George may well have extended the bishop's unconcern with theological controversy to a point which the bishop would not have accepted for himself. As for Mrs. Vincent, she was a character of no little spirit and independence. As an undergraduate at Wellesley she refused to wear a corset in an age when it was standard equipment for a properly dressed female. In later life she consented to wear one for state occasions. She loved mountain climbing, travel, and discomfort, while her husband preferred the best hotels and cuisine. She once persuaded a road engineer to relocate a projected section of the Merritt Parkway in Connecticut by showing him a route that was not merely more efficient but had the advantage of not going through the Vincent garage.

Although George Vincent was vulnerable to severe fits of depression, his daughter says that he could recover his customary spirits at once if amusing or interesting company appeared. Those who knew him credit him with a ready sense of wit. He was said to have the faculty of puncturing folly or tediousness without leaving those who took the cut feeling injured, though some of his recorded sallies seem sufficiently edged without his presence to season them. To a Chicago student who performed badly he said: "Thank you for your agreeable entertainment. Now will someone give us the facts?" And to another: "The variety of your misinformation is almost an excuse for its being." James Gray records that as president of the University of Minnesota, Vincent presided over a group of men who discussed an issue with less than good temper. Said Vincent: "Gentlemen . . . this argument has degenerated into a cat fight and I shall end it by putting the question to a vote. All those in favor say Miaow." Gray also reports that Vincent once called on an old friend, a garrulous woman who kept appealing to her children for a name, a date, a quotation. She finally apologized for being scatterbrained, and Vincent said, "You are working in the best academic tradition. You use your children as your footnotes." When radio came into use, Vincent, despite his prowess as a speaker, commonly refused

to be broadcast. Once the sponsors of a dinner at which he was to be heard tried to trap him by arranging to put the proceedings on the air without his knowledge. He became suspicious, was told that the broadcast was already under way, and that there was nothing he could do to prevent it. According to Gray's account: " 'Oh yes there is," Vincent retorted. 'I will use the words *syphilis* and *damn* in the first line I speak.' " In the early days of radio, the answer was sufficient to gain his point.

In 1896 William James paid a visit to Chautauqua and gave in the form of lectures the substance of his *Talks to Teachers*. George Vincent, by then Principal of Instruction and shouldering the kind of complex responsibilities Harper had borne, shepherded James around the Institution. James's letters to his wife, written from the scene, record his experiences in a way that fervent Chautauquans have found less than flattering, but his comments are as much epistolary *jeux d'esprit* as they are formal judgment. Moreover, they give a lively picture of the Institution in its bewildering variety of activities, both those that attracted or amused James and those that did not. They are interesting, too, for James's estimate of the Vincents at a time when George was in his early thirties.

James's first response is to a quality of mind that can be met with among students anywhere, but is hardly to be wondered at in an institution that began as a Sunday school training center and put a heavy premium on self-improvement and the pursuit of culture. On July 24 he writes: "I've been meeting minds so earnest and helpless that it takes them half an hour to get from one idea to its immediately adjacent next neighbor. . . . And when they've got to the next idea, they lie down on it with their whole weight and can get no farther, like a cow on a doormat, so that you can get neither in nor out with them. Still, glibness is not all. Weight is something, even cow-weight." Later in the same letter: "Young Vincent, a powerful fellow, took me over and into the whole vast college side of the institution this A. M. I have heard 4½ lectures, including the one I gave myself at 4 o'clock, to about 1200 or more in the vast open amphitheatre, which seats 6,000 and which has very good acoustic properties." On July 26: " 'Tis the sabbath and I am just in from the amphitheatre, where the Rev. ———— has been chanting, calling and bellowing his hour-and-a-quarter-long sermon to 6000 people at least—a sad audition. The music was bully, a chorus of some 700, splendidly drilled, with the audience to help." James then says that he declined to take part in a program the nature of which he failed to grasp, but which "Young Vincent, whom I take to be a splendid young

fellow," told him was the characteristically "Chautauquan" performance of the day. But James gave himself a sufficiently thorough dose of Chautauqua. He had gone on the previous day to four lectures, "in whole or in part. One was on bread-making, with practical demonstrations. One was on *walking*, by a graceful young Delsartian, who showed us a lot." James added a complaint: "No *epicureanism* of any sort!" On July 27: "I took a lesson in roasting, in Delsarte, and I made with my own fair hands a beautiful loaf of graham bread with some rolls, long, flute-like, and delicious." On July 29: "The Chautauqua week . . . has been a real success. I have learned a lot, but I'm glad to get into something less blameless. . . . The flash of a pistol, a dagger, or a devilish eye, anything to break the unlovely level of 10,000 good people— a crime, murder, rape, elopement, anything would do. I don't see how the younger Vincents stand it, because they are people of such spirit." One suspects that the young Vincents stood it, if endurance was the question, in part because they were in fact people of spirit and knew when to look at things with an amused eye, but also because George Vincent had his own kind of earnestness and desire to help in the world, as his long and very eminent educational and administrative career attests.

In 1911 Vincent was appointed president of the University of Minnesota, continuing his service to Chautauqua as honorary president and as a trustee of the Institution. Like Harper at Chicago, he proved to be one of the brilliant and imaginative academic leaders who transformed and advanced notable American universities. One of his achievements, against bitter opposition at the time, was to take a leading part in establishing the Mayo Foundation for Medical Education and Research in affiliation with the university. Again, as Harper did in moving to Chicago, Vincent carried Chautauquan practices with him. He reorganized and strengthened extension work, and in an effort to make the university serviceable to the whole state, he established "University Week," bringing lectures, dramatic entertainments, music, and discussions to small communities quite in the manner of a travelling Chautauqua. In 1917, during the convulsion of World War I, he became president of the Rockefeller Foundation, and embarked on the work of war relief and public health that brought him international recognition. At a memorial meeting in the Amphitheater, Judge William L. Ransom, a Chautauqua trustee, said of George Vincent's later career: "There was hardly any quarter of the globe to which he did not carry the helpful and healing ministries of the Foundation, and millions of people were blessed by what he and his associates planned and did. He went into many countries on his humane errands; with his charm of manner and

his complete freedom from personal motives he had the confidence of rulers and of leaders of public opinion; he was the partner of physicians, public health organizations, and humanitarians everywhere."

William Rainey Harper was cut off at fifty; George Edgar Vincent lived for some seventy-seven years. He died on February 1, 1941, during the year of Pearl Harbor. The two were both men of conspicuous and to some extent overlapping ability, but of sharply contrasting character. Together they form one measure of the biographical richness and diversity that enter into the story of Chautauqua.

World War, Economic Crisis, and Social Transformation

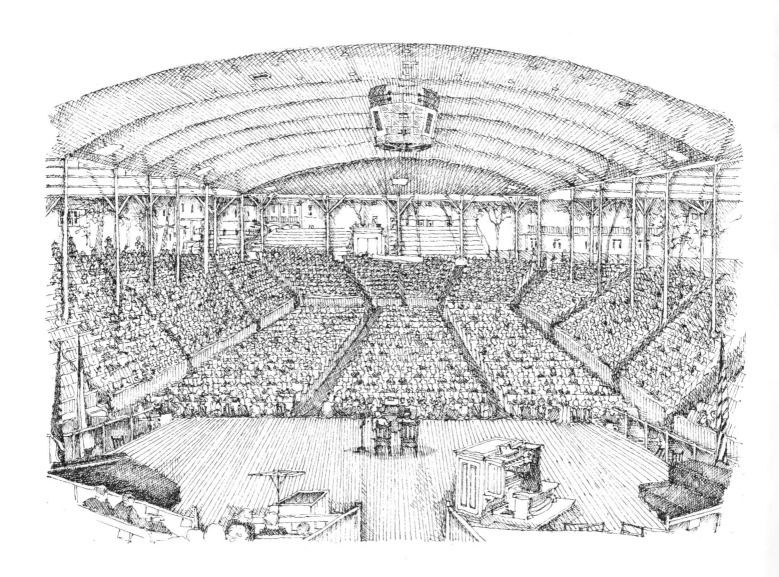

The Presidency of Arthur E. Bestor

Patriotism in Flower

When George E. Vincent retired from the presidency of Chautauqua in 1915, he was succeeded by Arthur E. Bestor, who conducted the Institution through the First World War, the depression of the thirties, with its almost fatal consequences for Chautauqua, and well into the Second World War. Bestor's presidency lasted nearly thirty years and spanned not only world violence and economic upheaval, but comprehensive and rapid changes in American life. His training in sociology under George Vincent at Chicago and his association with Vincent at Chautauqua made an appropriate preparation for his work of keeping Chautauqua responsive to the flux of the times.

Arthur Bestor was born in 1879 at Dixon, Illinois, the son of the Reverend Orson Porter Bestor, a Baptist preacher in various parishes in Illinois and Wisconsin. Orson's forebears had taken part in the American Revolution, and Orson himself interrupted his preaching to join an Illinois regiment in the Civil War. Arthur came under Chautauquan influences early in his life. His father promoted CLSC groups in his parishes, and took Arthur as a boy to neighboring assemblies modelled, as so many were, on John Vincent's original. After studying at Wayland Academy at Beaver Dam, Wisconsin, Arthur graduated from Chicago University in 1901. Appointed professor of history and political science at Franklin College, Indiana, he was back at Chicago in 1903 on a graduate school fellowship. For a number of years he lectured on political science in the University Extension Division, established by William Rainey Harper. In 1905 he married Jeanette Louise Lemon, whom he had met at Franklin College. In the same year he came to Chautauqua as an assistant to George Vincent. By the time he succeeded Vincent as president, he had already undergone a decade of Chautauqua repsonsibility.

Arthur Bestor's character has left an impress that still lingers in the memories of Chautauquans of long standing. An able and almost

ferociously energetic administrator, he is recalled also for qualities that evoke the phrase "gentleman of the old school," though they were accompanied by a ready sense of humor and an unforced democratic regard for people of whatever sort or age. His vocal power and fluency as a speaker link him to the days when oratory flourished unabashed. His unaided voice could reach without strain, it is said, the last row of the amphitheater, and while the accoustics of that open-sided structure are impressive, few voices after William Jennings Bryan would now dispense with the public address system that carries speakers, singers, and orchestra to the uttermost benches and beyond. A woman who has known Chautauqua for most of her life told the author an incident about the graciousness and courtesy for which Bestor was known—qualities that in this case, as it happened, were misdirected. As a meeting broke up in the Hall of Philosophy, Bestor noticed an elderly woman of some elegance still sitting while others went out, and also noticed a wheel chair in the corner. He put the two together in his mind, and suiting the deed to the thought, maneuvered them together physically, despite demurrers and expostulations on the lady's part. Chair and all, he wheeled her to her address, to be met by an alarmed daughter who could only think that her mother had fallen and injured herself. It was a chivalrous impulse, even if applied to the wrong recipient. The same informant recalled that her fourteen-year-old son surprised her with an ambition to become President Bestor's assistant as errand boy or messenger. Mother though she was, she was skeptical of his persistence and reliability, and tried to dissuade him, but Bestor interviewed him, took him on, and later made a point of telling his mother that parents heard so much bad news of their children he was glad to give the boy a faultless report.

Courtliness does not always go with eminent executive ability, but in Arthur Bestor the two were combined. As president of Chautauqua he was rapidly immersed in the problems of a country at war and of an Institution swept up in it. Samuel Eliot Morison has called World War I "the most popular war in our history while it lasted, and the most hated after it was over." A more recent war may have been even more bitterly hated while it was still going on, but the popular response to World War I showed itself in an all but universal flood of patriotism, in which Chautauqua ran with the current that engulfed the country as a whole. Jesse Hurlbut summarized the general picture sharply enough. President Bestor, he records, together with most other officers of the Institution, joined in the manual of arms drill with dummy guns. Headquarters of several denominations were given over to Red Cross work.

Hurlbut says of the Chaplain of the Week during the opening of the 1917 season that "his addresses blended fervent patriotism and fervent religion in about equal measure." Militant patriotism inevitably arouses suspicion and fear, and Hurlbut reports that "a stranger could scarcely get into the Methodist House without being scrutinized as a possible German spy, with a pocketful of poison or powdered glass to sprinkle on the bandages."

In keeping with its tradition of free and open discussion of current issues, Chautauqua had heard the question of peace or war agitated on its platform for well over a decade before war broke out in Europe. Much if not the bulk of this anticipatory controversy was hopeful and proved delusive. That the twentieth century was to be one of war and not peace only the twentieth century could reveal. In 1907 *The Chautauquan* had called attention to the National Peace Congress in New York, and Kate Kimball reported the second such congress in Chicago in 1909, with the German ambassador and a Japanese consul present. Members of the CLSC were encouraged to study and circulate Charles A. Beard's pamphlet, *European Sobriety in the Presence of the Balkan Crisis,* supporting the belief that reason would prevail over arms. *The Chautauquan* published extracts from the translation of the novel *Lay Down Your Arms,* by Baroness Bertha von Suttner of Austria, first woman to win the Nobel Prize for peace. In 1912 the Baroness herself made a plea for arbitration in the Amphitheater. She was to die two years later, just a week before the murder of the Archduke Franz Ferdinand which became the pretext for World War I. Another spokesman for peace was David Starr Jordan. Jesse Hurlbut thought Jordan had shown "conclusively that the day of wars was past and that the financial interrelations of nations would make a great war impossible." Colonel S. S. McClure departed, a little eccentrically, from the prevailing optimism. He saw "the most terrible question threatening us today" as the prospect that Germany would destroy the British Empire. Envisioning an Anglo-American supernation to dominate the world, he exclaimed, "What a disaster it was that we lost England in 1776!" In the same summer that Jordan and Baroness von Suttner spoke, H. H. Powers warned of dangerous areas and causes of conflict, and in 1913 a Serbian prince declared outright that there would be a war within months, "and such a war as has not stirred Europe since the days of Napoleon."

As war actually approached during the summer of 1914, a symposium was hastily arranged in late July. Faculty members of the Chautauqua schools provided speakers. One who had served in the German

army spoke for Germany; a Frenchman formerly in the French navy spoke for France; a member of the Chautauqua medical staff who had marched with Kitchener to Khartoum put the English case. Next summer a war correspondent described "Fighting in Flanders," and in 1916 a symposium was held on "Preparedness for War or Peace." Among Amphitheater speakers in that final season before American entrance into the war was Scott Nearing. He had taught for three years in the Chautauqua summer schools, and for his attacks on business interests had been dismissed from the Wharton School of the University of Pennsylvania under pressure from the state political boss. He was to be dismissed from another academic post and even brought to court for pacifist activity during the war, and would later become widely known for his inquiry into education in Bolshevik Russia and for his writings as a socialist on many political and economic subjects. He told Chautauquans in 1916 that it was the capitalist class that profited from war and that capitalist interests were trying to involve the United States in the struggle. Judge Alton B. Parker spoke on "The League to Enforce Peace," saying that its mission was not to halt the existing conflict but to prepare for the enforcement of peace afterward. Chautauqua also heard speakers who had sailed on Henry Ford's Peace Ship both criticize and defend that much-mocked venture, which had sprung from an international peace congress of women at the Hague in 1915 and had enlisted Jane Addams among the delegates who toured European capitals in the vain cause of mediation.

President Wilson's requested declaration of war was confirmed in April, 1917, the House concurring with the Senate, as Samuel Eliot Morison puts it, "in the small hours of Good Friday." Chimes rang in the first Chautauqua season of the war on June 28, and President Bestor gave an extended address, fully reported in the *Daily*. He began with a question: Has Chautauqua a part to play in the national crisis? He went on with a list of Chautauquans, from students to officials, who had gone into service or taken national posts of one sort or another, and recalled the symposium of 1914, arranged almost overnight, as an example of the Institution's resourcefulness. Then he expressed his sense of the progress of thought and feeling at Chautauqua as it had developed since the outbreak of the undesired war. His point of departure was again a set of questions. Why had Christians not established peace? Why not financial leaders? Why not socialists? Why had no strike of labor against war occurred? The next stage of response he found in the search for a personal devil, the Kaiser or the Czar offering a convenient candidate. This stage gave way, he considered, to the perception that every

country, in its own eyes, had what it believed to be its own cause. But finally, speaking obviously for himself but confident that he was expressing a Chautauqua consensus, he said that German actions, as evidenced in Belgium, had led to the view that "the cause of the allies is our cause. Their civilization is ours." He closed by affirming that "one of the results of this war must be the real internationalization of the world and the working out of institutions which will make war impossible. This is the great meaning of this struggle if it has a meaning. It is the hope of the future if there is a hope." Thus he ended on a note repeatedly sounded at Chautauqua, both in peace and war, though seldom with "if's" of such drastic implication.

The question why Christianity had not prevented war came up again in the sermon by Harry Emerson Fosdick on the Sunday following Bestor's address. If war proves Christianity a failure, Fosdick said, it similarly proves the failure of education, commerce, international law, all idealistic agencies. Despite the pacifism of some church fathers, Christianity and war were long closely allied, as Christianity and slavery had been. Now, said Fosdick, war and Christ are seen to be incompatible, as Christ and slavery are. The world conflict should therefore be regarded as a challenge and not as a cause for dismay, though evil using force must still be resisted by force. Fosdick's words, whatever note of rationalization one may find in them, stand in amusing contrast to the subhead that the *Daily* prefixed to its report of a sermon by another divine later in the season: "War Said to Be Teaching Unity and Loyalty, Helping to Make Country Dry, and Sustaining Nation's Faith in God."

Naturally enough, in accord with a practice that spread through the country and that made use of its churches as well as other forums, Chautauqua got its dose of German atrocities. Early in the season the *Daily* reports Captain A. Radclyffe Dugmore, of the King's Own Yorkshire Light Infantry, as lecturing in the Amphitheater on "Our Fight for Freedom" and records him as a witness to "horrible atrocities, some of which are so black that they can never be put on paper." It has been left to a later day to remedy such reticence about atrocities, and to learn that they are not the exclusive practice of any one nation.

A world war, the first of its kind and complexity, demanded organization, both national and institutional. A list of the offices in which President Bestor's patriotism and energy enlisted him makes a jaw-breaking roster. Some of his official titles are here abbreviated for convenience in reading. In 1917, he was made secretary, Committee on Patriotism through Education under the National Security League.

Promptly a Speakers' Training Camp was arranged for an early week in the Chautauqua season. Bestor was also made chairman, War Council, American Platform Guild, as also of the YMCA War Board Committee on Lectures and Entertainments in Training Camps. In September Herbert Hoover invited him to Washington as director, Lecturers' and Speakers' Division, U.S. Food Administration. It is hardly any wonder that although he continued to act as president of Chautauqua, the trustees released him "for as much of his time and energy as may be necessary to carry on this national work." After the war, but frequently as a result of it, especially in his work for countries of the Near East, with which extensive travel had made him familiar, he became chairman, Board of Trustees of Near East Relief; trustee, Near East Foundation; a director, American College in Sofia; member, executive board, American Association for Adult Education; Chairman, Board of Trustees of Town Hall; member, Commission to Study the Organization of Peace, and of the World Alliance for International Friendship Through the Churches; and finally, American member, Council of the World Association for Adult Education.

By 1918, education had become for Bestor a means of winning the war. Addressing the Amphitheater at the opening of the Chautauqua season, appropriately enough on the fourth of July, he spoke on "Mobilizing the Mind of America." This was a war, he reminded his audience, of fully engaged nations, not merely armies. The support of public opinion was essential; food restrictions must be accepted; morale must be sustained; and the way to these goals lay through education. The message must be extended to the "last unit" of the educational system. Praising the "four-minute men" who carried the theme into movie houses, he said that "community centers and school houses and church gatherings all furnish the opportunity for this intellectual mobilization." He expressed sympathy for skeptics or those who for religious reasons shrank from such total commitment, but closed with a vehement peroration against the current regime in Germany.

During the seasons of 1917 and 1918, the war could not help taking a chief place in attention, but it was not all war at Chautauqua. Instruction and entertainment continued to find a welcome. Summer of 1918 began with audience and soloists joining Alfred Hallam, then music director, in "The Star Spangled Banner," and the audience stood while the "Marseillaise" was sung as a solo in French, followed by solo presentations of Garibaldi's Hymn and "Rule Brittannia." But in the course of the two war seasons, lecturers dealt with various themes as usual, and science and amusement were not overlooked. Franklin D.

Roosevelt as assistant secretary of the Navy made the first of several Chautauqua appearances. Talcott Williams, Dean of the Pulitzer school of Journalism, spoke for the League to Enforce Peace. Another speaker, by contrast, gave a stereopticon-illustrated lecture on prehistoric man, allowing him an existence of half a million years, a mind-boggling figure since generously exceeded. In 1917, the Chautauqua Summer Schools were offering courses in foreign languages as usual, ten in French, four in Spanish and Italian, two in German when not a few Americans were in favor of annihilating the German language along with other German phenomena. In the same year, President Bestor paid tribute to the Chautauqua Traction Company on the opening of a trolley line from Jamestown past the Chautauqua grounds to Mayville and on to Westfield. The nearest rail connections had previously been a branch of the Pennsylvania road to Mayville and of the Erie to Jamestown. A spur to the northern boundary of Chautauqua had been abandoned. The trolley turned Chautauqua's original front door, at the pier reached by lake steamer, into its back door, and the new front approach considerably increased accessibility. When Old First Night arrived on August 7, Chautauquans turned out to welcome a visit from their beloved chancellor emeritus, Bishop Vincent himself, who took the occasion to speak of his associate founder, Lewis Miller. In 1918, military and nonmilitary activities went on in characteristic fashion. Amusement included motion pictures at Higgins Hall, and for one particular week the programs offered Mary Pickford twice, once in *Rebecca of Sunnybrook Farm,* and a turn each for William S. Hart and Douglas Fairbanks. Tickets, afternoons 10 cents, war tax one cent; evenings, 15 cents, war tax two cents.

Participation by women was one of the prominent features of the war effort at Chautauqua. The theme of woman's role in warfare was not entirely unprecedented at the Institution. In the aftermath of the Spanish-American conflict, in *The Chautauquan* monthly magazine for July, 1899, an article by Etta Ramsdell Goodwin said in part: "Nearly every woman in the United States would have liked to change places with the men who put on uniform last spring. They did not want war and they did not want their men-folk to go to war, but they had their little savage wishes nevertheless, and to be a soldier and a fighter to each feminine imagination seemed to be the most desirable thing in all this world. As she could not be a fighter, the American woman was inspired by the conviction that the career of an army nurse was the career for which she had come upon earth. The prospect of wearing a becoming uniform and fanning sick officers doubtless . . . inspired some . . . but

WIRELESS AND TELEGRAPHY

with the majority it was simply the unconquerable and passionate wish to do something, to have a part in the great war work." In 1917, women at Chautauqua marched in their own drill formations, wearing uniforms consisting of a white blouse, white tennis shoes, and khaki skirt, the latter costing $1.75 to $2.00. "One of the best ways for women to prepare for national defense," reported the *Daily*, "is to put themselves in perfect physical condition." In 1918, a Woman's Service Week was announced to begin on July 15. Among half a dozen prominent speakers appeared Anna Howard Shaw, suffrage leader and currently chairman, Woman's Committee, National Council of Defense; Mrs. Percy V. Pennybacker, long-standing Chautauquan from Texas, former president, General Federation of Women's Clubs and successor to Mrs. B. T. Vincent as president of the local club at Chautauqua; and Carrie Chapman Catt, president, National Woman's Suffrage Association, who addressed herself to the question: "For What Are We Fighting?" Concurrently with Woman's Service Week a National Service School for young women was launched. Its formidable routine borrowed freely from military terminology: Reveille, 6:00 A.M., Taps, 10:00 P.M., and in between "Military Calisthenics," Colors, Sick Call, Inspection, and classes in food conservation, first aid, dietetics, telegraphy, surgical dressings, typewriting, and braille.

The commandant appointed to take charge of the National Service School was none other than Mrs. George Edgar Vincent, already a member of the National War Work Council, YWCA, and of the Committee for the Fatherless Children of France, an important part of whose work was fund raising. She also belonged to the motor corps of the National League for Woman's Service, a corps that performed such useful transportation chores as driving trainees to a rifle range or youngsters under child welfare to centers where they could be weighed and measured for health and development. As Commandant of the National Service School, Mrs. Vincent could not altogether repress, even in wartime, her natural verve and turn for satire. A series of "Letters from N.S.S. Camp," with parenthetical "Apologies to Ring Lardner," began appearing in the *Daily* for August 8. They are addressed to "Dear Mabel" and signed "Betty" or simply "B." That Mrs. Vincent wrote them is attested by her daughter, Elizabeth Vincent Foster, though only a mildly brilliant guess could infer the authorship from internal evidence. Betty or B. is a recruit, a private, in the service school. She describes to her absent correspondent Mabel her arrival at Chautauqua in the midst of what she takes to be a riot, but which proves to be only a farewell, with shouting and flower-flinging, to the French Mili-

tary Band. "It made me feel creepy up my back," writes Betty, "to see so many brave heroes being appreciated." On August 10 Betty writes:

> Saluting is a very important part of being a soldier. Some people seem to think it's the only part. You do it whenever you meet your superior. You know they are superior by the pieces of blue braid sewed on their sleeves and by their haughty air. . . . [Saluting] should be done with "pep" up here. At first I got it all mixed up with "hep," but they are quite different. When you are marching somebody yells out "hep" every time you put your left foot down or else you put your left foot down every time somebody yells out "hep."

The letter goes on to describe standing at attention as:

> going stiff all over like that boy who used to have fits in school. The first time I saw a girl do it I thought she was having one and was just wondering whether it would be catalepsy or apoplexy when she came to. That's the trouble with first aid, you are always getting your hopes up and being disappointed.

In the same letter, B. makes a discovery:

> I've found out what "reconstruction" is. It isn't putting wooden legs and arms and artificial noses and things on them at all, like we thought, but basket making and chair caning, and weaving and a lot of things you can teach them in a hospital.

B. then complains of blisters and says the commandant calls them:

> a disgrace to a soldier and a sign of ignorance or neglect. Anybody would know she had never suffered. I wonder whether hard hearts always go with hard feet.

The result of this slur on the commandant is that B. and her fellow recruits are chewed out by their officers. No one, it appears, should make a contribution to the press without submitting it first to authority. B. is afraid of being dismissed from camp, but at dinner the commandant rises to say that she has an agreement with the paper not to print anything she has not seen in advance, and that she considered the letter an acceptable joke.

On August 20, B. deserts the ardors of war-training in favor of a bit of byplay with Chautauqua legend and topography. If she substitutes the Arctic Ocean for the Atlantic and fails to realize that the Senecas were a tribe of the Iroquois federation, she had little time after all to look up these niceties between reveille and taps.

Oh yes [writes Betty, as she signs herself this time], yesterday we had a picnic to Barcelona harbor on Lake Erie. Fifty-four of us in a special trolley and Mr. Bestor was along and explained the scenery to us as we went. If anything should happen to Chautauqua he would be fine on a rubber-neck wagon. It was most educating. We saw a barn where a drop of water divided on its ridge pole and one half goes into the Arctic ocean and one half into the gulf of Mexico. I don't know how they can tell it's the same drop all the way, but they do and that's how you know it's the water-shed between the St. Lawrence and the Mississippi. This is a very historical country for Indians too. I dreamed last night I was being portaged by a Seneca and an Iroquois came along and they had a fight whether I should go to the Gulf of Mexico or the Arctic ocean and they were just getting ready to split me in two like the rain drop when I woke up. It's a great life!

On the day before Betty's picnic letter appeared in print, Major Robert B. Moton, principal of Tuskegee Institute, Alabama, spoke in the Amphitheater on "The Black Man and the War." As reported by the *Daily,* he said, "I am glad that my people were brought over here as slaves, for we were placed beside the strongest race that the world has yet produced, the Anglo-Saxon race. . . . We are infinitely better off than if we had been left in darkest Africa. There are twelve million negroes in this country, speaking the English language, civilized, and essentially Christian, and they are a thousand years ahead of any other twelve million black people found on earth. And some day we hope to be able to go back and Christianize and civilize our brothers in Africa.

"The schools of the South have been solving the negro problem. Patience, Christianity, and forbearance are enough to make it possible for the white race and the black race to live together in peace and harmony." If a reader in the 1970s is tempted to rub his eyes at these words, he may find in them a measure of the changes the country and the world have undergone since 1918. "I believe," said Major Moton toward the close of his address, "that every negro should have the rights and privileges of every other American citizen and no more. But the serious thing is that the negro shall be fitted for democracy when it comes. We are coming on, we are behind you, but we are catching up."

Chautauqua could not supply its platform with the variety of speakers its program called for without sometimes being led into unexpected turns of circumstances. The *Daily* for August 21 printed the following report: "Press despatches this summer have carried a story telling of the execution as a spy of Major Vladimir Swartzkopensky, who gave

two lectures here last summer. According to these despatches Swartz-kopensky, a former member of the Czar's body guard, was one of the most trusted German spies sent to this country. . . . It is said that he was arrested in the United States on the instigation of British authorities, taken before a court-martial in London, and executed in the Tower."

Chautauqua during World War I reflected the prevailing temper of the country. If it exercised leadership, its leadership consisted largely in the prompt offer of its facilities and the administrative skill of its president and his fellow officers to such programs as the Speakers' Training Camp and the National Service School for Women. Its platform also kept open a forum for the discussion of organized peace, preparing the way for later discussion of Wilson's League of Nations and the question of American participation in it. But the current of war fervor set in and Chautauqua went with it. The kind of emotional product the current could generate, and perhaps also the remoteness of continental America from the actual struggle in Europe, are exemplified in the *Daily's* descriptive review of a pageant, "To Arms for Liberty," presented in the Amphitheater on August 15. The *Daily* reported

continuous interest in the picturesque tableaux, the appropriate running accompaniment of orchestral and vocal music, in the effective color schemes and groupings, and in the dramatic entrances of the nations, announced by the Voice of Humanity.

The pageant opened with an idyllic scene, the Valley of Peace. Belgian children playing in perfect peace and happiness. The children were members of the Kindergarten, the Elementary School, and the Girls' Club. . . . Mrs. Rose King of Buffalo was the Belgian mother. In the midst of a sweet child-song the storm of war burst upon the group . . . indicated by the crashing music of the Orchestra with the wild beating of the cymbals and the drums. The children gathered in terror about their mother, and when they finally retired a huddled figure in black was left lying on the stage. This was stricken Belgium, sympathetically and with great artistry played by Grace Hallam Smith.

At this point in the pageant France, together with Britain and her colonies, came to the aid of Belgium.

Prolonged applause greeted the appearance of the American Red Cross nurses as they marched in to the music of "The Battle Hymn of the Republic" and saved the little Belgians from Death.

All the other allies then made entrances with the exception of the United States.

At last the Allied nations spoke in one voice, "America, we
need you," and the notes of a bugle were heard in the distance.
The black robe of Belgium fell from her shoulders, and she
appeared in pure white. The sound of distant drums and marching
feet came again . . . and two score of Khaki-clad Yanks marched
down the aisles of the choir to the stage as Columbia entered.
Everyone in the Amphitheater joined in the singing of the Star
Spangled Banner, and the Allied Nations cried, "On to Victory,"
and the beautiful pageant closed with the soldiers marching off to
France as the Orchestra played "Over There" and the sound
of the bugle died away in the distance.

In 1929, on the eve of the stock market crash, and after a decade of
debate, social change, and delusive prosperity, Henry Ford, with other
celebrities including Thomas Edison and Adolph Ochs, visited Chau-
tauqua to help commemorate the centenary of Lewis Miller's birth. The
prominent men in the party agreed, according to the *Daily*, to answer
questions put in writing and presented by a journalist as spokesman for
the questioners. Asked his opinion of "Russo-Chinese affairs," Ford
said: "That's war again. Why bring that up? I forgot about war ten
years ago."

Expansion and Disaster

When in 1888 John Heyl Vincent was elected bishop, Chautauquans
were not above suspicion of the Methodist General Conference, fearing
that its members were less than enthusiastic about the Institution and
were deliberately imposing on the co-founder assignments that others
could have carried out and that would alienate him from the assembly
that he and Lewis Miller had together created. He was inevitably drawn
beyond the Chautauqua orbit, though he continued to the last to be
concerned for his cherished colony, visiting the lakeshore when he could
and participating in its affairs when opportunity offered. In 1920 a life
that had begun almost thirty years before the Civil War finally came
to an end after the First World War.

At the time of Bishop Vincent's death Chautauqua was taking stock
of its financial position. A special Campaign Edition of *The Chautau-
quan Quarterly* for January, 1919, records the problem and the resulting
action. The war had reduced the income of the Institution while its
costs were rising steeply, and this on top of debts that had been accumu-
lating ever since the 1890s. While its assets had increased to over
$1,000,000, its liabilities had also swollen to some $500,000. In 1919,
accordingly, the institution launched a campaign, under the title of the

Comprehensive Plan, to extinguish all debt, eliminating mortgage interest of over $25,000 and recouping this annual sum for repairs and improvements. Any considerable endowment was judged impossible to obtain while mortgage and debt remained in force. In organizing the Comprehensive Plan, the trustees resolved to authorize no capital expenditure over $25,000 and no bond issue of any amount until the cottage owners had been formally polled. They resolved further that any seasonal deficit should become the first charge against the budget of the following year. It seems that the twenties must have lost sight of these stringent but salutary resolutions, for physical development occurred on a scale that nearly proved fatal.

Meanwhile the actual postwar season of 1919 marked a heartening rebound after the years of conflict. President Bestor in his annual report recorded that gate receipts had gone up by 23 percent above the previous high record. Enrollment in the summer schools reached a new peak, and the books prescribed for CLSC study had to be reprinted to meet the demand. Allowing for fluctuations and adjustments, Chautauqua followed the country into a decade of delusive expansion and confidence. In 1926, trolley and lake-steamer service was discontinued, and this loss caused temporary apprehension. Increasing use of the automobile was at least partly responsible, and while the automobile eventually made Chautauqua more accessible, it also opened new patterns of travel to families who had been used to making annual pilgrimages to familiar resorts reached by rail. Throughout the postwar decade, the programs of the Institution varied with the issues and pressures of changing times, but the general design of activity kept to its established form. Chautauqua taught and studied, discussed national and international problems, worshipped, played games, conducted many kinds of club life, and entertained. During the twenties its musical life made extraordinary progress, aided by the administrative understanding and support of President Bestor, but the story of music at Chautauqua deserves connected treatment in its own right in another chapter.

A principal topic during the twenties and on into the thirties continued to be the preservation of peace through the establishment of some kind of international order. This enduring question found an immediate focus in the debate over the League of Nations. Already in 1919 a New Nations of Europe Week was scheduled, with representatives from Poland, Yugoslavia, Czechoslovakia, Serbia, Palestine, and Albania. "After the War" and "The New Map of the World" provided themes for lectures. Americanization, labor, child welfare, the problems of the Near East, with which President Bestor was closely acquainted,

Diversity of program was accompanied by diversity of personalities and events. Personalities included such contrasting examples as Franklin Roosevelt, Assistant Secretary of the Navy, and Attorney General A. Mitchell Palmer, who was to make himself notorious for his wholesale "Red" raids. Charles A. Eastman, a full-blooded Sioux, spoke to an enthusiastic audience on the affairs of his people. In 1924 the Institution celebrated its fiftieth anniversary, though the season was actually its fifty-first. It received tributes from national figures, political, educational, and religious, among them a letter signed by President Coolidge which conveniently summarized for President Bestor the pioneering ventures in popular education for which Chautauqua had become famous. If the letter told Chautauquans a good deal that they already knew, it no doubt had very practical publicity value. The program of the season was characteristic of the decade. A lecturer from London warned that the next great international problem would be posed by Asia. Count Michimasa Soyeshima, speaking for Japan, asked repeal of Asiatic exclusion as an immigration policy, and proposed a second naval-limitation conference in Washington. But Major General James G. Harbord cautioned against unrestrained zeal for disarmament, were not overlooked. Asian problems gained considerable attention, and science was not neglected in its ambiguous role as agent of progress or destruction. "Woman and the New Era" furnished a theme for a week's discussion with the cooperation of the National League of Women Voters. A School of Political Education occupied two weeks of the term in 1921. A Cooperative Christianity Week was conducted with the assistance of the Federal Council of Churches of Christ. Changing moral standards claimed notice, and along with them the younger generation was viewed with customary alarm and received some defense. H. L. Mencken was castigated from the platform, the speaker declaring that he was "as irreverent as Voltaire and as cynical as Byron." In 1928 Mussolini and fascism gained recognition from a lecturer who was self-assured enough to say that "fascism with its autocratic and dominating features is suited to the Italian people, because they are essentially adolescent and unfitted for the responsibilities of democratic government." In 1925, President Bestor gave an address on "Race Solidarity," saying that if the white nations do not stop trying to "wipe each other out . . . the black peoples of the earth may grip the torch of civilization from [their] faltering hands." He urged closer ties between English-speaking races, and commended the formation of the English-Speaking Union, a chapter of which was duly established at Chautauqua during the season.

though he stopped short of the vehemence of a later speaker who told a DAR rally that the proponents of disarmament were the "Judas Iscariots of patriotism." In 1926, mother or stepmother of the WCTU as it was, Chautauqua gave due welcome to Governor and Mrs. Alfred A. Smith.

In 1928 Chautauqua completed the cycle of transportation, from lake-steamer to railroad, trolley, and automobile, by receiving its first visitors from the air. Captain Sir George H. Wilkins and Lieutenant Carl B. Eielson earlier in the year had made the first transpolar flight. In anticipation of their scheduled Amphitheater appearance on Wednesday, July 18, Lieutenant Eielson had looked over the grounds on the preceding day for possible landing sites and had chosen the fourteenth fairway of the golf course, which offered a four-hundred-yard stretch of sward rising into the prevailing wind and free of wires or traps. Some three thousand people watched the plane land, and an estimated double that number crowded the Amphitheater in the evening to hear Captain Wilkins emphasize the value of their work for meteorological and other scientific knowledge rather than the heroics of arctic flight. In the following year it was announced that Amelia Earhart, who had flown with a pilot from Newfoundland to Wales and thus had become the first woman to cross the Atlantic by air, would land on the lake in an amphibian plane. But she changed her plan and made her descent on the same golf fairway that Eielson and Wilkins had used, aided by a strip of white cloth down the center and an arrow pointing due west. She too was enthusiastically received in the Amphitheater. The most famous flyer of them all, Charles Lindbergh, did not land at Chautauqua, but at least soared over and dropped a message.

Chautauqua not only had to maintain its activities but also to meet demands for physical development and improvement, as it did with almost fatal success. During roughly the first fifteen years of Bestor's presidency, the pace of development was rapid. The Arts and Crafts Quadrangle, which provides studios for instruction in weaving, ceramics, sculpture, jewelry, and painting, was enlarged from its original first section, dating back to 1909. In 1924 Smith-Wilkes Hall was built, principally for the use of the Bird, Tree and Garden Club, on the strength of a gift by Mrs. Addie May Smith Wilkes, and the same year saw the rise of the Hall of Missions, headquarters for the Department of Religion. In 1929 the present becomingly pillared house of the Women's Club, third in succession to the original quarters of the club in the home of Mr. and Mrs. Jacob Miller, brother and sister-in-law of Lewis Miller, took its position facing the lakefront, and Norton Hall, indispensable to

opera and theater, came into use. In 1931, the Smith Library, containing
a wealth of Chautauqua memorabilia as well as books for general read-
ing, made its appearance. Like Smith-Wilkes Hall, it resulted from a gift
by Mrs. Wilkes, in this case as a memorial to her parents. Hurlbut
Memorial Church was completed in the same year. Besides its summer
use, it serves as a community church during the winter for residents at
Chautauqua or in neighboring towns. As far back as 1913, a nine-hole
golf course had been laid out across the Mayville-Jamestown road from
the Chautauqua gate; during the twenties it became the present expan-
sive eighteen-hole course, and its club house, first built in 1921, was
both enlarged and improved. A new pier, a new entrance gate, and a
filtration plant were also constructed during the twenties.

Such additions and improvements, needed if Chautauqua were to
keep pace with the momentum of the country, nonetheless implied a
belief in continuing prosperity that received a shock with the stock
market crash of 1929 and the ensuing years of depression. Chautauqua,
as H. J. Thornton points out, was not a profit-making organization, not
a stock company. Its charter commissioned it to promote intellectual,
social, physical, moral, and religious welfare. But like all educational
institutions, it had to pay its bills and keep solvent, and could never be
unmindful of the number of visitors it could attract season by season.
Its sources of income have been mainly the sale of gate tickets, tuition
charges in its various schools, membership fees in the CLSC and the sale
of prescribed or recommended books, a percentage of the charges paid
by guests to cottage or hotel owners, and charges to residents for light,
power, and water. A very important source has also been Old First
Night giving. Surpluses, in years when they occurred, have been modest
and never enough to pay for capital improvements. For increased water
supply, sewage disposal, electricity, and roads, Chautauqua relied on
special bond issues; for buildings, it depended on personal bequests,
often commemorative, and again on Old First Night gifts, which have
been a source of scholarships as well.

No serious reason for alarm appeared until after 1929, when operat-
ing receipts reached nearly half a million dollars, the highest figure since
World War I. But costs increased with income, and the surplus of some-
what over $10,000 was converted into a loss by unusual expenses and
by interest due on bonds. President Bestor was able to view the season
of 1930 as a good one. He spoke confidently of Chautauqua's resilience,
and thought it should "assure the undiminished development and
growth of our many-sided activities." But from the peak year of 1929,
total income dropped to less than $200,000 by 1934, and gate receipts

from $105,000 to $61,000. Visitors in 1932 and 1933 feared that another season would bring no assembly, and newspapers fanned apprehension by announcing that Chautauqua was on the verge of going under.

Meanwhile, the season of 1933, though it was to be followed by drastic news before the end of the year, proved to be one of exceptional interest. It broke precedent by holding its formal convocation at Sunday morning service on July 2. The Traditional Sabbath gate-closing had been observed at midnight on Saturday, but not before players from Jamestown had performed a melodrama in Norton Hall and bonfires had illuminated the lake. A forecast of the season took justifiable pride in the expected visits of national political figures and put emphasis on the music program, which by then had established Chautauqua as a summer music center of country-wide prestige. The Women's Club opened its season with a week-long institute addressed by leading figures in women's work, including its own president, Mrs. Penny-backer. From the platform on July 11, James G. McDonald, chairman of the executive committee of the foreign policy association, warned that Hitler was not being taken seriously enough and said: "The Jewish problem under the Nazi regime in Germany is not primarily a Jewish problem at all; the Jews are just the victims. It is a Christian problem, because the persecution is being carried on in the name of Christianity." In a subsequent lecture, he called the prospect of war within a decade an open question. During the same month a Layman's Mission Conference and Forum discussed the report of the Layman's Commission for the study of foreign missions. Speakers urged that missions were still needed, especially for education, but one medical participant observed that "the use of medical or other professional service as a direct means of making converts, or as an advantage which can be secured only by listening to preaching, is improper."

Toward the end of July, Eleanor Roosevelt was expected for an Amphitheater address, and on the twenty-fifth the *Daily* elaborately described the preparations for her visit. This was not her first appearance at Chautauqua. On a previous occasion, she had been made a life member of the Chautauqua Women's Club in appreciation of a luncheon she had given the club at Albany when her husband was governor of the state. Now, with the New Deal beginning to entrench itself in Washington, her visit took on added importance. An elaborate reception was planned, in which the receiving line was to include, besides Mrs. Roosevelt herself, President and Mrs. Bestor, Mrs. Thomas A. Edison, and Mrs. Roosevelt's friend and associate Mrs. Pennybacker, who in the course of traveling and speaking for women's clubs had sent

back some helpful field reports during the presidential campaign. No less than nine committees of hostesses, mostly from the Women's Club, had been created, and since a Council of the International Federation of Business and Professional Women was in session, special individuals were told off to shepherd foreign dignitaries through the proceedings. To report the address Mrs. Roosevelt delivered to some six thousand in the Amphitheater, the *Daily* provided three women stenographers.

In the address itself, Mrs. Roosevelt ventured that "all change probably arose in the first place because of women," and she invoked a bit of fantasy about the cave woman as an aboriginal example. But she went on: "I think the real reason . . . women have a responsibility today is because they have the opportunity of directing some of the changes" needed in a less than satisfactory world. A family or a nation cannot permanently prosper unless others do, and the recognition of this fact must lead to local and worldwide cooperation, which "must go hand in hand with a revival of real religion . . . for real religion is based on the idea of sacrifice of the individual for the good of the many." Nor were men condemned to be mere agents of changes initiated by women; "one of the objectives of the new organizations of women should, I think, be to draw closer to the men's organizations" and to work more closely with them. Such an association would be especially important to the cause of peace. Going on, Mrs. Roosevelt said: "Now we have come to the place in history when we are deciding how our whole civilization is going to develop. . . . It may be that no one is ever again going to make as much, for instance, in this country, as they did during our years of great prosperity. It may be that many people are not going to reach certain heights of luxury again. It may be that many employers are going to have to be content with smaller returns on invested capital. . . . And undoubtedly many people are going to suffer. That is the unfortunate part of all change. . . . The only thing we can do is to try to direct change in such a way as to minimize the suffering." Coming from the wife of a newly installed president, whose New Deal was to be both castigated and defended at Chautauqua as throughout the country, these words must have set the thoughtful to thinking.

Later in the session, a speaker addressed the Women's Club on Asiatic problems, saying that overpopulated Japan had a choice of four courses: emigration—impractical because of the exclusions imposed by other countries—industrialization, birth control, or war. Dr. Morris Fishbein, editor of the *Journal of the American Medical Association*, inveighed against "socialized medicine." The International Order of the King's Daughters and Sons held a four-day series of programs,

listening to an address on Czechoslovakia and winding up its proceedings with a luncheon at the Golf Club. On August 21, the *Daily* reported the visit and address of Norman Thomas, listing in its "Who's Who" column some of the features of his career up to that time: graduate of Princeton and the Union Theological Seminary, associate pastor of the Brick Presbyterian Church in New York, associate editor of the *Nation*, one of the directors of the League for Industrial Democracy, author of numerous books. Best known as the presidential candidate of the Socialist party in the preceding year, a capacity in which he was to appear at Chautauqua again, Thomas chose as his topic, speaking about a month after Mrs. Roosevelt, "The New Deal from a Socialist Viewpoint." He saw three possibilities for the United States under the National Recovery Act and other New Deal measures. One was disaster, a second was fascism, and a third the chance that the New Deal might smooth the way toward socialism. "I want to pay ungrudging tribute," he said, "to the energy and courage with which the President has pushed action. He has given the country new hope." According to the *Daily*, "a spirited question period" followed the address.

President Bestor, speaking to the annual meeting of Chautauqua cottage owners, could tell them that the program to date had been received with enthusiasm. He reported the success of operas and plays, of broadcasts over NBC, and of intensified publicity efforts. Attendance had increased somewhat over 1932, but all income had shrunk severely, and no new sources were in sight. Chautauqua had responded to countrywide depression by both incentives and economies. Gate fees had been reduced by 20 percent, and other fees, such as charges for the kindergarten and various clubs, had been cut correspondingly. Staff had been reduced in number, work staggered, vacations without pay instituted, and salaries of all officers and employees had been pared by at least 25 percent. The season had been shortened by ten days. Even so, only the use of reserve funds had enabled the Institution to carry on into the current year. Not until the 1933 Assembly had closed was the full extent of the crisis revealed. In the fall, Chautauqua had to confess that it could not meet interest charges on $785,000 of debt. Toward the end of the year, shortly before Christmas, the Institution was forced into receivership.

Campaign for Survival

The blow it received was severe, but Chautauqua was not ready to give up. A committee of trustees was formed to advise with the receivers and with President Bestor. From this committee grew the Chautauqua Reor-

ganization Corporation, its immediate problem to conduct the 1934 session, as it guaranteed that it would do, without loss to the receivers, and its long-range mission to raise enough in gift money to redeem the debts and obligations of the Institution. The corporation hired a New York fund-raising firm to study the situation and undertake a campaign for money. The first response of this firm was disheartening. It held that the $785,000 of debt could never be repaid. But it also found that the financial plight of the Institution resulted from the extensive building and improvement projects of the twenties, not from operating losses, which might have implied mismanagement. Some Chautauquans at the time suspected that the trustees put such implicit confidence in President Bestor that they approved his capital commitments without looking closely enough into the problems of funding. Despite the first response of the fund-raising firm, Samuel M. Hazlett, as President of the Reorganization Corporation, set out to buy back Chautauqua from its pit of debt. Tirelessly he consulted with the receivers, worked on the bondholders, and pumped friends of Chautauqua for gifts and pledges. For 1934 the program was conducted without loss, and the corporation again guaranteed the 1935 season. By the summer of 1935, a total of $304,000 had been pledged to redeem the obligations of the Institution. Chautauqua still had a long way to go, and before the final euphoria of success, its ingenuity, excitement, and stomach for suspense were severely taxed.

Despite the $304,000 held as pledges in hand, the principal bondholders called a meeting in June in Buffalo prepared to insist on foreclosure. The Reorganization Corporation secured a delay, and Hazlett put the upshot bluntly. What the bondholders had done was to give the friends and property owners of Chautauqua an option on their institution. "If we rise to the challenge we can buy Chautauqua and it again will be ours," Hazlett's statement said. Otherwise, "it will be sold to someone else." During August, a representative of the bondholders visited Chautauqua and agreed to withhold foreclosure if the Reorganization Corporation secured subscriptions up to $125,000 by the first of September, and would pay the bondholders $75,000 by April of the following year. The bondholders also agreed to waive accrued interest. These delays, as announced by the *Daily,* had the result that in the summer of 1936 Chautauqua found itself with $150,000 still to raise by the end of August.

It was during the summers of 1935 and especially 1936 that Chautauquans felt the full heat of suspense in their redemption campaign. Appeals to generosity and loyalty could go far, but appeals could be

strengthened by ingenuity. Under a plan credited to Julius King, publicity director of the Institution, all Chautauqua property, bit by bit, was offered for symbolic sale. By "purchasing and giving back to Chautauqua," buyers could acquire a fictitious title to some tangible part or fragment of the property on which they set a particular value. The Bird and Tree Club sold trees as living memorials at $10 each. Two trees were singled out to honor President Roosevelt and his Republican rival, Governor Alfred Landon, while the *Daily* suggested that someone could buy a tree to commemorate Joyce Kilmer. The Golf Club offered its club house at $2,000, each complete hole at $1,000, each green at $250, and selected patches of the course at ten cents a square foot. The Women's Club sold seats in the Amphitheater at $10 each, the names of purchasers or those whom they wished to commemorate to be fixed to the backs of the seats. Each buyer of his chosen bit of Chautauqua received a "Certificate of Sentimental Ownership," and his identity was recorded in "A Book of Remembrance." Cottagers were given a different kind of opportunity to help rescue Chautauqua. Many agreed to contribute 20 percent of the assessed value of their holdings in return for a deed instead of the original lease.

Old First Night of 1936 fell on August 5, and led to gifts of over $55,000. With almost twice as much still needed, Mr. and Mrs. Ralph Norton of Chicago offered a matching fund, one dollar for every two given by others, up to a total of $35,000, but this generous pledge would not take effect unless the entire sum still in default were subscribed. At midnight after the Old First ceremony, a "Last $100,000 Club" was formed, with the Norton matching fund providing encouragement. But suspense was not in a hurry to yield. Five days later an editorial in the *Daily* was deploring complacency, and pointing out that Chautauqua was still $50,000 short of its goal. No secret fund existed, the editorial declared, and income from the large attendance of the summer would not count. Less than $1,000 had come in on the preceding Saturday; the *Daily* summed up: "It isn't enough." On August 10 the *Daily* devoted its entire fourth page to what had been done to save Chautauqua and to making a final appeal. If the last gap between pledges and goal were not closed, the Norton matching fund and with it all the effort expended to free Chautauqua from debt would be lost. On the twentieth Hazlett declared, "We shall either succeed or fail by the last day of August," and pointed out that $37,000 had still to be captured. On the twenty-eighth the Reorganization Corporation announced that two blasts of the fire siren would signal the close of the campaign if it were successful. No pledges were being held back, the

corporation said, and a sum of over $8,000 was still needed. Next day brought the news that the last $100,000 had been oversubscribed. According to Rebecca Richmond in her book *A Woman of Texas*, a biography of Mrs. Percy V. Pennybacker, it was this slight, attractive, formidably able woman who had the pleasure of channeling through the Women's Club the gift that clinched victory. Nationally known for her work with various women's organizations, president of the Chautauqua Women's Club and a trustee of the Institution as well, Mrs. Pennybacker had received a hint that John D. Rockefeller, Jr., would be sympathetic to an appeal on behalf of Chautauqua. She put the case to him, and he agreed to make up whatever deficit might still remain on the last day of the campaign.

So Chautauqua finally and completely won free from debt. President Bestor presided over a well-earned victory celebration, and the leadership of S. M. Hazlett was recognized by the Chautauqua salute. But triumph had been precarious, and measures were clearly in order to prevent any comparable disaster in the future. Obviously Chautauqua needed a permanent source of funds for capital improvements and extraordinary expenses. The Reorganization Corporation, which had done its work, was dissolved, and the Chautauqua Foundation was created to succeed it. The role of the foundation was to receive and hold gifts for an endowment fund, paying the annual income of the fund to the Institution, subject to restrictions by donors on gifts for special purposes. In addition to benefactions, the Foundation counted on the take of Old First Night ceremonies as a means of building up endowment, and it set a goal of a million dollars for its fund.

Other measures to put Chautauqua on a sounder footing followed the 1936 struggle for solvency. The charter of the Institution was amended by the state legislature to prohibit mortgaging or pledging property for capital outlay without approval of two-thirds of the trustees. It was specified that a majority of the trustees must be property owners, and also that property owners would themselves elect four of the twenty-four trustees. Another provision separated business operations from the direction of the elaborate Chautauqua program. Business was assigned to an executive committee of six trustees; the program was made the responsibility of the president of the Institution, who was also given a place on the executive board. Finally, another act of the legislature created the Chautauqua Utility District, enabling the Institution to levy taxes for such services as light, water, and sewage disposal and relieving it of capital expense or operating loss for such services. These are substantially the terms on which Chautauqua oper-

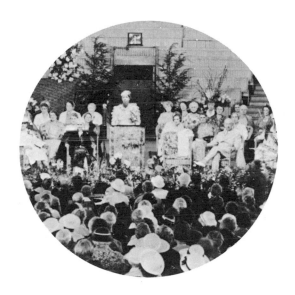

ates today, and whatever fluctuations or periods of stringency its budgetary officers have had to face, it has suffered no repetition of the almost fatally hard times of the thirties.

Aside from the melodramatic suspense of the financial campaign in 1936, the program of the season was enough to excite attention in itself. As a result of energetic publicity for three years, the *Daily* projected the largest attendance since 1929, and listed among expected speakers both Governor Alfred Landon, the Republican presidential candidate, and Mrs. Roosevelt, who as it turned out cancelled her appearance when the President himself decided to make Chautauqua the site of a still-remembered address. A strong supporting cast included Sir Herbert Ames, former director of the League of Nations secretariat; John Finley, Associate Editor of the *New York Times;* William Lyon Phelps, man of letters and professor at Yale and an affectionately regarded Chautauqua speaker for many years. But Chautauqua is the scene of unprogrammed as well as anticipated events. One such was reported by the *Daily* early in the season. On July 14, the steamer *Mayville* tugged a pile driver up to the pier, where both docked for the night. In the morning the *Mayville* was discovered heeled over on her side. A crew came to the rescue and secured a hawser to the bow, but the only effect was to detach the bow from the stern. The hawser was then secured to the stern, which came ashore "crumbling gracefully on the way." Officials and souvenir hunters, concludes the *Daily,* swarmed over the wreckage until fire broke out and brought the episode to an end.

Before the season was well along, Mrs. Eugene Meyer, wife of the former governor of the Federal Reserve Board, made known her opinion of the New Deal, speaking to the title: "The One Big Issue—The Federalization of Government." She came out for Landon and anticipated some of the animus of his later address. In a week-long series of talks to the Women's Club, Sir Herbert Ames described his League of Nations work. In a talk in Palestine Park, Raymond P. Currier discussed leprosy and its treatment. Digesting his remarks, the *Daily* wrote: "In stead of providing more stations where the infected ones go to die, science and the Church have set up colonies where they go to live, to develop their minds and bodies, to take part in many activities which were absolutely out of the question a mere twenty years ago." The speaker closed by reading poems written by a school of leper poets. As part of the World Missions Institute, meeting at Chautauqua, Mrs. Mary McCleod Bethune, President of Bethune-Cookman College in Florida, spoke as a representative of her race on "The Negro in the United States," with music by black singers.

But the unique circumstance of the season was the appearance at Chautauqua of no less than four presidential candidates in a campaign year. The first was the Prohibition candidate, D. Leigh Colvin, who told his audience that "the good people of the United States" must unite in a political party as long as the established parties had to cater to the liquor interests. Another contender was Norman Thomas, again running on the Socialist ticket. "Nearly all . . . conservative Chautauqua," the *Daily* reported, "turned out en masse to hear the third presidential candidate to appear here this month and enthusiastically greeted the former *Chautauquan Daily* newsboy with the traditional Chautauqua salute." In his address Thomas proposed revision of the Constitution "to make democracy constitutional," and said that "the issue this year, more than ever, is Socialism versus Capitalism."

If Chautauqua was prevailingly conservative by the confession of its own news organ, it could still give Norman Thomas its sacred salute, not unmindful that he had sold copies of the *Daily* on Chautauqua streets. With Landon, hospitality did not have to be stretched at all, but rather had a double motive for complacency. Not only was Landon the Republican candidate, but he had spent the greater part of his boyhood at Chautauqua, in a house built by his grandfather in the park named for Lewis Miller. His father had served as president of the *Men's Club,* and Landon and his daughter by his first wife, whom he had met at Chautauqua, were life members of the Bird and Tree Club. The *Daily* assiduously built up expectation of his late-August appearance. It described the elaborate arrangements for broadcasting his Amphitheater address and promised the greatest influx of journalists ever to reach the grounds, including the same H. L. Mencken who had been denounced years earlier from the platform.

For his address, Landon chose a sufficiently innocent theme, and one fitting enough for Chautauqua: education as the foundation for democracy. He favored local control of schools and feared the influence of the federal government. He praised the educational policies of his own state. "In Kansas we insist that no teacher should be required to take any oath not required of any other citizen," he said. "In Kansas we believe in academic freedom and we practice it." He declared against censorship of the spoken or written word, or control of the sources of news. But he was not running against Roosevelt and the New Deal for nothing, as he showed when he referred to "widespread use of the machinery of the Federal government to maintain the present Administration in power, and to bring into question the faith of the people in their form of government."

President Roosevelt's own 1936 appearance at Chautauqua actually anticipated Landon's by about ten days, but both his position and his theme made it a climactic occasion. The *Daily* needed a good share of space in two issues to prepare its readers for the event. It began on August 12 by describing parking arrangements and warning that no seats in the Amphitheater would be reserved. It announced that an enlarged public address system for overflow needs would be set up in the space in front of the Methodist House. Chautauquans were urged not to leave their premises unprotected during the presidential visit. On Thursday the *Daily* was back with more admonitions. People planning to leave the grounds in advance of the weekend were urged to get their baggage off by Friday and cottage holders to lay in needed groceries by the same time. Facilities to carry the president's address to thirty thousand cinema screens, the *Daily* said, were to be installed by leading motion picture firms. It detailed the state troopers, National Guardsmen, plainclothesmen, and other security agents who would be in action. No one would be admitted to the Amphitheater before 7:00 o'clock, it announced. During the hour preceding the address, George Volkel would play the organ and Walter Howe would lead community singing. Finally, the *Daily* listed other attractions open to the public on the day of the president's arrival: a matinee of *The Pirates of Penzance* at Norton Hall, a lecture in a series by James G. McDonald, and a ball game.

At last, on Saturday, the president arrived by train at Mayville, where his welcome began. Bestor, James G. McDonald, and others were on hand to greet him, and by the *Daily*'s estimate some twelve thousand people "braved muggy weather and threatening rain" to join in the reception. No comparable excitement, again according to the *Daily*, had occurred in the entire county since Theodore Roosevelt's visit in 1905. Franklin Roosevelt's theme for his address that evening had been announced as "International Relations of the United States." He gave a peace speech conscious of the threat of war. "I am more concerned and less cheerful," said the captain of the New Deal, "about international world conditions than about our immediate domestic prospects." Anticipating American neutrality if war broke out "on other continents," he said that many Americans would be tempted by the profits realizable from "industrial and agricultural production for a war market," but that if it became a choice between profits or peace the country must and would answer, "we choose peace." He allowed himself an explicit if subdued warning: "We are not isolationists," he said, "except insofar as we seek to isolate ourselves completely from war. Yet we must remember that so long as war exists on earth there will be some danger

that even the nation which most ardently desires peace may be drawn
into war." The most vehement passage in his speech reached its climax
in a sentence of three words which were rapidly engulfed in what they
sought to deplore. "I have seen war . . . on land and sea," Roosevelt said.
"I have seen blood running from the wounded. I have seen men cough-
ing out their gassed lungs. . . . I have seen cities destroyed. I have seen
two hundred limping, exhausted men come out of line—the survivors
of a regiment of one thousand. . . . I have seen children starving. . . . I
hate war." It was still some three years to Hitler's invasion of Poland
and some five to the Japanese attack on Pearl Harbor.

World War II—The Final Years of President Bestor

World War II brought Chautauqua experiences both like and unlike
those of World War I. Chautauqua was less of a marching camp. Its
officers did not shoulder dummy guns, and detachments of young
women did not dress up for squad drill in white tennis shoes. The Chau-
tauqua administration did not figure centrally, it seems, in the national
information and propaganda services as it had in the earlier struggle.
The country and its military needs had grown vastly more sophisticated
in technology and in social and industrial complexity. Yet fervor in the
national cause and concern for the progress of the war set the prevailing
temper as they had in 1917 and 1918. Music, lectures, entertainment,
education, club life went on, but the *Daily* boasted that by teletype
facilities set up at the entrance to the Colonnade Building Chautauquans
could keep in touch with military developments better than if they had
stayed at home, and the *Daily* itself rewrote war news from the United
Press wires.

In the season of 1942, the first after Pearl Harbor, fear was wide-
spread for the safety and continuity of Chautauqua as an institution.
A rumor sprang up that the government would take over the property
as a training center, and in fact the War Department had made an in-
spection during the spring, but the rumor proved groundless. Dread of
declining attendance and another financial crisis could hardly help
cropping up. Chautauquans "all over the world," said the *Daily*, won-
dered what would happen. But in 1942 attendance turned out to be
only 7 percent less than in the preceding season, and Chautauqua
maintained its stability throughout the war.

President Bestor was as keenly concerned by the need for national
unity as he had been at the start of World War I. Early in the session he
gave an address in which he said that the complete unpreparedness of
the country made acute the necessity to rally opinion in support of total

war. He recalled the clash of views before Pearl Harbor, running all the way from demands for immediate intervention to declarations of complete pacifism. Among influences preventing preparedness, he cited the Keep America Out of War Congress, the Fellowship of Reconciliation, the National Council for Prevention of War, the Peace Section of the American Friends' Service Committee, and the Women's International League for Peace and Freedom. These, in effect, he considered, gave Hitler weapons. "In the generation 1930–40" he said, "we trained a generation of young people who felt that we had been tricked into the first World War and that we had no obligation to fight, except in defense of the continental United States." As a result it became much harder "to see clearly the strength and ruthlessness of the Axis powers." But he also traced the country's unreadiness back to its failure to join the League of Nations and the World Court. The United States, he pointed out, had lent money to help rehabilitate former enemies without taking responsibility for world organization. And recognizing not only the need for national unity but also the formidable wartime powers of the presidency, he spoke for sustaining, within security limits, the guarantees in the Bill of Rights of free speech and free assembly, freedom of the press and with it the radio. "An institution like ours," President Bestor told his Chautauqua audience, "should regard as a first responsibility in the national effort, the maintenance of our work in full strength and efficiency." He wanted to keep open legitimate forums of discussion and opinion.

During the 1942 season, Chautauqua heard an eyewitness account by a schoolteacher from Honolulu of the attack on Pearl Harbor. Major Alexander de Seversky brought to Chautauqua his reputation and talents as an advocate of air power, declaring that to win the war it would be necessary to control the air over Germany and Japan. In a subsequent year he returned to predict nonstop flights to Tokyo. A war always brings fighting speeches, and it would have been surprising if Chautauqua had escaped its share. Florence Allen, federal judge of a Circuit Court of Appeals, asked her audience: "Did you ever stop to think that there will be . . . no Chautauqua, if the Japs and Hitler divide the world?" If the Axis could reach America, she warned, "bombs would be raining over our cities. In Buffalo, Detroit, Cleveland, the city halls, the court houses, the libraries, would be blasted from the air. . . . Independence Hall in Philadelphia and the Liberty Bell and the Capitol in Washington would crash to ruin." But beyond the war, Judge Allen saw the problem of peace, and thought that every citizen should be concerned with helping to formulate some kind of world association. Thus

she made her contribution to a pair of the most frequently agitated platform topics, the war itself and the still unsolved problem of organizing the world for peace.

Despite the encouraging attendance of 1942 Bestor and Hazlett felt the need for a financial margin of safety. To establish a Chautauqua War Chest, they asked officers of Chautauqua units down to the Bird and Tree Club and the Boys' and Girls' Clubs to persuade their members to buy war stamp albums and turn them over to the Institution when they were filled, thus all at once helping to win the war, prevent inflation, and endow Chautauqua. The trustees resolved that all Old First Night gifts not otherwise earmarked should be invested in war stamps and bonds, in the hope that the proceeds could be added to capital and not used except in necessity. They also decided to forego major improvements and to undertake only repairs and emergency replacements during the war. Programs during the war years did not suffer much retrenchment, but maintained themselves in representative strength. Edgar J. Fisher, who was working with the Division of Cultural Relations of the State Department, was a frequent and prominent lecturer, notably on Latin America under war conditions. Other speakers represented China, India, and Greece. The Indian spokesman expressed faith in Gandhi and feared that the struggle might become a war between East and West, white and nonwhite. Mission-minded speakers criticized the policy by which the United States had sold scrap-iron to Japan, making possible the bombing of areas where Christians from the West had taught the Gospel. A voice was raised on behalf of the Japanese-American citizens and aliens, the bulk of them described as Christians converted by American missionaries. None, the speaker said, had been convicted of espionage or treason.

During the war years, Town Meetings of the Air were regularly broadcast from Chautauqua. They ranged in topic from health and old age insurance to retention of United States military bases on foreign soil when hostilities were over. A Town Meeting on "The Churches and the War" enlisted among participants Dr. Albert W. Palmer of the Theological Seminary in Chicago and Reinhold Niebuhr of the Union Theological Seminary in New York. Both lamented war, but agreed that unjust aggression must be resisted. Arthur E. Bestor, Jr., the son of President Bestor and a frequently welcomed Chautauqua speaker, drew attention away from military concerns by his lecture series on "Five Great Interpreters of American Democracy," choosing as his examples Jefferson, de Tocqueville, Emerson, Frederick Jackson Turner, and Vernon L. Parrington. The problems of labor were not overlooked, a

spokesman for the CIO declaring that American labor would "Never again . . . accept a business cycle as an act of God." The situation of the American Indians came up for discussion, a speaker on their behalf finding no solution for their difficulties except complete integration into American life. A Negro educator, Dr. William Imes, considered that America, "like the empires of ancient times . . . is dying to the extent she allows only second class citizenship to large groups of her people." Calling the United States a "mongrel nation," he said that "whether we like it or not, America is becoming brown in color." If blacks were not doing all they should for the country, he suggested, the reason could be that they were treated as a people apart. Some of these utterances got away from the war, at least as a direct concern, but once the war worked its way in when it might not have been expected. Homer Rodeheaver, best known as the evangelist Billy Sunday's song leader, charged that the brewers were deliberately planning to create a quota of alcoholics among the eighteen-year-olds entering the army. He declared that all the twelve great battles of history were lost by the side contaminated by drunkards. He paid tribute to the WCTU, which was itself virtually an offshoot of Chautauqua. In 1945 the WCTU held its annual convention at Chautauqua, and the *Daily* praised its work, denying that its members were "grim-visaged and puritanically-repressive kill joys," and describing them rather as "authoritative students of social evil."

So Chautauqua carried itself successfully through a second World War, but for almost the last two years of the conflict it had to maintain itself without the aid of President Bestor. A strong man in physique, he had never been one to spare his strength. Though assemblies at Chautauqua take place in summer, the work of administration and planning goes on yearlong. In a letter to his three surviving children in January, 1944, Bestor described at length a particularly arduous journey he had been making, train-hopping at all hours from one city to another, giving speeches, consulting with Chautauqua trustees, snatching brief and uncomfortable sleep when he could. The letter did not express any concern for his health, but when on a Sunday he reached his home in New York, he admitted to Mrs. Bestor that he was finding it hard to stand up and that, in Thornton's words, "the strength seemed to be going out of his muscles." "It was not mere fatigue," Thornton adds, "but the onset of encephalomyelitis." He died on February 3, 1944, at the Neurological Institute in New York. Harry Emerson Fosdick told the funeral congregation in the Riverside Baptist Church that "a prince has fallen in Israel." A quartet of singers who had helped to make Chautauqua known as a music center—Annamary Dickey, Pauline

Pierce, Donald Dame, and George Britton—lent their voices, and Chautauqua itself held a winter service in the Smith Library next day. When the season opened in July, a memorial service was conducted in the Amphitheater, where Ralph Norton, who succeeded President Bestor after the acting-presidency of Samuel Hazlett, joined other Chautauquans in paying tribute. Bestor was buried in a cemetery adjoining the road between Chautauqua and Mayville, and the park he had many times crossed on his way from the Administration Building to the Amphitheater was designated the Bestor Memorial Plaza. On the four sides of its central stone shaft the words Knowledge, Religion, Music, and Art are inscribed.

Chautauqua as Music Center

From Bell-stroke to Symphony

An unnamed "faithful survivor of the earliest days," as Thornton describes him, was heard to observe at some point in Chautauqua's history: "Folks must have changed considerable. I can remember when they just got up and went home soon's a man came on the platform to play the pianner. 'Tain't so now. Why, there was a man played the fiddle 'tother night and the folks just listened to him as tho' he was preaching." The story gives a crude but significant measure of one of the more spectacular developments in the history of the Institution, a development that did not run contrary to the intentions of the founders, but one that took a course and reached a dominance they could not have foreseen. Music for a time almost swallowed up Chautauqua and constituted its chief line of progress. Today, without its musical resources, the Institution would be only a fraction of itself, and a much impoverished fraction.

When a single bell-stroke convoked the original Assembly in 1874, John Vincent called it the first man-made musical note to be heard at Fair Point, giving previous credit only to birdsong or the lapping of waves or the rumble of thunder. That first assembly sang hymns, heard choral performances, and responded to the Reverend F. A. Goodwin's cornet. It also listened to a band from neighboring Mayville, and Chautauqua has ever since presented visiting bands as part of its musical offerings, from Sousa to the United States Army Field Band and Duke Ellington. The second assembly heard two concerts by the lake, and participated in five "praise services" conducted by William F. Sherwin, who wrote the music for Mary Lathbury's famous hymns and became Chautauqua's first music director. It also was initiated into another recurrent strand of Chautauqua music, provided by groups of "plantation melody" or spiritual singers. "The Tennesseeans" and "The North Carolinians" appeared early, and later the Fiske Jubilee Singers made the first of numerous visits. Gay MacLaren, a spirited trouper in the travelling or circuit Chautauquas that thrived before and after World

War I, says that a turning point for the Fiske singers occurred when
after being refused a hearing at a large church council in Oberlin they
crept quietly into the gallery and began, sotto voce, singing "Steal Away
to Jesus." They went on to countless church appearances and to inter-
national welcome.

Characteristically for Chautauqua, instruction in music began as
early as the second session, with classes in music concerned no doubt
for the most part with Sunday school hymnody. Besides Sherwin,
teachers included P. P. Bliss and Eben Tourjee, founder of the New
England Conservatory. In the third session, "some selections from
standard music outside the realm of religion" were introduced. Jesse
Hurlbut, who records the fact, goes on to observe that "Nobody
objected . . . and it was not long before the whole world of music was
open to Chautauquans." "Not long" is an elastic phrase, but at least
progress was steady. In the fourth season, the Apollo Club of New York,
with its national reputation as a superior chorus, gave three concerts.
A band from Fredonia kept up the band tradition. The choir sang the
"Miserere" from *Il Trovatore,* and choir, band, and piano joined in the
"Anvil Chorus," not for the last time drafting an anvil into service as
accompaniment. Two seasons later, Ira D. Sankey, described as "the
most renowned singing evangelist in the world," presented himself to
Chautauquan ears. The band was Professor F. B. Boynton's from
Meadville, Pennsylvania, and its members were declared to be "gentle-
men of the highest character in their community." Professor H. R.
Palmer of New York lectured on singing, and in the course of illustrat-
ing "diffusive, explosive, and expulsive breathing" mentioned such
anatomical features as the chest and the lungs. Apparently recalling
with embarrassment that ladies were present, he told his audience that
they were all brothers and sisters and "should be able to call things by
their right names without giving offense."

Both Lewis Miller and John Vincent responded to such music as they
knew, and music was a part of their plan for Chautauqua from the start.
It is hardly to be wondered at if at first music served as an adjunct of
worship, but even for the founders it also served their purpose of pro-
viding recreation or outright entertainment. In 1882, after consider-
able persuasion from Vincent, the Royal Hand Bell Ringers and Glee-
men of London paid Chautauqua a visit and made a hit. Bell ringers
thereafter became a pretext for those who ridiculed Chautauquan pre-
tensions to culture, both at the institution itself and later on the circuits.
Much more important than the status of bell ringing on the cultural

scale is the promptness with which music was absorbed into the educational structure at Chautauqua, and the strides by which it became an object of study and performance as an art in its own right and as a dedicated profession.

When Chautauqua began, says L. Jeanette Wells, whose historical study of music at the Institution is a valuable source, music in America still lay under European and especially German influence, and did not catch up until the end of the century. Immigration during the mid-eighteen-hundreds brought to the East Coast cities and on into the hinterland musicians who had received better training than America could offer at the time. Only New York had a permanent resident symphony; only New York and New Orleans could claim similarly established opera. But as the seventies went on, a vogue for vocal, especially choral music, gathered force. Oratorio societies were established in Eastern cities and duly spread through the country. The Handel and Haydn Society of Boston could trace its birth back to 1815, but not until after the Civil War did the choral impetus extend itself widely through "Apollo Clubs" or groups named after Mendelssohn. In the twenty-odd years from the seventies into the nineties, such societies took root in Boston, Chicago, Brooklyn, Cincinnati, and St. Louis. In 1889 the Mormon Tabernacle Choir of Salt Lake City, three hundred strong, embarked on a tour. Choral music, says Wells, predominated over instrumental until the end of World War I.

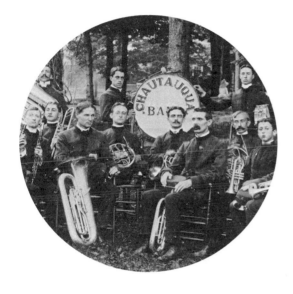

Chautauqua followed the prevailing pattern in its early emphasis on music for voice and choir. During its first decade, William F. Sherwin and C. C. Case, both American-trained, divided the musical directorship. Both were thoroughgoing professional musicians of their time. Sherwin eventually became chorus director at the New England Conservatory, and Case published collections of music, notably *Harvest of Song,* which were widely used, elsewhere as well as at Chautauqua. They expanded the assembly programs, including both sacred and secular music and interspersing choral scores with vocal and occasionally instrumental solos or combinations. Early choral work tended toward programs of selections—a chorus from Haydn's *Creation,* the "Hallelujah" chorus from Handel's *Messiah,* a chorus from Rossini's *Stabat Mater.* Not for some time would entire oratorios and cantatas become often repeated fare, but as early as 1881 Mendelssohn's *Athalia* was given complete. Meanwhile, in 1879, the School of Music, the importance of which was to swell with the years, was formally organized. Twenty-two music classes were listed for the season, as well as seven

concerts. Sherman, Case, and Horatio Palmer divided the work of giving singing lessons to children, teaching harmony, and lecturing on voice and on the "culture of musical taste."

Meanwhile, despite the choral predominance, Sherwin and Case took important steps toward expanding instrumental study and performance. In 1881 Max Libling, who had studied at the Leipzig Conservatory in Germany, was appointed to teach harmony and give piano recitals. The same year brought Joseph Vitale, a pupil of the Norwegian virtuoso Ole Bull, to teach and play the violin. F. P. Boynton organized an orchestra of nine instruments, including violins, viola, double bass, flute, and clarinet. A pipe organ was installed in the old Amphitheater, and led in 1885 to the appointment of Isaac V. Flagler of the faculty of Syracuse University as organist. Trained in London, Paris, and Dresden, Flagler was one of a considerable number of eminent musicians who remained on the staff of Chautauqua for many years, expanding and sophisticating its repertoire and advancing the experience and taste of its listeners. Besides initiating the organ recitals that have become standard fare at the Institution, he taught harmony, counterpoint, theory, and organ performance both for church and concert purposes. All this expansion of activities led to educational reorganization. During Sherwin's last summer at Chautauqua, music study was divided into four branches, one of them, especially characteristic of the Institution, a "Department of Public School Music." This department sought to train teachers in either public or private schools or academies, and showed Chautauqua's habit from time to time of affiliating with outside establishments, in this case the National Normal School of Music in Boston. The school's work at Chautauqua became its official summer session.

Thus during the first decade of the assembly, musical sophistication gained apace, but less sophisticated strains continued to be heard. Bands paid their visits, and music drifted shoreward from the lake. A chorus of one hundred voices, accompanied by cornet and piano, gave a program including a solo by Belle McClintock of Meadville, Pennsylvania, who was so enthusiastically received that as an encore she sang "Bonnie, Sweet Bessie, the Maid of Dundee," the mention of which will bring a pang of nostalgia to anyone who heard it at his mother's knee or under canvas at a circuit Chautauqua. Quartets of ladies performed —usually billed as "quartettes"—and also the Schubert Male Quartet. The male quartet is sometimes said to have been an original contribution of Chautauqua to the vocal tradition; Chautauqua must at least have given a push to its popularity. The resources of the colleges were naturally drawn upon. The Amherst Glee Club, the Yale Glee Club

appeared, and a quartet of Harvard students was favorably received. A bell chime was installed, fulfilling an ardent desire of John Vincent. The School of Music had hardly been first organized when, in 1879, Thomas A. Edison, Lewis Miller's son-in-law, demonstrated not only the telephone but the phonograph.

Before the session of 1888 could open, Sherwin's death brought to an end the first phase of Chautauqua's musical development. His successor was Horatio R. Palmer, who had become an organist by the age of seventeen, and had studied not only in America but also in Berlin and Florence. He established the magazine *Concordia* in Chicago, published highly successful choral collections, a *Theory of Music,* and a *Manual for Teachers.* Under Palmer's regime, lessons in guitar, mandolin, banjo, saxhorn, and zither made their appearance in the teaching program. Palmer performed Handel's *Messiah* in its entirety, a score that would become a Chautauqua favorite. In 1891 occurred a curious presentation, an odd foretaste of the much later establishment of opera as a cherished feature of Chautauqua music. It was, as described by the Chautauqua *Herald,* a performance of the "best choruses and solos" from Wagner's *Ring* series, given by the chorus and instructing staff and illustrated by "90 beautiful stereopticon views" to provide "realism, yet without any features that could offend." If the modern reader is bemused by this defensiveness, he should remember that moral prejudice against the stage and the profession of acting was a long time in being overcome, and not merely at Chautauqua.

In 1893, the old open-sided Amphitheater, with its view-obstructing wooden pillars, was replaced by the present Amphitheater, also open-sided, but successful in providing both visibility and excellent acoustics, especially with the aid of modern loudspeaker equipment. The new Amphitheater provided choir space for five hundred voices and stiff-backed bench seating once thought capable of accommodating eight thousand listeners, a figure now more modestly reduced to six thousand or less. Here Chautauquans gather for their principal programs, whether lectures, symphonic or vocal music, Sunday services, or entertainments. In the year of the new auditorium, Chautauqua made a catch of highest prestige when William H. Sherwood was secured to head a Department of Piano. Sherwood, in his mid-thirties at the time, was, according to Wells, "America's foremost piano virtuoso." He had studied piano, counterpoint, and composition in Berlin, and finally piano with Franz Liszt himself at Weimar. Wells calls him the only Anglo-Saxon pianist of his time to play with the leading German orchestras. After concerts in such American cities as Boston, Cincinnati, and Chicago, he joined

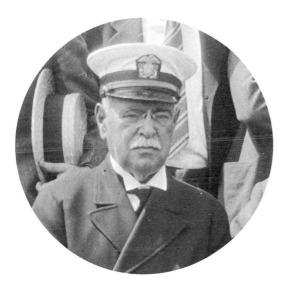

John Philip Sousa

the faculty of the New England Conservatory, later moving to Chicago and establishing a piano school of his own. In addition to his recitals and his personal teaching, he enriched Chautauqua by his analytic talks and interpretive classes. He was influential in forming a Department of Violin, first headed by Bernhard Listemann, later by Sol Marcosson, a Kentuckian whose studies abroad after a debut at age eight included a class with the celebrated Joachim and who served Chautauqua as violinist and instructor for more than twenty years. With Listemann, Sherwood began a tradition of joint violin-piano recitals that accustomed Chautauqua ears to principal string and keyboard works of the eighteenth and nineteenth centuries. For a sampling, Bach, Mozart, and Beethoven were represented, Schubert, Schumann, and Chopin, and on through Tchaikovsky, Saint-Saëns and Dvořak.

During Palmer's directorship, a short-lived "Musical-Literary Club" sponsored a concert of music by American composers visiting Chautauqua or in residence as members of the teaching staff, and such American figures as Edgar S. Kelley, Arthur Foote, and Edward MacDowell were represented on one or another program. Wells describes this inclusion of American material as the "first conscious attempt to further at Chautauqua the cause of the American composer." As the nineties progressed, the Chautauqua *Herald* congratulated the Institution on its improving taste and increasing tolerance for the "severer aspects" of music, declaring that the yodeler and banjo strummer "once charmed the popular hearts" but that "they have not charmed quite so much lately." Next year the *Herald* returned to the theme, taking satisfaction in the expansion of programs and the progress in musical education. "We are learning the fine art of listening," it said, without undue complacency. Sherwood, trained abroad as he had been, declared: "We have as good musical advantages here in America as in any country." Increasing response to music in its "severer aspects" did not mean that ladies' quartets, plantation singers, and "Tyrolean Troubadours" were silenced. To illustrate the scope of musical presentations during Palmer's later years, Wells chooses the season of 1899, which "included some fifteen programs by the chorus with orchestra and soloists, the organ recitals, the violin-piano recitals, and numerous open air concerts by the band." Though it still had a long way to go before reaching its full maturity, music had made notable strides since the single bell-note opened the first assembly, and Palmer, who resigned in 1901, had contributed to its progress.

His successor continued to expand and diversify Chautauquan programs. Alfred Hallam was a graduate of Rugby in England and among

his other teachers had studied with Sir John Stainer. When he came to Chautauqua he was supervisor of music in the public schools of Mount Vernon, New York, and an associate of Frank Damrosch in his work with the People's Singing Class and People's Choral Union of New York City. Among other collections, he compiled the *Chautauqua Hymnal and Liturgy,* for which Bishop Vincent wrote an introduction. Hallam served his appointment in 1902 until past the end of World War I, a span of seventeen years. He continued the prevailing emphasis on vocal music, including large-scale choral works, yet under his regime the way was prepared for the next two great steps that Chautauqua took toward its establishment as a comprehensive summer music center. Assessing the expansion of the music program under Hallam, Wells records that as early as 1904, more than sixty musical events were presented during the season, including instrumental and organ recitals, outdoor band and orchestral performances, and liberal use of choir and soloists. Hallam added to the Chautauqua repertoire such full-scale oratorios as Haydn's *Creation,* Handel's *Messiah,* and Gounod's *Redemption.* He introduced into the Sunday evening services of sacred song such cantatas as Stainer's *Crucifixion* and Rossini's *Stabat Mater.* He ventured into opera in modified form. A dramatic reader told the "story" of *Parsifal* while orchestra, organ, piano, and voices performed selections from the music. Gilbert and Sullivan, entrenched favorites as time went on both at the lakeside and on circuit Chautauquas, were given their first hearings, but when one recalls that during the first assembly decade the Reverend J. M. Buckley had taken the platform to deplore the popularity of *Pinafore,* declaring that those who went to see it were unconsciously "selling out their whole Christian influence" and expressing his sense of shock at learning that a church choir from Philadelphia had gone out to act it "all over the country," one is not surprised that the first Chautauqua *Pinafore* was given in concert form only.

Hallam organized concerts for children, and established a children's choir of 250 voices, which gave an operttta, *The Story of Cinderella,* the children supplying the soloists as well as the chorus. Hallam also showed a degree of hospitality to contemporary, including American, composers. He presented such oratorios as *Lazarus,* by Julian Edwards, dedicated to Hallam himself, and *Victory Divine,* by J. Christopher Marks, organist of the Church of the Heavenly Rest in New York, a first performance with the composer present. Under Hallam the public-school music courses were enlarged and directed toward a comprehensive program to meet the needs of all supervisers and teachers. As a part

of its educational effort, Chautauqua usually presented a guest lecturer to speak on some aspect of musical literature or training. In 1913, the lecturer was Olin Downes, then the very well-known music critic of the *Boston Post*. Downes returned next year for the full season to teach harmony and appreciation and to lecture on "Modern Musical Developments."

Another contemporary oratorio that Hallam introduced was *The Prodigal Son,* by Henry B. Vincent, nephew of the bishop. Henry Vincent had become assistant director of music with the beginning of the Hallam regime. He organized a Chautauqua orchestra of twenty-one instruments, a significant step toward orchestral maturity, and became the official organist of the institution. In 1907, Chautauqua had profited by one of many important benefactions. In that year the Massey Memorial Organ was installed in the Amphitheater as a gift of the estate of Hart A. Massey, who like Lewis Miller was known widely for his manufacture of agricultural implements, notably the Massey Plough. He was a Chautauqua trustee who had moved from Cleveland to Toronto. His son, Chester D. Massey, married a sister of Bishop Vincent, and the son of this marriage, Vincent Massey, became Canada's first minister to the United States. The Amphitheater was remodelled to receive the Massey organ, and Normal Hall was remodelled to provide for its predecessor. Visiting players, including Isaac Flagler, Chautauqua's former organist, gave recitals on the new instrument which, after some sixty years of service, was extensively renovated for the 1972 season.

In 1911 Chautauqua suffered a severe loss in the death of William H. Sherwood, who had conducted the piano department for twenty-two unbroken years. He was commemorated by the building of the Sherwood memorial studio, a product of Old First Night giving in the following year. The loss might well have seemed irreparable, but the successor Hallam secured, Ernest Hutcheson, proved an appointment as fortunate as Sherwood's. Hutcheson served even longer, retiring only in 1944, so that Sherwood and Hutcheson between them divided fifty-six years as nationally distinguished heads of the piano department. Born in Melbourne, Australia, Hutcheson made his first appearance at the age of five, studied extensively in Germany, played with the Berlin Philharmonic, and later with many of the principal orchestras in this country. He was important to Chautauqua not only as a resident virtuoso and teacher, but as an influence on its musical life generally. His appointment as dean of the Juilliard School of Music provided a valuable link between Chautauqua and this important musical institution. Another link with Juilliard and also with the Curtis Institute of

Music came about with the appointment of Horatio Connell, who served as head of the voice department of Chautauqua for some twenty years beginning in 1916.

At about the mid-point of Hallam's directorship, in 1909, Walter Damrosch brought the New York Symphony to Chautauqua for a full-scale symphonic concert. The effects of this event were momentous, but since they did not come to complete fruition until the twenties and thirties, it seems well to reserve this part of the story for separate treatment and to glance at the course of Chautauqua music, aside from symphony, down through the war and the end of Hallam's regime. For the season of 1914, as peace came more and more heavily under threat, a Music Festival Week was announced. The Schubert Club male chorus of Schenectady lent its forces, and Victor Herbert with his orchestra made the first of numerous appearances. The festival included a Wagner program, miscellaneous concerts ranging from Beethoven to Herbert himself, the *Manzoni* Requiem by Verdi, an American composers' night, and *The Chimes of Normandy* as an opera in concert. Music week was evidently marked by varying degrees of austerity. During the next year's festival, Carrie Jacobs Bond gave recitals, the first entirely of her own works, including "I Love You Truly," "Just Awearyin' for You," and "A Perfect Day."

When the United States finally entered the war, a fever of patriotism gulped up practically the entire nation, and did not spare Chautauqua. The war activities of the Institution are dealt with elsewhere, but Jesse Hurlbut records, as one would expect, that during the 1917 season young men were conspicuously absent from the music festival concert. The all but universal patriotic fervor temporarily stimulated, according to Wells, the effort to promote American composers and American musical training. In 1917, instrumental music was provided by the Russian symphony under Modest Altschuler, who included one or more American works on each of his programs. By the following season, though, emphasis shifted to solidarity with the nation's allies. The French Military Band of more than sixty musicians gave seven concerts, mostly transcriptions from French opera, symphony, or suite. Hallam led "community sings," which the *Daily* described as bringing into play a "mighty chorus of many thousands, singing the patriotic airs of the Allied Nations."

The postwar season of 1919 sustained the multiplicity of musical events and the prominence to which Hallam had brought music at Chautauqua, making it a conspicuous everyday feature of the seasons. Wells comments that the works that proved popular with Chautauqua

audiences "were largely those of the 19th century composers to which were added a few selections from the classic period and a limited number of contemporary American compositions." The extent to which Chautauqua programs were representative of the full available repertoire, from classic and preclassic to contemporary, has been a subject of comment and even stricture from time to time in Chautauqua musical history, but Hallam, by his energy, his appointments, and his professional devotion contributed stoutly to the development of the Institution as a music center. Though the admirably trained Chautauqua choirs continued to be a valued feature of its religious services as well as its secular concerts, the end of Hallam's regime marked the end of distinct choral domination in the musical life of Chautauqua and of the country. And the next important steps toward full musical maturity had already begun to take place during his directorship.

Albert Stoessel in Command

When in 1909 Walter Damrosch was engaged to bring the New York Symphony to Chautauqua for a single concert, the Institution scheduled a baseball game for those who might not want to risk an undiluted symphony program. No doubt the ball game had its fans, but an hour before the concert was to begin, an estimated eight thousand ambitious listeners were on hand. Wells remarks that ". . . few localities beyond the larger cities had been favored by a visit from a musical organization of the first magnitude." Damrosch's program began with the overture to *Mignon* and wound up with "The Ride of the Valkyries," but in between it contained Beethoven's Fifth Symphony. Damrosch said that Chautauquans made a "fine audience to play for," and remarked, "They took the Fifth Symphony like lambs." One of the players who made his first visit to Chautauqua with Damrosch was Georges Barrere, the celebrated flutist, who became another in the succession of luminaries who served the Institution for many seasons, as teacher and performer and as a valued personal presence and musical influence.

A single concert such as Damrosch's in 1909 can seldom have had such far-reaching effects. Next year the orchestra was back again, its program including the first movement of Edward MacDowell's Concerto in A Minor, with Sherwood as pianist, and Damrosch's own setting for baritone of Kipling's "Danny Deever." The success of these visits showed that an appetite for symphonic music existed at Chautauqua, an appetite that could be ultimately satisfied only by a permanent resident orchestra that the Institution could call its own. This culmination, though, could not occur all at once. After 1910, the New York

Symphony did not return for nine years, but during the three seasons from 1915 through 1917, Modest Altschuler brought the Russian Symphony not for single performances, but for concerts in series. His programs included a performance of Dvořak's *New World* Symphony, an all-Russian and an all-Wagner program with assisting voices. He also gave a first performance, with the composer present, of Frederick Converse's cantata, *The Peace Pipe,* and a first of Carl Engel's *The People's Anthem.* In an interview for the *Daily,* Altschuler is reported as saying: "Chautauqua will surely become the music center of the country. In fact, I question whether it is not already that."

Absent for nine years, the New York Symphony returned in 1919 under Rene Pollain as conductor, this time for twelve concerts. Next year the orchestra came again for a full six weeks of symphonic programs. This extended term, according to Wells, marked the beginning of the predominance of symphonic music at Chautauqua, though choral works continued to be conspicuous features. Six weeks of symphony need the support of more than ticket sales, and the appearances of the orchestra in 1920 and 1921 were underwritten by a gift from the directors of the Symphony Society of New York and by a guarantee of any deficit up to a generous sum by friends of Chautauqua. In the programs of 1920, Wells notes the emphasis on scores by nineteenth-century German, Italian, and French composers, the frequency of operatic overtures, and the limitation of contemporary music to a single first performance by an American composer, the Fantasie in D Major by Guy Ropartz. The limitation seems natural enough at this early stage of symphonic development, and the audiences did hear the first Chautauqua performance of Beethoven's *Eroica* Symphony, performances of Dvořak's Symphony no. 5, of the Franck Symphony in D Minor, and of the Saint-Saëns Symphony for Organ, Piano, and Orchestra. For the next successive seasons through 1928, with the single exception of 1922, when the Detroit Symphony took its place, the New York orchestra continued to be a full-season feature of the Chautauqua program.

Instrumental music was gaining ground, but not to the exclusion of older habits. In 1921, in succession to Hallam, H. Augustine Smith was appointed music director. His work seems to have carried on and even extended features of the preorchestral period. He had studied at Oberlin College and the American Conservatory, and had served as an instructor at the Theological Seminary of Chicago University. He came to Chautauqua from Boston University, where he held the unusual title of Director of Fine Arts in Religion. His tastes ran to massed choral productions. He brought regional choruses to Chautauqua to supplement

the local choirs, and used costumes and dramatic trappings to reinforce devotional purposes with pageantry. In 1925 he gave a performance of Handel's *Messiah* in which he directed a thousand voices drawn from the Chautauqua choir, the Junior Choir, and visiting organizations, together with soloists, the New York Symphony, and an audience said to number eight thousand who had been provided with copies so that they could join in the singing of the "Hallelujah Chorus." One wonders how Smith coordinated such a throng—there is no record that he didn't —and whether the volume of sound reached the ears of one particular musician and if so, what he made of it. This was George Gershwin, who was inconspicuously spending the summer at Chautauqua composing, in a practice shack, his Concerto in F, commissioned by Damrosch. Chautauquans were not much aware of Gershwin's presence at the time, but twenty-seven years later they dedicated a shack to him in belated compensation. Meanwhile his Concerto, his *Rhapsody in Blue,* and concert excerpts from his opera *Porgy and Bess* found their way into the Chautauqua repertoire.

In the year of Smith's appointment, Albert Stoessel made his first appearance as conductor for the opening three weeks of the symphony season. In the whole roster of eminent musicians who have served Chautauqua long and faithfully, Stoessel seems by all odds to have been the single most influential figure. The versatility of his gifts, his executive energy and imagination as well as his skill as a conductor, performer, and composer, made him preeminent. When he came to Chautauqua, Stoessel was twenty-six years old; beginning with his first full season in 1923, he brought sustained musical distinction to the Institution with only two leaves of absence until his sudden death shortly before the opening of the 1943 season.

Born in St. Louis in 1895, Stoessel studied violin at the Royal Academy of Music in Berlin. He is said to have made his debut by playing no less than three concerti in one evening. He was giving concerts in Europe when the outbreak of the First World War brought him back to this country. Enlisting in the army, he became a military bandmaster in France and eventually director of the school for bandmasters of the American Expeditionary Force. On his return after the war, he played with the symphony orchestras of Boston and St. Louis and was chosen as his assistant by Walter Damrosch in the Oratorio Society of New York. Eventually he succeeded Damrosch as conductor both of the Oratorio Society and of the New York Symphony. Meanwhile he was becoming known as a composer. Thus he combined the talents of a creator, a conductor both of orchestra and chorus and later opera, and

of a musical administrator with a flair for detecting young talent and making distinguished appointments. One of the chief and long-loved musicians he brought to the Chautauqua staff was Georges Barrere as head of a flute department formed in 1921. In 1925 Hugh Porter succeeded Henry Vincent as organist and began recitals representing the literature of the organ from its earliest exponents to American contemporaries. A third appointment of particular value was the choice in 1925 of Mischa Mischakoff as virtuoso and teacher of the violin. Concertmaster of the New York Symphony under Damrosch, Mischakoff later held the same position in Toscanini's NBC orchestra. At Chautauqua he established the Mischakoff String Quartet, an important instrumental step which led to the formation of the Chamber Music Society.

The growth of symphonic music in scope and prominence, says Wells, stimulated music on all fronts. Enrollment increased in the instrumental classes, and Stoessel carried the musical infection down to youth by beginning matinee concerts for children. In his first full season of 1923, Stoessel started off conservatively, Wells observes, playing for the most part scores that had established themselves with winter audiences, though in succeeding seasons he made definite efforts to promote contemporary and American works. Even in his initial complete summer, he conducted Strauss's *Death and Transfiguration* and Debussy's *L'Après-midi d'un faune* in company with Beethoven and Schubert. By the next season, Chautauquans were hearing local firsts of Borodin, Rimsky-Korsakov, Tchaikovsky, and Brahms, and among contemporary composers Stoessel himself and Gustav Holst. The following summer brought Stravinsky's *Firebird* suite and Honegger's *Pacific 321,* and the next after that the first Chautauqua performance of Gershwin's *Rhapsody in Blue.* In 1928 John Erskine played the keyboard part in Stoessel's Suite for Two Violins and Piano. Marion Bauer, a faculty member in the music department of New York University, gave five lectures on music appreciation, the last dealing with "The Twentieth Century in Music" and discussing Schönberg, Stravinsky, and Bartok. She also became music critic or commentator for the *Daily.* The same year saw the first appearance at the lakeside of another eminent musician, long revered and still active in Chautauqua musical affairs, Howard Hanson, who as guest conductor performed his own symphonic poem, *Pan and the Priest.*

Hanson could have called himself at least obliquely a Chautauquan before he became an important musical influence at the Institution itself. As a boy in his teens he had played piano and cello in one of the small Concert Companies of the Redpath-Horner circuit Chautauquas, his

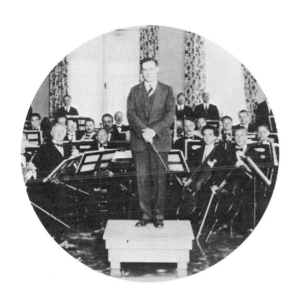

Albert Stoessel

earnings helping to pay for his studies. Born in Nebraska in 1896, he studied at Luther Junior College in Wahoo, his birthplace, went on to the University of Nebraska School of Music, graduated from Northwestern University, and while serving as Dean of the Conservatory of Fine Arts at the College of the Pacific in San Jose, California, won the Prix de Rome, the first fellow to enter the American Academy there as a result of that competition. From Rome he accepted the directorship of the Eastman School of Music at Rochester, New York, a position in which he served until 1964. At Eastman he initiated the American Composers' Concerts, furthering the cause of American music by this means as well as by his own compositions, the range of which has extended to music of all sorts, from scores for small ensembles to symphony and opera. As a frequent guest conductor, consultant, and lecturer, he has given long-standing support to music at Chautauqua.

In 1929, on the eve of the stock market crash, Chautauqua experienced a momentous season in its music history. Stoessel, already the prime mover in the rapid developments of the twenties, became Music Director in succession to H. Augustine Smith. The New York Symphony, during the previous year, had dissolved as an organization in its own right, merging with the New York Philharmonic Society. As its valedictory to Chautauqua, it played Haydn's *Farewell* Symphony, the music stands lighted by candles in eighteenth-century fashion, each performer blowing out his own candle as he finished his part and left the stage. Stoessel promptly organized Chautauqua's own symphony orchestra, and for its nucleus brought back many of the players from the disbanded New York Symphony. Later the Chautauqua Symphony recruited musicians from many established orchestras, and still more recently, as summer festivals have multiplied and absorbed regular symphonic organizations into their seasonal programs, Chautauqua has drawn its orchestral personnel from the music faculties of colleges and universities.

In its first season the Chautauqua Symphony played an extensive repertoire ranging from Corelli and Vivaldi to Honegger and Ravel. It also gave children's concerts, "pops" concerts, and accompanied performances by the choir. More American scores were presented, among them Ernest Bloch's *America* for orchestra and choir together. The symphony became the "indispensable element," as Wells puts it, in the whole musical structure. It furnished the members of the Mischakoff string quartet, it supplied the pit orchestra when opera was established, it accompanied the Sunday evening sacred song performances, and supplied soloists as programming demanded. Meanwhile other musical

indulgences were not neglected. In 1929, Sousa and his band made another of their repeated appearances, and the Southern Plantation Singers kept up an established tradition.

As if the formation of a symphony orchestra were not enough for the director's first season, Stoessel was influential in another important musical venture. This was made possible by the opening of Norton Hall, the cornerstone of which had been laid in the previous season. The hall was the result of a gift of $100,000 by Mrs. O. W. Norton of Chicago in commemoration of her husband and daughter. Mr. Norton had lost his sight, and found his chief pleasure in listening to music. The building was said to be the first monolithic concrete structure of its kind east of the Mississippi, and in Wells's words gave Chautauqua an enclosed hall with "a well equipped stage, an ample orchestra pit, and seating for over thirteen hundred persons." It was intended to be used for chamber music, vocal and instrumental recitals, symphony concerts, motion pictures, theatrical companies, and it was hoped, opera. With characteristic energy, Stoessel proceeded to organize the Chautauqua Opera Association.

Chautauqua had dabbled in opera for many years by way of operatic "numbers" and concert performances or adaptations, but it had yet to make a feature of music-drama as such. No doubt the appetite for opera had been stimulated by the visit in 1926 of the Rochester Opera Company from the Eastman School, giving six performances during which Mozart's *Marriage of Figaro* was sandwiched between *Pinafore* and *The Pirates of Penzance*. The open-air amphitheatre and the lack of an orchestra pit made production difficult, but the operas were enthusiastically received. By 1929, with Norton Hall at its disposal, Chautauqua was ready under Stoessel for its own operatic venture.

Stoessel, already active at the Juilliard School of Music and soon to become head of its opera department and director of its orchestra, brought Alfredo Valenti from Juilliard to serve as production director for the new company. Over a period of years, the close association of the two institutions proved of great value to Chautauqua, making possible the transfer of one or more Juilliard productions to the summer season at Chautauqua and opening an important pool of young talent. Valenti had a flair for imaginative productions on a limited budget. He was assisted at the start by Margaret Linley of the Theater Guild in New York as set designer. Miss Linley's ingenuity was taxed to create successful sets under difficulties. Before a later addition to Norton Hall provided greater space, the male chorus had to dress under the stage and the girls at the top of the building in rooms hardly big enough for six

at a time. Scenery and props had to be carried from another hall and often arrived rain-drenched.

Valenti supplied three principles for the Chautauqua Opera Association: opera should be given in English, with care for good translations; to preserve dramatic unity, acting as well as singing should be stressed; and young American singers should be given roles to offset the "star system" and to encourage native talent. Translations, as might be expected, proved a problem from time to time, but in giving important early experience to young singers who later went on to prominence in the Metropolitan Opera or on the stage or on radio or television, the Opera Association scored brilliantly, especially during its first two decades. A standard list would include Helen Jepson, Rose Bampton, Julius Huehn, Josephine Antoine, Annamary Dickey, Maxine Stellman, Donald Dickson, Donald Dame, Frances Bible, and Charles Kullman. Many returned for a surprising number of seasons to repeat old roles or undertake new ones, and established themselves in the affections and pride of their Chautauqua audiences.

With a company, a working philosophy, a music director in Stoessel and a production director in Valenti, Chautauqua opera launched itself on July 19, 1929, with a performance of Flotow's *Martha* before an audience including Mrs. Thomas A. Edison and Henry Ford. In all, the company gave five operas in eight performances, going on from *Martha* through Humperdinck's *Hansel and Gretel* and winding up with Gounod's *Faust*. Helen Jepson and Rose Bampton made appearances, and the general reception was enthusiastic. Taken in sum, the entire musical program for 1929, the concerts of the symphony and junior symphony, the operas, the choir, the Mischakoff Quartet, brought to a peak the remarkable musical expansion of Chautauqua in the twenties. The stock market collapse was still ahead; the worst effects of the depression would not reach Chautauqua for three or four years to come. Before the summer of 1930, the novelist and musician John Erskine, President of the Juilliard Foundation and from time to time a lecturer and soloist at Chautauqua, gave a radio speech, "An American Music Center in the Making." Chautauqua, he said, was "a place peculiarly favorable for the whole life of music, for musicians to perform, and for musicians to listen, for artists to teach, and for other artists to study, meditate, and create." He praised the "team work" of Stoessel, Hutcheson the pianist, and their colleagues, which he credited with bringing all the musical resources together in a "total effect." He went on to say that "at Chautauqua one can not only hear music but can live, for a while at least, in a music-world." For this totality,

Erskine maintained, and not for lack of good American teaching, Americans went to Europe. Chautauqua, he thought, created a similar atmosphere, on which the existence of a true center depends.

For the season of 1930, Stoessel planned an even more ambitious music program. Common hope expected the prompt recovery of the American economy, but as the next half-dozen years went on, the effects of the depression made themselves felt more acutely and the rise of Hitler became more and more ominous for peace. During this period, Chautauqua underwent its own financial ordeal, passing into receivership a few days before Christmas in 1933, a story already detailed in this record. Not until three years later was it able to announce that it had emerged debt-free. Meanwhile it continued to function as the music center John Erskine described, and with surprisingly little retrenchment. In one season the symphony concerts under Stoessel were reduced to a period of three weeks, but George Barrere with the Little Symphony he directed filled in for a week at the beginning and another at the end. In the year after receivership, the Opera Association still prepared a full program, though Robert Cowden, in his monograph on opera at Chautauqua, notes that the season emphasized light opera. The Association had to do its best to fill Norton Hall. Its budget had been cut, and extinction became a real possibility, but opera struggled through, partly supported, together with the Chamber Music Society, by guarantees from friends of Chautauqua. In the years under review, the Association made its first venture into contemporary American opera with *Jack and the Beanstalk,* its music by Louis Gruenberg, its libretto by John Erskine, initially performed during the previous winter at the Juilliard School. Early in the period the opera audience had heard Debussy's *The Prodigal Son,* and later it was to hear the first Chautauqua performance of Henry Hadley's *Bianca.* Along the way it was offered two eighteenth-century opera buffa, Pergolesi's *La Serva Padrona* and Cimarosa's *The Secret Marriage* in productions imported from the Juilliard School. Rose Bampton returned as a member of the Metropolitan Opera Company to take a leading role in the *Samson and Delilah* of Saint-Saëns, and others who had gained early experience at Chautauqua brought laurels back from elsewhere or made debuts that would lead them to wider prominence, among them Charles Kullman, Josephine Antoine, and Joan Peebles.

Both Stoessel and Barrere made definite efforts to further the cause of American music. During the years of depression and recovery, Chautauqua heard works by such composers as Howard Hanson, Ernest Bloch, Gershwin, Deems Taylor, Randall Thompson, and John Alden Carpen-

ter. Prokoviev, Sibelius, and Schönberg seasoned the prevalent repertoire. Schönberg himself, unwelcome in Nazi Germany, came to Chautauqua with his wife and daughter for part of the summer of 1934, seeking to regain his health. According to the *Daily,* quoted by Wells, he was persuaded to "accept private pupils in composition." Stoessel announced his presence and arranged a performance of his *Verklärte Nacht* as a sextet, Stoessel himself playing a viola part. Marion Bauer, lecturer and music commentator for the *Daily,* wrote in an interview: "I saw Schönberg in New York when he was ill. . . . He does not look like the same person after these four weeks in Chautauqua, living in the sunshine and feeling himself a part of a friendly community."

In 1931 Chautauqua began a summer series of radio programs presenting or discussing music. Initially these were broadcast over Station WJZ in New York and the NBC Red Network. John Finley gave the first four of a sequence of talks, Georges Barrere the fifth, and five music programs were broadcast. By the next season the number of broadcasts had increased to twenty-one. Inevitably changes and additions occurred in the music staff. In 1931 Gregory Ashman became conducting assistant to Stoessel. Walter Howe was appointed choir director, and served until his death sixteen years later. Like H. Augustine Smith, Howe was partial to the massed choral tradition, but without Smith's penchant for theatricality. He further developed the regional choir system, on at least one occasion bringing a visiting chorus from as far away as Georgia. Harrison Potter was appointed with him as assistant, and served even longer, through the summer of 1957. George William Volkel succeeded Hugh Porter as organist, and began still another long term of service to Chautauqua, continuing until 1955. He not only played comprehensively from the literature of the organ but supplied useful program notes for the *Daily.* In 1936, the year when Chautauqua announced itself out of the woods financially, Horatio Connell brought to an end his twenty-one years as head of the voice department. Known as a baritone soloist himself with orchestras and in recital, he was a teacher who could claim among his pupils Nelson Eddy and Rose Bampton. Stoessel was away, taking the second of his two leaves of absence and writing his opera *Garrick,* which after its New York opening was to be given at Chautauqua the following summer. Alberto Bimboni was brought in to help with operatic conducting.

From the return of Stoessel in 1937 to the end of his era in 1943, music at Chautauqua could be described as stabilized at an impressive level of excellence and abundance. When Hitler annexed Austria and sent his ultimatum to Czechoslovakia, talk was heard that Chautauqua

might become the American Salzburg. Hitler's exclusion of non-Aryans had led some American virtuosos to decline invitations to the famous festival, among them Chautauqua's Ernest Hutcheson. Julius King, publicity director for the Institution, wrote a letter to the *New York Times* staking out Chautauqua's claim without undue modesty, but his summary of the musical offerings makes a pertinent enough reminder of the range of Chautauqua's musical activities: "Symphonies and operas alone would make a festival, but Chautauqua had in addition a choir of 200, a choral festival of more than 500 voices, chamber music recitals, piano recitals by Hutcheson and Austin Conradi, daily organ recitals by George William Volkel, lectures on music by Marion Bauer and Harrison Potter." During these years, perhaps not in entire consistency with the desire of Stoessel and Barrere to undermine the star system, an anonymous gift brought to Chautauqua such visiting celebrities as Richard Crooks, tenor, Albert Spalding violinist, and Gladys Swarthout, mezzo-soprano of Metropolitan and concert reputation. Contemporary composers and scores represented, American or foreign, included Samuel Barber, Hindemith's Memorial Music for George V, the First Symphony of Shostakovich, Vaughan Williams's *London* symphony, Sibelius in a program entirely of his works, and Gershwin's Concerto in F. Choral work included Beethoven's Ninth Symphony presented by the orchestra, the choir, the chorus from the Opera Association, and the Jamestown choral society. Volkel's organ recitals included an all-American program, a historical program in which Frescobaldi, Buxtehude, J. S. Bach, Mozart and others were represented, and in eight 1940 concerts he performed the entire *Orgelbüchlein* of Bach. Opera ranged from Douglas Moore's *The Devil and Daniel Webster*, based on the well-known story by Stephen Vincent Benét, through Smetana's *Bartered Bride* and Wolf-Ferrari's *The Inquisitive Woman* to Victor Herbert's *Naughty Marietta*. Chautauqua talent aside, Alec Templeton, the blind pianist and musical entertainer, made an appearance, and the *Daily* recorded that "10,000 wildly applauding fans" greeted Paul Whiteman and his band.

In the season after Pearl Harbor, sirens interrupted the opening night first performance at Chautauqua of Massenet's *Manon*. Destruction was the rule on most of the world's continents and seas. Before another season could begin, Chautauqua suffered a severe personal loss of its own. On May 12, 1943, Albert Stoessel, in the act of conducting the New York Philharmonic in Walter Damrosch's *Dunkirk*, collapsed at the age of forty-eight. He had only the night before finished preparing the program for the coming season at Chautauqua; the works to be

performed had been chosen and soloists for the opera company, the orchestra, and the choir had been engaged. President Arthur E. Bestor lived to pay tribute to Stoessel during the summer, but himself died before the next season could open. These two deaths within a year of each other brought to an end a period that still stands distinct in the musical history of the Institution. If Stoessel was the animating force in the development of music itself, President Bestor played his own important part. As far back as 1929, he had clearly enough announced the direction in which he was seeking to guide Chautauqua. In an address at the opening of Norton Hall, he told his audience: "What we have been seeking for the last decade is to make a program which will appeal to people who can come only for individual events, especially the evening programs. Therefore the outstanding development of Chautauqua in recent years has been along the musical line." Bestor, says Wells, was "the executive force in surmounting the difficulties created by two world wars and the depression, and in capitalizing on changes in American habits that occurred in his span of office. To the traveling Chautauquas the re-shaping of American life that came with the automobile, the motion picture, and the radio were fatal; to Chautauqua Institution, under the leadership of a man with insight and imagination, they were a means of increased usefulness and influence. Stoessel's musical ideas could not have become realities" if Bestor had not given him wholehearted support. As for Stoessel, his importance in the development of music in America and his capital importance to Chautauqua were recognized both within and without the Institution. The program he had arranged for 1943 was largely carried out, Howard Hanson sharing with others in the direction of the orchestra. A concert was dedicated to Stoessel's memory, conducted by William Willeke, one of his colleagues at the Juilliard School. The program included a Concerto Grosso by Stoessel himself and his orchestration of the Bach Passacaglia and Fugue, fitting valedictories.

In retrospect, Robert H. Cowden, in his monograph on the history of the Chautauqua Opera Association, thinks that although Stoessel and Valenti favored new and American works in principle, they were conservative in their selection of the new. Chautauqua opera productions, he points out, did not include *Salome* or *Wozzeck* or *Brecht-Weill*, "in fact none of the protest or social operas of the 1930's! In terms of exciting American works, Thompson's *Four Saints in Three Acts* (1934), Gershwin's *Porgy and Bess* (1935), and Blitzstein's *The Cradle Will Rock* were all available, but they were all outside of *the Chautauqua experience* [italics Cowden's]. The Institution was a small, safe island

in the middle of turmoil." Any organization dependent on a public or an audience no doubt finds itself in some measure restricted by what its patrons will accept, and Cowden goes on to say that whatever the verdict on the programming of Stoessel and Valenti, "it was the correct formula for Norton Hall. The sources of funding would have dried up" under a different policy. When the author of this chronicle paid his first visit to Chautauqua, the present head of the Opera Association remarked somewhat wistfully that he wished a director did not have to feel that his every production must be an audience success. He would like, even at the cost of a flop now and then, to experiment more with American works or with chamber opera of unconventional dimensions, but it was still standard arias or standard climaxes in the accepted repertoire that brought zealous applause, a fact which a director might chafe at but could not ignore.

Realignment

Stoessel was gone, and his death compelled a fresh organization of musical forces. It would have been something of a miracle if a successor had been found who could combine in his own person so many musical capacities, who could draw on so many musical connections and sources of talent, and who could unite them all with comparable energy. To provide a center of coordination, a Director of Program, Ralph McCallister of Chicago, was appointed, but under him the various musical departments were given greater autonomy. In particular, the directorship of the opera and the directorship of the symphony were permanently divorced. Though the orchestra for the operas continued to be derived from the symphony, Alfredo Valenti was put in charge of opera and a new symphony conductor was appointed, Franko Autori. Born in Naples, Autori became a United States citizen in 1936. After early experience in opera, he conducted the Dallas Symphony and founded the Dallas Sinfonietta, a group of eighteen string players. He came to Chautauqua from Buffalo, where he had headed the Federal Music Project in the wake of the depression and had turned its orchestra into an independent organization with local civic support.

During Autori's first two seasons, both parochial and international events claimed attention. In 1944, Frieda Hempel, former Metropolitan soprano, regaled her audience with the same program that Jenny Lind, the Swedish Nightingale, had used in her American debut under the sponsorship of P. T. Barnum. The Columbus Boychoir made Chautauqua its summer headquarters for the first of many seasons. Ernest Hutcheson retired as head of the piano department, though he made a

final Chautauqua appearance four years later. His place was taken by James Friskin, a colleague at Juilliard and Hutcheson's own choice as successor. The final orchestral concert of the season occurred on the day when Allied troops entered Paris. Perhaps Percy Grainger, as visiting piano soloist, profited by the additional enthusiasm aroused by this event. He had to play two encores, and Autori wound up by leading the audience in the "Marseillaise." As if one coincidence were not enough, Old First Night in the next season fell on V.J. Day. The audience began to flow toward the Amphitheater at the end of the choir rehearsal, which broke up with the director leading a cheer. Then "the organ went into action, small boys began vaulting over seats, . . . a couple of bats skimmed from the Congregational House to Presbyterian Head-quarters." Quiet finally took over and allowed the Old First Night service to follow its traditional form. At the close McCallister tried to make an announcement, but could not finish a sentence. "A man in uniform on the front row leaped up. He said nothing but raised his arms. At once everyone was standing and clapping and shouting, and then singing the Star Spangled Banner."

In his eight years of service as conductor of the symphony, Autori treated orchestral literature comprehensively. He carried on Stoessel's practice of introducing contemporary works and of freely using soloists with the orchestra. Guest pianist Paul Wittgenstein, for example, who had lost his right arm, played Ravel's Concerto for the Left Hand, a score especially written for him. Wells speaks of Autori's "devotion to contemporary music . . . to complement the pre-classic, the classic, and the romantic" and as an example of his "preoccupation with the un-usual," she cites a program made up entirely of concertos ranging from Handel through Ravel and including such infrequently heard combina-tions as Dubensky's Concerto Grosso for Three Trombones, Tuba, and Orchestra. Among contemporary and American composers, he played works by Milhaud, Bartok, Samuel Barber, Charles Ives, Walter Piston, and Aaron Copland—both Copland's *Lincoln Portrait* and his film score for *Our Town*. He conducted Bloch's Hebrew Rhapsody for cello and orchestra, and the Chautauqua first performance of Howard Hanson's Concerto for Piano and Orchestra, commissioned by the Koussevitsky Foundation.

In 1948, the Institution celebrated its diamond jubilee year, provid-ing an elaborate range of musical activities, old and new. A peak of the season was the final appearance of Ernest Hutcheson as soloist in the Fourth Piano Concerto of Beethoven. He received the Chautauqua salute as a part of his ovation. In 1949, David Holden, a composer and

member of the music faculty at Mt. Holyoke College, became music critic for the *Daily,* and from time to time exercised the critical faculty with less restraint than Chautauquans were accustomed to. By 1950, the student symphony under Edward Murphy had reached a point at which it could undertake as many as nine Amphitheater appearances and use young performers in concertos and arias ranging from Mozart to Broadway hits. In 1952, another period of orchestral conducting came to an end with the resignation of Autori at the close of the season.

Meanwhile opera was being produced in plenty. In view of the difficulties of production and rehearsal and of finding time and space for them in competition with all the other activities at Chautauqua, the figure of six or seven operas in twelve to fourteen performances over approximately eight weeks is impressive, even allowing for revivals and productions at least partly prepared elsewhere. Valenti, in sole charge after Stoessel, was, as Cowden observes, an imaginative producer who also understood the importance of keeping the Association solvent. Under his regime, receipts exceeded the budget for a dozen seasons or more, at the cost, Cowden thinks, of relying heavily on works that could be counted on to please the audience. Yet in summing up Valenti's Chautauqua career, which came to an end in 1957, five years after Autori's, Cowden credits him with almost single-handedly keeping "the company together through thick and thin," and says that "on those occasions . . . when he had a first-rate conductor in the pit and good singers in his cast, the results were equal to those obtained by any other opera director of his generation."

A sampling of productions and incidents during the years in hand would show that in 1945, Strauss's *Die Fledermaus* was performed. and the husband-and-wife team of Pauline Pierce and Gean Greenwell, who had sung for a decade in the opera company, made the last of over one hundred and seventy Norton Hall appearances. In the jubilee year of 1948, Chautauqua heard its first performance of Mozart's *Cosi Fan Tutte,* a production in which Patricia Neway made her Norton debut on the way to larger fame. During the next year Gluck's *Orpheus and Eurydice* was given its Chautauqua first as a fully staged opera. In 1950 the association produced *In the Name of Culture,* a musical comedy of manners by Alberto Bimboni, the company's principal conductor. In the following year, the first Chautauqua *Aida* received the praise of Holden, not always easily won, and the next year saw two new American operas on a twin bill, Lukas Foss's *The Jumping Frog,* based on Mark Twain's extravagant anecdote, and Gian-Carlo Menotti's *Amahl and the Night Visitors,* the title role in the latter sung, to the enthusiasm

of Holden, by Richard Mincer, a fourteen-year-old member of the Columbus Boychoir. In 1954 Julius Huehn, who after early Chautauqua experience became a baritone with the Metropolitan Opera Company and joined the staff of the Eastman School of Music, was appointed director of the School of Music at Chautauqua. The season of 1956 brought the resignation of Alberto Bimboni, leaving only Valenti and Jessie Mockel, able chorus trainer, who on her retirement became one of those to receive the Chautauqua salute, as remnants of the Stoessel era. The next year was the last for Valenti himself as director in full charge of opera. The association faced readjustment as the whole musical program had after the death of Stoessel.

On the retirement of Autori, the symphony needed a new conductor, and in 1953 Walter Hendl was appointed to succeed him. American born, Hendl was trained at the Curtis Institute and studied piano and conducting under Fritz Reiner and Serge Koussevitsky. When he became conductor of the Dallas Symphony, Hendl was the youngest man of his time to hold such a position with a principal orchestra, and he was still in his mid-thirties when he took over the symphony at Chautauqua. At least in his first seasons he did not escape the charge of conservatism. According to Wells, he tended to concentrate on "monuments of the musical past," and she quotes Holden, summing up the programs of 1955 in the *Daily,* as saying that "the few contemporary novelties which salted the diet" were "on the whole unpretentious or in relatively popular style. . . . Once again the Baroque period was left unexplored. It was the 19th Century which was ploughed, disked, and culled from end to end." Yet a dip into programs during Hendl's first five years shows what may well seem more than a sprinkling of the less conventional. To take American examples, Chautauqua heard scores by Barber, William Schumann, Bloch, Arthur Foote, Walter Piston, and Howard Hanson, who served as guest conductor in the first local performance of his "Elegy to the Memory of My Friend, Serge Koussevitsky," commissioned by the Koussevitsky Foundation and initially played by Charles Munch and the Boston Symphony Orchestra. Americans aside, Sibelius was represented by a concert entirely of his own works. His friend Sixten Eckerberg, of the Gothenberg Orchestra in Sweden, made a special visit to this country to conduct it. Symphony programs also included Bartok's posthumous Concerto for Viola and Orchestra and Poulenc's Concerto for Two Pianos and Orchestra.

The Student Orchestra meanwhile reached a strength of sixty-five, and began a series of Saturday morning concerts broadcast coast-to-coast over the ABC Network. The choral tradition was not neglected.

The Student Orchestra supported the choir in a performance of Mozart's *Requiem.* Dello Joio's *Song of Affirmation* was presented by the Mendelssohn Choir of Pittsburgh, and the Columbus Boychoir gave a first performance anywhere of the Mass for Treble Voices composed for them by their assistant conductor, Donald Bryant. Entertainment was not allowed to languish. Pop concerts included programs of Gershwin, Rodgers and Hammerstein, and Cole Porter. In 1956, George William Volkel brought to an end his twenty-three seasons of organ recitals. He bowed out by playing Handel's "Largo," according to custom, as a postlude to the Service of Sacred Song. Next year the black contralto, Marian Anderson, once notoriously refused an appearance by the DAR, enriched the tradition of visiting recitalists by an early-season appearance.

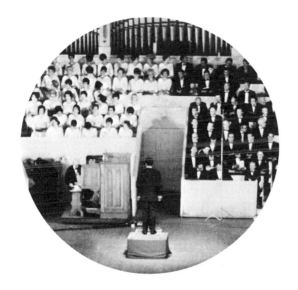

After Valenti, the Opera Association found itself in search of a director who could uphold its standards, keep reasonably within budget, and establish himself in a congenial relation to the Institution and its audiences. Valenti's first successor was Julius Rudel, general director of the City Center Opera Company of New York. On his appointment, David Holden wrote in the *Daily:* "Chautauqua grounds are buzzing as busily as is the operatic world from coast to coast with Chautauqua Institution's great scoop in bringing Julius Rudel here to become General Director of the Chautauqua Opera Association." Rudel served for one season with Valenti and the next in sole charge himself. He opened his programs with a new production of *Don Giovanni,* in which two singers from the City Center took leading roles. Next he presented Carlisle Flood's *Susannah,* which had been chosen, after a New York success, to represent American opera at the Brussels World Fair. Holden quotes Rudel as "eager to balance the . . . standard operatic repertoire with . . . American operas which have succeeded in New York," adding his wish to bring world firsts even before they reached New York. During the season he gave two contemporary American works, Vittorio Giannini's *Taming of the Shrew* and Carlisle Flood's *Wuthering Heights.* Cowden credits his Chautauqua productions with excitement, and reports that young people, after a period of slackening interest, began to appear in Norton Hall in greater numbers. None the less, whether for budgetary or temperamental reasons, and despite the "scoop" celebrated by Holden, Rudel was not recalled for the season of 1960.

As business manager and stage director, Rudel had brought with him John Daggett Howell, who was appointed general director for 1960 and kept his post for six years. Interviewed for the *Daily,* Howell ex-

pressed hope for a "flow of young people" who would "sing their lead-
ing roles for the first time at Chautauqua." He made free use of guest
conductors, among them Walter Hendl, thus once again briefly uniting
the leadership of opera and orchestra. Emerson Buckley, who had
given Douglas Moore's *Ballad of Baby Doe* its first performance at the
City Center, conducted it for Chautauqua. Howell diversified the estab-
lished repertoire by such other scores, American and foreign, as
Carousel by Richard Rodgers, *The Unicorn in the Garden* by Russell
Smith, based on a story by James Thurber and double-billed with
Hansel and Gretel in a special matinee for Children, as well as Haydn's
Apothecary, completed from the imperfect manuscript by Kurt Saffir
of the City Center. According to Cowden, Howell's "orientation was as
much to theatrical effectiveness as it was to the music itself, and he was
not averse to experimenting with the meaning or direction of a work."
His *Mikado* seems to have been characteristic. Cowden describes it as
"symbolic" and puts it down as a brilliant failure. Holden's review
called it "an almost surrealist fantasy . . . a sort of dream world in which
our own repressions . . . confront us again as monstrosities." Norton
Hall, it appears, was not prepared to have its familiar *Mikado* reinter-
preted in such terms.

During the Howell years, Chautauqua benefited by grants intended
to support the expensive business of music drama. In 1962 the Ford
Foundation provided a two-year subsidy enabling a score of opera
companies, including the association at Chautauqua, to engage a
nucleus of young opera singers. Two years later the same foundation
made a five-year grant of $20,000 a season in the unfulfilled expectation
that it would increase local support. In 1963 the Martha Baird Rocke-
feller Fund for Music subsidized a Chautauqua performance of *The Mar-
riage of Figaro* by the Festival Opera Theater under George Schick, and
two more similarly funded Mozart productions followed in successive
years. Such sponsorship ensured performances of thorough professional
excellence and somewhat lightened the heavy seasonal work of the As-
sociation, but it remained a question whether the series of grants in the
end solved the budgetary problem or helped the Association stand as
a tub on its own bottom. Change, in the meantime, went on with its ac-
customed work. In 1961, two resignations occurred from positions
important to the Institution. Julius Huehn gave up the directorship of
the School of Music and Ralph McCallister the directorship of pro-
gram. Curtis Haug became Acting Program Director and treasurer of
the Institution, and in 1964 its President. In the same year Walter Hendl
succeeded Howard Hanson in the directorship of the Eastman School,

a step at least partly compensating for Chautauqua's loss of close association with the Juilliard School.

In 1965, Chautauqua again found itself looking for a new director of opera. Recurring financial problems no doubt affected the issue, but Howell's very successes at their imaginative best may not altogether have helped to secure his position. Given the situation as it stood, Chautauqua turned to the Eastman School and appointed Leonard Treash, director of the opera program there, to succeed Howell. Treash began under difficulties. His appointment came so late that he had only one rehearsal week with the company to mount his first Chautauqua production. Comments in the *Daily* suggest that he was plagued by production problems through his first season, with the result that much depended on a successful second year. The natural recourse was to build a program on established favorites, but along with *Madame Butterfly* the Rockefeller-sponsored *Marriage of Figaro,* and *The Gondoliers,* Treash reached a seasonal peak with a production, imported from Eastman, of Robert Ward's *The Crucible,* based on Arthur Miller's impressive dramatization of the witchcraft trials in Salem.

Early in the 1968 season, a grant from the Martha Baird Rockefeller Fund for Music and from the New York State Council of the Arts enabled Chautauqua to announce an Apprentice Artist program to bring twenty-odd competitively chosen young singers, designers, and directors from the country at large into summer quarters for training and for performance. Here was a promising fresh impetus to the flow of young talent, singers especially, to which Chautauqua had been accustomed under Stoussel. And while the young were being recruited, seasoned veterans continued to find a welcome. In the year announcing the apprentice program, Gil Gallagher, singing in *Pinafore,* added one more to over one hundred and fifty Chautauqua appearances. He had begun under Stoessel, and had not only sung in leading and minor roles, but had been a man of all work, writing program notes, furnishing translations, and editing the brochures of the short-lived Opera Guild. The *Pinafore* in which he took part saw the opera company more firmly established again, recovering from some of the uncertainties of the Rudel-Howell period. If the season ended with a financially unsuccessful *Kiss Me, Kate,* given in the Amphitheater instead of in Norton Hall, and if the specter of stringency revived despite a sold-out house, the opera company has gone on giving a generous number of productions each summer, as witness for 1972 its seven operas in thirteen performances, including for contemporary fare Benjamin Britten's *Midsummer Night's Dream* and Mitch Leigh's *Man of La Mancha.*

Looking back over the century-long story of music at Chautauqua, one is struck by the diversity and vigor of its growth, by the astonishing acceleration in the twenties under Stoessel, by his power, when expansion reached a limit, to sustain music on all fronts at a high professional standard through the next decade and into World War II. And one is struck again by the irony that has dogged Chautauqua from its early years. In music, as in the conception of summer study itself, in extension work, in correspondence work, in the propagation of home reading through the CLSC, Chautauqua has pioneered only to have its work taken out of its hands by differently funded and differently established institutions or to find itself divested of the glitter of outright leadership and reduced to being one, however notable, in a company of rivals. In the thirties, with Hitler at large, Chautauqua more than half expected to become unique as the American Salzburg, and while the expectation may have been excessive, it was by no means hollow. In 1951, the *Daily* tacitly acknowledged the shift in perspective. "The Chautauqua musical season," it said, could "compete successfully" with the many summer festivals that had sprung up throughout the country. "Chautauqua is capable of keeping this music center one of the most outstanding in America." The change from being preeminent, or unique, or nearly so, to being "one of" had to be recognized. One thinks of Robert Frost's lines,

> And soon it is neither here nor there
> Whether time's rewards are fair or unfair,

but one can feel a twinge of sympathy for an institution which has so often led the way on such important fronts only to find leadership all too successful in breeding formidable competitors.

It was no doubt inevitable that music at Chautauqua should reach a kind of plateau. The question is at how high an elevation the plateau stands above ground level. In educational scope, Chautauqua's pedagogical effort in music must be nearly comprehensive. An instructing staff with solid to eminent professional and academic credentials offers all-summer training in voice, piano, organ, in theory and composition, in the representative orchestral instruments and such others as the classical guitar and saxophone, or three- to five-day workshops ranging from jazz to the tuning, structure, and care of pianos. If a chronicler who is not a trained musician may let his own direct impressions obtrude for a moment on the historical record, the Chautauqua Symphony, in its total sound as an ensemble, its balance of choirs, and its expressive flexibility, can hold its head up in any company. In 1972,

during the absence of Walter Hendl, it was directed by guest conductors ranging from Howard Hanson to Michael Tilson Thomas. A recurrent comment among them took note of the quickness of the orchestra, with much less than normal rehearsal time, in responding to the conductor's desires. The Student Orchestra gave concerts that at least to this pair of ears bore up well in comparison with the adult symphony, and the young soloists who appeared with both groups performed with an assurance and competence that this listener found exhilarating. Under its general director Leonard Treash and its conductor Evan Whallon, the opera company showed its vitality by offering seven operas in seventeen performances, ranging from *The Marriage of Figaro* and *The Flying Dutchman* to *The Man of La Mancha*. Its productions were staged with attention to acting and to visual effect, and its supply of good young voices, both male and female, in the chorus and in principal roles, suggested that the flow of young talent is still being tapped. In sum, Chautauqua, though it no longer stands alone in preeminence as a summer music center, can still lay claim to a considerable part of the recognition John Erskine gave it at the end of the twenties, as a place where comprehensive musical resources unite, at least for the eight weeks of the season, to make possible a life of music.

Ventures in Other Arts

"Among Chautauqua's many early ambitions," writes Thornton, "was its aspiration to become a great center of the fine arts." As far back as 1885 a Chautauqua Society of Fine Arts was established. In the art department of the summer schools, students were not only enrolled in person, but by correspondence as well. "Every morning at nine o'clock," said the *Assembly Herald,* "the students present a busy appearance as they sit at their easels, some trying to give just the right expression to a face that is assuming a familiar look . . . others to express by the delicate blending of colors, the proper light and shade in an attractive landscape scene, or in a bunch of lovely flowers, fresh-culled from by-way or forest." The *Herald* mentions outdoor sketching classes, others in object drawing and perspective, and also decorative work on satin, plush, or velvet, resulting in hangings, screens, banners, scarves, and covers. Thornton records the "boast" that students did no copying from reproductions; they worked directly from objects or in life classes. Annual exhibitions by the Society of Fine Arts included oil and watercolor paintings, drawings in charcoal, pen, and pencil, lithographs, photoengravings, and sculpture, and not only resident students were represented, but correspondence pupils as well. By 1907, the *Chautauquan Weekly* could describe the growth and success of courses which included design, drawing and painting, and the history of art, and in craft work cane and rush seating, basketry, leather-tooling, and bookbinding. The *Weekly* described the purpose of the latter offerings as "To place before average men and women a variety of crafts entirely within their ability and requiring no great expense for either material or tuition."

In 1806 a picture gallery opened in Higgins Hall, its collection including oils and watercolors, painting on china, and drawings by "some of the best illustrators in the country," as the *Chautauquan* put it. Time, as Thornton observes, showed that Chautauqua was not destined to become a center of significant collections. But if it was disappointed in this particular ambition, it did attract to its grounds and its region pro-

fessional artists recognized in their time, who found the lake and its surroundings a congenial place of work. Among them was Will Larymore Smedley, whose clergyman father had been a member of the first CLSC class, the "Pioneers." Smedley himself was long a resident of Chautauqua, where he met and married his wife. He was a correspondent of Mark Twain, who admired his work. He began professional activity as an architect, but could not resist the lure of painting. He studied in New York and during summer terms at Chautauqua, and eventually exhibited at a variety of academies and galleries. Among his paintings was one of Halley's Comet on its appearance in 1910. Another professional well known at Chautauqua was Carl J. Nordell. Interviewed in 1940, he said of the neighboring country: "An artist could paint here for 100 years and still have more material than he could use." First known as a portraitist, he later concentrated on landscapes. Examples of his painting are among the collections of the Cleveland Art Museum, the New York Public Library, and the Library of Congress. When the Athenaeum Hotel mounted an exhibition of his work in 1941, the *Daily* reported that his figure painting, *The Listeners,* had been shown at the National Academy Exhibition in New York and reproduced in its catalogue, and another figure painting, *Breakfast Hour,* had won the Annual Oil Exhibition at the Salmagundi Club. Numbers of Chautauquans have an added bond with the Institution through the Nordells they have acquired.

But not only professionals or avowed students of the arts exercise their aesthetic leanings at Chautauqua. People whose principal vocations lie in other areas make use of a summer visit to paint for the love of it. Among them is Dr. Karl Menninger, known throughout the country for his psychiatric work with the young, and known to Chautauquans for a generous number of seasons as an almost annual lecturer on psychology, penology, and their philosophical implications. Dr. Menninger returns not only to speak to the Amphitheatre or the Hall of Philosophy but to enjoy painting sessions with Chautauqua's artist and teacher, Revington Arthur, who since the mid-forties has not only worked with students and clients in painting but has discussed and demonstrated approaches to various problems and styles and has lectured on a wide range of art history. The Menningers, in the best Chautauqua fashion, have been known to paint as a family—husband, wife, and daughter.

In 1953 a Chautauqua Art Association was established; it has continued to be one of the notably active organizations within the Institution. It opened its fourth season with a loan exhibition from the

Albright Art Gallery of Buffalo; in the same year Doris Lee visited Chautauqua to demonstrate her style of painting and to act as a judge in the Bestor Plaza Art Festival. In 1962 the Athenaeum Hotel mounted an exhibition of the work of Madame Shoa Fang Sheng in jewelry employing semiprecious stones and enamel on copper. Madame Sheng had been a protégée of Frank Lloyd Wright, and had been commissioned by the Chinese government to copy the ancient frescoes in the Caves of the Thousand Buddhas at Tua Huang. She not only exhibited her work but took part in art classes for children. In 1972 the *Daily* reported classes in Art for Young People and Art for Teens as active under the tutelage of Diane Funk, a teacher of art and design at the Rocky River High School in Ohio and at the Cleveland Art Institute. The *Daily* called attention to a corner reserved in the Refectory for the display of work by these classes.

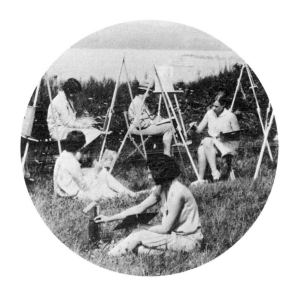

In the fifties, the Art Association described its annual National Jury Show as its "most ambitious undertaking." The fifteenth such show was conducted in 1972, offering thirteen prizes ranging from $500 to $50 for works in oils, polymers, watercolor, casein, pastel, or mixed media. Among the awards listed was one for a traditional oil painting, another for an abstraction in oil, and another designated the People's Favorite, to be given "at the close of the exhibition to the painting receiving the highest number of votes cast by the viewing public." The Association promised every effort to sell paintings, charging a commission of 25 percent. The announced juror both for selection of entries and for decision on awards was Edward B. Henning, Curator of Contemporary Art at the Cleveland Museum. A second annual enterprise of the Association is the Bestor Plaza Art Festival. This is a gala, outdoor, one-day show, held rain or shine, though space is reserved in adjacent buildings in case of downpour. No restrictions are put on entrants. Anyone can show his art or his craft work if he brings his wares to the plaza and removes them within the allotted day. Again sales are expected, this time at a commission of 5 percent.

Chautauqua's relation to the visual and practical arts must be accounted at the least estimate as cordial, varied, and active. Without neglecting appreciation, theory, and history, it has put weight on performance both in its classes and the work of its Association, encouraging a personal and expressive and not merely academic bond with art. Chautauqua has also tried to provide opportunities for performance in the art of writing. One of its ventures in this direction occurred in 1941, when Rebecca Richmond, herself a versifier as well as biographer and author of a pleasant historical account of Chautauqua, was invited by

the Women's Club to form a poetry circle to which members could bring their work for discussion. They met in Alumni Hall over coffee and dessert supplied for a small fee, but they brought their own sandwiches and so became known as the "Sandwich Poets." In 1946 a Writers' Workshop was inaugurated under the direction of John Holmes, widely recognized for his poetry and his teaching at Tufts University. It was described as "a program of lectures, laboratory exercises, and conferences on the forms and techniques of poetry." Next year this enterprise blossomed into a full-scale workshop for writers of both verse and prose. John Holmes was joined on the staff by an array of teachers and visiting lecturers including Margaret Widdemer, novelist, who continued to serve the workshop down into the early sixties; Rollo Walter Brown, widely known lecturer and essayist; Oscar Williams, poet and anthologist; Henry Goddard Leach and William Sloane, writers and editors, the latter at one time Robert Frost's publisher. The Writers' Workshop has continued in the Chautauqua program down through the present. If it can hardly be said to have left a discernible mark on recent or contemporary letters, this is not for want of instructors who might be expected to conduct the delicate task of teaching writers as well as any in the profession. Among poets, the workshop staff through the fifties included, besides John Holmes himself, David Morton, Robert Francis, and Donald Hall. Among writers and teachers of prose, Walter S. Spearman, professor of Journalism at the University of North Carolina, not only took part in the workshop but discussed social problems in the Amphitheater and served for a time as director of the CLSC. After passing in later years through various directorships, the workshop for 1973 came into the experienced hands of John Ciardi, poet, translator of Dante, and for upwards of fifteen years director of the Bread Loaf Writers' Conference of Middlebury College in Vermont.

It might be expected that the dance would not commend itself to the pieties of early Chautauqua but that sooner or later, as the Institution adapted itself to changing times, it would take its place in the program for purposes both of instruction and public exhibition. For a considerable number of years classes in the dance were announced under the heading of Physical Education. Training in national folk dances appeared among the summer school offerings before World War I. In 1926 the school was conducting an hour's instruction daily in classic dances, "modern social dances," and folk dances, and a children's class for ages six to twelve "designed to teach rhythm, grace, self-confidence, and poise." In 1929 the New York University summer session at Chautauqua offered credit courses in Elementary Folk and National Dances,

Elementary Clogging, and Natural and Interpretive Dances. In 1932 a course in Teaching the Activities of Little Children included singing, games, and folk dancing. In 1933, again under the heading of Physical Education, the university offered folk and clog dancing which were to employ "a variety of material for the use of teachers of rhythmical activities . . . vigorous dances of simple rhythms, with a large social content suitable for playgrounds, recreation centers . . . elementary and junior high schools."

Still under the New York University Department of Physical Education, a course in modern dance made its appearance in 1936, to be taught by Charlotte Elton, a Vassar graduate who had studied both with Ruth St. Denis and Ted Shawn and with Martha Graham and Charles Weidman. According to the summer schools bulletin, the course was to present the dance from the standpoint of its use in education and physical education. Miss Elton continued to direct Chautauqua's work in the dance through 1941, and under her married name of Charlotte Elton Cross resumed the position in the latter fifties. In the same year of 1936, a dance recital by visiting performers, Edwin Strawbridge and Lisa Parnova, provided a feature of the season. Strawbridge, it was announced, had given a command performance for the Emperor and Empress of Japan, and Parnova was identified as *première danseuse* of the Cologne Opera. In more recent years, dance recitals by visiting troupes and soloists have increasingly found a place on Chautauqua programs.

When opera became established with the opening of Norton Hall, it created a different kind of need for ballet. In 1948 the Opera Association acquired a ballet mistress in the person of Winona Bimboni, daughter of Alberto Bimboni, then principal conductor of the company. A former soloist with Fokine's Russian Ballet, Miss Bimboni invited experienced candidates to form a ballet corps for productions during the season of *Carmen* and *Faust*. Next year she trained the dancers and provided the choreography for a production of Gluck's *Orpheus and Eurydice* which won a tribute from Chautauqua's exacting music critic, David Holden. Miss Bimboni had high praise for the dancers, who appeared as volunteers from the blue in answer to her call for candidates, and who ranged, she thought, from amateurs of talent to individuals of professional qualifications. Miss Bimboni continued for a number of years to act as dance director at Chautauqua. In 1952, the summer schools, in association with New York University, announced that she would offer private instruction as well as courses in classic ballet and Spanish dancing. The 1955 season expanded the announce-

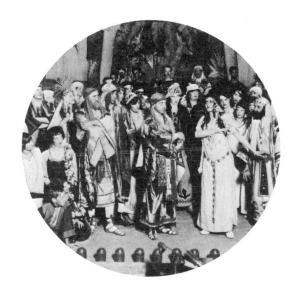

ment to include the technique of castanet playing and heelwork, with routines from various Spanish provinces and gypsy flamenco dancing.

In 1956 Charlotte Elton Cross returned for a four-year stint as dance directress. As a prelude to a lecture, she presented in 1958 a recital by students of the dance classes, and another pre-lecture recital was given by the Green Willow Dancers of Warren County, Pennsylvania, a company ranging from children of ten to teen-agers of fifteen. In the same season the bacchanalian scene in the last act of the Saint-Saëns opera *Samson and Delilah* put heavy demands on the ballet corps of the Opera Association. Soloist for the production was Aubray Lansing, who had studied with Charlotte Cross at the Litchfield School of Dancing in Connecticut and had appeared with Agnes de Mille on TV in the *Omnibus* program. In the following year the *Daily* announced a program designed to satisfy the Chautauqua appetite in lectures, films, and entertainments for the exotic and the ethnic. It was given under the title "A World of Dancing" by Carola Goya and Matteo. Goya, the *Daily* reported, had been a member of the original Jose Greco Ballet in Spain, and was especially known for her work with the castanets as well as for her dancing. She had joined with the American Matteo to build programs representing a variety of nations, Scotland, India, Ceylon, and Italy as well as Spain.

In 1960 Chautauqua acquired a dance director who still remains in service at the present writing. Statia Sublette, born in Schenectady, New York, began studying dance at the age of five, and at ten became a pupil of Sergei Orloff in New York City. She first danced professionally at concerts and summer theater performances in Woodstock, New York. She toured with the Orloff dancers through schools and communities where ballet was unknown. She also trained at international seminars at Copenhagen and Havana, and at the School of American Ballet and Ballet Repertory in New York City. At nineteen, she suffered a knee injury and was told that she would never dance again. After marriage, she gradually worked her way back to dancing despite this ominous prognosis, using light opera, especially Gilbert and Sullivan, as a step toward professional rehabilitation. She took up choreography and began to teach and currently performs and gives instruction in dance schools throughout the country. She has also worked in Tokyo in both traditional and contemporary Japanese dance forms.

Miss Sublette with her staff not only conducts what is now an extensive curriculum in the dance, from classic to jazz, in classes graded from elementary to advanced, but has formed a Chautauqua Dance Company with the object of giving a regular schedule of performances dur-

ing the annual seasons. In 1965 the company announced a matinee at Norton Hall with numbers including *Peter and the Wolf* and the pas de deux from the *Nutcracker Suite* of Tchaikovsky. Other evenings or matinees of ballet have followed, and Miss Sublette has arranged performances illustrating the various levels of instruction in the School of the Dance. In 1962, Miss Sublette danced the role of Eva in the "Uncle Tom's Cabin" episode of the Rodgers and Hammerstein musical, *The King and I*, based on Margaret Landon's *Anna and the King of Siam.* Choreography was provided by Mara, who had advised on Cambodian and Siamese dancing for the original Broadway production, and who took the role of the Royal Dancer in the Chautauqua production. Mara had lived in many parts of the Orient, graduated from the Sorbonne, and become an American citizen. "If I had studied in America," she told the *Daily* interviewer, "I would be a dancer of jazz . . . Oh, yes!" She observed that in America "everything is arranged for the convenience and pleasure of women. I would hate to be a man in this country. I am really spoiled now." She said that she had learned her way of walking in the Philippines. "I carried 40 pounds of live ammunition on my head day after day during those years in the mountains of Cebu where I helped the guerillas. I went barefoot those years and wore a sarong." Her months in a concentration camp she dismissed as too dismal to think about. Next year a production of *The Merry Widow* brought Mara back to dance again, with Naomi Richardson and Tom Adair from the Ballet Russe of Monte Carlo and Joe Carow from the American Ballet Theatre. The entire ensemble, Mara told her interviewer, worked from ten in the morning until six in the afternoon. They had to bandage ankles and toes, but they kept on working. "I never thought they could do so well," said Mara, "in such a short time of rehearsal. Just two weeks . . . !"

In 1970 Susan Hendl and Edward Villella appeared in a dance program. Miss Hendl, daughter of Walter Hendl, then conductor of the Chautauqua Symphony, was a member of the New York City Ballet. The *Daily* recorded that Balanchine had created a dance for her in his recent *Who Cares.* Edward Villella, of the resident company at Lincoln Center in New York, had gained widespread acclaim as a male dancer. According to the *Daily,* he was the only American of whom an encore had been demanded in Russia, where encores are apparently a rarity at best. In 1971 Statia Sublette and the dance company performed a new ballet based on *Hansel and Gretel.* In the following year they presented a first performance of *Forces,* a ballet choreographed by Miss Sublette to the music of Howard Hanson's *Pan and the Priest.* All in all, it can be

said that the dance has developed at Chautauqua in a way similar to the progress of the other arts, and that it has secured its place both in the educational and aesthetic endeavors of the Institution.

During the first Chautauqua years, the theater was an object of clerical denunciation. The views of the Reverend J. M. Buckley on the unseeemly popularity of *Pinafore* have already been cited apropos of opera. The Reverend Theodore Flood, editor of the *Chautauquan,* added his bit in 1880. It could come as no surprise, he wrote, that "in close proximity to every theatre there are saloons and gambling rooms, and rookeries." A rookery, sense 3, is elegantly defined in one edition of Webster's as "A dilapidated building with many rooms and occupants." Yet Thornton records that in the same year M. Lalande, a language instructor, lectured in French on the evolution of the drama from Greece and Rome through the miracle and morality plays to Shakespeare's England and Corneille's France. Biblical episodes and vignettes of Oriental life had been presented as early as the seventies, and during the next decade readings from plays, presented by such elocutionists as Leland Powers, became highly popular. Ben Johnson's masque, *The Sad Shepard,* was performed in 1902, and by 1910 a visiting company was offering plays of Shakespeare. Max Eisenstat, important as a director and manager in the Cleveland Play House and what became its summer extension at Chautauqua, observes that for long the Institution "shared the opinion, then common among many church-going people, that there was something inherently sinful in the production of plays and in the acting profession." Bishop Vincent, although his educational ideas were for his time radically innovative, could not extend his instinct for experiment to the theater, and put it on his "better not" list. George Vincent, his son, "was of another mind," says Eisenstat, "and while he was president of Chautauqua Institution brought Francis Wilson, a famous comedian, to the Amphitheatre to talk about Eugene Field. . . . Wilson returned to direct and act in a pageant." This was in 1910, and the pageant, *A Little Father of the Wilderness,* by Lloyd Osbourne and Oscar Strong, was, according to Thornton, the first modern play produced at Chautauqua. Still speaking of George Vincent's regime, Eisenstat recalls that "Joe Jefferson was enthusiastically received when he spoke from the Amphitheatre platform. A local Dramatic Club enjoyed robust life for several years. The Redpath Players and Jamestown and Erie theatre groups came willingly to the Amphitheatre although a theatre was the last thing that the building was designed for, and lighting, scenery, and dressing rooms were make-shift in the extreme. But the huge audience stayed even when the remoter portions

of it could only half see and half hear." Chautauqua would not have been what it is if lectures had not done their part to encourage changing attitudes toward the theater. In 1908, William Norman Guthrie urged respect for the actor, attendance at plays chosen for their salutary character, hospitality to travelling companies, and insistence on a religious spirit in the drama, which originated, he said, in religious feeling. In 1914 the Chautauqua Players produced *The Passing of the Third Floor Back,* and Percy H. Boynton lectured in support of the Drama League as training audiences in discrimination. By 1924, Barrett H. Clark was commending Eugene O'Neill as "the first American dramatist to have something to say, to know how to say it, and to say it."

Norton Hall, opening in 1929, marked the change from makeshift to a theater with suitable facilities both for the performing company and the audience. At about the time Norton was making its debut in opera, Frederic McConnell, director of the Cleveland Play House, was vacationing at Maple Springs across the lake. Curiosity led him to visit Chautauqua to see what was going on there. He discussed with President Bestor the possibility of introducing the Play House company into the summer programs. The result was an association, officially beginning in 1930, which has continued active ever since, first under the title of the Chautauqua Repertory Theatre, later as the Cleveland Play House Summer Theatre. As a first production, the company presented Wilde's *The Importance of Being Earnest,* and the initial season also included Shaw's *Candida* and O'Neill's *Beyond the Horizon.* Besides its productions, the summer Theater has developed over the years a school of dramatics currently offering courses for high school and for college students, with a provision for two tent productions for each group.

Three college friends, Frederic McConnell, K. Elmo Lowe, and Max Eisenstat, founded the Cleveland Play House and brought it to widespread recognition as a repertory theater. Of the three, the career of Max Eisenstat is especially interesting. Born in Chadrin in the province of Minsk in Russia, Eisenstat was brought with his family to America at the age of two. His father worked in Paterson, New Jersey, as a silk dyer until a strike in 1913 removed the family to Pittsburgh. Eisenstat enrolled in the Carnegie Institute of Technology, where he set out to study engineering but rapidly transferred his allegiance to the drama. At Carnegie Tech he met his associates, McConnell and Lowe, and still as an undergraduate followed them to Cleveland, at first as janitor, later rising to become a stage technician, a director, and a manager. In 1930 he fought his way through the difficulties of obtaining a visa to Russia, finally securing one through the Polish embassy in Berlin, and

for five weeks he saturated himself as fully as he could in Soviet plays and movies. Leaving Russia, he went on to Warsaw, Vienna, Munich, and Paris, and so returned to the Play House.

By its association with Cleveland, Chautauqua acquired ready-made a thoroughly professional company of established repute. Its prestige has suffered nothing at the hands of the *Daily,* which regularly reviews its productions with only minor deviations of enthusiasm. If its repertory has tended to concentrate on plays of current popularity, Broadway or off-Broadway hits, with obedient dips into Shakespeare or standard texts of older or modern tradition, it can only maintain itself by attracting audiences to Norton Hall. Its production of T. S. Eliot's *The Cocktail Party* in 1953 marked an event which the *Daily* discussed at length. In the following year it presented Christopher Frye's *The Lady's Not for Burning.* Perhaps not many seasons have offered as varied and interesting a series of plays as those announced for 1959, including Chekhov's *Uncle Vanya, The Diary of Ann Frank, Macbeth, The Magnificent Yankee,* a dramatization of the life of Justice Holmes, and Sean O'Casey's *Pictures in the Hallway.* In 1971, the repertory included an adaptation of *The Spoon River Anthology* by Edgar Lee Masters, *The Devil's Disciple,* by Shaw, and *The Price,* by Arthur Miller. There are still Chautauquans who are not happy with the linguistic license or subject matter of much modern theater. Some would like more Shakespeare and Sheridan, some no doubt more Brecht or Beckett. Chautauqua can justifiably pride itself on the distinction of the company it has secured for its summer theater. If melodramas and comedies in the prevailing fashions of success make up a good deal of the theatrical fare, the impetus surely comes from the audiences as much as from the company and its managers. Dr. Johnson summed it up some two centuries ago in a couplet of his Prologue for the opening of the Drury Lane Theatre in London:

> The drama's laws, the drama's patrons give,
> For we that live to please must please to live.

In the year that saw the opening of Jordan Hall, Lucien Price, Boston journalist and writer on music, published in the *Yale Review* an essay entitled "Orpheus in Zion." Price had begun spending summers at Chautauqua as a boy of four and stayed long enough to serve a term as a cub reporter for the *Daily.* He found in Matthew Arnold's theme of Hebraism versus Hellenism a way of describing the development of the Institution as he approvingly saw it. "Thus, at the start, Judea was the main tent and Hellas the side show," he wrote. "But as years went on,

Judea became the side show and Hellas the main tent." The verdict would not please all Chautauquans, but if Price could deliver it in 1929, later developments in the arts would give it considerable substantiation. One might even say that the lines of growth Chautauqua has followed were implicit in the ideas that John Heyl Vincent cherished from the beginning, despite his "better not's" and the strait-laced infancy of the Assembly. In his aplomb toward theological controversy, his confidence in the value of all knowledge, his instinct for showmanship, his belief in continued personal growth, the development of Chautauqua was inherent if it was to develop at all. Certainly by now, whatever else they may have done, the arts have deployed themselves in force throughout the main tent of the Institution.

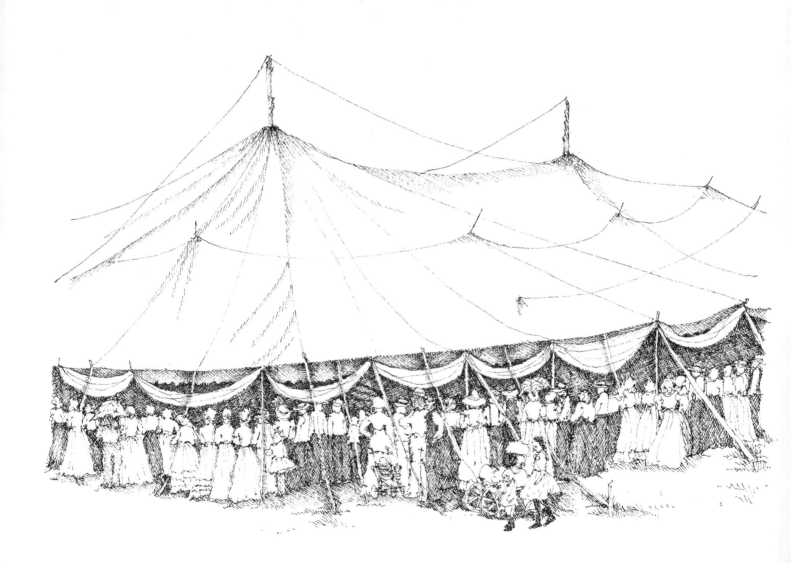

Tents and Tabernacles

The Independent Chautauquas

Chautauqua had no sooner fairly launched itself than it began to receive the flattery of imitation. The Chautauqua movement sprang from a set of impulses for which the time was ripe, and which could not be confined to a single place or institution, but spread over the country, seeping into larger or smaller pockets everywhere. Offspring or stepchildren of the original Assembly took two principal forms, the independent or permanent Chautauquas and the circuit or tent Chautauquas which carried packaged programs to organized chains of towns, first by rail, later increasingly by automobile and truck. Independent Chautauquas were locally instituted by groups of citizens who coveted an assembly for their own communities. They were called permanent because they were annually convoked on the same site and because they were expected to last indefinitely where they were established.

Chautauqua was sometimes honored and sometimes embarrassed by the uses to which its name was put. Many of the independent assemblies faithfully emulated the original and did credit to its example, but the very fact that Chautauqua acquired such prestige made its name vulnerable to profanation. Gay MacLaren, a circuit trouper who wrote an extremely diverting account of her lyceum and Chautauqua adventures in *Morally We Roll Along,* records that in Texas a poultry show called itself a Poultry Chautauqua, and that Warren G. Harding, a popular circuit speaker before he became president, was once sidetracked when, in a hurry to meet a Chautauqua engagement, he was driven, not to the assembly where he was expected, but to a carnival show of a very different character which had helped itself to the elevating title. Harry P. Harrison, one of the principal circuit owners, recalls in his *Culture under Canvas* that a manufacturer of farm machinery used the word Chautauqua for a travelling exhibit of his wares, and that the Ku Klux Klan at one time conducted what it called a "Klantauqua."

Against such free and easy attempts to trade on its renown, the Institution had no practical recourse. It did encourage and help many of the independent assemblies that tried to work in the spirit and design initiated by Vincent and Miller. Without entering into any official or organizational bond, it provided them with leadership and moral or practical support, sharing staff and speakers with them and sending out its own emissaries to help sustain their programs. The opportunity to do so began almost simultaneously with Chautauqua itself. Hugh Orchard, a writer, minister, and circuit platform manager, says in his *Fifty Years of Chautauqua* that independent assemblies began to spread as early as 1876. One of the first was the Bay View Assembly at Petoskey on Lake Michigan. Like the parent Chautauqua, it occupied the grounds of a Methodist camp meeting. In common with many independents, it profited by the presence of a reading circle patterned on the CLSC. John Vincent himself was active in the Lakeside Encampment at Lakeside, Ohio, which began as a Sunday school assembly in 1877, and he served as the first superintendent of the New England Assembly at South Framingham in Massachusetts, where Jesse Hurlbut supervised instruction, as he did also at the Wisconsin State Sunday School Assembly. William F. Sherman, Chautauqua's first music director, had charge of music at the Interstate Sunday School Assembly in Kansas and later at South Framingham. By 1886, when his book *The Chautauqua Movement* appeared, John Vincent could list thirty-eight "Other Chautauquas" from Maine to Southern California and from Oregon to Florida, including one in Cape Colony, Africa. By 1904, according to Rebecca Richmond, 150 independent Chautauquas had come into existence.

"Other Chautauquas" tried to follow parental example by choosing a site in attractive natural surroundings, by a lake or river, or failing these, in a well-shaded park. Again as at the Institution itself, rented tents at first provided a refuge for visiting between sessions or for overnight family occupancy. Old Salem Chautauqua, near Petersburg, Illinois, used grounds along the Sangamon River, grounds that according to Orchard included Lincoln's former home and a Lincoln Memorial. Its tents were so thickly strewn that "the guy ropes actually overlapped." Programs required more substantial buildings; in particular an ample auditorium was essential, sometimes called a tabernacle, sometimes a pavilion, roofed over in one or another style, but commonly open-sided and capable of seating as many as several thousand listeners. Arthur E. Bestor spent summer weeks in his boyhood at the Chautauqua Assembly at Monona Lake in Wisconsin, where again

lodging was for the most part in tents but the assembly had its Normal Hall and its Hall of Philosophy, and enjoyed the guiding hand of Jesse Hurlbut. Independent assemblies, like their prototype, were able to draw speakers and performers from all parts of the country. Some of their "talent" could be local or regional political or professional figures, but often enough they were nationally known spokesmen for one or another cause or subject, who travelled immense distances to reach their Chautauqua audiences. Victoria and Robert Case, in *We Called It Culture,* describe the twelve-day program of the well-established Willamette Valley Chautauqua at Gladstone, Oregon, in 1902, in terms that show how strenuous the effort to approximate the New York model could be. Classes began at eight in the morning, and ranged over parliamentary law, elocution, English and American literature, American history, Sunday school teacher-training, Bible study, choral singing, and photography, with a class in physical culture free for season-ticket holders and another in painting for a special fee. Among speakers were Henry Watterson, editor of the Louisville, Kentucky, *Courier Journal*, Rabbi Stephen Wise on "The Mission of Israel," and the inevitable William Jennings Bryan. These were supported by bands, baseball games, and a cartoonist in the Frank Beard tradition, the whole program crowded into less than a fortnight.

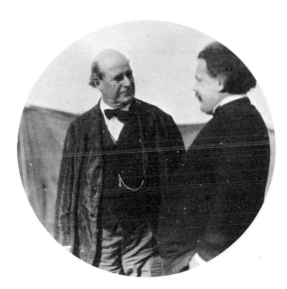

William Jennings Bryan

Only an encyclopedia with an ample corps of contributors could trace in full the local and cultural history embodied in the hundreds of independent Chautauquas dispersed over the country. A small handful must be allowed to stand here for a great many with one or another claim to attention. Chautauqua's links with the South make it appropriate to notice at least one independent in that region. Many Southerners have made the journey to the parent assembly, and John Heyl Vincent, it will be remembered, took pride in his Alabama birth and helped Chautauqua do what it modestly could in the years after the Civil War to mitigate sectional antipathies and further the cause of reconciliation. The Piedmont Chautauqua outside Atlanta, Georgia, not only forms a regional link but gains additional interest from the fact that its moving spirit was Henry Grady, ebullient journalist, promoter, orator, and interpreter of the "New South." Grady as an orator scored both by humor and by a rhetoric that could become perfervid when it touched on the pathetic or the visionary. Some impression of his temperament and of one side of his style as a speaker can be gained from an incident recorded in the *Atlanta Constitution* years after his death by one of his neighbors, a Mrs. Peel. Grady gave her a passage from a draft, just finished, of an address important to his career. He settled her in his

study to read it, and looking in on her later, "he screamed with laughter and cut up like a boy, saying, 'I've got her crying; it's all right'."

Grady used the phrase the "New South" in an editorial in the *Atlanta Herald* during the very year Chautauqua was founded, 1874. For him the concept meant an idealized vision of the potential resources of his region; it meant diversifying crops, promoting manufacture, balancing agricultural and industrial interests; it meant attracting capital; and at a time when the South could still turn an apprehensive ear to "Bloody Shirt" threats from Congress, it meant justice and opportunity for the Negro combined with social separation of the races and political solidarity among whites.

It was in March of 1888 that Grady summoned a group of Atlanta citizens to explain the Chautauqua idea and to discuss the possibility of a local assembly. He had already made himself nationally known as a journalist by his writing and editing for the *Atlanta Constitution*. The Piedmont Exposition had established his talents as a promoter, bringing President Cleveland as its most notable guest and luring people from all over the South by train, wagon, even ox cart, to sleep in their vehicles when no quarters offered or to pay for a barber's chair or a pool table in lieu of a bed. He had established himself as a spokesman for his region by his reply to the toast, "The New South," at the New England Society in New York City, a reply adopted by ambitious young orators throughout the land as a practice vehicle for eloquence.

The Chautauqua sponsors whom Grady enlisted decided on a plan calling for two hundred subscriptions at $100 each. A wealthy businessman was elected president, and Grady vice-president, of the incorporated Piedmont Chautauqua, and the project was under way. The promoters chose as a site the town of Salt Springs, later Lithia Springs, where some of them owned property. It was about twenty miles west of Atlanta, and the distance from the city proved a handicap, but the site offered a spring-fed stream that could be dammed to make an artificial lake and a hotel advertised as "the most sumptuous summer hotel in the south." The spring, according to a 1968 articles by Inez Watson Croft in the *Atlanta Historical Bulletin,* supplied bottled mineral water which was widely shipped throughout the United States, and the hotel enjoyed the patronage of Astors, Whitneys, and Vanderbilts as well as the elite of Atlanta. The new Chautauqua planned two smaller hotels, classroom buildings, a restaurant that would accommodate a thousand diners, and a tabernacle seating seven thousand, and the Georgia Pacific Railroad promised special trains. The additional buildings were all to be finished and the lake scooped out and filled, according to

Grady's buoyant plans, within a month. The frenzied activity that tried to meet this impossible schedule is described in an article by Benjamin W. Griffith in the *Atlanta Constitution Magazine* for January 31, 1971. At least the buildings if not the lake were ready for use some eight days after the formal opening of the Chautauqua.

The Chautauqua was preceded by an introductory barbecue on the Fourth of July. Its President, Marion C. Kiser, who had begun his business life in Salt Springs with little advantage in education or money, was to deliver a speech of welcome. It had been written for him by Grady, but when he rose he could find no copy in his pockets. He surveyed the crowd in front of him, said, "Right down thar is whar I used to hunt foxes," and at a loss for more, asked: "Whar's Grady?" Grady's *Constitution* complimented Kiser next morning on his brevity and good sense. Thus haltingly launched, the barbecue proved a disaster. According to Griffith's article, the "giant feast" provided "50 lambs, 40 pigs, 10 young beeves, 30 kids, 300 chickens, 12 sheep, 300 pounds of butter," and supplementary fluids, condiments, and breadstuffs by the gallon, bushel, or dozen. The unfinished fence around the area allowed some three thousand people to enter without tickets. Griffith quotes the press account of the following morning: "The crowd surrounded the tables for a while in silence, and suddenly with a convulsive gasp threw itself on them, and the barbecue was over. All that remained after that first spasm of activity, was an occasional tomato hurled through the air at some conspicuous hat, or a shoat bone sent like a boomerang around the neighborhood."

The Chautauqua itself considerably redeemed the "fiasco" of the barbecue. Grady sought to recruit as many of his faculty as he could from his admired alma mater, the University of Virginia. For a term of unusual length among the independent Chautauquas, classes were announced in the Bible, English, foreign languages, natural sciences, fine arts, physical education, and "every chair of a first-class university," all for an inclusive fee of $10 or $5 in any one department. Grady perceived, as Miller and Vincent had before him, that the Chautauqua could not make ends meet merely by tuition fees, but must attract substantial crowds for a diversified program. From Washington the Piedmont Chautauqua brought two congressmen, William McKinley, later president, and Roger Q. Mills to present different views on the divisive issue of the tariff. DeWitt Talmage gave his standby lecture on "The Bright Side of Things," and Thomas Nelson Page read his "Unc' Edinburg's Drowndin'." Sermons, chalk talks, "scientific demonstrations," a "Hungarian Orchestra," and assorted bands filled the interstices of

the programs. Four fireworks manufacturers competed for the "Chautauqua championship" and a prize of $1,000 for the best display. Grady himself drew the largest crowd on closing day, August 28, with his speech on "Cranks, Croakers, and Creditors." Cranks initiated the Chautauqua, croakers predicted its failure, creditors brought it successfully through. Grady showed his personal belief in the Chautauqua idea by giving $5,000 to complete the buildings and $2,500 toward a deficit in the salaries of the instructing staff. Grady spoke twice during the next season in 1889, but his short, crowded life came to an end in December of that year after he had made a celebrated appearance in Boston, sick and exhausted, to plead once more for understanding of the South. The Piedmont Chautauqua survived his death by only two years.

Atlanta, as it happens, is the scene of another Chautauqua offshoot of more than common interest. In a description of documentary collections in the Trevor Arnett Library at Atlanta University, the "Chautauqua Circle" is identified as "one of the oldest Negro women's clubs" in the city. It sprang from a proposal by Mrs. James R. Porter in 1913, and is still active as this page is written. Mrs. Porter, by her own account, became acquainted with the CLSC program through an older friend who had received her diploma at Chautauqua as a member of one of the regular graduating classes. Mrs. Porter undertook the CLSC course herself, and persisted for three years until her books were destroyed by fire. Disappointed in her own hope to graduate, "to pass through the Gate," as she puts it, "while those who had finished in other years tossed roses at our line," she initiated instead the Chautauqua Circle in Atlanta as a study club for discussion of reports by members on a span of issues from politics to religion to Negro problems to the special concerns of women. Apparently the club considered and rejected affiliation with the CLSC, since a proposal to make the *Chautauquan* a formal basis of study was discussed and at least for the time being dismissed. The Atlanta circle stands as one more case in which the educational beliefs of John Vincent fell on productive independent ground and took enduring root.

Even a glance at the independent Chautauquas would be incomplete without an example or two from the central states. In the course of lecturing in Kansas, John Vincent met a Presbyterian minister, Duncan C. Milner, a Civil War veteran who had survived a wound considered fatal and had been told by Horace Greeley in person, at a temperance meeting, to "go west." Vincent suggested to him that a Chautauqua should be launched in Kansas, and Milner helped form an organization

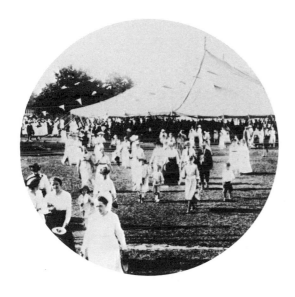

to undertake the project. After three seasons at Bismarck Grove, outside Lawrence, where attendance proved somewhat disappointing, and a single season in Topeka, where Vincent himself was later stationed when he became bishop, Milner in 1883 took the assembly to Forest Park on the Marais des Cygnes River at Ottawa. Occupying a grove above a dam, the park could be reached by trains from all directions or by a steamboat invitingly called the "Gertie." Here the Assembly conducted sessions of two weeks, making use of instructors and other emissaries from Chautauqua itself and charging for its season tickets from seventy-five cents in 1883 to a dollar and a half in 1911. Its tabernacle may have seated as many as five thousand, and it listened to a roster of familiar and less familiar Chautauqua speakers. It heard Rutherford Hayes after his presidency and William McKinley before his. It heard Senator Robert LaFollette, Booker T. Washington, the omnipresent William Jennings Bryan and his later antagonist at the Scopes trial, Clarence Darrow. It welcomed such campaigners for women as Carrie Chapman Catt, Susan B. Anthony, and Anna Howard Shaw, and responded to the preachers of established fame, DeWitt Talmage, Frank W. Gunsaulus, and the reformed alcoholic evangelist, Sam Jones. Discussions provoked by the assembly in a summer fortnight, at Ottawa as elsewhere, often continued throughout the year, reechoed by local newspapers and further agitated in local pulpits. The Ottawa Chautauqua Assembly carried on its programs down to the verge of the First World War and was taken as a model for other independents in the region. A flood in 1915 forced the cancellation of its last scheduled season.

Another Kansas town, Winfield, distinguished itself by going through all the representative phases of the Chautauqua movement, establishing first an independent assembly, then with its decline importing packaged circuit programs, and finally attempting "local talent" Chautauquas as a last effort to maintain a fading tradition. Winfield was natural assembly soil. With a population of some seven thousand in the years before World War I, it could boast of both a Lutheran and a Methodist college, a music college, and several CLSC groups, which were commonly important incentives and cooperating arms in the establishment of independents. Winfield took strong pride in its public school system. Earl J. Johnson, retired editor and vice-president of United Press International, writes the author that when he was growing up in Winfield "education was the town's chief industry. Let a youngster earn a fortune drilling for oil—he was nobody. Let him get a professorship at Rensselaer or a job in a symphony orchestra and he was looked up to."

At a time when a commission from the governor of the state was visiting Winfield and awarding it a citation and a cash prize for its educational system, members of the school board paid almost the amount of the prize to keep "a rowdy street carnival," as Johnson puts it, out of town until the commission had left. The town also rejected an oil refinery, disapproving of the kind of population it would bring in.

A series of feature articles by Roland M. Mueller in the *Winfield Daily Courier* traces the history of the Winfield Chautauqua Assembly. The board of directors met in 1886 to plan the first session for the following year. They fixed on Island Park as a site and began constructing the necessary buildings. Winfield's original tabernacle seated upwards of two thousand people and was subsequently enlarged to accommodate another thousand. Later a dining hall, WCTU house, gymnasium, women's building, band shell, and Hall of Philosophy took shape, the last the final surviving structure, torn down as late as 1967. Winfield programs followed the established range and pattern, offering classes in the Bible, Sunday school teaching methods, travel, literature, language study in Hebrew, Greek, and German, and instruction in voice, choir, and harmony. Tabernacle topics dealt with social issues from temperance to women's suffrage, labor problems, juvenile delinquency, socialism, war and peace. Along with other Chautauquas, Winfield heard political figures such as La Follette, Speaker Champ Clark of the House of Representatives, and his predecessor, "Uncle Joe" Cannon. Earl Johnson recalls that when Cannon spoke, "the soft drink stand in the park whipped up a claret-colored drink called Cannonade." The lads behind the counter encouraged a rumor that it was spiked with real claret, with the result that they "sold ten gallons of the stuff on a hot Sunday afternoon at 5¢ per glass." Kansas was dry, and all branches of Chautauqua were hospitable to the WCTU, but this was not the only time when private inclination and public principle failed to coincide.

Winfield, like other Chautauquas, paid attention to the children who made up an important share of its population. It organized boys' and girls' clubs, formed groups to listen to storytellers, provided sessions, according to Earl Johnson, in "color-crayon drawing, clay modeling, dancing games and singing," and encouraged sports. Roland Mueller records that the boys' club in 1902 was under the charge of James Naismith. Naismith was an orphan who had worked in Canadian lumber camps, where he responded to the uninhibited language he heard around him by deciding to enter the ministry. Gifted at sports, he eventually turned to working with the young, studied at the YMCA Training

School at Springfield, Massachusetts, and went on to take a medical degree in Colorado. Given an assignment by a Springfield instructor to devise a game that would fill in the winter months between football and the revival of baseball and lacrosse in the spring, he singlehandedly invented basketball, the only major world sport designed from scratch by an individual. He provided the scoring essentials by tying peach baskets at either end of the track ten feet above the gym floor.

According to local press reports, Winfield could attract seven to ten thousand people to its grounds on a given day, especially when some crowd-gatherer such as Bryan appeared. For the ten days of the assembly, the season ticket charge was commonly $2, or, allowing some ten events to a day, two cents for each attraction. On this modest scale the Winfield Chautauqua maintained its vigor for almost thirty years, but about 1915 it began to meet with declining support, traceable particularly to the competition of circuit Chautauquas which had sprung up in the region. It held its last session as an independent assembly on the standard model in 1917. For the next five years, Winfield imported "canned" Chautauquas, first from the Redpath-Horner circuit with headquarters in Chicago, finally from the Cadmean circuit centralized in Topeka and operated by J. Benjamin Franklin, who bought out most of the surviving bureaus when the circuits declined in the late twenties, and became the last of the principal managers. Many in the Winfield region who had faithfully supported their independent assembly would have nothing to do with the circuit programs and refused to accept them as constituting a true Chautauqua.

But before coming to the story of the circuits, this record must dip into one more independent Kansas assembly. An undated pamphlet, kindly lent to the author by Roland M. Mueller, tells, to reproduce its title, *The Story of / LINCOLN PARK / Cawker City, Kansas / and / THE MARVELOUS CHAUTAUQUAS / HELD THERE AT / THE TURN OF THE CENTURY*. The pamphlet invokes the authority of a large number of reports gathered from local newspapers, "compiled and arranged by Tula Draher Emigh," and presented, the reader is assured, "in almost all instances" in "the exact style and language as was used in that time." The compiler goes on to say that "There may be what seems to you to be errors, but we are none of us infallible and they were human too."

Lincoln Park Chautauqua was chartered in 1897 by the Beloit District Campmeeting Association and persisted in its original form through 1912, when it found itself in debt, and, as the original New York Assembly was to do in 1933, passed into receivership. It aroused

strong local pride, and its programs were comparable to many of the superior independent assemblies that emulated the parent institution. In 1907 Bishop Vincent himself conferred the diplomas on its graduating CLSC class. Not the least interesting aspect of the Lincoln Park story is the endearing quality of the prose in which it is presented. If the writing allows spontaneity to triumph over grammar, the result is to give a sense of immediacy and genuineness to the account, which adds up to an almost blow-by-blow record of the assembly from its inception to its death.

In establishing itself at Lincoln Park as a site, the Chautauqua bought from William Belk thirty acres of land at $100 an acre. The pamphlet reports what seems to have been his chief point of reluctance in parting with his acres:

> Mr. Belk said that the saddest thought in selling his grounds was that if at any time in the future it should become prostituted to the uses of a beer garden or something similar.

A few columns later the pamphlet comments:

> In the transaction, last week, of the Lincoln Park Association's purchase of the 30 acre tract from William Belk homestead for $100.00 per acre, recalls that 100 years ago this same land was part of the Louisiana Purchase that Napoleon sold to President Monroe for 2 cents per acre, at that ratio what will it be in another hundred years.

If the Louisiana Purchase occurred under the Presidency of Jefferson, not Monroe, the slip is a minor flaw in a nugget of historical memory and calculation.

The importance of a suitable site, and the rural drawing power of a well-established Chautauqua, appear in another entry:

> Thomas A. McNeal, editor of the Mail and Breeze, who spoke last week at Lincoln Park, gives a lengthy account in his paper of his trip and visit to the Park, from which we quote in part: "We supposed we knew Kansas pretty well, but there are a large number of places that nature has fixed up in a manner calculated to please the eye, that we have missed. For example we had no idea until last week that out in Mitchell County, which is supposed to be in the treeless short grass region, there is one of the handsomest Oak Groves in the United States. We could not understand until we went there, why a Chautauqua had ever been organized at Cawker City. . . . That Oak Grove . . . has made it possible to keep a Chautauqua Assembly and make it a financial

success at a point 125 miles from any city of considerable size, with only a village of less than 1000 inhabitants to back it up. Already locations have been selected for not less than 100 cottages and tents, locations that will be permanent."

Still another entry pays concise tribute to the disruption that an act of nature could inflict. During the session of 1905, various speakers appeared on Grand Army Day, and the reporter of the occasion laments, in parentheses:

(We are sorry, that we are unable to give the remarks of Past Commander A. W. Smith, also those of Past National Secretary, Mrs. Sue Wrench, but they are gone with the pages of lost history, being scattered with clothing, when the Record tent blew over).

"Different Views" occasioned this paragraph:

A Cawker City woman wouldn't go to hear Booker T. Washington lecture because she didn't want to "endorse the equality of the white and colored races." What makes us feel bad is because we are not as smart and eloquent as Booker. The President of the United States does not hesitate to associate with and entertain so principled a man as Booker T. Washington, even if his skin is dark.

Hopeful entrepreneurs were not lacking who missed the point of an assembly altogether:

Some folks have a queer idea of a Chautauqua, applications for permission to run bowling alleys, wild west shows, prize wheels, merry-go-rounds and fortune telling "parlors" have been made to the management.

Elsewhere the allowed concessions and their proprietors for the season of 1907 are listed:

Welch of Glen Elder will have Hires Root Beer; Mr. Schafer the Popcorn privilege; a Glasco man the Candy Floss Machine, and Candy Charlie will again have the Taffy Stand.

As much as John Vincent's own Chautauqua, Lincoln Park was conscious of the need for effective publicity. In 1909 it boasted:

Nothing that has ever been done to advertise a Chautauqua is superior to the methods used by Lincoln Park Chautauqua this year. Thirty-eight newspapers, the railroad company and several auto excursions have made everyone in northern Kansas hear of this assembly.

Such automotive excursions were celebrated at length by the *Cawker City Ledger*:

> In conclusion we wish to say this was one of the most unique things ever done in Kansas; never before has a party of 40 or 50 people in 7 to 10 automobiles, made a trip of this kind. . . . We do want to call attention to the fact, that on all first day runs and most of the second day, the pilot car, which is the most trying position, was driven by Miss Mae Hudkins, the young lady's skill as a driver entitles her to a place among the best.
>
> All the cars were furnished free of charge, and not an accident occurred, no tires were punctured, no machinery was broken and no engine balked.

In 1911, the Lincoln Park Assembly suffered a severe flood. It managed to conduct its program as planned except for a single evening, but "Small Chautauquas at near by towns spread the report that Lincoln Park Chautauqua Program had been called off." These, it seems, must have been circuit Chautauquas, and Lincoln Park had already complained of their competition. After it passed into receivership in 1913, Lincoln Park underwent one unusual attempt at revival. Its lands were bought by a Chautauqua-minded benefactor and given to an association drawn from the Kansas Women's Temperance Union and Protestant churches in surrounding counties. This association conducted a final Chautauqua in 1914, but gave up in the following year. The pamphlet, *The Story of Lincoln Park,* ends by quoting from the *Emporia Gazette,* as though it were an epitaph, what seems to be really a seasonal elegy on the close of any Chautauqua session. The lines are by Walt Mason, once nationally known writer of newspaper jingles arranged as prose, and they conclude:

> there are strings of mouldy language hanging on each limb and vine, let us take them home and put them down for winter in the brine. For the Feast of Reason's ended, we have heard the closing chimes, and the man who sold the tickets is now counting up the dimes.

Walt Mason was not the only versifier for whom a Chautauqua assembly provided an occasion for his talent. Chautauqua itself and its independent sisters found something like a bard in a well-travelled celebrant with the formidable doubly-Scotch-heroic name of Wallace Bruce. His *Old Homestead Poems,* published by Harper and Brothers in 1888 and lent to the writer by Robert Woodside, organist and administrator at Chautauqua Institution, contains a lyric called "Our

Nation Forever," which according to Bruce's note was "sung by six thousand voices at the close of a Union Concert of Northern and Southern Songs in the Chautauqua Amphitheatre, 1883." He made the rounds of many of the independents, recording that his "Ad Astra Per Aspera" was "Read July 4, 1884, at Ottawa Kansas before the Chautauqua Assembly on the banks of the Marais des Cygnes." One stanza reads:

> What does it mean—this tinted grove,
> These camps that slope unto the stream?
> Arcadian bliss where lovers rove,
> And quiet haunts where scholars dream?
> Where music lives forevermore,
> And joyous song and sweet refrain?
> It means Chautauqua to the core—
> A partnership of soul and brain.

Another piece of his occasional verse is addressed "To J. H. Warren, Superintendent of Monteagle Assembly, Monteagle, Tenn." and evokes the names or place names of a roster of independents he visited:

> And now with news from Lakeside fair,
> From bright Waseca's bracing air,
> From Island Park, sweet nestled there
> In hoosier State,
> From Kansas fields, beyond compare,
> With promise great;
>
> From Lake de Funiak's land of pine,
> From sweet Montana's crystal shrine,—
> All tendrils of Chautauqua's vine,
> And loving feast,
> I come, Monteagle dear, to thine,
> Last, but not least:
>
> To rich dessert in camp and hall,
> The closing banquet of them all,
> Before the Autumn curtains fall
> On Summer's life.

The next turn of the Chautauqua cycle brought the phenomenal rise of the circuits in the early nineteen hundreds. Although in general the independent assemblies were swept under in the circuit competition, some managed to survive until the circuits themselves had run their course. A handful have continued active even into the nineteen seventies. On July 4, 1972, the *Chautauquan Daily* paid tribute to an assembly

which was conducting its seventy-fifth annual session at Chautauqua Park outside the city of Boulder, Colorado. This assembly sprang from a search by the Texas School Teachers' Association for a site where its members could enjoy a summer retreat. It derived support from the Texas-Colorado Chautauqua Association, incorporated in Austin, Texas. Monteagle Assembly in Tennessee was still active in 1972, and in the same year the Mountain Park Chautauqua at Remington, Indiana, received recognition from the *Daily* for its seventy-seventh season. A year earlier, Remington had heard reports from Chautauquas at still other points, one at Ocean Grove, Maine, another, among the oldest of all, at Lakeside, Ohio. At other Chautauqua sites in widely dispersed parts of the country programs had receded into the past, but remaining parks and especially auditoriums were arousing historical concern. To take only two examples, a movement was under way to restore the Chautauqua Pavilion in Red Oak, Iowa, already included in the National Register of Historic Places, and the unusual auditorium at Lake de Funiak in Florida, mentioned in Bruce's verse, was similarly registered, while local efforts were trying to preserve it and adapt it to new community use. The triumph of the circuits over the independents was overwhelming but not total.

The Circuits

Truly innovative as Chautauqua was in its educational programs and methods, it did not altogether lack forerunners. One of the most important was the lyceum movement as it was conceived and promoted by Josiah Holbrook in the decades before the Civil War. Born in Derby, Connecticut, Holbrook graduated from Yale in 1810. His intellectual curiosity was evidently not exhausted by his degree, for he used to ride back to New Haven to listen to the scientific lectures of Professor Benjamin Silliman. Silliman himself was a considerable pioneer in extending educational opportunities to adults outside university halls. Down to his eightieth year he carried his explanations and illustrations of chemistry, mineralogy, and geology to general audiences, first within reach of New Haven, and eventually as far south as Mobile and New Orleans and as far west as Pittsburgh and St. Louis. Following his example, Holbrook in turn became an itinerant lecturer on scientific and technical topics. But Holbrook had ideas that went beyond lecturing and demonstrating.

The aspiring title "Lyceum," from the grove near the temple of Apollo Lycius where Aristotle taught young Athenians, was already in use for various societies for self-improvement and literary or scientific

study. It attached itself naturally to the local study groups which Holbrook began to organize. Holbrook, like John Vincent, believed that education was for all, old and young, male and female, that it should not stop with elementary schooling, and that it could be carried on by any who would undertake it, especially in the helpful fellowship of a group with a common purpose. An important goal he set for his lyceums was the improvement of the public schools, and a part of his motivation was moral. He believed that mental occupation would help keep the young from common temptations, notably alcohol.

A lyceum, in Holbrook's scheme, could be formed by any voluntary group in a village, town, or city. It was expected to meet weekly or at stated intervals. A "cabinet" was recommended for books, minerals, plants, or scientific apparatus. In their original form, the lyceums depended on their own members for lectures, discussions, or demonstrations. They met at any place of convenience, in private houses, churches, or schools. The lyceums did not grant diplomas, enjoyed no Recognition Day, erected no Golden Gate, and did not organize a book-club distribution of prescribed readings, though Holbrook dreamed of a plan to provide "numerous cheap and practical tracts" which would be circulated to "branch lyceums, schools, academies, taverns, steamboats and private families," producing a "universal diffusion of knowledge." But even without Chautauqua ceremonials, the lyceums provide an obvious precedent for the CLSC, and they appealed to the same craving for self-improvement. Their propagation was similarly rapid.

Holbrook initiated "Millbury Branch, Number I, of the American Lyceum" in Massachusetts in 1826. By 1840 Horace Mann reported that in the previous year Massachusetts alone supported 137 lyceums with an average attendance of over thirty-two thousand. Lyceums proliferated especially in New England, but by 1839 some four to five thousand had spread through the West to Detroit and through the South to Florida. Holbrook's grandiose plans included county conventions of delegates from towns and villages, and on top of these state conventions, and again above the state level a National American Lyceum. National organization was discussed at a meeting presided over by Daniel Webster in Boston in 1828, and launched three years later at a gathering in New York City attended by one thousand town delegates. The National Lyceum, according to John Noffsinger's study, "was one of the most powerful agents of propaganda for the establishment of public schools everywhere," and partly led to the formation of the State Board of Education in Massachusetts with Horace Mann as superintendent. The National Lyceum convened for the last time in

Philadelphia in 1839, but town lyceums continued active, especially in New England. Entire families, including older children, listened to lyceum lectures or debates. "In these meeting places of the democracy," writes Noffsinger, "were formed opinions on education, the tariff, the national bank, the annexation of territory," and especially on the overriding topic of slavery.

But Holbrook's "home-talent" lyceums were no more immune to change than other social institutions. Home talent ceased to be enough. Visiting speakers were increasingly in demand, and required fees. Remuneration could begin on the scale Emerson is supposed to have accepted, five dollars and oats for his horse, but they could hardly continue at such a level. With increasing fees, lecturing as a profession sprang up, and brought to widely dispersed audiences not only Emerson himself, but such other notables as James Russell Lowell, Edward Everett Hale, Oliver Wendell Holmes, Horace Greeley, and Wendell Phillips. During the Civil War, the lyceum movement virtually disappeared. After the war, the name was revived by talent bureaus that perceived a business opportunity in the appetite for lectures, but what the name stood for had been totally transformed and no longer bore any resemblance to the lyceums of Josiah Holbrook.

It was James Redpath who organized the most famous of the professional lecture bureaus and in so doing laid the foundation for the development of the circuit Chautauquas. Born in Scotland, Redpath was brought by his family to this country about 1850, worked in a printing shop in Kalamazoo, Michigan, and went to Detroit where his newspaper writing attracted the notice of Horace Greeley, who gave him a job on the *New York Tribune*. All his life a man of causes, Redpath reported on "Bleeding Kansas" when that territory was the arena of conflict between proslavery and antislavery settlers and guerillas in the years before the Civil War. Redpath visited John Brown and his sons in camp and became a ardent abolitionist. After the war he was made superintendent of education in Charleston, South Carolina, and founded a colored orphan asylum. He was an author of books as well as a newspaper writer.

Settled in Boston, Redpath went to a lecture by Charles Dickens in Tremont Temple in 1868. It was apparently this occasion and what he learned of the exasperations and difficulties Dickens experienced on his American tours that led Redpath to think of establishing a clearinghouse to smooth the travels of distinguished speakers, foreign and native, and to relieve them of the burden of personally negotiating dates, fees, train schedules, and dealings with local committees. His Boston

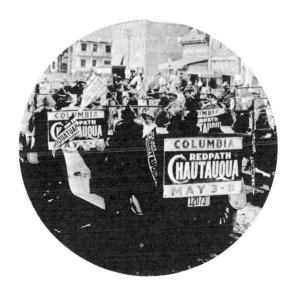

Lyceum Bureau, later known by his own name as the Redpath Bureau, became a prompt success. To the dignitaries, both men and women, who were already established lyceum figures, he added humorists such as Mark Twain, Artemus Ward, and Josh Billings, and as time went on enlarged the lyceum repertoire to include musical ensembles and the whole span of performers of all sorts that became characteristic of both the lyceum programs and the circuit Chautauquas. The lyceums made up a winter system of lectures and entertainment; the Chautauquas were a summer extension of the system. Lyceums were respected fare in towns and cities; the Chautauquas flourished largely in smaller centers and rural areas. City newspapers commonly looked down on the circuits, yet the programs of the two were similar in composition, and often the same "talent" who appeared on the circuits in summer displayed themselves on lyceum platforms in the winter. Chautauqua Institution itself, for all its dignity, was not above contracting for bureau talent. It is amusing to discover, in the Chautauqua files, a letter from no less a personage than George Vincent, in his younger years, dickering with the Redpath Bureau for a "Ladies' Quartette."

Before the final successful organization of the circuit Chautauquas, much inefficiency persisted in routing performers by rail from one engagement to another. "Talent" commonly had to zigzag and backtrack, often enormous distances, from date to date. Gay MacLaren records the ordeals of such errantry in *Morally We Roll Along*. Gay's mother was a CLSC member in South Dakota, and Gay caught the Chautauqua infection early at a local assembly. When the family moved to Minneapolis, she enrolled at the Manning College of Music, Oratory, and Dramatic Art. Forbidden to enter dancing classes or take parts in plays, she stole visits to stage performances and began to mimic all the roles herself, eventually becoming a play reader before plays as such became accepted fare. Her first contact with the Redpath Bureau, she recalls, included "two dates in South Dakota, three in Nebraska, four in Ohio, one in Massachusetts, three in Illinois, one in Texas, one in Florida, and so on. Instead of listing the four dates in Ohio consecutively, the schedule called for me to enter and leave the state four different times. Instead of booking the one Colorado date after the Nebraska town, the schedule listed it at the end of the season. . . . I had to jump clear from Kentucky to fill it." When she once protested to a manager of dirt, sleeplessness, exhaustion, and hunger, he invoked the standard Chautauqua moral sentiment in reply, telling her to think of the good she was doing.

Bureau managers, according to Hugh Orchard, made several at-

tempts to persuade independent Chautauquas to cooperate for efficiency, but found them stubborn. They wanted their own dates, which often overlapped with other assemblies, and they objected to packaged programs, which deprived them of any choice of talent. It was Keith Vawter, a partner in the Redpath Bureau with his headquarters in Chicago, who eventually designed the plan that made circuit Chautauquas a success. In 1904 he organized a nine-day program and tried to sell it at reduced rates to local independents. Their resistance made this first venture a financial failure, and Vawter saw that he must either give up or venture on a business of his own without regard to the independents. In 1907 he took the field again, this time successfully, though it was not until 1910 that he fully established the plan that led to the spectacular growth of the circuits.

Vawter's plan was marked by two chief features, one the contract, the other "tight booking." The notable characteristic of the contract was the guarantee. In each community that accepted a circuit Chautauqua, a committee was formed which undertook to raise an agreed fund by the sale of season tickets. Each member of the committee was personally and legally liable for the amount of the guarantee. This provision, which later became a bone of contention, at first induced a high degree of community cooperation. The clergyman, the schoolmaster, the banker, the doctor, the Democrat, the Republican, the Baptist, the Methodist, had powerful reasons to see that the contracted sum was made up. Community pride in many forms came to the support of the Chautauqua. Local press and pulpit supplemented the efficient advertising sent out by the bureaus. According to Charles F. Horner, one of the chief circuit owners, people would turn out to cut weeds, mow grass, decorate windows, and paint buildings to make the town look spruce. Stores closed. Local hosts gave lodging to members of the troupe. Women trimmed tents with flowers, furnished rugs or lamps for the platforms, and farmers left gifts of watermelons.

The guarantee provision of the contract was universal. Other features varied from circuit to circuit. Sometimes profits from the sale of single tickets went entirely to the bureau; sometimes they were divided between bureau and local committee. The committee provided a site and undertook to supply it with such indispensable commodities as water and ice. It furnished lumber for the stage and for bench seats with backs, and a piano "tuned to international pitch." The bureau shipped in its big brown tent, with sides that could be rolled up, allowing the voice of a Bryan to be heard by listeners far beyond the canvas walls. The bureau provided tent-crew, program, and talent.

"Tight booking," as Vawter worked it out, meant booking towns in reasonably compact strings at feasible distances. But it also involved an elaborate logistical scheme for moving baggage and personnel to the points where they were expected. Programs were commonly scheduled for five, six, or seven days, though longer and shorter terms are on record. "Talent" was divided into teams according to the day on which each team was to perform. Thus first-day talent appeared only on the first day of the Chautauqua, and so on with second-day, third-day, and fourth- or fifth-day performers. This restrictive arrangement, according to Horner, had one definite advantage. It enabled the manager planning the program to "build to climax." The repertoire of many performers was limited, and if they had been forced to appear several times at any one Chautauqua, the whole program would have sunk progressively. But distribution of talent by days meant that tents had to be ready and waiting at each successive town of the circuit. Thus a five-day circuit required six tents, and usually an extra tent was provided against emergencies. First day talent opened the Chautauqua in the first contracted town, then went on to open the program at the next town, where tent two had to be prepared to accommodate them. Not till the five days of the term had been completed at town one could the first tent be released for service farther on, and by then first-day talent, after performances in five towns, would be ready to begin the sixth town, where tent six would be set up to receive them. At this point the first tent would be leapfrogged ahead of all the others and raised in town seven to keep the cycle going. Such tight-booking by consecutive days raised the problem of the Sabbath. Managers at first tried to omit Sundays from their schedules, or to adapt programs to make them acceptable to Sabbatarian scruples. But particularly when seven-day circuits became established, it was impossible to provide special Sunday performances and at the same time to preserve the division of talent by days. Victoria and Robert Case, in *We Called it Culture,* think that the travelling tent Chautauquas had their part in undermining the rigid standards of rural Sabbath observance. By the time the circuits approached their peak, audiences were accepting the packaged programs on Sundays as on weekdays—plays, operas, and the rest of the varied fare thrown in.

Circuits developed their hierarchy of personnel with its appropriate nomenclature. At the top of the pyramid was the bureau manager and owner. His booking agent would arrive in a town, scout for one or more prominent citizens, and persuade them to form a committee and sign a contract. An advance man would appear to check on the sale of season tickets and the prospects of the guarantee. A platform manager

would take over the immediate running of the program and try before it came to an end, often by high-pressure, last-minute salesmanship, to book a renewal for the following season. A crew, generally consisting of college students glad of an adventurous summer job, would supervise the raising of the tent, generally with local help, and would try to protect it against intrusion or outbursts of weather. Crews also served as ticket-takers, with abundant opportunities for peculation. Fully accurate auditing would have been impossible, says Horner, and his policy as a manager consisted in complete trust. He records receiving some fifty letters from crew members containing confessions of lining their pockets or restitution of proceeds.

A very important figure, often called the Junior Girl, was the young woman who organized the activities of children. Part of her function was to prevent disruption. Small boys in front rows could be formidable sources of disturbance, and in any case the managers wanted to reserve seats near the platform for the aged and the deaf. But the Junior Girl did much more than merely keep young fry from making trouble. She told stories to groups, often coached her charges to produce a last-day pageant on a theme of patriotism or health or local government, to the admiration of their parents, and she preached the need for playgrounds and improved local resources, with the result, according to Horner, that parks and fields for sports sprang up along the circuits. The Cases point out that the bureaus gave women new opportunities, not only as Junior Girls but also as talent and sometimes in executive positions, with pay equal to their male counterparts.

After 1910, when Keith Vawter had established their plan of operation, the circuits proliferated with a rapidity recalling the spread of Holbrook's lyceums and the CLSC, and with vastly more sweeping statistical results. A number of manager-owners, by a division of the Redpath Bureau into branches, organized independent circuits, sharing experiences and generally respecting each other's territories. It was not long before enterprising owners had divided practically all North America into districts covered by their programs. New England and the Eastern seaboard, the mid-continent, the South and Southwest, the Pacific Coast, and rural Canada were all penetrated by the brown tents. Besides Vawter, Harrison, and Horner, principal managers included Paul Pearson, a member of the faculty of Swarthmore College and father of the journalist Drew Pearson, who was known for trying to sustain the educational content of his Swarthmore Circuit when the tents were becoming more and more places of entertainment, and J. Benjamin Franklin—"Ben Franklin"—who kept his respected Cadmean

Circuit going until the whole movement collapsed. One manager, J. R. Ellison, not content with his bailiwick of the Pacific Coast, dreamed of a worldwide brotherhood of Chautauqua culture. He actually exported a program to Australia for one season that turned out, according to the Cases, to be comically disastrous, and met with mixed success for two seasons in New Zealand. His vision of gathering South Africa and India into the fold lapsed after these ventures.

Estimates of total circuit patronage are enough to invite the incredulity of a later generation. Glenn Frank, himself a lecturer and later a university president, wrote in the *Century Magazine* in 1919 that one out of every eleven persons in the country, man, woman, or child, attended a lyceum or Chautauqua program every year. Bruce Bliven in the *New Republic* in 1924, at about the peak of the circuit movement, reported that "last year more than 10,000,000 people bought in excess of 35,000,000 tickets to individual Chautauqua performances," and a like number attended similar lyceum programs in the winter. Charles F. Horner, manager and also biographer of James Redpath and founder of the Horner Institute of Fine Arts in Kansas City, supervised a report of 1921 for a bureau of statistical research of the International Lyceum and Chautauqua Association. "So far as I know," Horner wrote in *Strike the Tents* in 1954, "that report contains the only definite and accurate information concerning the numerical scope of the movement." His summary, as of 1921, is that nearly one hundred circuits were reaching 9,597 communities in the United States and Canada, and that some 40,000,000 people bought single or season-ticket admissions. Forty million is a considerable number, yet if over nine thousand communities were being served, an average attendance of four thousand and more would almost make up the total. Any choice among estimates is enough to suggest the statistical hold of the circuits on the country.

Gaining impetus in the years before World War I, the circuits rode the tide of patriotism that the war itself set in motion, when audiences would respond night after night to "Keep the Home Fires Burning." In turn, the circuits did their bit for the war effort. "President Wilson," writes Horner, "appreciated the wide and direct channels for information which the platform commanded, and he declared that the Lyceum and Chautauqua were an integral part of the National Defense." He goes on to say that "a great tide of information and exhortation was carried to the ears of millions. So far as I know, none of it cost the Government a penny." Horner was thinking of "four-minute men," Red Cross speakers, and other direct agents of the national cause. Chautauqua circuits paid their own talent with their own funds, and consistently

Harry "Gatling Gun" Fogleman

resisted efforts by business or other interests to subsidize speakers for their private ends. The war enabled the circuits to tap new sources of talent, correspondents, nurses, and such figures as Ian Hay (Major John Beith), author of *The First Hundred Thousand,* and Arthur Guy Empey, whose *Over the Top* made him an eagerly desired presence on countless platforms. Naturally, restraint was not always characteristic of war speakers. Frank Luther Mott records in his *Time Enough* that in 1917 a quartet of disabled Canadian veterans interspersed "Tipperary" and "The Long, Long Trail" with Hun atrocity stories that grew more and more lurid until Mott, as platform manager, complained to his bureau and the quartet toned down its presentation.

Weathering the war and the adjustment to peace, the circuits carried on into the twenties and the presidencies of Harding and Coolidge. They offered a mixed bag to their hordes of patrons. "A Chautauqua programme," writes Gay MacLaren, "was made up of about two-thirds music and dramatics and one-third lectures" and was "served by the greatest aggregation of public performers the world has ever known. There were teachers, preachers, scientists, explorers, travelers, statesmen, and politicians; singers, pianists, violinists, banjoists, xylophonists, harpists, accordionists, and bell-ringers; orchestras, bands, glee clubs, concert companies, quartettes, sextettes, and quintettes; elocutionists, readers, monologuists, jugglers, magicians, yodelers, and whistlers." As she puts it, "Music was provided Chautauqua patrons in every conceivable form from banjo trios to forty-piece bands, from ladies' quartettes to Madame Schumann-Heink and Alice Nielsen." If the barbershop male quartet did not originate on the circuits, as has sometimes been said, it acquired an association with them that explains the legend.

Stage production of plays and operas, which at the peak became the most popular feature of the tent programs, at first had to labor upstream against moral prejudice toward the theater. The tours of the Ben Greet players in Shakespeare, beginning in 1904 and venturing on a Chautauqua circuit in 1913, and the production on circuit of Charles Rann Kennedy's safely pious *The Servant in the House,* helped to soften resistance. But even when Gilbert and Sullivan and the current Broadway hits of what now seems an age of innocence became the delight of circuit audiences, censorship of scripts was practiced with a fine disregard for artistic scruple. Gay MacLaren cites the instance of a musical company touring in Kansas with scenes from *Carmen* in which the girls were cast as workers in a dairy instead of a cigarette factory. Enter Carmen with a milk pail! According to Horner, the popularity of plays proved a mixed blessing. They brought new audiences to the tents, but

diminished the zeal of local committees, who thought of a Chautauqua in terms of education, culture, and piety.

As a social phenomenon, the circuits did their serious work through their platforms, on which issues of a wide variety were freely agitated by spokesmen of different views. Summing up the scope of discussion, H. P. Harrison, another of the principal managers, writes: "Inside the big brown tents, millions of Americans first heard impassioned pleas for a Federal income tax, slum clearance, free schoolbooks, world disarmament." Roosevelt's New Nationalism of 1912, Wilson's New Freedom, La Follette's National Progressive program, he says, contained no idea that had not been repeatedly advocated on some circuit program. As examples he gives "tariff revision, the initiative, referendum and recall, woman suffrage, prohibition of child labor, a corrupt practices act, and dozens of other social ideas." Circuit orators, Harrison says again, "praised and condemned socialism, the protective tariff, Wall Streeet; rural cooperatives, votes for women, the Yellow Menace, free verse." The same week's program in the same town could present speakers as diverse as Senator Albert Beveridge and Lincoln Steffens, or Boss Champ Clark and Labor leader Samuel Gompers. The circuits heard Jacob Riis on the subject of his book *How the Other Half Lives*, Judge Ben Lindsay on juvenile problems, Harvey Wiley, whose work led eventually to the Pure Food and Drug Act, on public health. The list of speakers eminent in public life would be a long one, but of course lesser figures also invaded the platforms, lame-duck politicians, "jobless, and full of unuttered oratory," in Harrison's phrase, or in the words of other critics the misfits of the professions. Harrison, consulting his gate receipts, observes interestingly that in what is now thought of as the conservative Midwest, the speakers who attacked the "interests" and the status quo were those who got the larger fees and brought more patrons.

Tent platforms justified their boasted freedom in the sense that speakers of very different views were allowed to present them as they saw fit. "If in any field the approach to a problem was one-sided," says Harrison, "it was national prohibition." Chautauquas were formally and firmly dry, from lecturers to management to talent. Efforts were made, of course, to prevent one or another speaker from presenting a case that offended some interest. Carl D. Thompson, in a *New Republic* article in December, 1924, writes that the Public Ownership League of America interested Keith Vawter in the issue of public power. Vawter contracted with Thompson to lecture on the subject, but Thompson met with persistent attempts by private power companies to prevent his

appearance through pressure on local committees, platform managers, and Vawter himself. Thompson gives no hint of interference from within the bureau, but asks, a little plaintively, whether the managers could afford to ignore the public power issue without giving the impression that they had succumbed to commercial influence. Thompson says that a standing bureau announcement promised after every lecture an open forum during which any question or criticism would receive a hearing, but the use of direct debate or of the question-and-answer period, in which the audience could enter the discussion, seems to have been limited at best. Examples are few, and speakers of antagonistic views generally appeared on different dates. Both Peary and Cook, according to Harrison, aired their rival claims to reaching the North Pole, but not on the same platform. Glenn Frank, in his sober assessment of the circuits as "The Parliament of the People" in the *Century Magazine* in 1919, laments their general failure to follow such a model as the Ford Hall Forum in Boston, founded in 1908, the more so as "The Lyceum and Chautauqua," in Frank's words, "represent an extensive national machinery of influence, reaching into all sorts of communities. With the exception of the church and the public school, no word-of-mouth institution equals its scope."

When they did not deal with national or broadly social issues, lecturers fell into certain classifications by theme. One set devoted itself to local community improvement. A speaker of this stripe, according to Marian Scott in her *Chautauqua Caravan,* would survey a town and inform his audience what was wrong with it, from sewage disposal to conditions bad for youth. One such lecturer, Harrison records, told his listeners that he had examined the local schools and found all but seven of them fireproof. He added that the town had a total of seven schools. Other speakers took science as their province, demonstrating such phenomena as the gyroscope or operating models of the Wright brothers' flying machine on wires. Still others were globe-trotters who gave illustrated travelogues. But a particularly characteristic, and to a later generation appallingly successful species of lecture, was the inspirational talk, known in the trade by the generic theme of "Mother, Home, and Heaven." Bruce Bliven, in his *New Republic* piece of 1924, putting himself in the place of a Chautauqua-bound family, describes the hold that the inspirational speaker could exert: "To hear him, we have risen before the sun this morning; have hurried through such of the day's work as could not be postponed; have dressed ourselves and our children in Sunday clothes; and have driven in, some of us, thirty or forty miles in the family Ford, over those beautiful new roads for which we

are paying such heavy taxes this year." Harrison gives a specimen from an inspirational talk on "Life and Love" by Governor Robert Taylor of Tennessee, known as "Fiddlin' Bob." A single sentence will illustrate: "Life and love with a halo of parting days upon their brows and the star-light tangled in their hair, walked arm in arm among the gathering shadows and wove all the sweet memories of the morning into their happy evening song and I wished the Heaven of the evening might never end."

One of the themes of the inspirational lecture was self-improvement, or more simply, exhortation to succeed. A man rose or sank in the scale, maintained Ralph Parlette, solely by what he was in himself, and to illustrate his point he shook a jar of mixed beans and walnuts before the eyes of his audience. The beans always descended to the bottom of the jar, and the moral was clear, or if any cynic ever asked how a bean could transform itself into a walnut and stay on top, the question has not reached the record. Parlette's lecture, says Harrison, was given four thousand times. The reader may raise a skeptical eyebrow, but such endless repetition of the same performance was commonplace, and at least one example surpasses the record of Parlette. Chautauqua patrons of one year, according to the Cases, would come to the tent in a succeeding season, sometimes bringing friends, to hear again the same speech by the same man. This childlike appetite for repetition was no doubt one reason why managers liked to keep the text of a successful lecture on file, and discouraged ad-libbing or deviation from the canonical version.

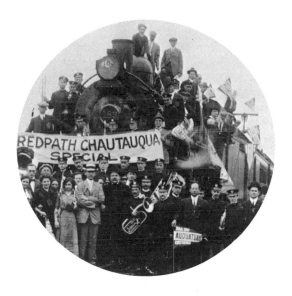

Most famous of the preachers of success was Russell H. Conwell. The Cases describe him as a poor boy from Massachusetts who graduated from Yale, worked as a book salesman, reporter, editor, lawyer, and finally as a clergyman. He served as pastor in two churches on the understanding that his salary would be doubled each time he doubled church membership, succeeding to the embarrassment of his employers. Becoming a Redpath Lyceum lecturer, he produced the paragon of all success talks, "Acres of Diamonds." Appropriately enough for a lecture fabulous in more ways than one, Conwell began in Oriental vein, with a Persian farmer who learned from a Buddhist monk of the incomparable value and beauty of diamonds. He sold his farm and set out to find a diamond mine. He never did discover diamonds, but the man who bought his farm found that this discarded home ground itself consisted of "acres of diamonds." Conwell went on with an array of instances in which men by mother wit had discovered ways to wealth in their own backyards or immediate circumstances, while those who had

voyaged afar or gone to California to grub for gold had only missed the opportunities that lay at hand. Conwell pressed what is now called or miscalled the Protestant ethic to its extreme point. He preached the duty of getting rich, fairly and responsibly rich, but rich nonetheless. When he was told that the Bible branded money as the root of all evil, he appealed to his Testament and pointed out that it was the *love* of money that was so stigmatized. Rich men were not to be slandered for success, but rich men's sons who had not worked for their wealth were to be pitied. Every man should and could make himself wealthy for the sake of the good that money can accomplish. Such, without justice to Conwell's elocutionary flair, was the burden of "Acres of Diamonds." Conwell gave the lecture at Chautauqua itself in 1886. He carried it to many platforms and communities, including the Chautauqua circuits. In 1914, Gay MacLaren records, a meeting at the Academy of Music in Philadelphia listened to his five-thousandth rendition. If Conwell preached the duty of making money for the sake of doing good, then by any common standards of good his use of his own very considerable acquired wealth followed his preaching. He gave large sums of money, according to the Cases, to help students work their way through college, and he capped his career by founding Temple University in Philadelphia and becoming its first president.

If there was one speaker without a rival on the Chautauqua circuits, it was the "Great Commoner," the "Old Dependable" of managers and crew boys, William Jennings Bryan. He was so nearly ubiquitous that it seems as though one can scarcely read of a circuit or an independent that did not at some time hear his voice. Three times unsuccessful candidate for the presidency, Secretary of State under Wilson, campaigner for free silver, prohibition, woman suffrage, government ownership of railroads, and the League of Nations, Bryan made himself notorious at the end of his life as a foe of the teaching of evolution. According to Lawrence W. Levine in his *Defender of the Faith,* Bryan once told a reporter: "People often ask me why I can be a progressive in politics and a fundamentalist in religion. The answer is easy. Government is a man made affair and therefore imperfect. . . . But religion is not a man made affair. If Christ is the word, how can anyone be a progressive in religion?" Levine quotes Bryan as saying that he "would rather speak on religion than on politics," and again that "the most important things in life lie outside the realm of government." It has been said that Bryan did not talk politics on the circuits, but echoes of his free-silver campaign of the nineties made their way into early appearances, and he used the Chautauqua platforms in the months after he had resigned

from Wilson's cabinet to deliver his speech on "The Causeless War," in which he asked his audience, according to Levine, whether it was willing to doom thousands of young men "to avenge the death of a few Americans who went on ships which they should not have taken into zones which they knew to be dangerous." Harrison reports that this speech, in contrast to Bryan's usual popularity, met with the hostility of crowds and press night after night. Once war had been declared, Bryan was ready to say, "Whatever the government does is right and I shall support it to the uttermost." Wilson's League again gave Bryan an occasion to carry to the tents an issue he believed in. During midsummer of 1919, Ida Tarbell encountered him on a circuit in the Northwest. Both were lecturing for the League, but they differed over the question of guarantees to France against future invasion, and Bryan, the luminary of the circuits, in whose favor other speakers had to postpone their appearances or cut their time, forbade her to express views contrary to his. Miss Tarbell acceded for the two weeks during which their paths coincided, then took her own position again.

Bryan was criticized for going on Chautauqua tours while he was Secretary of State. Amusingly enough, the criticism had persisted over the years into Samuel Eliot Morison's *Oxford History of the United States,* in which he remarks that Bryan "had so little sense of dignity as to go on the Chautauqua circuit, along with Tyrolean yodelers and vaudeville acts." Forced to reply to such strictures, Bryan said that lecturing was a legitimate activity, that President Wilson approved, and that he needed his lecture proceeds to support himself and his family. He might have added that the flow of oratory that came so naturally to him gave him a sense of power and vocation in which relief weighed at least as much as exertion. On the circuits he could speak of those "most important things in life . . . outside the realm of government," and prevailingly he did. Of all his Chautauqua addresses the one most in demand, according to Harrison, was "The Prince of Peace," given in three thousand circuit tents over a period of some two decades up to 1924, the year preceding his death. Buoyed by such a theme, he could indulge the pieties bred in him since boyhood, assuring his audience that the watermelon was a miracle and that it was God by his divine power who caused the "cold and pulseless acorn" to grow into an oak. The inspiration for which audiences rallied to hear him found its chief agent in his vocal cords. According to the Cases, his mouth was so wide that one observer said, "That fellow could whisper in his own ear." Describing his platform manner, Horner wrote: "One hand held a palm leaf fan which was never still. The other rested alternately on a block of ice

in a basin on the table, and then on top of his head upon which the heat beat down pitilessly. . . . Water would stream down his face for he had the hottest place in an acre of discomfort," but Bryan remained oblivious to heat or fatigue. Horner continues: "Once or twice, on a quiet summer evening, I have stood at a distance of a block away and even then I could hear what he said. His tones would never swell to a shout nor break into a roar. When the volume expanded in a climactic phrase, there was no loss in the fullness and music in his tone. Along with the melody of his voice and the grace of his gestures, the flash of his eyes would seem to reach even those who sat far away." Bryan not only spellbound tent patrons in their thousands but was something of an idol to managers and crews. He was on friendly terms with the college crew boys, says Harrison, and never complained of travel hitches or inconveniences. He was generous with tips, and shared with talent the esprit that made them all professional in one respect, however amateurish some of them may have been as performers. This was their determination to "get there" and put on their acts, whatever the obstacles. The Cases report that Bryan was once held up thirty miles short of an engagement in Sioux Falls, Iowa, by a derailed car. He procured a horse and wagon and started plodding over the country roads, reaching his platform half an hour after midnight. His audience was still there, waiting, and he talked faithfully until eight minutes after two in the morning.

Many tales are told of the ingenuity and persistence of performers in trying to keep dates despite the conspiracies of railways, Model T's, and weather to prevent them. Gay MacLaren reached an engagement by riding with an undertaker in a hearse. Another time, stranded at a small junction, she begged a ride with a track crew on a handcar. Marian Scott records a similar exploit. Her play troupe, performing *The Taming of the Shrew* in oil and cattle towns in the Southwest, got mired in Texas gumbo behind a mule team while trying to reach rail connections for their next date. They missed their train, and tried to wheedle a handcar from the station agent. Rules forbade his providing one, but he intimated that he might connive at a theft, which was duly carried out, with the addition of a trailer for baggage. Harrison tells of an entertainer who, in order to board a nonstop train, brought it to a halt by building a fire on the track. A magician discovered that in order to reach the tent where he was expected he would have to take an electric train that refused to carry trunks but would accept coffins. He rented a coffin, packed his equipment in it, presented himself as a relative of the deceased, and kept his date. MacLaren reports that an enter-

tainer named Wilbur Starr, in order to keep an Ohio engagement in 1916, tried to ford a flooded stream and was drowned.

Once inside their tents, troupers faced a miscellany of hazards. One of the chief was weather. Tornadoes cracked poles, wrecked canvas, and blew borrowed pianos off platforms. Water from thundershowers gathered in pockets where the canvas slumped, and crew boys had to prod the sunken pouches from below to try to drain off the water. Even so a rent could allow a performer to be drenched in mid-act. But weather was not the only peril. Harrison records that Alice Nielsen could not resist an anguished if vain protest to headquarters when stock for a forthcoming cattle show debouched in an adjacent lot and out-mooed the voice that had sung with Caruso in Covent Garden. Dogs were a recurrent threat. Harrison tells of a performance invaded by bloodhounds pressed into service in a local rape case. Frank Luther Mott remembers the plight of the lecturer who got caught short by "summer complaint" in the midst of his speech. Growing more and more desperate, he finally told his audience that he wouldn't keep them sitting too long on hard benches, but would give them a five-minute stretch. He disappeared through the back curtains, dashed out to a cornfield behind the tent, and came back relieved to finish an address good for an hour and a quarter.

A scrupulous standard of behavior was expected of circuit personnel, but now and then a lapse occurred—more frequently, one suspects, than the record admits. In 1916, Gay MacLaren found herself travelling the same circuit with a highly popular musical group known as the "White Hussars." In one town, she records, the drummer was seen weaving down the street, not in a state of sobriety, with a girl on each arm. Next week, she says, he received a letter containing the words: "If I hadn't of loved you, I wouldn't of let you did what you done." Sometimes the moral prestige of Chautauqua failed, as when Gay, her mother, and a Des Moines clergyman tried to obtain lodging in a New England hotel. The clergyman mentioned that they were members of the Chautauqua company, thinking to confirm their respectability, but Chautauqua, to the desk clerk, meant show people, and he refused to take them in. The same association led to a remarkable dispute described by Marian Scott. In Tuxedo, Texas, it seems, the Methodist minister wanted a Chautauqua, while the Baptist minister considered Chautauqua depraved. The town divided behind the two champions, and all factions came together, first to argue, then to pray. Failing any manifest answer to prayer, the two ministers agreed to fight, the town

Alice Nielsen

shut its businesses and rallied to watch. Before squaring off, the two contestants prayed again. Then they set to, the Methodist won, and the town got its Chautauqua.

Harrison cites 1927 as a discouraging year for the circuits, though omens of decline had begun to accumulate even earlier. Keith Vawter had already sold his tents and his territory. Audiences were falling off. Beneath the stock-market prosperity lurked rural depression. Harrison observes that 145,000 people paid two million dollars to watch Gene Tunney defend his heavyweight title against Jack Dempsey in Chicago, but failures were occurring among small town banks where Chautauqua guarantees were deposited. "Hard times on one side, changing times on the other," Harrison writes, struck a double blow at the circuit enterprise. The country was making the turn from a prevailingly rural to an urban society, and with this transformation came technological changes that would have been enough in themselves to put the tents out of commission. When radio became universal, people could sit at home and obtain their news and discussion, their music, theater, and vaudeville for the trouble of turning a knob. When the automobile became a standard family appurtenance, they could drive to the nearest movie house on any evening they chose. But the circuits themselves contributed to their own undoing. As the twenties went on, serious lecture and informed discussion gave way increasingly to entertainment, partly for want of issues to which the tent audiences would respond, partly for lack of enough commanding speakers to go round. As Horner remarks, actors and singers could be trained, but no manager could manufacture a speaker who could excite and sustain interest in a serious topic as an earlier and more oratorical generation had been able to do. The tent Chautauquas were being more and more recognized as primarily agents of entertainment at the very time when the quality of their entertainment was being diluted by the competition that their own success had brought on them, a competition that inevitably debased the standard of talent. And the more the Chautauqua tent was seen as a shell of entertainment, the less reason appeared for the guarantee in the contract. Entertainment could be had without any such personal liability and without any need for community pride and cooperation.

By the end of the 1933 season, the circuits had virtually vanished and the tents had been struck for good. But after some forty years they have not been forgotten. At least among people on the far side of middle age, they have left a deposit of memories ready to surface at the merest mention of the word "Chautauqua." Writers, teachers, physi-

cians, scholars, men and women, can turn up in almost any gathering who look back on their own experiences of the circuits with amusement and nostalgia. A biographer remembers raising tents as a crew boy during summers between college terms. A horticulturist remembers hearing her first Gilbert and Sullivan opera as a child taken by elders to a circuit tent. Plentiful evidence testifies to the excitement generated by the Chautauqua, both by anticipation and actual presence. To many communities the Chautauqua was the climax of the year, looked forward to from season to season. One who remembers this excitement will often say, "Of course, there was nothing else." John F. Noffsinger puts the point dourly, granting the circuits the lugubrious distinction of saving "the village and township of the American interior from utter boredom." To a child, watching a magician perform meant an experience far more positive than mere relief from vacancy, and so to his parents did theater or opera or the voice and presence of a famous politician or preacher. Circuit experiences could be intense, and however unsophisticated they may seem in retrospect, they were on the whole experiences of enlargement and enrichment. Out of a considerable fund of conversation and correspondence from a variety of quarters, here is one bit of postcard testimony received by this chronicler from a friend who is a novelist and scholar:

> I remember the Chautauquas I saw—I think I saw two—verbatim. I can sing you the songs and describe you the vaudeville and act you the plays. Mrs. Malaprop, no less, as well as Mrs. Wiggs of the Cabbage Patch. And a basso profundo who put the nose of the local church-choir basso out of joint . . . when he sang "As we went rolling down by the rolling Down by the rolling sea."

In 1916, Ida Tarbell signed a circuit lecture contract for forty-nine towns. She writes that "scoffing eastern friends" told her, in keeping with the criticism Bryan encountered, that she would be travelling with "bell ringers, trained dogs, and Tyrolean yodelers." Actually her fellow circuiters turned out to be a quintet of young singers and an evening entertainer whom she respected for their professional attitude. Her first appearance was in a steel town; the tent, "ablaze with electric lights," was pitched in dim streets "where the heavy panting of the blast furnaces could be clearly heard." Men, women, and children flocked toward the tent from "unpainted, undrained rows of company houses." Miss Tarbell found herself respecting her audience as well as her fellow troupers. "They were so serious, they listened so intently to get something." In short, they were not unlike those early Chautauquans by the

lakeside whose earnestness was too much for William James. It would be possible to take the view that the circuits do not belong in a history of Chautauqua, the Institution, originally the Assembly, in New York State. But the Institution, the independent "other Chautauquas" of John Vincent, the lyceums of Holbrook, anticipating the CLSC, the lyceums of Redpath, which at least tried to balance prophylactic entertainment with serious discussion, and the circuits as organized by Vawter, are all intertwined. The circuits were less than a child and more than a namesake of Chautauqua the Institution. They operated outside its walls and beyond its control, but they shared at least some of its purposes, exerting, while they lasted, a similar influence as a forum and on a much vaster scale. Chautauqua, the true and original Chautauqua, has survived them for some forty years, and survived the changes that put them out of business. It can surely accept them with good grace as a part of its complex history.

Continuity in a World of Upheaval

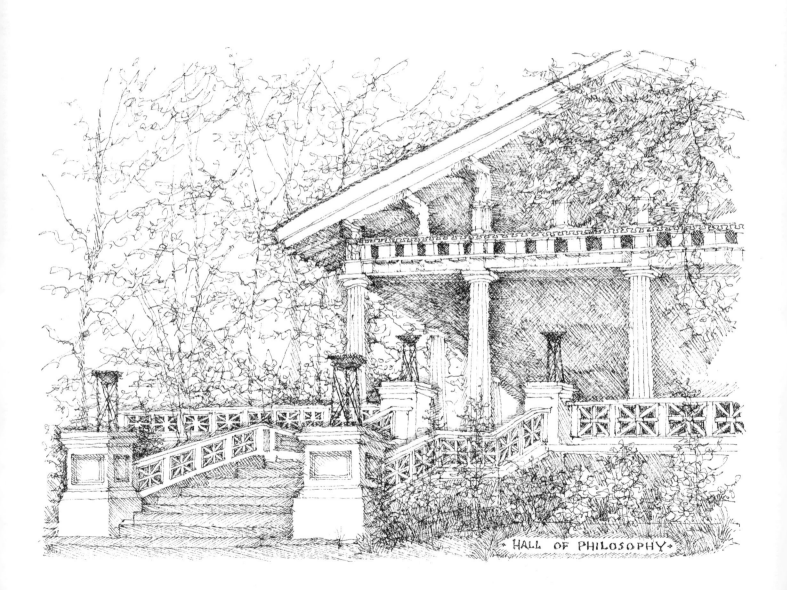

· HALL OF PHILOSOPHY ·

Chautauqua since World War II

Aftermath

In 1909, according to Jesse Hurlbut, George Vincent said in his annual report that Chautauqua must "be kept in close and sympathetic connection with the great currents of national life. It must be a center from which the larger and more significant movements may gain strength and intelligent support." Of course the support that Chautauqua could offer did not consist in taking official positions or in political action as an institution. Its role was discussion. It must respond to national and international currents by bringing intelligence to bear on them and so somehow using its influence for good. This it could do, Vincent thought, through its function as a "center." But the eminence of Chautauqua as a center, a physical locus of dissemination for thought and influence, could not help relatively declining from its early days. Speaking in 1972, Mayor Lindsay of New York paid the Institution a compliment of perhaps unintentional irony. He called it "the media before radio and TV," as though Chautauqua had performed on a national scale the function of all the organs of information and opinion. In fact Chautauqua had both used and been aided by the press and in due time by radio and TV, but its claim to central importance as a specific place of origin for national utterance could scarcely avoid shrinking as population multiplied, as TV audiences began to number in the millions, and as words and images were transmitted from satellites or from the moon. A symptom of the change may be found in the regrets that the Institution has accumulated from personages it might earlier have expected to welcome. It could once take pride in having played host to seven presidents, past, current, or later to be elected. The last was Franklin Roosevelt in 1936. Since World War II, invitations hopefully recorded by the *Daily* have been declined by General MacArthur, Adlai Stevenson, President Eisenhower, President Kennedy, and Richard Nixon as vice president and candidate in 1960, together with other figures of comparable public standing. In 1965, Senator Robert Kennedy and his wife paid a visit to Chautauqua. His assassination three years later

prevented his presidential candidacy from coming to an issue. Presidents and candidates, it seems, do not think of Chautauqua as much as they used to in the past as a sounding board of national opportunity. They reach the millions by the TV screen and the thousands by handshaking in factory yards and supermarkets.

Yet no one could interest himself in Chautauqua over the time from the first release of nuclear energy to the dissensions of the Vietnam war without recalling George Vincent's words and using them as a measure of the Institution's record. To what extent, in what spirit, has Chautauqua reflected the events and issues of a period of conflict and upheaval? In applying the measure, it is necessary to remember that Chautauqua is not an arena where events that shake the world happen, but rather a forum where the meaning and consequences of such events are discussed and debated. It is a place of withdrawal, where people can retreat from the world only to meet the world again at another level, the level of discourse and understanding. It is a *summer* institution; its doings are seasonal, and they are reported by its own house organ, the *Daily*, devoted to its own local news. If George Vincent's measure is to be fairly applied, it will be necessary to remember what Chautauqua is and is not, its limitations as well as its achievements.

Chautauqua began its season of 1946, the year after Hiroshima, with a week of lectures on the inescapable topic of the atomic bomb. Six speakers discussed the implications of the bomb for security, for morals and religion, for education, and for world community. They expressed both fears for survival and hope that the new energy would lead to medical and other benign applications. Their fears still await the mercy of history, their hope has at least been supported by technical progress. One of the speakers, Bernard Iddings Bell, canon of the Cathedral of St. Peter and St. Paul in Chicago, gave a less familiar turn to the discussion. "Atomic science," he said, "has placed upon education a burden which it cannot fulfill." He saw no hope for the world except "the interposition of God to make people a rational species so that they will not continue their present process of self-destruction." In more human terms, he felt that salvation could come only through a true world community, not a league of states, but a liquidation of independent sovereignties. Meanwhile, sustaining the variety of its activities, Chautauqua was offering courses in a School of Aeronautics, including model airplane construction, and still other classes in lipreading.

Beginning on July 4, Chautauqua played host to a series of Town Meetings of the Air. The first debated the question: "Should the United States adopt the Baruch report on the international control of atomic

energy?" Among others, Hanson Baldwin, military editor of the *New York Times,* spoke in favor, and Senator Revercomb of West Virginia, a member of the Senate Military Affairs Committee, spoke against. The debate was lively, but its arguments have long passed into history. A prize for the best question addressed to the panel was awarded to the query: "Where is the Atomic Commission to get its Big Stick to enforce the provisions of the Baruch Report?" The next Town Meeting asked: "Should the United Nations abolish the veto power?" Some of the panel thought abolition essential to the Baruch plan, but Quincy Howe, editor and publicist, declared that "the choice is between the United Nations with the veto or no United Nations at all." A pair of sixteen- and seventeen-year-old friends collaborated on the best question: "If there had been a U.N.O. before this war, would you have given Germany the power to veto preventive action?" Further Town Meetings dealt with themes that would echo and reecho from the Chautauqua platform. "Can We Have World Peace Without World Law?" and "Can We Keep on Friendly Terms with Russia?" Atomic energy, the Baruch plan, and the United Nations did not preempt all concern. Mbonu Ojike, author of *My Africa,* spoke for the peoples of his continent and observed, "We don't want missionaries who snub our culture." He preceded the Institute of World Missions, which regularly held meetings at Chautauqua.

Next year the United Nations was back again in the forefront of attention, and would continue to occupy a good share of it through the whole period after World War II. A United Nations Week assembled speakers from England, Denmark, New Zealand, India, Australia, and China to discuss the problems of the veto, of trusteeships, and of human rights. Another result of the war brought Justice Robert H. Jackson, Chief of Counsel for the United States at the Nuremberg trials, to defend the Nuremberg procedure and to declare that the principles it established applied to Americans as much as to others, a point not overlooked later by critics of the American presence in Vietnam. Meanwhile other preoccupations were not slighted. An Edison Week brought a number of speakers to sustain Chautauqua's concern with science. World Missions Week heard the Right Reverend John A. Subhan, bishop of the Methodist Church of India. Born of a Moslem family but sent to English schools, he became a Christian, studied for the Catholic priesthood, but finally settled into Methodism. He hailed the independence of India and its division into the Union of Free India and Pakistan as eliminating the prospect of civil war. Dr. Eddy Asirvatham took the opposite view, pointing out the thousand-mile separation of the two

districts of Pakistan as making unified government virtually impossible. The season of 1947 also witnessed a campaign to raise the Chautauqua endowment fund to a million dollars, a campaign similar in suspense to the melodrama of 1936. Mr. and Mrs. Ralph Norton added $225,000 to their previous benefactions, leaving $135,000 to complete the total. Offers followed from other aroused campaigners to match one or another sum if a giver would come forward. The *Daily* reported gifts received and tabulated the narrowing gap toward the goal until it could record that on Old First Night Chautauqua had reached an endowment of $1,005,789.90.

For the next two seasons, much the same round of activities prevailed. Women could discover a Chautauqua Charm Course among the institutional offerings. Norman Thomas, still a presidential candidate in 1948, spoke to the Amphitheater on "a Program for Peace," and Mrs. Owen Rhode, daughter of William Jennings Bryan, addressed the Women's Club on the same perennially fruitless topic. Dr. Edgar J. Fisher, a Chautauqua lecturer and news commentator for a considerable number of seasons, told his listeners that "we are living in a state of fear, wondering whether we shall have World War III and annihilation or a world of cooperation." A physiologist declared world hunger a danger more threatening than the atomic bomb. He advocated eugenics and planned parenthood and described "security from the cradle to the grave" as "unsound biology." A hundred Grangers in costume presented a pageant of their aims and activities. Nationalism and sovereignty again were condemned by a speaker who wanted to see an association between America and a United Europe. David Dietz, science editor of the Scripps-Howard newspapers, spoke on the reconciliation of science and religion, which he thought had been made possible by advances in physics which had undermined a mechanistic conception of the cosmos. Dr. Ernest O. Melby, of the New York University School of Education, asked, in 1949, whether freedom could be saved, and forthrightly denounced witch-hunting by the Un-American Activities Committee. On this occasion, the Declaration of Independence was read to the audience by a representative of the Chautauqua County oratorical society.

Voices of faith and alarm, spokesmen for many interests and areas, delivered their messages. Stringfellow Barr, President of the Foundation for World Government, predicted to his audience at the Woman's Club that they would probably see world government within their lifetime. He also remarked on the refusal of blacks and of the impoverished nations to accept the common excuses they were given for inequality.

A panel under the direction of Benjamin Fine, educational editor of the *New York Times,* disagreed on the question of whether Communists should be allowed to teach. The debate was vigorous, but its arguments have long since been interred. Dr. Kahlil Totah, of the Institute of Arab-American Affairs, denounced Israel as an aggressor and called the Arab refugees a responsibility of President Truman and the United Nations. Carl J. Friedrich, Harvard political scientist and Adviser to the Military Government of the United States in Germany, gave the first of several series of lectures he delivered at Chautauqua. War is not inevitable, he told his audience, and assured them that the Soviet Union doesn't want it. In a Recognition Day address to the CLSC, he expressed faith in the common man, deploring the condescending use of the term and defining it as concerned with the common interest. He used as an example the Berlin airlift. We had faith in the common man as Berliner. The Russians, by failing to take him into account, lost that round in the cold war. For the dignity of the common man, Friedrich urged, let the Jews have their homeland. Dr. T. Z. Koo varied Chautauqua's religious fare by giving a devotional hour to "The 'Tao' of Confucius," attributing to him the doctrine that God is known through right living and not through speculation on his nature. Toward the end of the season of 1949, Dr. Takuo Matsumoto related that he was sitting at his desk in his office in the Methodist Girls' School in Hiroshima when the atomic bomb was detonated above the city. He survived, but 350 girls were killed, 149 lost fathers, and 144 mothers. He told his audience that the chief need of Japan was for Christian and democratic education.

Korea was to prove the nation's next crisis. At Chautauqua it took up a good share of the program in 1948. Induk Pahk, who had represented Korean women at the International Women's Conference in 1946, spoke to the Women's Club on her people and her country. She had gone to school at the age of seven disguised as a boy for want of girls' schools in her part of the country. After World War I she had become involved in the Korean independence movement and had spent five months in solitary confinement. She had studied at Columbia Teachers' College and lectured in the United States, England, China, India and other countries under such auspices as foreign missions and the Christian Youth Movement. She told Chautauquans that the Korean people would not let the Americans go until democracy had been achieved, and she urged the need of religious teaching as a counterpoise to otherworldly Buddhism and Confucianism reduced to its superficials. Dr. Frank L. Eversull, Chief of Colleges in the American occupied zone, lectured under the title "Korea—Russia and the United

States in the Orient." In true cold-war style, he represented Russia as anxious to take over everything in sight, including Australia and the Philippines. Dr. Hyungki Lew, identified as a leading Christian editor and author, praised the work of the American military government, and while the *Daily* does not put the words in quotes, it reports him as saying that after the Japanese surrender the Russians came into Korea to rape the women, rob the banks, and take away the livestock.

In late June of 1950, little over a week before the Chautauqua session began, North Korean forces launched their invasion of the South. The United States, with other members of the United Nations, and at a time when Russia was boycotting the Security Council and could not exercise its right of veto, engaged itself for the third time in the century in a savagely fought war of no small proportions. At Chautauqua, on August 19, the *Daily* printed a feature article signed by William Clinger, reporting interviews in which he sought to find out "how those who will be most intimately connected with war, the young people" were responding to the situation. He found them resigned. "They feel that they are caught up in something over which they have no control. . . . If war is inevitable, then the part they must play in it is just as inevitable, but until the time comes they plan to enjoy themselves." Asked what they thought the future might hold for them personally, they gave various answers. A veteran said he would probably enlist, mainly because he had nothing better to do, but also because he had "a whale of a good time in the last war." Another veteran, who had planned on marriage and graduate work, said that he would do his best to keep out. The interviewer was impressed by "the lack of false heroics" among those he talked with. A draftee preparing to leave for basic training expressed indifference, and when asked what outcome he expected of the war, said "Sure I think we'll win," adding, "But that won't solve anything. The world's too messed up." The interviewer found no bitterness against an older generation for allowing the conflict to break out, and only vague ideas of what had brought it on. One blamed Russia, another the United States and Russia equally; still another is quoted as saying, "It's the fault of Adam and Eve; the fault of the human race for the last two thousand years." Some suspected that in one way or another big business had its share of responsibility. The girls interviewed had mostly reached the same mood of resignation as the boys. The expectation of peaceful family life had become "a fading dream." One girl indulged in a melancholy joke, foreseeing a world in which women would outnumber men even more than at Chautauqua. The article in the *Daily* concludes in a way certainly at variance with George

Vincent's precept for the Institution. "Here at Chautauqua," the interviewer writes, "perhaps more than other places, the atmosphere is one of indifference to the problems of the world." On the young people's "own little world, comprising the lake, the beach, and the sun, the complex and disturbing international events of the outside world seldom intrude." But events had intruded. If the young responded at the time by resignation to what they saw as inevitable, if they chose to forget as much as they could and sun themselves while they were able, this hardly means that they were totally oblivious or actually indifferent at heart. Two global struggles had failed to make a secure world. The response of those eligible for combat to the prospect of war in Korea, even though the war was sanctioned by the United Nations, could not have been the same as the response to Hitler or Pearl Harbor. In any case, the year was 1950. Another decade, another war, and it would not be easy to think of students as resigned or as accepting the inevitable.

Discussion of the Korean War began promptly on the Chautauqua platform, merged with the themes of the cold war in general, the United Nations, the organization of the world for peace, and the relations of the country with mainland China and Chiang Kai-shek's government on Formosa. No speaker opposed President Truman's decision to resist the North Korean invasion. On July 4, scarcely more than a week after the attack had begun, Edgar J. Fisher envisioned Russia as the power behind the invasion. "Our movement in supporting the resolutions of the U.N.," he said, "has not only strengthened that organization but has added considerable prestige to our wavering influence in all Western Europe." Three days later, Judge Michael A. Musmanno, known for his part in the Nuremberg trials, anticipated that military action in Korea would be followed by judicial action. President Truman's order sending troops into Korea, he declared, "should light a lamp of hope and cheer in the home of every civilized being on earth, because it affirms the law laid down at Nuremberg." Later David Dietz, speaking as a science editor, called Korea the only hope of avoiding World War III, and considered that the atomic preponderance of the United States kept the war from spreading. Senator William F. Knowland of California took the view that American troops under the United Nations flag should carry the battle beyond the thirty-eighth parallel, that we should continue to refuse recognition to mainland China, and continue to support the government in exile. "We closed the front door to communists in Europe," said the Senator, "but we left the back door wide open in the Far East." In the following season, "with the entire world's attention focussed on the truce talks," as the *Daily* put it, Dr. Younghill

Kang, of the Department of Comparative Literature at New York University, recommended that Koreans be allowed to work out their own government. North and South need each other, he declared. "Uncle Sam is hated although he is spending millions in Korea, and Uncle Joe is also hated although he is not spending a cent." Dr. Tingfu Tsiang, representing Chiang Kai-shek's government to the United Nations, warned that peace in Korea would bring only a temporary respite from the Communist quest for world dominion. He praised the regime on Formosa, and viewed its function as not to conquer mainland China but to help the mainland overthrow its Communist rulers, who were insecurely contending, he said, against 1,600,000 guerillas. Senator Knowland returned to criticize the United States armistice terms and to charge the State Department with intrigue while China was being lost to Communism. Such a sampling may suggest the range of discussion that Korea received at Chautauqua, and the limitations of foresight that any segment of history must abundantly illustrate.

Meanwhile other concerns and activities competed for their places on the program. In 1950, Henry Steele Commager, then professor of history at Columbia, delivered three lectures on "The American Mind." He dealt first with a topic congenial to Chautauqua, "The American Mind in Religion." He found the American mentality secular rather than spiritual; Americans were religious but not theological. There were no nationally known religious figures, he said, as there had been a century past; the best minds were not going into the church. "In the great moral crisis of the atomic bomb, it has been the scientists who took the lead in pointing out the moral implications of the new age and we have listened to science rather than the church." In a subsequent lecture he dealt with war and the military, supporting civilian control and the American custom, as he viewed it, of going into wars only after being persuaded of the rightness of the cause, even if the country was unprepared. Later in the season, Louis Bruce, Jr., a full-blooded Mohawk, told the Amphitheatre that the hardest problem for an Indian was to overcome the sense of inferiority ingrained in him over the years, and that Indians "are becoming competitively assertive in the best American sense." He himself had taken a job as a clothing salesman to learn aggressiveness. Interspersed among lectures, concerts, and plays, a Danish drill team gave a gymnastic performance, and Harlan Tarbell, announced as a "world-famous magician," preceded his Norton Hall appearance by driving a car blindfold twice around the Bestor Plaza in a downpour. Dr. Martin Niemoeller, German U-boat commander in World War I, served as a Chaplain of the Week. Before the Second

World War he had headed a movement which resisted Nazi persecution of the German Evangelical Church, had been confined at Dachau, and after emerging, "preached the call to repentance in Germany," as the *Daily* expressed it. Dr. Karl A. Menninger gave a series of lectures on "The War Between Love and Hate." Nationally known as author and psychiatric physician, Dr. Menninger had founded, with his father and brother, a hospital, clinic, and school for children with problems of emotional disturbance. From it came the Menninger Foundation for psychiatric treatment, education, and research. Dr. Menninger has continued to be a frequent lecturer and a familiar and affectionately regarded figure at Chautauqua. The Institute of World Missions in August heard a native Fiji Islander, the Reverend Setareki Tuilovoni, praise the work of missionaries for their establishment of hospitals, schools, and churches. He touched also on the Fijian desire for independence aroused by the war in the Pacific.

While the Korean War and the prolonged armistice negotiations were in progress, the figure of Senator Joseph McCarthy appeared on the national scene. The danger of his charade of accusation was promptly recognized at Chautauqua by Henry Steele Commager in his lectures of 1950 already cited. Thereafter he was condemned by other speakers, whether or not he received attention proportional to the havoc he wrought. That this havoc extended beyond national bounds was indicated by Carl Friedrich when he spoke in 1953 of the anti-Americanism prevalent in Europe, for which not only McCarthy but the execution of the Rosenbergs for conveying atomic secrets to Russia provided focal points. The damage done to American prestige by McCarthy, Friedrich said, makes "the Europeans feel that the U.S. is not a worthy ally," and again, "Senator McCarthy obliterates for them the difference between the U.S. and the U.S.S.R." After McCarthy's censure by the Senate in December, 1954, Edgar J. Fisher could dismiss him from the Chautauqua view during the next season as a demagogue in eclipse.

In the course of the McCarthy years, Chautauqua programs presented their usual range. In 1951, Governor Ruben Wagnsson of the Province of Kalmar in Sweden spoke in the role of Chief Templar of the International Order of Good Templars. He sustained the note of the cold war by saying his country knew that hundreds of Soviet rockets were targeted on its coast and that only the United States could keep them from being fired. James G. McDonald, first United States ambassador to Israel, reviewed the history and problems of that embattled country. Dr. Huh Shih, Chinese Ambassador to the United States during World

War II, who had studied at Cornell under a Boxer Indemnity scholarship and at Columbia under John Dewey, declared that a people who had "lived through 20 centuries of freedom cannot long endure the ruthless absolutism of the communists." In the election year of 1952, the *Daily* devoted a box to the contest for the Republican nomination, and reported a sampling of local opinion which heavily favored the nomination of Eisenhower. No comparable sampling of Democratic opinion appears, but Edgar J. Fisher in his news commentaries gave attention to the Democratic contest, and Mrs. W. Glenn Suthers, a candidate for the Illinois legislature, reviewed the prospects of both parties for the Women's Club. She referred to Adlai Stevenson as "a likable person and a good after-dinner speaker," but said that a strike against him was his appearance as a character witness for Alger Hiss, the only mention of the Hiss trial that this chronicler has been able to discover in the *Daily*. In the same season Dexter Perkins, first professor of American history at Cambridge, England, discussed the general American attitude toward war. America, he felt, as a result of its freedom from attack in the nineteenth century and its concern for material progress, showed a distaste for war, and a tendency to regard particular wars as mistakes. "Americans have a bad conscience on war. We don't like war." Paul Engle, poet and teacher at Iowa University, spoke to the Amphitheater on poetry. Carlos Fallon, an American citizen of Irish and Castilian descent who had been born in Bogota but spent much of his boyhood in New Orleans, explored and contrasted Anglo-Saxon and Latin American cultures. Speaking for science, David Dietz assured his audience that flying saucers were not vehicles from other worlds and did not constitute a menace. Willy Ley addressed himself to "The Conquest of Space." On a Sunday an audience in Norton Hall listened to a Christian Science lecture by a member of the board of lectureship of the Mother Church in Boston. On Old First Night four Chautauquans were seated on the platform who had been present at the first assembly in 1874. Three years later the number had dwindled to two.

Chautauquans could always ask questions of their speakers, but in 1953 an experiment sought to promote audience participation and discussion by organized methods. The experiment was made possible by a grant from the Fund for Adult Education of the Ford Foundation. It sought to supplement information gained from lectures with films and readings, and offered training in techniques for those who might want to conduct similar discussion programs at home. The *Daily* claims the plan as another Chautauqua innovation in adult education, bringing together "for the first time" scheduled discussion groups after Amphi-

theater lectures. It reports that Ralph Lapp, speaking on science, invited his audience to help him write a magazine article on atomic energy, and that another lecturer rewrote his text in the light of what listeners said they wanted to hear about. In 1954 the experiment was repeated under the general title, "Our American Heritage and Today's Responsibility." Seven courses developed by the Experimental Discussion Project of the Fund for Adult Education were offered during the season. No fee was required for participating, but a small charge was made for materials. A five-session clinic was established to observe and evaluate methods of conducting discussions.

Besides the programs organized under the Fund, discussion groups were set up to follow the lectures of Ralph Bunche, Negro winner of the Nobel Peace Prize and director of the Department of Trusteeship of the United Nations. Bunche described the structure of the United Nations, gave his judgment of its limitations, failures, and achievements, and during the course of his visit, while watching a Little League baseball game, found himself drafted to act as umpire. Discussion groups were also scheduled to follow lectures by Karl Menninger. One dealt with the attitudes toward sex of Freud and Dr. Kinsey. Menninger began this lecture by answering questions from the discussion group. Do psychiatrists find a higher incidence of mental illness among those who lack religious faith? Yes, Dr. Menninger felt, but cautioned that faith is not an automatic protection against such illness. After a later lecture he was asked what he thought of using sex in descriptions of God. Menninger recognized an increasing tendency to speak of "our father and mother in heaven," and pointed out that the notion of a female component in the deity is very old. Such were some of the results of trying to put discussion on an organized rather than impromptu footing. The *Daily* notes that women predominated in the groups. Whether or not this imbalance was significant, the experiment, at least in its formal aspect, seems to have lapsed after two trials.

Other speakers and topics for the years under review include Ashley Montagu, then chairman of the Department of Anthropology at Rutgers University, who excoriated current education. It taught unrelated subjects, he declared, and not the means of becoming human. Right education would turn the "undifferentiated human being into a creator who will love and cooperate with his other human beings." Fulton Lewis was announced to speak as a "Washington columnist and radio commentator with 13 million listeners each night." The president of the General Federation of Women's Clubs told a full house at the Chautauqua chapter that "the threat to our liberties will never come from with-

out; it will come within, and a man must first be a good patriot before he can become a citizen of the world. . . . I am asking each club to own an American flag; to give the Pledge of Allegiance and to open each meeting with a prayer for ourselves, our leaders, and our country." Peter Viereck, poet, historian, and Pulitzer Prize winner, gave a series of lectures on "Non-Material Values in a Material Age." He traced historically what he regarded as the erosion of Western beliefs and institutions. "Although militant nationalism and class-war socialism intentionally undermined the values of the West," he said, "relativist liberalism unintentionally caused the same result. . . . Human nature is not good enough for the liberal blueprint. . . . When human nature is faced with an abstract theory of liberal reform which is unfitted for it, one or the other must give way." Oliver Vickery, a San Francisco exporter and importer, presented a film lecture resulting from a six-thousand mile journey through Russia in 1952. As a consequence of trade negotiations he had undertaken with the Kremlin, he was able to take photographic equipment with him on this unusual trek. The CIA had asked for copies of his documentary, and Vickery had shown his film in the caucus room of the Senate. He was accompanied on his journey by a retired Soviet general, whom Vickery later met again in Switzerland. The general informed him that flying saucers were an electronically controlled Russian defense against invading planes. He also said that every important American city had been targeted for destruction, but that Chicago had recently been removed from the list because the Soviet Union planned to make it the Western capital of the world, reserving Moscow as the Eastern capital. Literary concerns were again represented by Edward Weeks, editor of the *Atlantic Monthly*, who spoke on "The Joys and Trials of an Editor" and gave the Recognition Day address to the CLSC. The Reverend John A. Havea from the Tonga Islands praised the work of missionaries under the British protectorate and instanced four colleges and forty-two primary schools supported by missions. A panel on "Academic Freedom: Is It Endangered?" must have owed its origin to the influence of Joseph McCarthy.

In the midyear of the decade, 1955, familiar voices such as those of Carlos Fallon, Edward Weeks, and Karl Menninger continued to be heard, and new voices were added. Clarence Cook Little, former president of the University of Michigan and director of the Roscoe B. Jackson Memorial Laboratory, put the case for scientific research and addressed the Women's Club on "Women in Scientific Achievements." Perry Miller brought his formidable scholarship to bear on "American Literary Individualism," using as examples Emerson, Thoreau, Haw-

thorne, Melville, and Whitman. In the next season the archaeologist Dr. Immanuel Ben-Dor, who had excavated in Palestine, Egypt, Assyria, Turkey, and other countries and had been present in Jerusalem when the Dead Sea Scrolls were found, made them the subject of a lecture. Eugene McCarthy spoke as a member of Congress from Minnesota, the *Daily* making the point that as a Democrat he balanced the appearance of Eisenhower's deputy when the president himself could not come. A United States Navy plane caused excitement when it plunged into the lake. Its pilot was rescued by two brothers conveniently trolling nearby. Several speakers reiterated the cold war theme. Soviet Communism, according to Senator Duff of Pennsylvania, still presented "the chief challenge to all who believe in freedom and a Supreme Being." Charles E. Wilson, secretary of defense and former president of General Motors, declared that "our military strength is not for aggression, but it must be sufficient to deter aggression and to win if war is forced upon us." Judgment of the military strength we need, he said, must take into account its effect on the economy. The *Daily* called attention to the secretary's importance in the Republican convention of that election year. John W. Nason, president of the Foreign Policy Association, pointed out that Russian diplomacy was cultivating the uncommitted nations. "As a result you have a policy more versatile, flexible and far more dangerous. It has the danger of soothing us into a state of self complacency."

Direct preoccupation with the cold war aside, other speakers discussed the probems of India, of hostility between Israel and the Arab nations, the state of civil liberties, and "our first countrymen," the American Indians. A more general review of global stresses came from Norman Cousins, then editor of *The Saturday Review of Literature,* who according to the *Daily* had made four world survey tours during the past six years. "We will not survive," the speaker said, "unless we know the needs, hopes and wants of the overwhelming majority of the world's peoples." In the course of the season Chautauqua received a bequest of $5,000 that marked a tribute to its power of gaining affection in what on the surface might seem improbable quarters. It came, as reported by the *Daily,* from Eugenie Marie Garchery, who under the stage name of Yvonne Garrick had performed in plays of Molière and other repertory classics in the Comédie Française. She had come to this country when Otto Kahn financed a tour by the French company, had resolved to become an American citizen, and after thirty years had done so. She made Chautauqua her summer headquarters, joining and graduating from the CLSC. In mid-session of this same year occurred the death

of Samuel M. Hazlett, who had been the mainstay of the Institution in its recovery from debt in the thirties and its president since 1947. Judge W. Walter Braham, as vice president, succeeded to Hazlett's post. A man of historical tastes, Braham had distinguished himself on the bench and on judicial committees of importance in Pennsylvania and besides his administrative duties had taught the Jesse L. Hurlbut Adult Bible Class in the Methodist house at Chautauqua.

School integration as a major social theme received, in 1957, attention in some proportion to its importance. Since the Supreme Court had handed down its decision in the case of *Brown* v. *Schoolboard of Topeka* some three years earlier, the attention may seem somewhat overdue. It came in an address by Walter S. Spearman, professor of journalism at the University of North Carolina and a member of the staff of the Chautauqua Writers' Workshop. Leadership for integration in the South, Spearman said, had come not from political figures but from preachers and editors. The South had been stunned by the decision. Politicians said nothing or attacked the court. White Citizens' Councils stepped in, and resistance hardened. Ministers and influential laymen did better. They, but not all members of their congregations, knew that integration was Christian. One of the greatest dangers lay in the loss of communication between white and black. Spearman expected the pattern of social response to show itself in the border states, where the ratio of blacks to whites was smaller and where schools were being integrated without too great stress. "If the North and the Courts push us too fast," he observed, "there may be bloodshed. If they don't push us at all, there may be no integration." Later in the season Thurgood Marshall, then legal officer of the NAACP, later appointed to the Supreme Court, assessed the situation to date. He remarked on the three stages of Negro experience, first slavery, then the doctrine of separate but equal schools and facilities, finally the step toward integration. Social problems in a democracy, he observed, are always slow to work out. Progress might have been faster, but criticism, attempts at nullification, and white citizens' councils brought the court's decision into question and blocked communication. Our world prestiage is at stake, he told his audience, but our motive should not be prestige but human decency.

The season of 1957 presented more than a common number of events and discussions that stand out in the record of the decade. Conservation formed a prominent topic, dealt with in a week's lecture series by the secretary of the interior, the commissioner of the Bureau of Reclamation, an engineer of the United States Geological Survey, and other

largely governmental representatives. Activities on the grounds were suspended for thirteen minutes by a practice air alert, a civil defense test of readiness for atomic attack. Dr. A. L. Kershaw, an Episcopal clergyman who, as reported by the *Daily,* had appeared on the "$64,000 Question" TV program and on a broadcast series for the National Council of Churches on religious resources in the arts, explored a range of writers from Arthur Miller to Tennessee Williams and from Kafka to Becket. "The arts in our time," said Kershaw, "bring judgment, candor, relevance, and discovery." Victor Reuther, brother and assistant to Walter Reuther of the United Automobile Workers, promised to clean out any racketeers who had sought to hide in the labor movement. These and other events were in keeping with Chautauqua variety, but the most ambitious intellectual program of 1957 was presented in conjunction with the Institute of Religion in the Age of Science. The institute came into existence when a group of ministers at Star Island, New Hampshire, invited a number of scientists to meet with them for discussions that resulted in an annual conference. Its meeting at Chautauqua enlisted as speakers Harlow Shapley, director emeritus of the Harvard Astronomical Observatory, known in popular acclaim as the man who measured the universe, and Edwin P. Booth, a theologian who would make numerous appearances in the following years. Shapley and Booth dealt in the large with "Man and His Environment," Shapley principally with man in relation to his physical environment, Booth with history and with evolution both organic and cultural. Perhaps the chief difference between them turned on their different temperamental estimates of man's capacity for knowledge and his chances of endurance. Shapley acknowledged areas which the human mind does not and may never comprehend. He pointed out that man's lease on earth depends on the earth's relation to the sun and the sun's to other stars. Man cannot affect cosmic events. He can be responsible only for his own social goals, such as world peace or a world economic organization to alleviate suffering. Man can expect not to be eliminated by animals or microbes. "The greatest danger to man is man himself." Booth was more confident of man's capacity to understand the universe, of the power of human mentality in principle to arrive at truth and the criteria for recognizing it. Only in relation to the galaxy, to cosmic facts, would he admit with Shapley that men are peripheral. In relation to an "ethical, volitional, religious universe," each man is central. "God is in evolution, and it is in the concept of nature that the concept of God must change." Moreover, "Areas of science feel the concept of ethics. We will have a better ethics because of science."

In three years a new decade would begin, and a period for America of increasing dissension and ordeal. Chautauqua kept characteristically on its way during these years, which will here be selectively reviewed as a unit. A new tower rose over Smith-Wilkes Hall for the comfort and preservation of bats, while on the floor of the Amphitheater the rhetoric of the cold war continued to resound. Chautauquans heard that "there is no mollifying the Soviet power—it will demand and keep on demanding." This by a speaker who saw no difference between the Russian ideology and the Russian people. "Communism and Russia are synonymous." General Maxwell D. Taylor, then Army Chief of Staff, gave an address as part of a Theodore Roosevelt Centennial week. It was preceded by elaborate ceremonies—dinner at the Golf Club, preliminary organ music, the "Star Spangled Banner" sung by the audience and two verses of "America the Beautiful" by a soloist. The general invoked Roosevelt's big stick, and said it should be "of varying size necessary to cope with any combination of thugs or foot-pads we may encounter." He reminded his audience that "we have pledged ourselves to assist . . . some 50 foreign nations that may be threatened by Communist aggression." None the less our need was not for bluster, but "clear, truthful, credible speech about what the United States can do and will do." On August 19, watchers on the Bestor Plaza, with a good sprinkling of high-school-agers among them, followed the passage of Sputnik across the night sky, Next year Oliver H. Beale, Australian ambassador to the United States, during a lucid account of Australia's history and position in the Pacific as a result of World War II, referred to "your great Secretary of State, Mr. Dulles," and warned that resistance to Communism might have to go on through crisis and tension for a lifetime.

Chautauqua's more general interest in remote lands and peoples was sustained by such representatives as U Win, Burmese ambassador to the United States, who put the case of a nation that wanted to remain uncommitted, aspiring to what America aspires to without taking sides in the world power struggle. His lecture was followed by a film on the Burmese water festival in Rangoon. Eduardo C. Mondlane from Mozambique, of the Department of Trusteeship of the United Nations, criticized American discrimination against blacks, which he had encountered growing up in mission schools in Africa. Swiss missionaries, he told his audience, would welcome natives into their homes and sit with them at table, while their American counterparts even seated Africans separately in their churches.

Among other topics, organized labor continued to find a place.

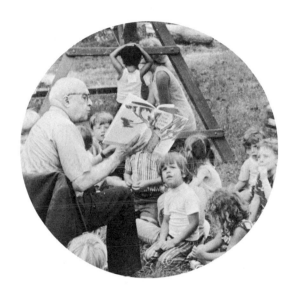

Stanley Ruttenberg, of the research department of the AFL-CIO, said that much of the often feared political activity of his organization had the purpose of getting people to vote. "Let us make our electorate the best informed in the world and then no group will ever take over our government." He cited the deterioration of cities as a principal current problem. James P. Mitchell, Secretary of Labor, deplored the lack of cooperation between labor and management, but in answer to a question said that Communists had nothing to do with instigating or prolonging the current steel strike. Joseph A. Beirne, president of the Communications Workers of America, urged concern on the part of labor with community problems as well as higher wages or better conditions. "A new hospital in a town may be more important to trade union members than, say, an extra holiday written into a contract." In a different vein, Rudolph F. Bannow, president of the National Association of Manufacturers, decried inflation, government spending, and confiscatory taxation. "It wouldn't hurt," he said, "if we had a few more millionaires creating thousands of new jobs." Besides labor, the problems of older people furnished the subject of a conference on "Aging with a Future." Lectures by Professor Leo W. Simmons, Yale sociologist and author of *The Role of the Aged in Primitive Society*, were capped by a Senior Citizens' Day bringing oldsters to the grounds by bus load and car pool.

Among speakers new to Chautauqua, D. W. Brogan, as an urbane analyst of both English and American society and history, addressed himself to "The Crisis of Freedom in the Western World." In America, he saw the balance of power as shifting inevitably toward the presidency as the only place of decision in such a grave choice as the use of the H-bomb. To slow this power by giving Congress a share would "weaken the United States in a way in which the United States cannot afford to be weakened." He warned that the American pattern of living would not spread through Asia and that the expectation of friendliness toward democracy would not be rewarded. Of England he remarked that the snobbery of the English was unequalled in any other nation. "The Queen is the only rich person in England," he said, and observed that the disappearance of poverty on the scale on which it had previously been known had been accompanied by an increase in crime. "The poor were better behaved when they were poor than they are now that they are prosperous." Another speaker new to Chautauqua was Professor Edwin O. Reischauer, Far Eastern scholar and later ambassador to Japan. He supported admission of China to the United Nations and advocated a free Formosa. He had originally thought the dropping of

the atomic bomb unnecessary, he said, but had come to think that it saved millions of lives, and that the fire raids over Tokyo had done more damage and caused more resentment. Among familiar speakers, Karl Menninger, discussing "Crime and Punishment," observed that 90 percent of those behind bars are poor, and that "well-to-do people do not get in prison." His prescription for dealing with destructive energy was, "Don't destroy it; employ it!" In the midst of such discussions the *Daily* reported on July 13, 1959: "The Chautauqua Amphitheater reverberated with enthusiasm last Saturday night as over 10,000 people, the largest crowd in the 15 years that Ralph McCallister has been Program Director, enjoyed the lively songs of the Kingston Trio." The *Daily* took notice of the standing-room crowd and of boys spreading newspapers on the aisle floors to protect the dresses of girl friends.

Chautauqua rounded out the decade with another change of administration. In July of 1960 Judge Braham resigned as president of the Institution, to be succeeded by J. William Carothers. The new president had gained extensive experience in management and personnel work with leading corporations and committees on industrial relations. He told Chautauquans: "We raised our children here, and now we're having our grandchildren here." He expressed his desire to keep Chautauqua a "family-place."

The Sixties and Vietnam

A pair of off-season events affected the Chautauqua season of 1961. In midwinter, on January 22, fire broke out in the Colonnade. This was not the first mishap of the sort that Chautauqua had suffered as a vulnerably crowded community of largely wooden structures. Despite the salvage of some equipment and records, the Colonnade fire left an aftermath of debris and destruction. Tons of ice, said the *Daily*, added to the damage caused by smoke and flame. President Carothers thanked the Firemen's Auxiliary, local volunteers, crews from surrounding towns, the staff of the year-round St. Elmo Hotel, and other Chautauqua units who pitched in to help. The work of rebuilding began in April, resulting in the present serviceable brick Colonnade. In the same month Ralph McCallister resigned as program director, a post he had conducted resourcefully since the death of Stoessel in 1943 and the ensuing death of President Bestor, which had left a critical gap in the Chautauqua administration. Informed Chautauquans suggest that McCallister and the new president were less than congenial with each other, but whatever lay behind McCallister's abrupt resignation, it took effect. He was succeeded by Curtis W. Haug as acting director. In 1964, after the

one-year presidency of George L. Follansbee, Haug himself became president of the institution. He had been prominent in YMCA work, and said that he regarded his Chautauqua post as an extension of it "on a much broader basis."

Meanwhile events on the national and world scale were leading toward a period of dissension, violence, and ordeal that was to continue into the 1970s. Chautauqua suffered one disturbance of its program in 1961 which directly reflected such outside occurrences. In August Wilhelm Grewe, German Ambassador to the United States, told a lecture audience: "The Western Allies should be prepared for civil war, restricted war, subversion, revolution, or any other means employed by the Soviets to gain their ends." Before dawn on the day preceding his address, East Germany had closed its borders with the West, and during the next few days began building the Berlin Wall. Ambassador Grewe was called to Washington and forced to cancel his next lecture. Otherwise Chautauqua programs carried on as planned. In July the *Daily* paid tribute to Rebecca Richmond, whose death had occurred in February. She was a devoted Chautauqua author and familiar presence, who sometimes feared that the Institution was in danger of losing the liberality of perspective it had inherited from the first generations. Dr. Karl Menninger continued to be a welcome and benign lecturer. In 1962 he took up the question, "Can We Afford to Punish?" He deplored the fact that the death penalty remained in force, infected, as he believed, with recrimination and vengeance inconsistent with Christianity. "The State has no more right to commit murder than the individual has." Asked what Israel should have done with Eichmann, he said the world would have received a better lesson if he had not been executed. Questioned about juvenile criminals, he said that the first step in dealing with them should be the reform of our system of detention, which operates under conditions that breed hate.

Chautauqua has always welcomed spokesmen from remote lands and peoples, whether from curiosity about the exotic or concern for world problems. This continued to be true during the developing sixties. In 1962 Dr. Chun Ming Chang, representing the government in Formosa to the United Nations, told the Amphitheater that "The very existence of the Republic of China implies the eventual overthrow of the Communist regime on the Mainland." It was not a question, he said, of a population of eleven million against six hundred million, but of six hundred million against their oppressors. Next year Vera Micheles Dean gave a lecture series on "West and Non-West." Born in St. Petersburg in Russia, where her father represented American firms,

she lived for two years during World War I in Finland. She later took a Radcliffe Ph.D. and became a member of the writing and editorial staff of the Foreign Policy Association and a correspondent of the United Nations for the News and Feature Alliance of India. Her conception of "Non-West" included nations that had undergone little or no experience of the forces that had shaped the West, from ancient Greece through the Renaissance, the Reformation, and the Industrial Revolution. In this sense she considered South America and Russia as non-Western. All sorts of societies, she observed, had come to call themselves democracies. The word had become a symbol of respectability, and it was unsafe to assume that democracy prevailed simply because the title had been adopted. Democracy must be preceded by the elimination of such practices as agrarian serfdom or indentured labor. She suggested other criteria such as the separation of church and state and equal opportunity regardless of sex. "The newly emerging nations of the Non-Western world are facing the enormous task of telescoping all the revolutions that have shaped the West into a few decades," she declared, and warned against any easy assumption of Western superiority.

Similar views were expressed in 1965 by S. O. Adebo, ambassador from Nigeria to the United Nations. Democracy, he said, had become an abused word. Within a wide spectrum of socialism very diverse forms of democracy existed. He declared that thirty-six African countries were governed by leaders who represented majorities, but that one, South Africa, did not choose to follow their example. In the same year, George R. Laking, New Zealand's ambassador to the United States, observed that it took the depression of the thirties, the Second World War, and the dissolution of the British Empire to make New Zealanders realize their full independence and to understand that their security was bound up with developments in Asia. No longer sheltered by the British Navy, New Zealand defense depended on the emergence of the United States as the dominant Pacific power. Japanese-American relations were explored for three days during the next session by a meeting at Chautauqua of the American Assembly. Some seventy delegates from business, government, education, and religion met in small groups and in a plenary session and issued a report on such topics as trade, defense, and the status of Okinawa. The assembly deplored its own ignorance of the culture and history of Japan. In 1967 Lisa Sergio, introduced by the *Daily* as a well-known lecturer from Washington, discussed the Middle East and related problems. Communism, she observed, was not the monolith it has been supposed to be. She chided

the State Department for not consulting missionaries, educators, and businessmen on what was going on in the Middle East, and remarked that the department did not have a desk on Africa until well after 1957. "We were officially ignorant in that area."

While these excursions into distant arenas of tension were taking place, problems nearer home and topics of general intellectual or cultural interest were not overlooked. John Ciardi, translator of Dante and poet for both adult and younger readers, discussed the maker's art. Two presidents of railroad unions attacked the rail systems of the country for ill-advised merger proposals and for undermining passenger service. By contrast, a vice-president in charge of public relations evoked an as yet unfulfilled vision of rail service in the 1970s, predicting travel on super-trains transfigured by such technologies as automation. Dr. Walter H. Clark, professor of the psychology of religion at Andover Newton Theological School, joined Harlow Shapley and Edwin Booth in another Chautauqua session of the Institute of Religion in the Age of Science. Professor George H. Williams of the Harvard Divinity School reported on "The Vatican Council from John XXIII to Paul VI." He praised the ecumenical spirit of Pope John, declaring that "he liberated the Catholic Church from a kind of captivity of Western European society." Williams reported that twenty-eight Protestant and Oriental observers enjoyed the best seats and were allowed to stay when deliberations began, while many Catholics were dismissed. Pope John, according to Professor Williams, granted these observers an audience, originally scheduled for eleven o'clock on a Sunday morning. The time was changed to allow for their customary devotions, and when the audience took place, the Pope urbanely explained himself. His chambers were full of buttons, he said, "a button for everything." If he wanted to consult an expert on the population explosion, he had only to press the button for that topic. All he lacked was a button to tell him the proper time to meet Protestant ministers.

Population was only one of the unresolved problems that did not originate with the decade of the sixties but occupied much of its attention. Another was the global problem of race, in its American aspect the struggle for equality of citizenship, chiefly for blacks. In 1963, Harlan Cleveland, assistant secretary of State for International Affairs, described the multiplicity of commitments to international organizations that Americans had made, often unawares, and took occasion to say that "1963 is the year patience ran out for the American Negro." In 1965, Dr. Clarence Jordan, lecturing for the department of religion, discussed the racial aspect of the Vietnam war. While the world is two-

thirds colored, he said, "we are just now barely convalescing from our own racial strife and now we have the white men bombing and destroying men of color" John G. Stoessinger, a frequent lecturer during this period, gave similar emphasis to race. Forced to flee from Nazi-occupied Austria at the age of eleven, and again from Czechoslovakia across Siberia to China, Stoessinger had come to this country, taken his Ph.D. at Harvard, and taught at leading American universities. Developing nations, he said at Chautauqua, do not forget colonialism. "Racial equality is of utmost importance." In Africa, the United States is judged almost exclusively by its handling of the race problem.

Inseparable from the problem of minorities was the twin theme of poverty and the cities. In 1966 Samuel D. Proctor, Negro director of the Institute for Services to Education, spoke on "Breaking the Poverty Cycle." Of the six thousand Negroes earning $25,000 a year, he said that "These people with their Cadillacs and pretty wives only confuse the picture. . . . The poverty cycle is an inherited condition, passing from one generation to another . . . with a strong correlation to dropouts from school, crime, broken homes, illegitimacy and disease." And he added that "where the poverty problem is at its worst, the resources are most limited." He considered that for the first time Americans were attacking the problem in a large way, but that only a massive and more than local program could expect results. In 1967, Governor George Romney of Michigan was hailed by the *Daily* as "the forthright top-runner" among prospective presidential candidates for 1968. Born in Mexico of American parents, Romney had resigned both his official position in the Mormon church and his presidency of American Motors Company when he was elected governor. He was presented to the Amphitheatre by another Republican political figure with the words, "We welcome you to a riotless Chautauqua." The *Daily* reported that "The hour-long speech of Governor Romney was marked by burst after burst of spirited applause." The governor's picture of America was less than favorable. "Abysmal poverty amidst affluence, rising crime rates, increasing drunkenness, drug addiction, immorality, deterioration of family life, pollution of air and water, urban decay . . . riots and race-hatred—all these can make us seem to be what our enemies say we are." He attacked Stokely Carmichael for advocating guerilla warfare in American cities, and "drew tumultuous applause" when he emotionally charged that "Carmichael's action was traitorous." With less vehement rhetoric, the black mayor of the District of Columbia, Walter Washington, dealt with similar themes during the next season. "The American city," he said, "is our most challenging frontier. . . . Every city in

America that has had a disorder or a riot has had one common denominator: too many people in too little space." A power failure due to violent weather, says the *Daily*, reduced the Amphitheatre to darkness, but Washington went on with his speech and greeted hundreds of listeners who came to the platform when he had finished. If the weather somewhat cut down the size of the audience, the *Daily* still thought the occasion one of the most enthusiastic Fourth of July ceremonies for a number of years.

Race and urban decay again pressed for attention during the following season. Joel L. Fleishman, assistant provost for urban studies at Yale, gave a series of lectures on "The City in Black and White." Bernard Eisman, news correspondent, warned of the consequences of "suburban apartheid." In 1971, Carl T. Rowan spoke on "The United States and Revolution." The *Daily* introduced Rowan as one of the first fifteen Negroes in the history of the country to be commissioned as a naval officer. Formerly chief of the United States Information Office, ambassador to Finland, and member of the American delegation to the United Nations, he had made himself known as a TV commentator, reporter for the *Chicago Daily News,* and roving editor of the *Reader's Digest.* Rowan recalled his own rise from poverty. But for the accident of finding a $20 bill on campus, he might not have been able to pay his tuition and finish his education. He considered busing an attempt at educational justice. America, he declared, faced collapse unless the affluent majority responded to Negro poverty and unemployment. Black Panthers and Weathermen were no more than "symbols" of revolution in the United States. Wiretapping and "no-knock" crime legislation were eroding freedom, while "white vigilantes and black guerrillas" were omens of a society "not worth living in." He regarded the black separatist movement as "one of America's great tragedies." Most black Americans, he maintained, were not copping-out but demanding "their fair share of their American birthright." But Chautauqua's receptiveness to blacks was not limited to platform discussion of national policy. Twice during 1972, week-day and Sunday religious services in the Amphitheater were conducted by Negro Chaplains of the Week, the first the Right Reverend John W. Burgess, bishop of the Episcopal diocese of Massachusetts, the second the Reverend Kelly Miller Smith, minister of the First Baptist Church of Nashville, Tennessee.

When the times are out of joint, youth becomes a subject of disparagement, bewilderment, and occasional defense. With it goes a tired but unavoidable string of labels and clichés—drugs, the generation gap, juvenile delinquency, and alienation, to name a few. Officials of the

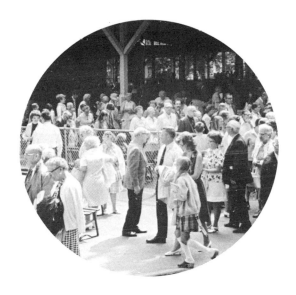

Institution privately report that Chautauqua has not up to the present been vexed by any serious manifestation of drug use, but it has had its say about the incidence of the problem in the larger society. In 1963 the *Daily* reports a lecture to the Woman's Club by Lois Higgins, president of the International Association of Women Police, under the title "I Am a Cop." As principal problems of delinquency, she listed narcotics, pornography, and gang warfare. She gave statistics of addiction, asked her audience to be aware of legislation on the subject, and spoke of the need for strong moral values as a preventive. Later in the season Milton Luger, of the New York State Division for Youth, said that "When you get beyond the bravado, hostility and cockiness of the juvenile delinquent, you find people who are inadequate, have a miserable self-image, consider themselves worthless." They see no place for themselves in existing society, "and will let somebody know about it before they go down." He saw delinquency as a complex problem with no easy solution. Like Dr. Menninger, he recommended trying to absorb rebellious energy rather than meeting it with fixed resistance. He considered the school system geared to conformists and thought that "clamps on kids," such as labor laws favoring adult workers, harmfully delayed growing up.

In 1967 Representative Charles E. Goodell observed that more than eighty million Americans were under nineteen years of age, and offered the figure as a challenge to youth as it faced the future. But he found it "a shocking fact that the seven most serious crimes listed by the FBI are committed by young people." He considered permissiveness an important though not the only cause. He expressed sympathy with those of draft age who wondered why we were at war in Vietnam, but did not advocate that we "cut and run." In 1970 a two-week course in narcotics education came under the direction of Helen M. Allen of the Narcotic Education Bureau of the WCTU. A similar class had been offered some seventeen years earlier. In 1972 Douglas H. Heath, professor of psychology at Haverford College, gave a lecture series in which he sought to interpret the experience of young people in a world of dislocation and their attempts to cope with or relieve themselves of the pressures that weighed on them. He spoke of their sense of meaninglessness. "Youth's problem today is how to get themselves together . . . they feel that they are unraveling because of our incoherent society." He asked why so many young men were interested in work with children, and suggested that they wanted an outlet for their feelings of tenderness, and could find it in the school room, "reclaiming part of their suppressed childhood." He thought nothing so damaging to youth as

failing to see anything done about problems they considered in need of immediate solution. He lamented "the increasing number of loners" and thought that young people were growing less interested in durable personal relationships. Women's liberation and gay liberation were transforming the conception of male and female roles. We are beginning to learn, he said, that "sexual stereotypes are destructive," and that in the future the sexual role "will be more personally than culturally determined." He pointed out that a homosexual had been appointed president of the student body at the University of Minnesota and that in Sweden both sexes are encouraged to discover the sexual pattern of their choice. "Money, material success, and security," he said, were no longer powerful incentives to the young.

On one occasion youth was not merely discussed but given a chance to speak for itself. In 1969, Landrum Bolling, President of Earlham College in Richmond, Indiana, spoke on the responses of the young to the Vietnam war, a theme which must be treated separately. His remarks included a plea for understanding of youthful styles of dress, and at the end of his lecture series he opened himself to questioning by a youth panel in a "Sidewalk Session." When the generation gap came up, one of the panel said that a gap exists not only between thirty and fifty but between fifteen and twenty-one: everything moves fast! Another member asked Bolling what he would do if a building at his college were taken over. Bolling answered that he would take the case to all the students. If they did not support the occupiers, the take-over would collapse. If they did, the administration ought to listen. The question of values brought from a girl freshman the statement that the young were challenging the values of their parents, and parents were finding it hard to answer. The case went beyond the problem of communication. "You should draw values that are important to you . . . reject them if they are not for you . . . find those values that are useful to you." If the statement left much out of account, it certainly was not unique.

In a period that faced small danger of running out of problems, population, birth control, and ecology came in for prominent attention during the years from 1966 on. Robert E. Jensen of Syracuse University observed that the industrial societies had secured a higher standard of living than the agricultural, but warned that the gap would close. "As industrial nations expand, the standard of living will decline." Four hundred million people, especially in Asia, he said, were living beneath the level of subsistence, and he urged a regional approach to the problem of population and resources. With a projected global population of thirty-two billion by the year 2075, the world was already in a state of

starvation, and a beginning toward conservation and wiser use of resources might already be too late. A speaker for planned parenthood remarked that interest in the control of conception went back to the "ladies and gentlemen of the court" in ancient Egypt, but had become a concern of all levels of society. He recognized the variation in their attitude toward birth control of different cultures. Israel and Cuba, he observed, both wanted to increase rather than restrict population, but hoped that modern contraceptive methods would reduce abortion. He discussed advances in birth control technique, and pointed to the statistical effectiveness of the pill and the IUD. Acknowledging that incentive was important to family planning, he said that "patriotism as a motive is not enough," and that some prospect of personal gain or advancement must be shown.

In 1972 Chautauqua presented an Ecology Week. Its theme was anticipated in one of the impressive lectures on "Judaism in a Christian World" given for the department of religion by Rabbi Robert Gordis of Temple University and the Jewish Theological Seminary. Speaking on "Ecology and the Bible" and making his case from Biblical and Rabbinical tradition, Dr. Gordis opposed the doctrine "that every nation has a right to develop its resources as it sees fit. . . . There are legitimate limitations upon the rights of peoples and communities to expand their resources in any direction they like. This ecological crisis which is coming upon us . . . now threatens the very survival of the human race." Ecology Week itself presented a thoroughgoing exploration of the subject by speakers from the scientific faculty of Fredonia University. It went beyond the bounds of the Amphitheater platform, offering, in addition to a formal lecture series, a workshop sponsored by the Social Science Research Institute. It also furnished the topic for the CLSC address on Recognition Day, and enlisted the boys' and girls' clubs in the collection and disposal of newsprint and the inspection of the grounds for undesirable ecological practices. It took note, besides such general technical questions as ecosystems, population, and pollution, of the critical deterioration of neighboring Lake Erie and of sources of contamination to which Lake Chautauqua itself was subject.

Amid such a jostle of social problems, the arts might have received short shrift, but they continued to have their spokesmen. In the Hall of Philosophy, Russian writers of current interest such as Pasternak, Voznesensky, and Yevtushenko were discussed. In the Amphitheater, poetry was again represented by John Ciardi and by David McCord, affectionately known for his essays, his light verse, and his poems both for adults and children. Howard Hanson, familiar to Chautauqua as

composer and conductor, observed that "the greatest friends of the Arts are the scientists and the mathematicians, and the greatest enemies are those working in the humanities." He conceded that the artist had a harder time obtaining grants and fellowships than the physicist, but was cheered by increasing governmental and public support for artistic concerns. He objected to a common pattern which he found exemplified by the New York State Commission on the Arts: it did not have a single practicing artist on its board. He recalled, as an example of the traditional Puritan prejudice against the arts, that when he told the school superintendent of his town that he wanted to study music as a career, he got the answer: "You don't need to be a musician; you have brains."

On the political front, Drew Pearson, Washington columnist and son of Professor Paul Pearson, who established the Swarthmore Chautauqua circuit, appeared in 1966. Recalling his service as a tent boy and later lecturer under canvas, he went on to predict that Governor Romney would win the next Republican nomination and that war in Vietnam would end with the current or following year. Time did not bear out either prediction. Tom Wicker, then chief of the Washington Bureau of the *New York Times,* observed that Congress had become a subordinate branch of the government, inferior to the president. In the actual election year of 1968, the *Daily* reported that in a small poll of Chautauqua opinion, Eugene McCarthy ran two votes behind Governor Rockefeller, but that both lagged far behind Nixon. In the same season another speaker observed that "our State Department professionals and the Russian Foreign Office both see an end to the Cold War but there is a military attitude in both countries that would like to keep it going." On the medical and geriatric front, Dr. Paul Dudley White spoke trenchantly about coronary disease, and in 1972 Judith Wieczorek, of Mercyhurst College in Erie, discussed the Mercyhurst experiment in classes for the elderly on health, leisure, and conversational study of foreign languages. Shortly after her address, the *Daily* reported incipient plans for some sort of permanent machinery at Chautauqua for making more use of the retired talent it attracts and for research into ways of improving life for the elderly in general.

One overmastering ordeal distinguished the years that took the country through the sixties and into the seventies. It was intertwined with virtually all the other anxieties, dissensions, and threats that vexed the period—race, poverty, ecology, youth, revolution—but for purposes of this record it may be treated as a distinct strand.

An early discussion of the Vietnam war occurred at Chautauqua in 1962 when Philip Van Slyck, of the Foreign Policy Association, spoke

on "Laos and Vietnam, a Test of U. S. Policy." Van Slyck observed that among the peoples of Indochina, Cambodia alone had hitherto kept outside the ideological struggle. He said that "free Laos was existing solely on Communist sufferance." For victory in South Vietnam, he declared, the United States would have to combine military and civilian planning. He advocated closing the routes by which invasion was supplied, increasing our military forces, and extending control of rural areas through political action and economic reform. Where control proved impossible, he recommended moving people out, destroying villages, and burning crops. "This is not a pretty policy and it is not a pretty war." The object of United States policy should be "the construction of the basis of a society for which the people will be willing to fight."

Three years later, in 1965, the number of United States troops in Vietnam had vastly increased, and the season at Chautauqua proved especially prolific in discussions of the war. July provided a Vietnam Teach-In sponsored by the CLSC and moderated by its director, William Keyser. A Special Assistant in the State Department, Turner Shelton, began the proceedings by supporting the determination of Washington to stand firm, but said that the way to negotiation was always open, though Hanoi did not appear interested in a peaceful settlement. President Johnson had made every effort to bring about a multilateral solution through the United Nations, but "we cannot break faith with the people of South Viet Nam." Donald Bishop, Professor of Political Science at Syracuse University, also upheld the administration in "taking a stand" to contain Communism. He thought that the moral position of the United States had improved during the past months, and that efforts to negotiate had become more active. Dr. Clarence Jordan, appearing as guest lecturer for the Department of Religion, sang a different tune. He has already been quoted on the racial aspect of the war. At the teach-in, he declared that "public opinion is almost totally disregarded. The nation clearly repudiated Goldwater, but the policy of the Government has not changed one whit since Johnson became President." He questioned aid to a Vietnamese government he regarded as corrupt, and he carried dissent to its ultimate principle, saying, "I am prepared to take part in civil disobedience when compliance with government becomes defiance of God." Edwin P. Booth declared that "People of one continent have no business trying to control people of another continent" and looked to the United Nations as a way toward settlement. John G. Stoessinger feared involvement with China and Soviet Russia, and said, "We are losing our values in this fighting in Viet Nam."

At a Sidewalk Session, the panel of speakers replied to questions. The *Daily* reports an anonymous young man who expected soon to serve in Vietnam as asking what future course of action President Johnson would take. From the State Department representative he received a professionally bland answer: no unnecessary action. Some days later a questionnaire on the war was circulated, prepared by the director of the CLSC. It asked those who filled it out whether they expected Russia or China or both to enter the conflict and whether it should end in withdrawal, victory, or negotiation. It also asked whether the teach-in had affected their opinion, and whether they supported or did not support United States policy. So far as this chronicler has been able to discover, the results of the questionnaire were not reported.

On July 24, the *Daily* devoted an editorial column to the report of the Clergymen's Emergency Committee for Vietnam. The committee, said the column, had met with leaders of many faiths, with soldiers, students, correspondents, labor leaders, teachers, and with both American and Vietnamese political figures. It had talked with supporters of Hanoi and members of the National Liberation Front. The committee declined to pronounce either side wholly right or wrong. It had seen courage and conviction on both sides, and both using terror and violence. It could foresee no immediate military solution. It considered that the major powers were using Vietnam villages as testing grounds for conflicts of ideology, and that life was being degraded and brutalized by both parties to the struggle. It urged a stop to bombing as a pledge of good faith in seeking a cease-fire. Once more the United Nations was invoked to help toward a settlement, and the committee favored inviting even nations who were not members, such as Communist China and the two divisions of Vietnam itself, to participate in negotiation. Independence or reunion of North and South should be left to the principals, the Committee said, but with guarantees against outside intervention. A week after this editorial summary had appeared, Gerald R. Ford, then minority leader of the House of Representatives, spoke at Chautauqua on a "Face the Press" program. "For the United States to withdraw from Viet Nam and take our defense line back to Pearl Harbor," he said, "would be disastrous," but he opposed bombing population centers, and thought that the military potential of the North could be destroyed without such measures. He felt that committing increased numbers of troops was justified to protect American men and material, but not if war on a large scale resulted. Asked by a reporter if he had any answer to the mess, he saw no specific answers, but declared, "We will make the cost of a Viet Cong victory so high they will not want to continue when they realize they cannot win." Criticizing

the President's economic management of the war and his piecemeal method of giving information to the public, he called for supporting him nonetheless and tightening belts as a protection against inflation.

In August Chautauqua received a visit from Senator Robert F. Kennedy, former Attorney General and brother of the assassinated president. The senator took part in another "Face the Press" program in the Amphitheater. The *Daily* introduced him as a good-will traveller who with Justice William O. Douglas had made a tour through Central Asia in 1955 and later had visited Japan, Formosa, Hong Kong, Indonesia, Thailand, and South Vietnam as well as Western Europe and South America. At the time of his Chautauqua appearance, Senator Kennedy was still supporting his brother's successor, President Johnson, "having voted," as he said, "for the 700 million for the Vietnam war." He added: "I would be happy if we also provide 700 million for schools and the like to meet more of the social needs of Viet Nam." He feared, as previous speakers had, that the Vietnam struggle might turn into a "white man's war against the Asians . . . if we do all the fighting. . . . We must offer the people of Vietnam something for the future; not just napalm, bullets and bombs . . . there must be political effort working toward a political solution." He anticipated higher casualties and "a considerable length of time" before a settlement. "If we send a million American soldiers to Viet Nam we are not going to win if the people themselves are not going to fight." At this point the *Daily* reports a "spontaneous wave of applause." Nearly three years later, after President Johnson had announced that he would not seek reelection, Kennedy was assassinated in the midst of his primary campaigns for the Democratic nomination. The *Daily* recalled his visit of 1965, saying editorially: "Chautauquans share the deep sense of national loss in the death of Senator Kennedy and horror over the circumstances which surrounded it."

A single pair of examples must stand at this point for all the multiple activities that went on at Chautauqua notwithstanding Vietnam and other topics of a disordered world. During July, Marian Anderson gave the last of her several Chautauqua recitals, a part of her farewell tour. Born in the Negro quarter of Philadelphia, where her father sold coal and ice, she became known at the age of eight as a baby contralto. Her first fee came to the munificent sum of fifty cents. Graduating to membership in adult choirs, she sometimes filled in for an absent soprano, tenor, or bass, rising to fame as one of the leading singers of her time. An audience generously estimated by the *Daily* as approximating ten thousand gave her the cherished Chautauqua salute as a farewell. In

the same month a concert by Guy Lombardo and his Royal Canadians brought to the grounds the greatest number of cars ever known for a special event, and created a parking problem that spread from the arts and crafts quadrangle in the northwest quarter to the ball field near the lake in the southeast.

After 1965, Vietnam did not cease to press for consideration. During the next season, the South Vietnamese ambassador, Vu Van Thai, predicted that the war would be over by the end of the year, and said that "because the Communist challenge is one and everywhere, we should attempt a global response." Increased air assaults in the North, he declared, were actually de-escalating the war instead of enlarging it, and he was applauded for his answer to the question: would your government accept a freely elected Communist regime? "No Communist government," he said, "has come to power through generally free elections." His principal theme was the need for a regional approach to Southeast Asia, where he thought the separate nations too small and economically limited to hold their own against such societies as China. Later in the season, the Right Reverend William E. Crittendon, bishop of the Episcopal Diocese of Erie, Pennsylvania, said that the crucial question was "whether or not the war in Vietnam is a just war." Observing that "No Christian would take up arms . . . until about the year 175," the bishop said that since the fourth century the Church had held that its people could participate in a "just" war. This position changed with the Stockholm Conference of 1937, which conferred on Christians the liberty of taking part in armed conflict. "I am not a Pacifist," the bishop declared, but expressed concern for many questions raised by Vietnam that seemed to run counter to the Church's principle that all nations, creeds, and colors form a brotherhood. He reported Secretary of State Dean Rusk as telling him in conversation that more civilian casualties were being inflicted than military; this, for Christians, raised a serious moral problem. No war in American history, the bishop said, had provoked so much criticism. In the same year of 1966, Senator Thruston Morton of Kentucky, debating the issues of the mid-term campaign, told Senator Edmund Muskie of Maine that the words of dissident Democrats were being printed daily on the front pages of Hanoi and Chinese newspapers.

One discussion of Vietnam inquired specifically into the responses of the generation called on to fight it. In 1969, Landrum Bolling, president of Earlham College, whose Sidewalk Session has already been reported, addressed himself to his sense of how students felt about the struggle. "The youthful repudiation of the war in Viet Nam," he said, "has been

the most important single political fact of our times." The young had been turned into severe critics of society, he declared, by the "whole broad issue of war and peace" and the threat of nuclear annihilation. Many people with whom he had discussed Vietnam saw the conflict there as a civil war, involving no vital American interest and offering no promise of benefits. The failure of any president to ask Congress to declare war had left the young "cynical and appalled." Students felt guilty about Vietnam, unjustly protected by their college status. He observed two psychological reactions: "wild rage" and "hopeless withdrawal." Two seasons later, in 1971, Bolling spoke again of Vietnam and its reverberations. He chided those of the young whose answer was to cop out. He was concerned that America was becoming the "polar center . . . of the status quo . . . of the haves against the have nots." If we had found a leader comparable to De Gaulle, who "turned France around" in relation to her Algerian struggle, we might not be in Vietnam. Neither our leaders nor our people were capable of admitting a mistake. He saw "blame enough to go around." It would include the military, the politicians, the citizenry. In its first days, the war had enjoyed bipartisan support, and escalation met with approval on the TV, in the press, and among current doves who had been hawks in the early sixties, not excluding "Senator Fulbright, the *New York Times,* and Huntley-Brinkley." The country, said Bolling, "shared a dream of what our mission was . . . we genuinely did want to help small nations," and to prevent Communist take-overs. President Kennedy's decision to send in troops had been the real turning point, after Eisenhower refused to come to the rescue of Dien BienPhu and declared, "I am not going to bail out France." But Kennedy's decision had not been purely military; it had been political and strategic.

In the same season of 1971, Bill Hatton, of the organization of Vietnam Veterans Against the War, spoke and showed a film to the Student Union. The *Daily,* in a special article signed by Doug Miller, reported him as giving an "incredibly interesting and convincing speech on the need for immediate U.S. withdrawal. . . . Wearing his old combat fatigues and a new moustache," Hatton told of "murder and torture of civilians and prisoners by the Americans." He had served three years in the marines before Vietnam, but two weeks there turned him against the military. "I hated what I had done and permitted to go on in Vietnam," Hatton is reported as saying, "and when I came back I spent time figuring out ways to torture my cat, and was so paranoid I carried a pistol in my pocket for eight months, until I could finally get my mind straightened out."

Hatton's words bring the discussion of the Vietnam War full circle, from support of its avowed purposes to ultimate revulsion and repudiation. Reviewing what the Chautauqua platform has had to say on the major issues and dissensions of the sixties and after, one must conclude that virtually all that come readily to mind were reflected, often repeatedly, by speakers of one or another degree of insight or variety of conviction. Population, ecology, crime, poverty, race, youth, drugs, the decay of cities, the omens of revolution, all found voice, all were debated or given expression. To this extent, Chautauqua exemplified George Vincent's precept that it must be kept "in close and sympathetic connection with the great currents of national life." Different readers may well feel that different themes on the convulsive list received short shrift or might have been explored in greater depth. On race, for example, it is obvious that Chautauqua has welcomed Negro singers, Negro chaplains, Negro speakers, and from some of them has heard sufficiently firm and unfettered words on the needs and rights of black Americans. But it would be hard to sustain a claim that Chautauqua has been in "close and sympathetic" touch with the black movements and developments, political, religious, literary, or social, and the changes they have undergone since the civil rights struggles of the fifties and after. Again, some readers may be surprised that for an educational institution, Chautauqua has paid so little attention to campus disruption. Yet a reminder is once more in order that Chautauqua is a *summer* place, a "family place," and a place of vacation. Its buildings have not been occupied, its files have not been rifled, it has not suffered the confrontations that threw universities into turmoil from Berkeley to Columbia. Chautauqua did have its bomb scare, which proved to be a hoax, probably originating from outside, but which emptied the Amphitheater in the midst of a Sunday evening service and caused its transfer to the drawing room of the Athenaeum Hotel. From much of the violence of society at large, Chautauqua has enjoyed an immunity of which no one would want to deprive it, unless there are those who would object on principle to any place of refuge in a world of conflict. And if immunity sets a limit to "close and sympathetic connection" with great social currents, if Chautauqua can discuss riots while remaining riotless, nonetheless its removal from the experiences of Watts or Detroit or Washington does not invalidate its function of debate and discourse.

On the Vietnam War, the issue of issues for its time, it must be said that Chautauqua largely paralleled or reflected the divisions and movements of opinion in the country at large, from approval of the national

involvement or acquiescence in it to the misgivings, the mounting frustration and revulsion as the conflict dragged on. Reflection rather than leadership or influence may well represent all that could have been expected. Yet Chautauqua has claimed leadership as one of its distinctions, and it has worn the character of a moral and religious as well as educational and cultural center. Some readers may feel that specifically moral discussion of the war kept within fairly meager limits. They may feel that more attention might have been given to the whole topic of civil disobedience, to the evidences of secrecy and deception toward the public on the part of two administrations, to the problems of the young men who exiled themselves to Canada or Sweden, or who deserted from the armed forces, or who are still serving jail sentences for conscience. On a free platform, such blood-heating issues would be discussed pro and con, but Chautauqua may seem a place where they might have been more strenuously explored. In seasons to come, they may still thrust their way to the fore.

Whatever its gaps or imbalances, the record does reflect the divisions and heart-searchings of the country in its Vietnam ordeal. And while the Amphitheater and the Hall of Philosophy and the clubs and denominational houses discussed and debated, the other activities of the Institution went on in all their multiplicity. Its fishermen fished, its preachers preached, its teachers taught everything from pedagogy to foreign languages to Braille and Japanese paper-folding, its baseball and tennis and golf players put their muscles to work in their sports, its plays and operas and ballets kept the stage active at Norton Hall, its bands and choirs, soloists and orchestras and ensembles, visiting stars and youthful talent sounded their instruments or raised their voices, its bats flew unmolested through the evening air. In a world wrenching itself with change, Chautauqua provided an example of institutional continuity which is at the least a tribute to its holding power and its stout if sometimes bewilderingly complex pursuit of its inherited goals.

Tradition and Evolution—A Trial Balance

Chautauquans are accustomed to hearing their Institution praised, as it has been by presidents, scholars and administrators, men and women of distinction in many kinds of careers extending over a heyday from Ulysses Grant to Franklin Roosevelt. Generations at Chautauqua have been taught to regard it as a uniquely American phenomenon, as unique also in an absolute sense, American or not. In their familiarity with its manifold activities they often seem unaware of the impression of incongruity it can give to someone less immersed in its daily life. Yet Chautauqua has had its critics and taken its knocks from them now and again. Two in particular bulk large in the annals of American and English writing. Their responses to the place belong to its history and provide a means for considering how it has changed and how it stands today in a world transformed out of recognition from the world of its beginning.

The letters that William James wrote home to his wife from Chautauqua in 1896 have already been sampled earlier in these pages. But the effect of his visit there worked on him to such an extent that he returned to his principal charges and gave them considered form in 1899 when he published his *Talks to Teachers*, which included some chapters addressed to students. In one of the latter, entitled "What Makes A Life Significant," James gave with one hand and took away with the other.

A few summers ago [he wrote] I spent a happy week at the famous Assembly grounds on the borders of Chautauqua Lake. The moment one treads that sacred enclosure, one feels one's self in an atmosphere of success. Sobriety and industry, intelligence and goodness, orderliness and ideality, prosperity and cheerfulness, pervade the air. It is a serious and studious picnic on a gigantic scale. Here you have a town of many thousands of inhabitants, beautifully laid out in the forest. . . . You have a first-class college in full blast. You have magnificent music. . . . You have every sort of athletic exercise from sailing, rowing,

swimming, bicycling, to the ball-field and the more artificial doings which the gymnasium affords. You have kindergartens and model secondary schools. You have general religious services and special club-houses for the several sects. You have perpetually running soda-water fountains, and daily popular lectures by distinguished men. You have the best of company, and yet no effort. You have no zymotic diseases, no poverty, no drunkenness, no crime, no police. You have culture, you have kindness, you have cheapness, you have equality, you have the best fruits of what mankind has fought and bled and striven for under the name of civilization for centuries. You have, in short, a foretaste of what human society might be, were it all in the light, with no suffering and no dark corners.

I went in curiosity for a day. I stayed for a week, held spell-bound by the charm and ease of everything, by the middle-class paradise, without a victim, without a blot, without a tear.

And yet what was my own astonishment, on emerging into the dark and wicked world again, to catch myself quite unexpectedly and involuntarily saying: "Ouf! what a relief! Now for something primordial and savage, even though it were as bad as an Armenian massacre, to set the balance straight again. This order is too tame, this culture too second-rate, this goodness too uninspiring. This human drama without a villain or a pang; this community so refined that ice-cream soda-water is the utmost offering it can make to the brute animal in man; this city simmering in the tepid lakeside sun; this atrocious harmlessness of all things, —I cannot abide with them. Let me take my chances again in the big outside worldly wilderness with all its sins and sufferings. There are the heights and depths, the precipices and the steep ideals, the gleams of the awful and the infinite; and there is more hope and help a thousand times than in this dead level and quintessence of every mediocrity."

Surely only the most thin-skinned of Chautauquans could bridle at this passage today. Surely one's immediate response to it must be delight in its verve and impetuosity. Any attempt to reply to it solemnly would be pompous beyond measure. One may nevertheless venture a few comments. The serious part of the indictment is the charge of mediocrity, similar to the charge of superficiality with which Bishop Vincent himself tried with less than perfect success to contend. Let it stand for what it is worth. Where thousands are gathered together, a collective level of truly high distinction is hardly to be expected. For the rest, one notes the romantic coloring of James's protestation. No civil-

ized man really wants an Armenian massacre, or for that matter wants
to suffer unless he is a confirmed masochist. And has James allowed it
to slip his mind that Chautauqua is a summer institution, that the
middle-class thousands among whom he found himself would be going
home after a day, a week, a season to their occupations in that same
outside world to which James himself was returning?

But James's strictures raise another question. In a place as populous
as Chautauqua, sin, suffering, and stress simply cannot be absent, even
though they do not surface to the public eye, even though discretion
keeps them off the record. Ida Tarbell, looking back on her Chautauqua
days, was aware that behind the scenes everything could not always
have been kind, good, and untroubled, though her own direct acquaint-
ance with misdemeanors was limited to such childish mischief as
monkeying with the models of cities in Palestine Park. Lucien Price, in
his essay "Orpheus in Zion," dealt with James's critique and found it
partly right and partly wrong. Against James's verdict of "no effort,"
Price cites the frenetic efforts of the staff to get out their issues of the
Daily. He thinks unnecessary suffering—James would have agreed—
was imposed on people who could have done without it by strait-
laced religious mandates. "Still, even here," he remarks, "sanctification
was not one hundred percent." An unsuccessful attempt at whiskey-
running has already been cited from Alfreda Irwin's *Three Taps of the
Gavel*. Price adds the example of a musician who agreed to accept a
consignment of "hymn books" addressed to him under the rubric
"Handle with Care." The steamboat express agent in charge of the
crate failed to respect the injunction, with the result that "one of the
hymnals broke and leaked all over the wharf planking." Price also
records that "a quiet, friendly little man" who had been his summer
landlord hanged himself with a clothesline during the winter because
he had been accused of theft. Two informants have told this writer of a
stabbing, if not an actual murder, that took place in the kitchen of one
of the Chautauqua hotels. In July of 1971, the considerable sum of
more than $30,000 was stolen from the Colonnade Financial Office,
which performed such services as cashing checks and accepting money
for safe keeping. The thieves wormed their way in on a Sunday night
through the ventilating system. Part of their loot, it seems, included
collection money from the morning service of worship. The *Daily* reas-
sured its readers that no one would be out of pocket, since the loss was
fully insured. Despite their roots in piety, Chautauquans do not make
and never could have made a community of saints immune to human
temptations or troubles. What James has left to the world is a spirited

personal response by one of America's best minds to Chautauqua at a time when its early innocence and earnestness were still much in force.

Rudyard Kipling did not bother as James did to balance praise and criticism. His account of his brief visit, a comic tale of woe and distaste, appeared first in magazine form in 1890 and was reprinted under the title "Chautauquaed" in *Abaft the Funnel,* a collection of early pieces published by B. W. Dodge and Company in 1909. A character whom Kipling calls "The Professor" tells him: "If you want to see something quite new let's go to Chautauqua . . . it will show you a new side of American life." The following exchange occurs: "Can you get anything to drink there?" "No." "Are you allowed to smoke?" "Ye-es, in certain places." They start off by train, and the company in the car attracts Kipling's notice. "There were very many women and a few clergymen. Where you shall find these together, there also shall be a fad, a hobby, a theory, or a mission." From Lakewood they take a steamer. James was later to write home to his wife from Chautauqua that he had never seen so many women or so little beauty, but on this count Kipling's impression was different. "Once inside the grounds on the paths that serpentined round the myriad cottages I was lost in admiration of scores of pretty girls, most of them with little books under their arms, and a pretty air of seriousness on their faces." Kipling was diverted from his inspection of the girls by coming suddenly and without warning on Palestine Park. "Then I stumbled upon an elaborately arranged mass of artificial hillocks surrounding a mud puddle and a wormy streak of slime connecting it with another mud puddle. Little boulders topped with square pieces of putty were strewn over the hillocks." Stubbing his foot against one of the boulders labelled "Jericho," Kipling demanded an explanation, and Bishop Vincent's scale model of Palestine was duly expounded to him.

The program did not elicit Kipling's enthusiasm. "The Syndicate in control had hired various lecturers whose names would draw audiences, and these were lecturing about the labour problem, the servant-girl question, the artistic and political aspect of Greek life, the Pope in the Middle Ages and similar subjects, in all of which young women do naturally take deep delight." Kipling thought it would be better for the girls if they all got married. "One never gets to believe in the proper destiny of woman until one sees a thousand of 'em doing something different." Asked his denomination, Kipling replied that he lived in India, and was promptly taken for a missionary. "The home-returned preachers very naturally convey the impression that India is inhabited solely by missionaries." Kipling indulges in something of a tirade against

missionaries, and says that he saw on the face of a preacher at Chautauqua the same look he had seen on the face of a man in Peshawar who had turned and spat in Kipling's tracks. Gate-closing and other Sabbatarian restrictions did nothing to alleviate Kipling's resentments: "the barbers must not shave you, and no milkman or butcher goes his rounds." He tried to escape through the wicket on the jetty, only to be fined five dollars for losing his gate ticket. How should the gate man know that he hadn't been hiding on the grounds for two weeks? Kipling ends his tale of frustration with a comprehensive verdict: "I don't like Chautauqua. There's something wrong with it, and I haven't time to find out where. But it is wrong."

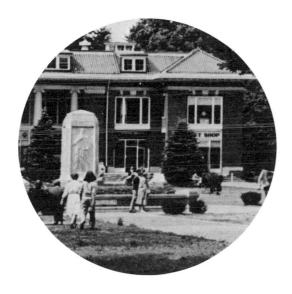

A piece of deliberately grumbling jocosity is nothing to quibble with seriously, but changes have occurred in the many years since Kipling's visit. Sabbatarian rules have been lifted, and smoking is not restricted to "certain places." If anyone today asked, "Can you get anything to drink there?" the answer could no longer be a flat "No." Despite hospitality to the WCTU, despite language in the cottage deeds, taken over from the earlier leases, which prohibits the possession or use of alcohol, Chautauquans drink decently and hospitably in their rooms and houses. Inebriation would not win favor, liquor would not be served with hotel meals, facilities for sale or consumption do not exist on the grounds, though during Governor Romney's 1967 visit an unadvertised bar was set up in a room of the Athenaeum for the benefit of reporters. Still, for all these austerities, a state liquor store a few miles up the road in Mayville has followed widespread example by taking the name Chautauqua, and it may be patronized without disapproval. A story is told of a lady who expressed a preference for a room on the top floor of a Chautauqua hotel. This occasioned some surprise, but she explained with fine simplicity, "That's where the best cocktail parties are."

Kipling was enticed to his visit by the promise that he would see "a new side of American life." Chautauqua has always taken pride in the words Theodore Roosevelt is supposed to have used of it, calling it "the most American place in America." Certainly in its hodgepodge of activities, religious and secular, intellectual and popular, serious and frivolous, all wrapped up together in one bulging package, it has dripped with the authentic juice of the national character. Yet Chautauqua could no more represent the whole range of the country and its people than any single place or institution could hope to do. The CLSC could and did reach nearly the entire span of the population, the poor and the immigrant included, but the large numbers who people the Chautauqua grounds necessarily represent on the whole the middle-

class segment of America, ranging from a line above poverty to outright wealth. If as many as ten thousand persons on a given day are present, they can hardly help composing a wide variety of origins and differences, and Chautauqua has proved its ability to make devotees of individuals from many lands and languages. Nonetheless its representativeness has limits. While a substantial number of variously talented Negroes have attracted audiences to the Amphitheater and excellent young Negro voices are heard in considerably more than token numbers in the productions of the Opera Association, one does not see many black Americans on the walks or about the Plaza. The Jewish presence at Chautauqua is considerably more numerous, not always to the comfort of traditionalists who would like to see the Protestant heritage preserved undiluted, and who are less than happy with the ecumenical influences, religious and social, pushing in the opposite direction.

The Chautauqua population can in fact be sorted into three strands. The first consists of the large miscellany who come for single or special events, the second of those who return year by year for more extended visits, often as vacationing families, and the third of a kind of inner constituency in whom the real control of the Institution vests. The word "constituency" seems a fair one to apply, because the heart of the inner group is composed of the cottage-owners, from whom a specified number of the trustees must be elected and who must be polled on significant questions of expenditure. This institutional structure resulted from the financial crisis of the thirties, when leases were converted, for a price, to deeds. It could be thought to contain dangers to the program of education, music, art, and free discussion which it is the higher business of Chautauqua to present. Nothing prevents a cottage-owner from regarding the program as a necessary way of maintaining the value of his property as part of a vacation colony with no more important purpose. Nothing, on the other hand, prevents him from regarding his property as a pledge of concern for the historic aims of the Institution. But whatever its spread of views on any particular issue, whatever the number of exceptions, the inner constituency can only be described as strongly white-Protestant in its composition—conservative in temperament, Republican in politics, WASP in religion, to parody T. S. Eliot. It may well seem astonishing that so various and flexible an institution as Chautauqua should have sprung from the upper level of Protestant denominational Christianity, that Orpheus should have invaded Zion under such auspices and with such encouragement. The fact is a tribute to capacities in this strand of American life for which it is not always given credit. But to the extent that this once dominant tradition has

relatively lost influence, Chautauqua's claims to being uniquely American must allow for some historical shrinkage. During the Sidewalk Session, already noticed, that Landrum Bolling conducted with a youth panel in 1969, a well-known Chautauqua official and lecturer intervened, apparently with a certain irrelevance. He described Chautauqua as a place for a summer vacation with a purpose, asserted that no other vacation spot equalled it for creativity, and recalled the remark attributed to Theodore Roosevelt. All this provoked an answer from a student, who said that while he was passionately devoted to Chautauqua, he thought that as an American institution it belonged to Roosevelt's America of 1905.

Religion at Chautauqua currently occupies a somewhat equivocal position. The Protestant denominations, the Jews, Catholics, and Christian Scientists are active in their various houses, and missions are still a theme of discussion and concern. But religion has pretty obviously lost relative ground to other activities of the Institution. On a sign at the gate advertising the multiple enticements to be found inside the fence, religion occupies a position below the middle of the list. Of course Chautauqua never did have an official theology or creed. It regarded itself as firmly Christian, but imposed no defined articles of belief. Two statements, one by Bishop Vincent, another by President Bestor, illustrate a kind of shift of balance that again was no doubt inevitable. In describing one of his most cherished projects for Chautauqua, the Hall of Christ, Vincent, as quoted by Bestor in the American Historical Society's *County History,* said that it should be

> a building of appropriate architecture, devoted exclusively
> to the study of the Man of Nazareth, in which every day, at all
> hours, there shall be . . . courses of study in the life, words, deeds,
> spirit, and results of his life who "spake as never man spake". . . .
> In this hall it is proposed to collect all engravings of Christ
> which the art of the ages puts within our reach, and a library of all
> the lives of Christ which have ever been written. It shall be a
> memorial hall with historic windows . . . each window may
> become a memorial window for families choosing to place at
> Chautauqua lasting souvenirs of departed friends. . . . Thus shall
> the central building of Chautauqua symbolize to the world the
> controlling aim and force of all her diverse ministries.

The bishop's words, remarkable for numerous features, and not without a certain naiveté to modern ears, is characteristically untheological. It bespeaks ardent and personal devotion to the idea of the Man of Nazareth rather than invoking Christology or the theory of Christian

redemption. But the Hall of Christ is to be the "central building" of the Institution and to express the aim that controls all its other "ministries." President Bestor defines his religious ideal for Chautauqua in different terms:

> The Institution has stood for a conception of religion which includes . . . intellectual integrity, moral earnestness, appreciation of beauty and above all a social solidarity and obligation of service. Chautauqua has played an important part in breaking down the barriers between churches, . . . and in shifting the emphasis from a personal, individualistic salvation to the concept of "The World the Subject of Redemption," from the idea of the Kingdom of God as a remote society in another world to that of a social order to be realized in this.

Religion has become "intellectual integrity" and the creation of the good society in the mundane world. Gone is the personal and devotional tone of the bishop's vision, for gain or loss as one may decide. But whatever decline religion may have suffered as a "controlling aim and force," whatever the activities of the various religious houses according to their several allegiances, the Sunday morning public services in the Amphitheater are generously attended. The five or six thousand seats are, if not filled, at least well peppered with participants. The vigorous congregational singing and responsive reading show the training its members have received in their accustomed hymnology and psalms. If a degree of uncertainty exists about its end or its institutional function, devotional life does not lack for loyal adherents.

As it launches on its centennial celebration, Chautauqua is undergoing the pangs of assessing itself. In 1970 Curtis Haug resigned as president, to be succeeded by Oscar E. Remick, who officially took office on August 1, 1971. His election was the result of a full-scale canvass by a search committee, a practice not always followed at Chautauqua in the choice of important officials. His still new administration confronts both practical and intangible problems. On the practical side, the problems run from the small and particular to those of much more formidable scope. Some Chautauquans complain of the state of the swimming beach, and would like to see it enlarged and improved. Others would like to see Palestine Park brought into decent condition; it does, in fact, correspond all too closely with Kipling's unflattering description. Chautauqua suffers from an acute housing shortage and a need to renovate many of its older buildings if they are to provide reasonable living space and conveniences for families or for teaching staff. It is perpetually immersed in the struggle for adequate endow-

ment for its programs and for foundation or other grants for special purposes. But its intangible problems are no less important. One of these is the question of identity: what is Chautauqua? If it is unique, as it has been called and as Chautauquans proudly assume, in what does its uniqueness consist? A frivolous answer could be that Chautauqua is uniquely incongruous. The *Daily* for July 5, 1951, illustrates the point. A double-column head across the right-hand half of the front page announces the opening play for the season. The play is *Room Service.* Cuts of two actors appear underneath in the left-hand column, and below these another head reads: "Memorial Concert Will Be Presented By Military Band." Under that a third head reports: "Capital Scenes Are Presented in Color-Film." To the right, below the announcement of *Room Service,* appears the head: "Savior's Teachings Offer Lasting Hope, Chaplain Concludes." What is one to make of an institution that tries to be so many discrepant things at once? Judge Braham, speaking in 1958 as Chautauqua president, tried to sum it all up in a "formula" which he described as "a simple one":

Promote whole-hearted enjoyment of a summer vacation for the whole family beside one of the beautiful New York lakes. . . . Make available the best in music, drama, art and literature. Encourage self-expression in all the arts. Furnish sound and responsible instruction from the kindergarten to graduate work in a great university. Remember the Heavenly Father as the giver of all good things and worship him.

However applicable seriatim, the formula hardly seems simple. Perhaps the uniqueness of Chautauqua consists in a combination of two things. One is its history, of which Chautauqua as a community remains more conscious than most, and which is still physically present in its characteristic building styles. The other is the very multiplicity of its activities, incongruity and all.

In his book *The Gathering of Zion: The Story of the Mormon Trail,* Wallace Stegner writes that "those who with a whole heart set out to create the future find that instead they have created a past." The founders and successive leaders of Chautauqua down through President Bestor created a past of which Chautauquans may rightfully be proud. But Chautauquans can also be conscious that the past will not of itself sustain the future. Here it is appropriate for this chronicle to come to an end, leaving it to President Remick in an epilogue to discuss the problems of the future as he sees them. This writer feels bound, though, to express his sense that no one who has read the Chautauqua story, or

who has walked its grounds or exposed himself to its program, will wish it other than well. Even when one is amused by some its divagations or is impatient with them, one feels that it is in some positive way unique, and that despite its bewildering complexity it hangs together and possesses a felt character and identity. It is a character worth preserving and wherever possible strengthening. A century of durability in response to change suggests that Chautauqua can continue to change in ways appropriate to unforeseen times while continuing to be itself.

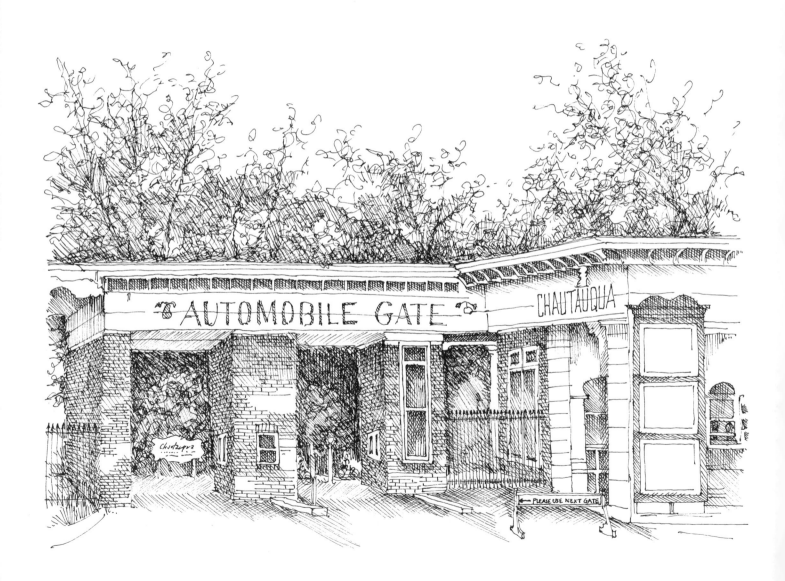

The Future

by President Oscar E. Remick

The history of Chautauqua is the unfolding of an idea. From simple beginnings through a long development into complex and diversified programming in education, religion, the arts, and recreation it has continued to be guided by the ideals and values which gave birth first to a community and then to a movement. The vitality of that original vision is clearly evidenced in its capacity to generate various interpretations of its purpose, a new sense of relevance, and an ongoing self-criticism without which past success becomes the barrier to future achievements.

As Theodore Morrison's account has demonstrated, Chautauqua was conceived by men whose courage proved equal to their faith. The latter part of the nineteenth century was not an easy time for our country or for Western culture, which had to a large degree been built on the correlation of the Judeo-Christian faith with certain classical traditions. One need not gaze too intently at this era in order to detect those forces which shook the foundations of both America and the West. Consequently, Chautauqua was destined to serve as something of a symbol of the "typically American" at a time when there was a need to discover those identifying characteristics of our nation. The Civil War, the growth of industry, the expansion of cities; the flood of immigrants, and many related forces of change were substantial threats to the "American" image of the earlier part of the nineteenth century. And yet one would miss the greater genius of the Institution and the movement it sparked were he to overlook the broader significance of Chautauqua's founding ideals and visions for modern Western culture, itself in the process of secularization.

That a need to train teachers for church schools was recognized in the latter part of the nineteenth century reflects an awareness of the times as well as a perception of the relationship between Christianity and the "American way." Already the forces of secularization, not always recognized as such, were straining the earlier formulations of faith. The lecture topics of Chautauqua conclusively reveal a concern for those ideas and issues which, products of the emerging modern

mind, challenged the more traditional expressions of the Christian religion. A hallmark of liberal Protestantism was the attempt to forge a new correlation of faith with the modern concepts. Chautauqua's determination to make the church a more effective instrument of the Good News in what was recognized as a new day took place in the mainstream of such endeavors. The debates about science and religion, the social gospel, the concern over poverty and pauperism, especially in terms of their adverse effects on the American economy, the focus on the problems of the city—emphasis on such program topics as these confirms the judgment that Chautauqua was born in response to the challenges of the modern era.

The record suggests that Chautauqua is first and foremost an expression of faith in education and its ability to resolve the disharmony and strife which frequently mark the relationship between the old and the new. That a singularly purposed effort would grow so quickly into a massive program in education, the crowning achievement of which was the CLSC, can be readily understood when one recognizes this implicit faith in education as a means of human enrichment. By the last quarter of the nineteenth century this nation was beginning to experience a new concern for education, but Chautauqua's founders envisioned providing "the college outlook" for a far greater number than was considered possible or advisable by most of the private institutions of higher learning. The story of Chautauqua's contributions in this area has been well documented in this book. It is no accident that the word Chautauqua became a symbol for continuing educational efforts in so many ways. What is perhaps overlooked by many Chautauqua enthusiasts, because it remained an implicit force throughout the century, is the regard for education as a means of human enrichment.

This view raises the question of the definition or identification of that "human good" by which "enrichment" is measured. Here one discovers the relevance of the founders' faith. Provided by Christianity with values and interpretations of life, they perceived education as a valid instrument for human fulfillment. One who failed to consider this aspect of Chautauqua's history would miss a certain aspect of uniqueness which has earned for the Institution a world-wide reputation. In America and in the West there had emerged new strains between faith and the modern world, and nowhere is this more evident than in the schools themselves. The history of modernity is a fascinating account of such tensions that would eventually result in the emphasis on the secular and the seeming triumph of secularism so pronounced in our own time. Chautauqua was part of that Protestant effort which at-

tempted a new synthesis of the modern mind and the Christian faith. Hence Chautauqua was inevitably subject to rather severe criticism that sought to discredit any attempt to reinterpret biblical faith in terms consistent with modern understanding. Such efforts could be regarded as trying to retard the birth of a brave new world by holding on to the outdated values and perceptions of faith. Yet the persistence today of a strong Protestant religious emphasis suggests the degree to which faith informed the efforts of Chautauqua Institution. While some blamed education for the crisis of faith, Chautauqua's founders hailed it as the handmaid of faith.

This religious commitment was to inform everything that came to be part of the program. Education was justified in terms of its ability to foster understanding and dedication to those values and ends prescribed by faith. In fact, the study of the words and works of God became the justification of much that characterized both the summer offerings and the year-round reading efforts of the CLSC. Clearly, the founders realized how much faith determined the ends and means of education. Such a vision made easy the recognition that the secular was but the sacred awaiting accreditation.

There are other aspects to this earlier vision of religion that deserve a summary comment. The history reported on these pages shows there is a religious diversity which Bishop Vincent was to term "pan-denominationalism." One might recognize Chautauqua as a very early expression of ecumenism, granted that it was for all practical purposes limited to the Protestant traditions. Nevertheless, a determination to transcend the more parochial boundaries of denominations could not have succeeded without a commitment to the beliefs held in common by so many Christians. Measured by late nineteenth-century and early twentieth-century realities, this view is most significant.

A question likely to be prompted by this volume concerns the development of Chautauqua as a center for the performing arts. An answer involves an interpretation of what was surely a component of the founders' faith, a component implying a theology of culture. If God's creation declares his glory, then man's creations, his culture, must reveal something of him who was made in God's image. Therefore, it is easy to understand why music, for example, itself a prominent aspect of the earliest services of worship, could find a special niche in the unfolding program. For some the arts have the appeal of culture, for some the appeal of a status symbol. But the history of Chautauqua persuades one that more was involved here than ego satisfaction. A view of man as created by the Creator would lead inevitably to an ap-

preciation of man's works and creativity as potentially sacred, thus grounding the arts, as well as education, in the perceptions of faith.

One cannot pass by this element of history without suggesting how important this insight proved to be. Religion, for many, has relevance only to the deficiencies, needs, and crises of human existence. Chautauqua's rich program in the arts, offered under the inspiration of a daring faith and challenging vision, was an attempt to relate the totality of the Christian message to the totality of human experience. In short, Chautauqua emerged as something of a symbol to suggest that the biblical God is as present or as related to man's health as to his illnesses, a view not often captured in the myopic interpretations embraced by many Christian communions. This is not to deny that it took a good deal of time and adjusting to bring Chautauqua to its present comprehensiveness. As the records indicate, there was genuine reluctance to introduce the theater, associated as it was by a certain pietism with the more negative aspects of the human spirit.

The determination of the founders to find a spot where recreation could be enjoyed with programs of human enrichment suggests a deep appreciation for nature and man's need to be recreated by it. Sports and related activity have always been a part of Chautauqua's offerings, undeniably appealing strongly to many for whom the more formal aspects of Chautauqua lacked compelling significance. The beauty of the grounds, indeed of the region, continue to be an important part of the Chautauqua experience.

Finally, the story of Chautauqua emphasizes the importance of a community as the proper context for programs in education, religion, the arts, and recreation designed to provide the abundant life. Throughout the pages of this book there is ample testimony to the power and appeal of coming together to study, worship, create, and play. As in the past, so even now, one cannot experience the fullness of Chautauqua without taking up residence on the grounds. People obviously come to the program offerings as they would to any other art or educational center. Nevertheless, the uniqueness of the place is felt only when one shares in that rare experience of community living, united with others by values and visions related to abundant life.

Through these five concepts—education, religion, the arts, recreation, and community living—Chautauqua's history has been written and pictured throughout this work. The purpose which has given unity and comprehensiveness to these concepts has been the enrichment of life according to the vision of biblical faith. Chautauqua, itself the steward of certain ideals, can accordingly be interpreted as the unfolding of an idea.

A Forward Glance

This history raises a question as to the relevance for today of an institution with such ideals and commitments. The question is twofold. First, are the founding ideals and purposes relevant to this postmodern world? Second, if the answer is yes, is Chautauqua Institution a vital and viable means of their realization? Nor should one assume that such questions can be raised without eliciting anxiety and concern. It is obviously difficult for an institution, impressive though its record of achievement may be, to avoid defying history by trying to repeat past successes. This is a natural propensity for those whose memories of the past are keener than their awareness of the times in which they live. And there is some wisdom in the observation that when institutions become concerned for self-survival rather than with their role as servants of ideals, then it is indeed late in their histories. At the outset it should be stressed that Chautauqua's future can only be discussed in terms of those founding ideals and goals which transcend all times and all institutions.

Education

Chautauqua's future will be significant through its ability to provide continuing education in ways that accommodate the social realities and needs of our day. Clearly, the new frontier is not the mass of uneducated people whom Vincent and Miller served. Rather, it seems, the deeper challenge is to provide opportunities for continuing education for those whom, by most standards, one must consider educated.

There are two aspects to this challenge. First of all, the knowledge explosion has dated our "knowing." There must be new ways to "keep up" the learning process and to do this without depriving individuals of their opportunities for time with family and means of enrichment. The projected increase in leisure time will afford such opportunities for those motivated to take advantage of them. Chautauqua's educational efforts must become more and more geared to the needs of those seeking updating of knowledge and skills in their fields.

But it must, by providing opportunities for short periods of study, encourage those who are able and willing to explore the new frontiers of learning. In this context one envisions a greater working relation between the Chautauqua community and institutions of higher learning that need established instruments beyond the campus to share with society the benefits of their finest minds. Exactly how this could be accomplished is to be determined by those interested in providing such a needed service. Obviously, individual effort must be fostered, and yet

at the same time a sense of community, a fellowship of co-learners, must be provided.

The second concern with regard to education involves the value dimension of learning and living. There has been a growing tendency of education to give up its responsibilities in the moral area of human experience. There is perhaps some truth to the claim that we have gained knowledge at the expense of wisdom. However, it becomes increasingly clear that efforts in this area involve some basic value-decisions or choices. Educational institutions need to come to grips with this problem and declare those ends and purposes which determine their strategy or curriculum. Chautauqua has the capacity and the responsibility to provide this kind of education as one of today's options. The need to understand divergent value systems is critical—too much so to surrender to subjectivity or to mere opinion the implicit foundations and commitments which determine the lives of individuals, nations, and cultures.

Chautauqua has been able to hold together the vision of faith *and* learning while many have denied their correlation. It would seem that there is again a place for a platform on which can be vigorously debated the alternative interpretations of the summum bonum.

To the degree that Chautauqua can achieve this goal it may well be able to serve as something of a critique for much that passes as education today. The pulls and strains during these recent years on our institutions of higher learning have been substantial. The tensions within colleges and universities are to some extent the products of modernity itself. There is an urgent need to discover anew what has been the implicit intention of Chautauqua's educational program—that learning provide living power as well as earning power. The classical ideals have in these past decades justly come under a certain amount of criticism. But there may well be insights and values within that generally rejected tradition that should be reclaimed and reprocessed for our day. Continuing education faces this challenge, a challenge Chautauqua has been aware of in various degrees at various times. It must now become a determinative in the ordering of the Institution's priorities over the next decades.

In this context one can appreciate the relevance at Chautauqua of special-interest learning opportunities, designed as they are to provide insights and skills in such varied areas as cooking and the Chinese language. Valid is the projection that more and more individuals will seek to learn during vacation and leisure time

One detects in the past achievements of this institutionalized idea

called Chautauqua a vision and faith possessing burning relevance to the new educational frontiers which we are only beginning to take seriously. A strong emphasis on the traditional concerns of liberal arts, responses to the knowledge explosion, the relevance of special-interest courses, and the importance of "value education" suggest how Chautauqua will achieve new levels of service to this society.

Religion

When one examines the role of religion, and questions its place in the future of Chautauqua, he is brought face to face with certain realities that must be taken into account. Should Chautauqua abandon or compromise its commitment to biblical faith it would cease to survive in a way demanded by its heritage. And yet there is in this strength a weakness characteristic of religion as a dimension of human experience. It is easy for religion to become a barrier to its own light because of a human tendency to accord the sanction of universality to particular and parochial expressions of religion that necessarily reflect the unique experience of individuals and, indeed, races. This is to admit that even an institution such as Chautauqua can unwittingly be limited by a faith which, though always at work, may fail to transcend the human finitude through which religion necessarily finds expression. How then can the religious orientation of the Institution serve an emerging world consciousness in a way that will prove meaningful and prophetic?

The question of religion in the modern world has been frequently debated during the past century. The fact that Chautauqua has itself sought an understanding of the modern mind and the issues shaping that particular mentality is ample proof of the Institution's faith and vitality. The alternatives of a secularism blind to its own deities or a religion withdrawn from and indifferent to the times should be regarded as equally unappealing. Chautauqua will continue to make a significant contribution to contemporary society as it mounts programs capable of demonstrating the abiding relationship between what is known as the sacred and the secular. Programs relating religion and culture can prove effective critiques of both. Chautauqua has championed such a cause, and it would now seem imperative that it continue to do so with renewed vigor and sensitivity.

Religion is a strange and at times dangerous phenomenon. The narrowness and parochialism of each person's experience are all too often protected by religion. The Good News surely has something to say about the *totality* of man's experiences. The practical consequence is that, while this orientation proclaims man's creativity as potentially

"sacred," it also precludes interpreting the arts merely for the sake of art or even for the sake of the artist alone. Art in this context is viewed as a means to human enrichment, to a "good" perceived through the eyes of faith. This relationship between religion and culture has remained far more implicit than explicit over the course of Chautauqua's history. One can with little effort imagine the kinds of creative programs in which the artist and his art are exposed in such a way as to be sources of inspiration, enrichment, and insight. The need for constant dialogue and self-criticism in both religion and culture are urgent in this day, which has sought escape from the tensions and agonies of such a relationship.

As the preceding chapters suggest, Chautauqua has been identified as predominantly a Protestant stronghold. Even today there is at best a token involvement of non-Protestant communions in the program and community. It need not and must not remain this way. The diversity of the Christian faith is a great resource which ought to be tapped for the sake of extending tolerance and compassion. Because Chautauqua is the kind of community it is, and because the arts and education provide means for understanding and acceptance, there is every reason to be certain of Chautauqua's ability to become far more comprehensive in its religious expressions.

The consequence of this need not be a loss of Chautauqua's tradition but rather a new appreciation of its place and role in the midst of a diversified family of religious expression. There should prevail in the future a daring ecumenism, envisioned as extending beyond the Christian family to include all major living religions. There is a compelling need for this experience today, and Chautauqua is uniquely equipped to satisfy it.

There is always the fear and risk that in being this open there could be a loss of identity, that the institution will be "taken over." While understandable, the fear is unnecessary. Strong and dedicated leadership among trustees and officers will greatly minimize such a danger. Opening up one's house to the winds of diverse views should not be interpreted as a willingness to be blown out of one's own home.

Implicit in such a position is the obvious judgment concerning the religious diversity of mankind. It is possible to interpret one's faith as the center to which all men must come if they would enjoy certain fellowship. On the other hand, that center may more adequately be regarded as an impetus by which one is enabled to create an ever-expanding community not dependent on conformity but rather on compassion, the power of which does not allow diversity to become divisive.

The arts help us here, since we will listen to the music of countries or cultures whose politics and economics, to say nothing of religion, offend or even frighten us. We need opportunities to confront those who are different, in order to understand and accept them, in order to be understood and accepted. Otherwise, we will hate and destroy. A program in religion must provide the occasions for such encounters, and Chautauqua has the tradition and capacity to do just this.

The changes and growth needed in this area, if Chautauqua is to remain faithful to its heritage, will not come easily, threatening as they are. And the relevance of such transformations is to be appreciated only against the backdrop of the new horizon exposed by our slow and erratic ascent to present achievements.

The Arts

Much has been written of the arts and their place in the history of this Institution. Perhaps it is true that the survival of man's humanity in a day when so many forces threaten to deprive him of this heritage of dignity depends in large measure on discovering the significance of his own creativity. A center for fullest human enrichment without the arts would be incomplete, as would a center for the arts without concern for human enrichment. Chautauqua's dedication and commitment to both the arts and the enhancement of life are among its most significant characteristics.

During the past years programs in the performing arts have expanded at an ever-quickening rate, outdistancing offerings in other areas. While this growth reflects the tempo of post-World War II America, it has imposed new demands and a need to clarify the Institution's purpose and its priorities. None would want to see this dimension of the Institution's program in any way diminished. There must be, however, greater correlation between the educational and religious thrusts of Chautauqua and that of the arts.

One obvious means to this end is the use of the performing artist as a teacher. Chautauqua's music school grew out of such a philosophy and is influenced by it today. But one could easily push the implications of this concept to include an impressive array of master classes in opera, dance, and the theater. And this orientation would remain consistent with Chautauqua's early record of providing young artists with the best of instruction by the best of performers as well as opportunities for performing before sizable audiences. The diversity of offerings, to say nothing of Chautauqua's milieu, can enrich the artist even as he in turn enriches the community.

The Challenge

The translation of these views and values in the last part of the twentieth century will prove at times more difficult. Chautauqua, once characterized as typically American, will find its future by representing what is ideally human. This means that the narrowed identification of Chautauqua with a certain segment of our society must give way to an openness, a universality, expressed in practice as well as in principle.

There are prejudices at work against such a view, and a failure to recognize this fact would be to suggest that Chautauqua has been spared human limitations. It has not. Even as this country has been experiencing considerable agony in bringing its practice into accord with its ideals, so have its institutions. Chautauqua can learn from such difficulties and thereby make its transition less traumatic. But the transition will come because it must come. In anticipation of such a history the greatest needs are for clarity of vision, the force of faith, and the courage of convictions on the part of institutional leadership.

Chautauqua is many things to many people. The greatest challenge lies in its ability to remain precisely this. The temptation to become a traditional educational institution must be shunned. The appeal to develop at the expense of all else a center for one or all of the performing arts must be rejected. Efforts to make it only an institution for religion must not be allowed a victory. Any attempts to elevate recreation to such prominence as to deny significance to other programs must be challenged. As an institution designed to encourage meaningful living, Chautauqua is all of these or nothing. In these terms and these alone it remains an idea whose time has come.

Chautauqua in Photographs

Chautauqua in Photographs

The story of Chautauqua should not be told only in words. The success of what was begun on the shores of Lake Chautauqua late in the nineteenth century cannot be captured by any single medium; even so, to some it is only possible fully to appreciate Chautauqua Institution by taking up residence and participating in the daily activities. Fortunately, however, the activity of photographers through the years has provided a library of preserved history. Some of their photographs have found their way into the Institution's archives and from there into this collection.

Variety has long been the strength of the Institution, but in attempting to assemble photographs that accurately reflect that variety, both fully and fairly, it is obvious that many of Chautauqua's essential elements cannot be captured even in photographs.

This collection shows Chautauqua as a place. It also reflects the changes wrought by people as they expanded their ideas to include structures and programs regarded as necessary if the perceived needs and hopes of individuals were to be addressed.

Chautauqua Lake was, for many years, the front door through which passed thousands of individuals in quest of insight, faith, culture, and recreation. The expansion of the grounds was westward from the lake to the main highway over which people today travel to Chautauqua's "front door," the main gate. Gradually, tents were replaced by small frame houses in ever increasing numbers. From the earlier "rough" accommodations to the later elaborate and enduring buildings, Chautauqua was transformed into a self-contained village whose architectural style speaks eloquently of concern for art and the preservation of certain cultural values. The buildings, the narrow, winding streets and walks, together with the natural beauties of the region, have appealed alike to the artist, photographer, poet, and outdoorsman.

For many, even today, Chautauqua is essentially people. What is most important, perhaps, is that the photographs illustrate the kinds of people who came to capture the "college outlook" through lectures,

learning laboratories, and the arts, in addition to exchange with teachers and visiting performers. In scanning the early scenes and comparing them with the activities of our modern day, one has the feeling of a continuing industry and purpose which have always been a part of Chautauqua and which can readily be detected through photographs.

"Chautauqua Through Time" attempts to show Chautauquans and their styles of living from the earliest days to the present. There are the founders, the perpetuators, and the benefactors of this grand tradition. In these pictures one can perhaps witness the power of the original purpose as the Chautauqua idea expanded. Not unimportant is that Chautauqua, as seen in this collection, resembles a mirror reflecting something of America during these years.

The photographs collected under "The Arts" capture Chautauqua's commitment to provide a variety of opportunities for people to experience creative self-expression through music, drama, clay, and pen. To thousands of people Chautauqua represents these things before all others. No photograph captures the feelings engendered through successful completion of a difficult music lesson or performance, but it can point to those who led many others to realize such satisfaction in their work.

"Education" as a special topic for illustrating Chautauqua is an elusive category since most of what occurs at the Institution can be defined as educational. The contribution of Chautauqua to innovative forms of education is, however, of special significance and should be identified for its uniqueness. To modern educators, the university-without-walls concept is somewhat new; to Chautauquans and the CLSC, it is almost as old as the Institution itself. Nursery schools, visual education, informal classrooms, field trips, and exhibits are all part of the Chautauqua story which can be captured through photographs.

The Instruction has always attracted to its grounds leading thinkers and performers who have contributed their special talents and skills. Some returned often while others made only a single appearance; all left something. The few such individuals pictured here in the "Personalities" collection demonstrate the variety of people who came to participate in the Chautauqua experience.

"Architecture" could easily dominate any photographic collection of Chautauqua, but early photographs of buildings here are quite rare. Some of the selected pictures illustrate certain structures no longer standing. It is remarkable that comparatively few of the important edifices have vanished over the years. Except for renovation due to fire or the desire to make a structure safer for habitation, Chautauqua has

remained largely unchanged over the last decades. To view the institution today is almost to catch a glimpse of the northeastern United States as it appeared earlier in this century.

Chautauqua, in its variety, was also a place for "Leisure." Such activities were a daily part of the Institution since its beginning, though seldom the sole purpose of any individual's attendance. All ages have found outlets for exercise or competitiveness while partaking of the fuller programs going on around them.

Were it not for purpose, there would be no unity to Chautauqua as a place, program, and people. The treasured community awareness would be missing. That purpose is embodied in the Chautauqua idea, namely, the enrichment of life interpreted in terms consistent with biblical faith. As Chautauqua has been over the years so it is now, the expansion of an idea.

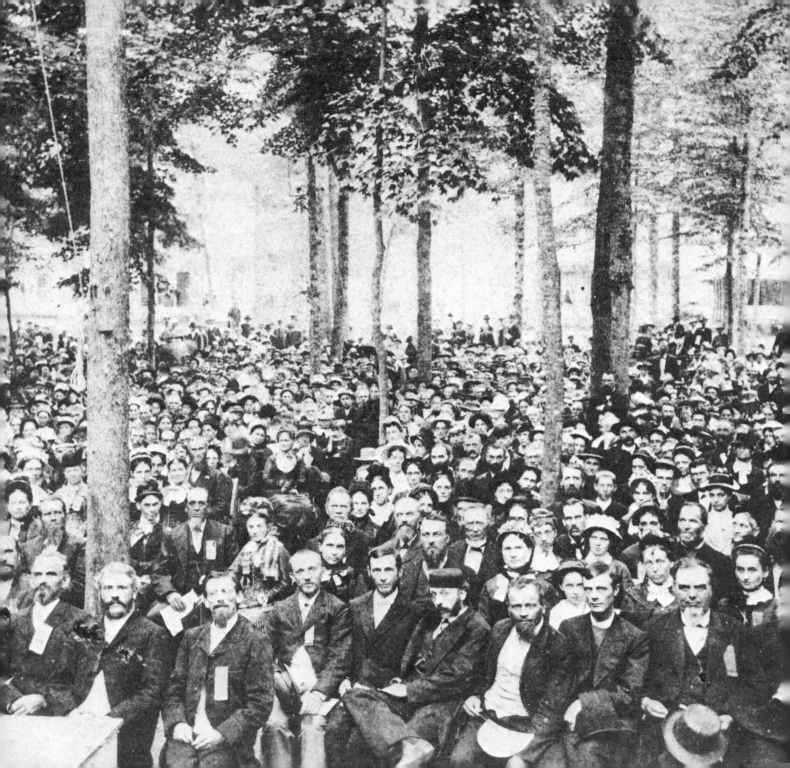

1. An audience among the trees gives an impression of response to the earliest call for an assembly.

2. (*a*) Lewis Miller (photographed in 1890) and (*b*) John Vincent (in 1911) were the co-founders of Chautauqua. (*c*) The document below explains the spirit in which they labored together to expand the Chautauqua idea.

Chautauqua through Time

2a

2b

The "Chautauqua idea" is an idea embracing many features, developed through years in many forms, originated and developed thro' personal thought, experience and conversation by Lewis Miller & J. H. Vincent. The question of personal preeminence or priority as to the original elements & plans is forever dismissed. The two claim joint ownership & fellowship; and no recognition of the one shall by our permission be acknowledged without recognition of the other — that we may stand and abide as brothers, & with a perfect mutual understanding & a spirit of love which shall not allow alienation or even difference between us. Lewis Miller J. H. Vincent.

Found 1899.

cap. 1920 Mary E. Miller Nichols

2c

3. This Sunday-school building was an outgrowth of Lewis Miller's great interest in Sunday schools and was a part of his "Akron Plan." It figured in the development of the rapport between Miller and Vincent. Miller, an Akron inventor, persuaded John H. Vincent, Secretary of the Sunday School Union, that the fortnightly conference of Sunday-school teachers be held out-of-doors at Fair Point in 1874. Vincent came with Miller by boat and agreed.

4. William Rainey Harper, later to become president of the University of Chicago, was made principal of the Chautauqua College of the Liberal Arts in 1885 and was for a number of years the mainstay of the entire Chautauqua educational effort.

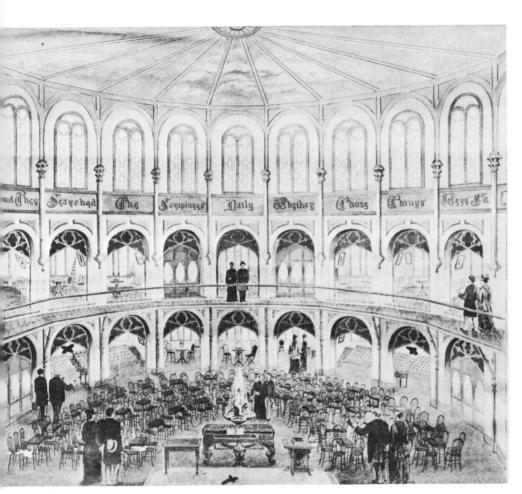

3

4

5. The steamer *Chautauqua,* demolished in 1871 at Whitney Bay below Chautauqua. It was probably from such a steamer as this that Miller and Vincent, accompanied by George Vincent, aged nine, first glimpsed Fair Point in 1873, when the Chautauqua idea was born.

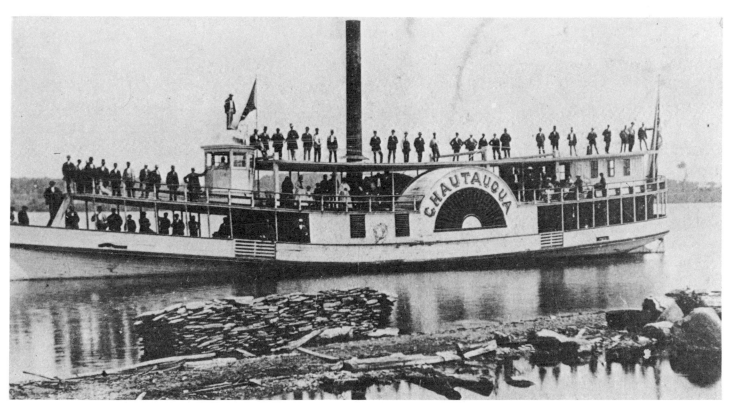

6. A close-up view of the auditorium site shows the board cottages which were built on surrounding lots in 1874. The auditorium and fifty acres of land at Fair Point belonged to the Chautauqua Lake Camp Meeting Association, of which Lewis Miller was a trustee.

7. The first auditorium was inherited from the camp meeting association that preceded the Sunday school assembly. The post in the foreground was one of a number that supported boxes of earth in which pine knots were burned for light.

8. Frank Beard, noted Civil War artist, is making a sketch for a little girl and other onlookers. Beard was a favorite performer for both children and adults.

6

9. Tent life at
Chautauqua evidently
was not too rustic.

7

8

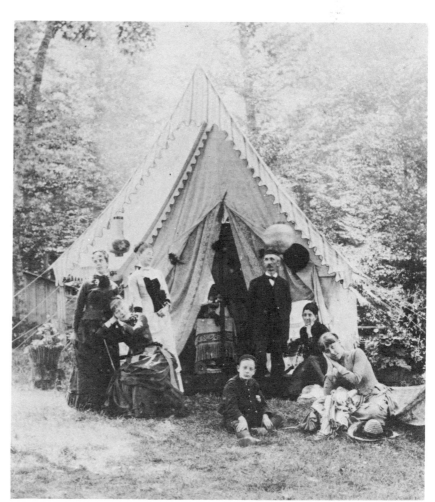

9

10. Longest and most famous of the lake steamers was the *Jamestown,* a four-decked stern-wheeler. It was rebuilt in 1878 from the three-decker *Nettie Fox.* She rivaled some of the cottages in gingerbread ornamentation, and her third deck was kept clear for dancing.

11. Anyone consulting the bound volumes of the *Assembly Herald* may well wonder how so much thoroughness and order emerged from these editorial quarters.

12. The gravity railway, in 1892 located north of the old skating rink, at the intersection of Scott, Root, and Palestine Avenues, near the present McKnight Hall. It was advertised during the 1880s as a gravity railway or roller coaster, offering

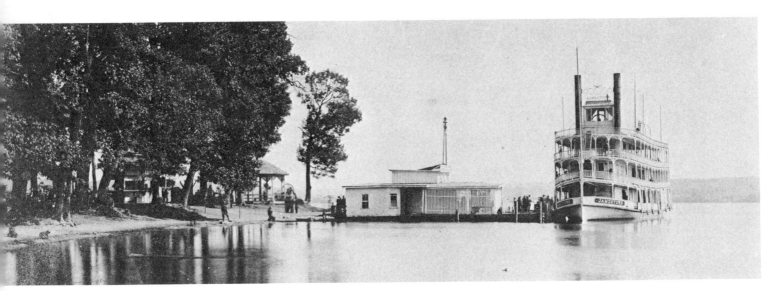

10

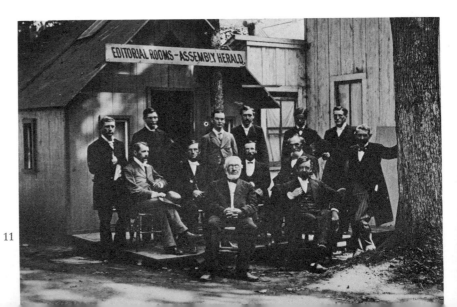

11

ten rides for twenty-five
cents, and thereby
providing "fun, frolic,
and fresh air."

13. Denominational
headquarters, like living
quarters, began in tents.
The Congregationalists
were the first to build
such a center. This tent
in 1882 preceded the first
denominational wooden
structure.

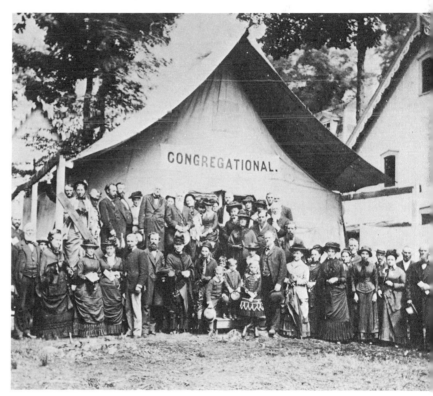

12

13

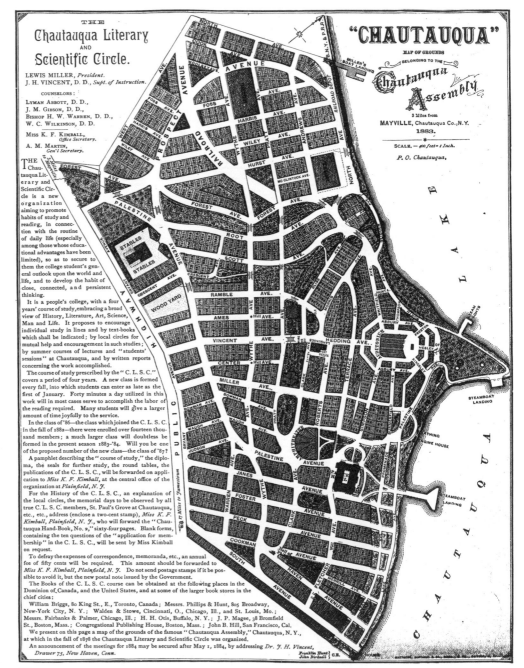

THE Chautauqua Literary AND Scientific Circle.

LEWIS MILLER, *President.*
J. H. VINCENT, D. D., *Supt. of Instruction.*

COUNSELORS:
LYMAN ABBOTT, D. D.,
J. M. GIBSON, D. D.,
BISHOP H. W. WARREN, D. D.,
W. C. WILKINSON, D. D.

MISS K. F. KIMBALL,
Office Secretary.
A. M. MARTIN,
Gen'l Secretary.

THE Chautauqua Literary and Scientific Circle is a new organization aiming to promote habits of study and reading, in connection with the routine of daily life (especially among those whose educational advantages have been limited), so as to secure to them the college student's general outlook upon the world and life, and to develop the habit of close, connected, and persistent thinking.

It is a people's college, with a four years' course of study, embracing a broad view of History, Literature, Art, Science, Man and Life. It proposes to encourage individual study in lines and by text-books which shall be indicated; by local circles for mutual help and encouragement in such studies; by summer courses of lectures and "students' sessions" at Chautauqua, and by written reports concerning the work accomplished.

The course of study prescribed by the "C. L. S. C." covers a period of four years. A new class is formed every fall, into which students can enter as late as the first of January. Forty minutes a day utilized in this work will in most cases serve to accomplish the labor of the reading required. Many students will give a larger amount of time joyfully to the service.

In the class of '86—the class which joined the C. L. S. C. in the fall of 1882—there were enrolled over fourteen thousand members; a much larger class will doubtless be formed in the present season 1883–'84. Will you be one of the proposed number of the new class—the class of '87?

A pamphlet describing the "course of study," the diploma, the seals for further study, the round tables, the publications of the C. L. S. C., will be forwarded on application to *Miss K. F. Kimball*, at the central office of the organization at *Plainfield, N. J.*

For the History of the C. L. S. C., an explanation of the local circles, the memorial days to be observed by all true C. L. S. C. members, St. Paul's Grove at Chautauqua, etc., etc., address (enclose a two-cent stamp), *Miss K. F. Kimball, Plainfield, N. J.*, who will forward the "Chautauqua Hand-Book, No. 2," sixty-four pages. Blank forms, containing the ten questions of the "application for membership" in the C. L. S. C., will be sent by Miss Kimball on request.

To defray the expenses of correspondence, memoranda, etc., an annual fee of fifty cents will be required. This amount should be forwarded to *Miss K. F. Kimball, Plainfield, N. J.* Do not send postage stamps if it be possible to avoid it, but the new postal note issued by the Government.

The Books of the C. L. S. C. course can be obtained at the following places in the Dominion of Canada, and the United States, and at some of the larger book stores in the chief cities:

William Briggs, 80 King St., E., Toronto, Canada; Messrs. Phillips & Hunt, 805 Broadway, New-York City, N. Y.; Walden & Stowe, Cincinnati, O., Chicago, Ill., and St. Louis, Mo.; Messrs. Fairbanks & Palmer, Chicago, Ill.; H. H. Otis, Buffalo, N. Y.; J. P. Magee, 38 Bromfield St., Boston, Mass.; Congregational Publishing House, Boston, Mass.; John B. Hill, San Francisco, Cal.

We present on this page a map of the grounds of the famous "Chautauqua Assembly," Chautauqua, N. Y., at which in the fall of 1878 the Chautauqua Literary and Scientific Circle was organized.

An announcement of the meetings for 1884 may be secured after May 1, 1884, by addressing *Dr. J. H. Vincent, Drawer 75, New Haven, Conn.*

"CHAUTAUQUA"
MAP OF GROUNDS
BELONGING TO THE
Chautauqua Assembly
3 Miles from
MAYVILLE, Chautauqua Co., N.Y.
1883.
SCALE.— 400 feet = 1 Inch.
P. O. Chautauqua.

14. An 1883 Chautauqua Literary and Scientific Circle map of Chautauqua, the other side of which had a CLSC letterhead and was used as stationery.

15. Chautauqua attractions for 1884 included a steamship ride, the Athenaeum Hotel, the School of Languages, and Chautauqua Lake sports.

16. The steamer *Jamestown* made daily runs to Chautauqua, stopping on the other side of the Bemus Park landing. It also plied the lake carrying passengers from the steamer *Griffith* to the spacious Bemus Point Hotel.

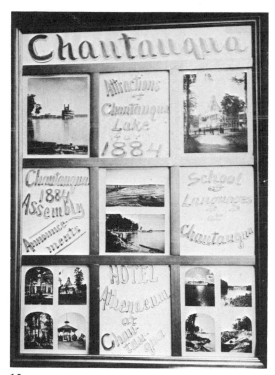

15

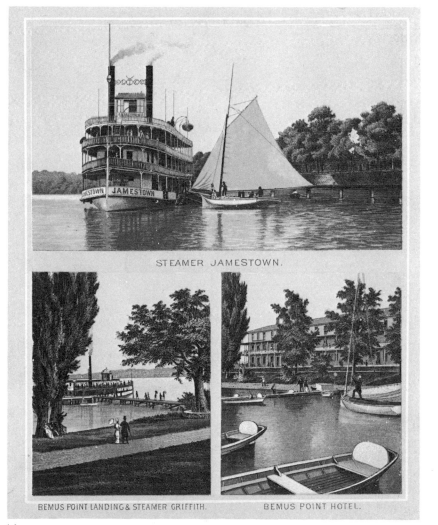

STEAMER JAMESTOWN.

BEMUS POINT LANDING & STEAMER GRIFFITH.

BEMUS POINT HOTEL.

17. In March of 1887, a fire destroyed some fifty cottages in or near the present Miller Park.

18. The early power-house, a supposedly medicinal sulphur spring on the right. Lewis Miller's boys, instructed in electricity by Thomas Edison, rigged wires from the powerhouse to the tin cups, thereby shocking and mystifying drinkers unfamiliar with electricity.

19. In nearby Celoron the trolley track ran out on the pier to meet the steamer *Cincinnati*.

20. Captain P. W. Bemis, Chautauqua's chief of police from 1899 to 1904, is caricatured in the July 13, 1899, *Assembly Herald*. His bicycle "police car" was well known as he sped along the Chautauqua grounds, his unusual whiskers flying.

17

18

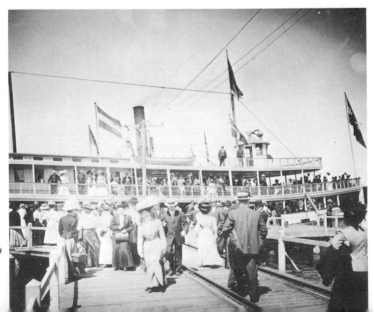

19

The Genial Protector of the Public Safety.

20

21. The steamer landing on Chautauqua Lake, together with steamboats, docks, and a railroad, show how thousands of Americans found their way to Chautauqua Institution.

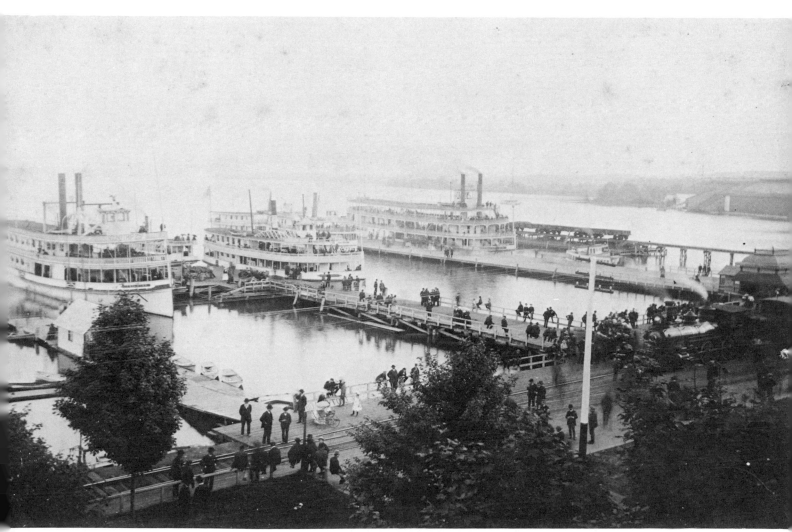

22. Frank Wood's Mammoth Supply Store spread wares along the area from Vincent to Clark on Pratt Avenue.

23. The visit of President Theodore Roosevelt in 1905 brought about many preparations for his welcome. He was greeted by this array of children.

24. From this dock scene in 1914, with its piles of luggage, one sees that the steamers must have been busy transporting Chautauquans.

25. Bishop Vincent was a passenger on the Chautauqua Traction Company line from Jamestown to Chautauqua, which was opened for regular traffic July 4, 1904. The traction station was erected just

22

23

outside the roadgate. This wooden structure was converted to brick in 1916.

26. In 1908, the steamer *City of Cincinnati* ran afoul of a submerged pile and listed, but was later repaired to continue carrying Chautauquans to the pier.

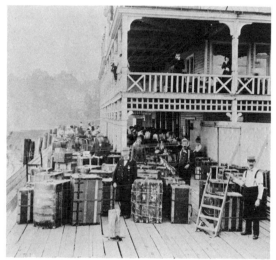

24

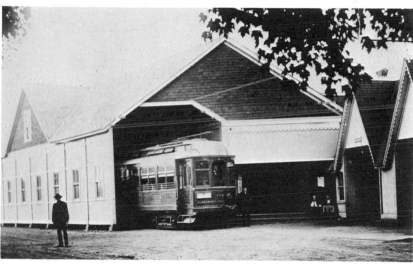

25

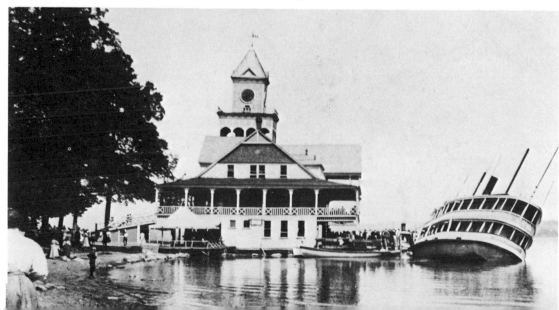

26

27. The double-decker trolley Celoron was named after a neighboring town. Trolleys were a popular means of transportation to the Institution by 1915.

28. The fire department of 1921 was a volunteer organization, as it is today. Now numbering eighty, it includes women.

29. (*a*) This 1921 scene suggests that the current "automobile problems" at Chautauqua are not new. (*b*) In August, 1922, fire destroyed the garage and many autos, as shown below.

30. Buses provided faster transportation over the grounds and became popular for tours (1930).

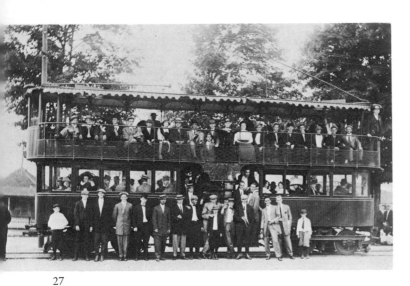

27

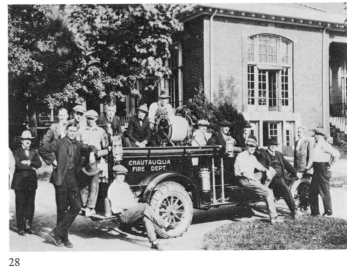

28

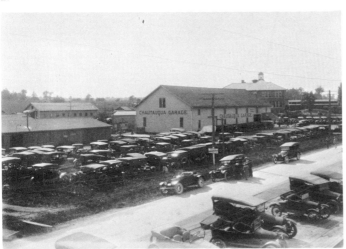

29a

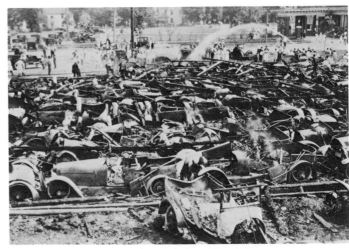

29b

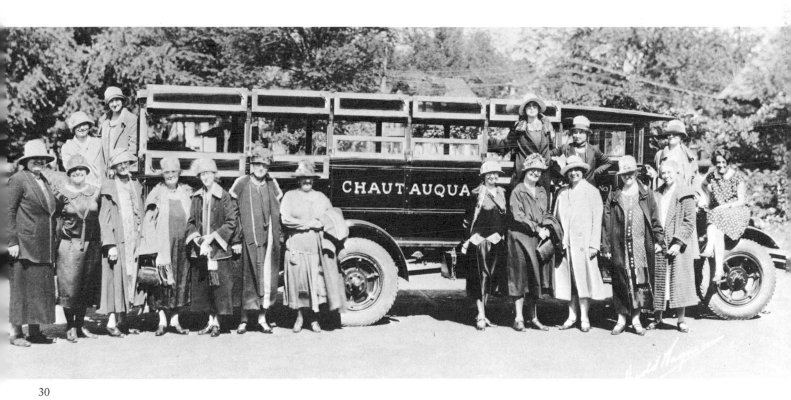

31. Thomas and Mina Edison with members of the Miller family. From left to right: Lewis A. Miller, Mrs. Cotta Miller, her son Milton, the Edisons (seated), Mrs. Robert Miller, and Mr. John Miller (1929).

32. Samuel Hazlett, president of Chautauqua from 1947 to 1956. Hazlett chaired the Pittsburgh Committee that spearheaded the movement "to save Chautauqua" in the 30s. The first $50,000 of the new Chautauqua Foundation was designated as the S. M. Hazlett Honorary Endowment.

33. A source of institutional income has been the gifts contributed on Old First Night, Chautauqua's birthday celebration (1950).

31

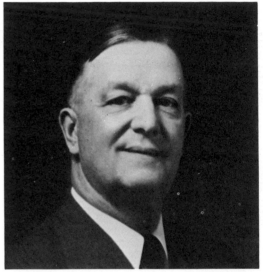

32

33

34. Bestor Plaza, looking toward the Colonnade at the northwest end. The Plaza, the center of business life, also offers great sociability (c. 1960).

35. Current social issues receive due attention— from the platform and in the streets (1972). A group of youngsters participates here in an Ecology Week project.

36. The Sunday morning service of worship is an inspiring moment in a week of full programming. It remains an impressive symbol of the Chautauqua idea.

34

35

36

37. The current map of Chautauqua Institution shows present accommodations and buildings. The original tract at Fair Point was fifty acres. By 1968 it had grown to seven hundred acres.

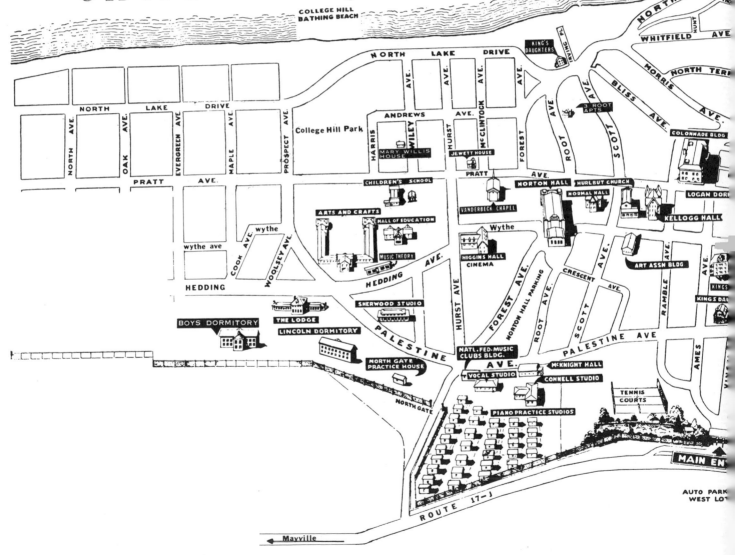

CHAUTAUQUA LAKE

COLLEGE HILL BATHING BEACH

NORTH LAKE DRIVE

NORTH LAKE DRIVE

NORTH AVE.
OAK AVE.
EVERGREEN AVE.
MAPLE AVE.
PROSPECT AVE.

College Hill Park

PRATT AVE.

ANDREWS AVE.
WILEY AVE.
HURST AVE.
McCLINTOCK AVE.
FOREST AVE.
ROOT AVE.
SCOTT AVE.
BLISS AVE.
MORRIS AVE.
NORTH TERR.
WHITFIELD AVE.
IRVING PL.
HUNT

KING'S DAUGHTERS

3 ROOT APTS

COLONNADE BLDG

HARRIS
MARY WILLIS HOUSE
JEWETT HOUSE
PRATT

LOGAN DORM

CHILDREN'S SCHOOL

NORTON HALL
NORMAL HALL
HURLBUT CHURCH

VANDERBECK CHAPEL

KELLOGG HALL

ARTS AND CRAFTS
HALL OF EDUCATION

wythe
wythe ave
COOK AVE.
WOOLSEY AVE.

MUSIC THEORY

Wythe

HIGGINS HALL CINEMA

ART ASSN BLDG

HEDDING AVE.

SCOTT AVE.

RAMBLE AVE.

KINGS

KING'S DA

HEDDING

SHERWOOD STUDIO

CRESCENT AVE.

BOYS DORMITORY

THE LODGE
LINCOLN DORMITORY

PALESTINE AVE.

HURST AVE.
FOREST AVE.
NORTON HALL PARKING
ROOT AVE.

PALESTINE AVE.

AMES

VINE

NORTH GATE PRACTICE HOUSE

NATL. FED. MUSIC CLUBS BLDG.

McKNIGHT HALL

NORTH GATE

VOCAL STUDIO
CONNELL STUDIO

TENNIS COURTS

PIANO PRACTICE STUDIOS

MAIN EN

ROUTE 17-J

AUTO PARK WEST LOT

← Mayville

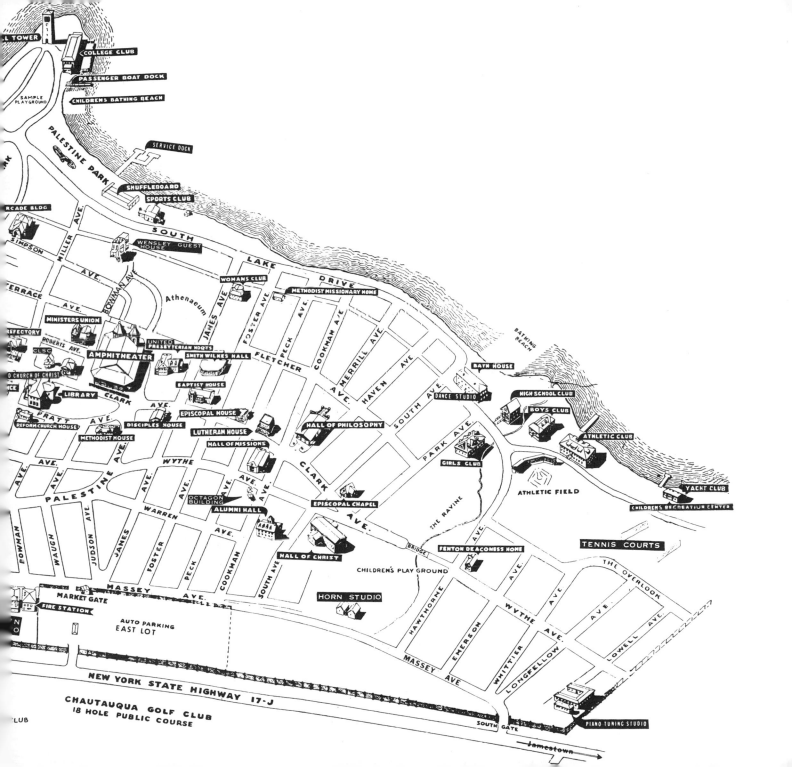

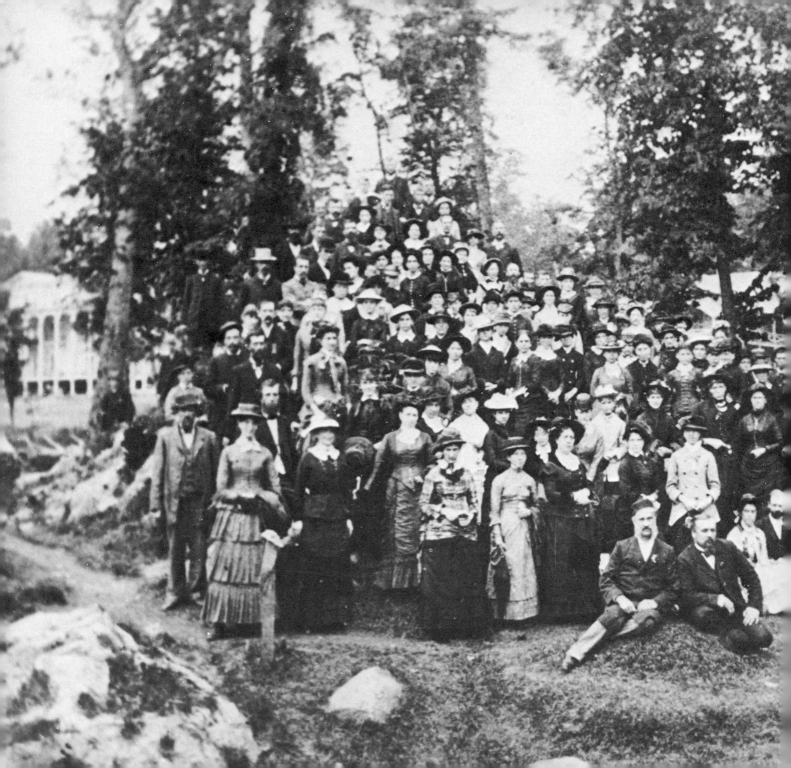

38. The Chautauqua Choir gathers on Mount Hermon in Palestine Park. The chance to sing under inspiring choral leaders has always been a treasured opportunity for Chautauquans (c. 1879).

39. The Chautauqua Band, directed by Henry B. Vincent, provided music from the front lawn of the Athenaeum Hotel, as well as in more formal Amphitheater programs (c. 1903).

The Arts

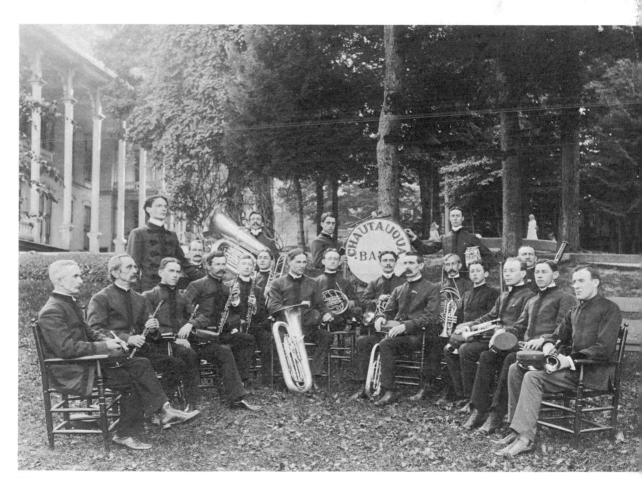

39

40. A painting class by the lake.

41. Chautauqua settings provide inspiration for the artist. R. T. Van Laer sometimes conducted his 1902 sketch class outdoors.

42. This 1924 choral pageant, *Xerxes*, was written and directed by William Dodd Chenery.

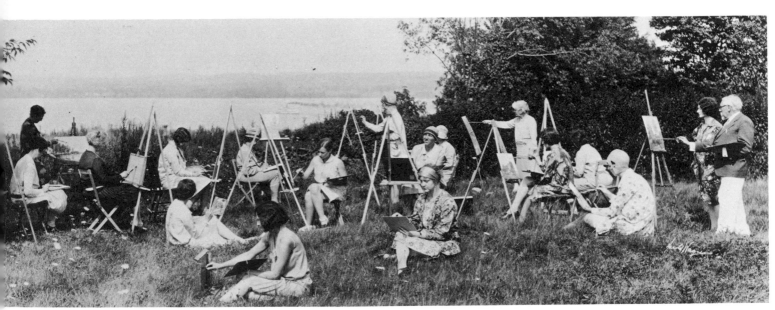

40

41

43. Ernest Hutcheson (chair, center), piano department head, and John Erskine (chair, right), president of Juilliard Foundation and also noted as author and lecturer, are seen in this 1927 photo with other Chautauqua musicians.

44. A 1928 photograph of the Mischakoff String Quartet in the Ralph Norton Garden.

45. One of the foremost violinists of his day, Paul Kochanski (chair), was named head of the violin department in 1928. Kochanski, Polish-born, is surrounded by the Russian Hine Brown, the Rumanian Schuchari, the Americans Clare Harper and Miss Baker, and the Austrian Jacques Singer.

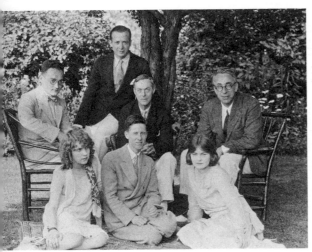

43

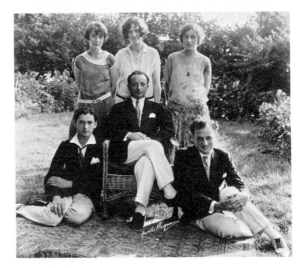

44

45

46. A frequent star of the Chautauqua platform was pianist John Erskine, who made a 1930 radio address entitled "An American Music Center in the Making."

47. The first opera presented at Chautauqua was *Martha*. This 1929 photograph captures one of the opera's scenes.

48. Albert Stoessel (center, arms folded) stands with original members of the 1929 Opera Association. Among those shown here are Helen Jepson (third from left, middle row),

Brownie Peebles (to Jepson's left), Rose Bampton (third from right, middle row), and Alfredo Valenti, production director (standing at extreme right).

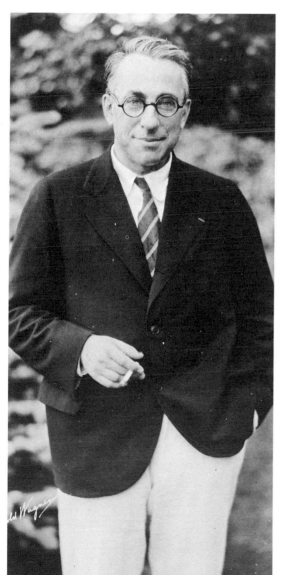

46

47

48

49. Albert Stoessel and the symphony orchestra perform in the parlor of the Athenaeum Hotel (1931).

50. A cow, scored for bass voice, was required for the Erskine-Gruenberg opera, *Jack and the Beanstalk* (1932).

51. Albert Stoessel and Arnold Schoenberg (right) were together at Chautauqua in 1934.

52. Bust of Georges Barrere by Marian Sanford. Devoted to the flutist and his music, Miss Sanford, then in her twenties, worked on the bust during sittings at Chautauqua. The

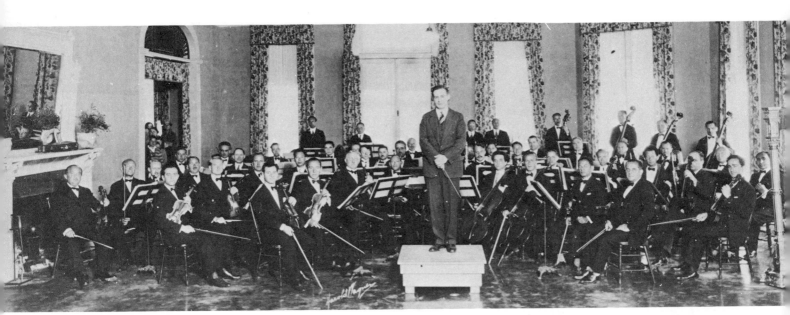

49

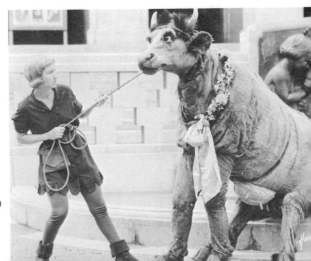

50

casting in bronze resulted from the generosity of Rebecca Richmond (1934).

53. The student symphony orchestra rehearses with Edward Murphy (1940).

54. For thirteen years, beginning in 1944, James Friskin headed the piano department. This soft-spoken Scot, a devotee of Bach, sustained the high quality of music heard at Chautauqua.

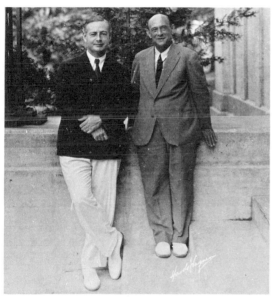

51

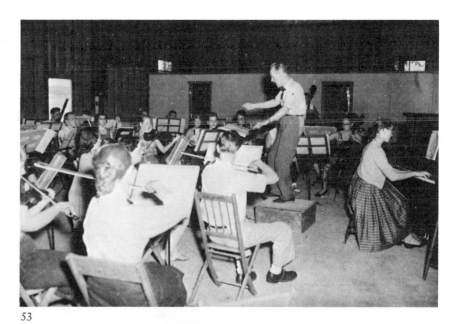

53

52

54

55. Howard Hanson sits while Revington Arthur paints. One of America's foremost musicians, Hanson has for years been featured in Chautauqua's symphony programs (c. 1962).

56. A class in sculpture illustrates Chautauqua's emphasis on the creative arts (1965).

57. The art center provides many opportunities in the creative arts. Revington Arthur instructs this class.

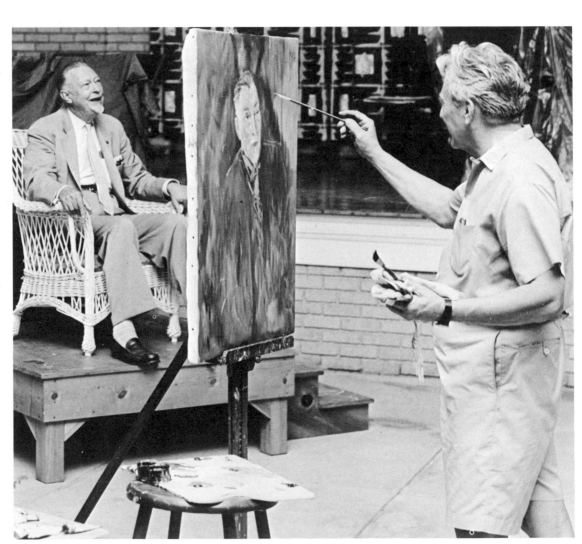

55

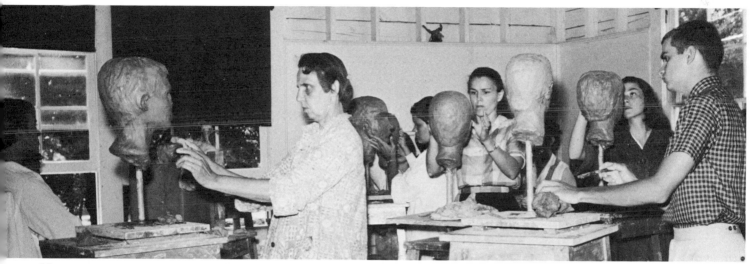

56

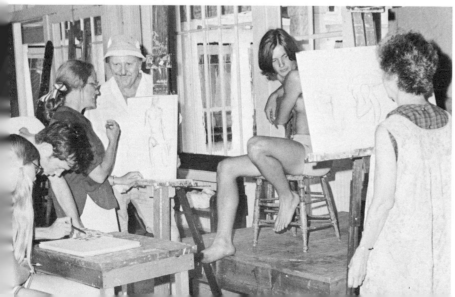

57

58. Performing groups from around the world find large and enthusiastic audiences in Chautauqua's Amphi-theater. This is a 1967 performance by the Salt Lake City/Mormon Tabernacle Choir.

59. Chautauqua youngsters sometimes have the fun of being in operas. These children appeared in the 1972 Chautauqua Opera Association production of *A Midsummer Night's Dream*.

60. Though late in gaining full standing, the theater today is one of Chautauqua's main program components. This is a dramatic moment in the 1971 production of *The Price*.

61. Duke Ellington, as he opened the 1972 season. Such nationally renowned artists have become an important aspect of Chautauqua's popular programs.

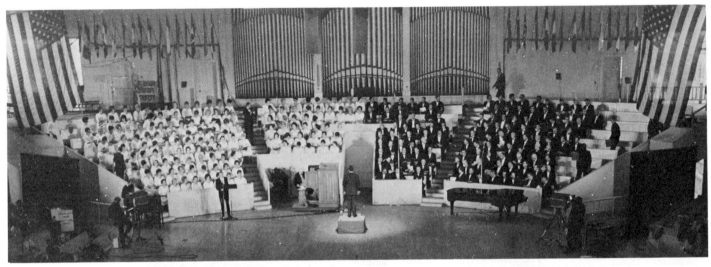

58

59

60

62. The program topics
and the summer schools
reflect a growing world
consciousness that
transcends national and
cultural barriers. Here a
class is introduced to
Indian classical music
(1973).

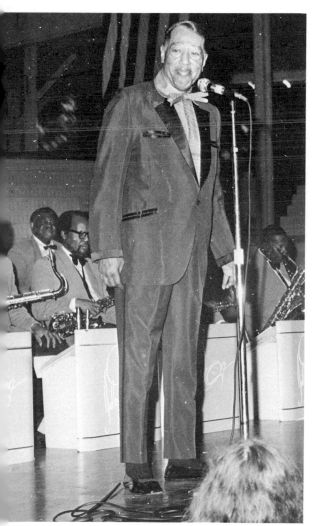

61

63. The symphony orchestra concerts are among the most treasured elements of Chautauqua's programming. On other occasions student orchestras combine learning with performing, a philosophy long a part of the Chautauqua tradition.

64. The dance, one of the fastest growing art forms in America, is an expanding department in the summer school. Members of the School of Dance are often given opportunities to perform in the operas (1973).

65. Workshops are used with increasing frequency in Chautauqua's educational programs. Here a group of students learn from Bunyan Webb.

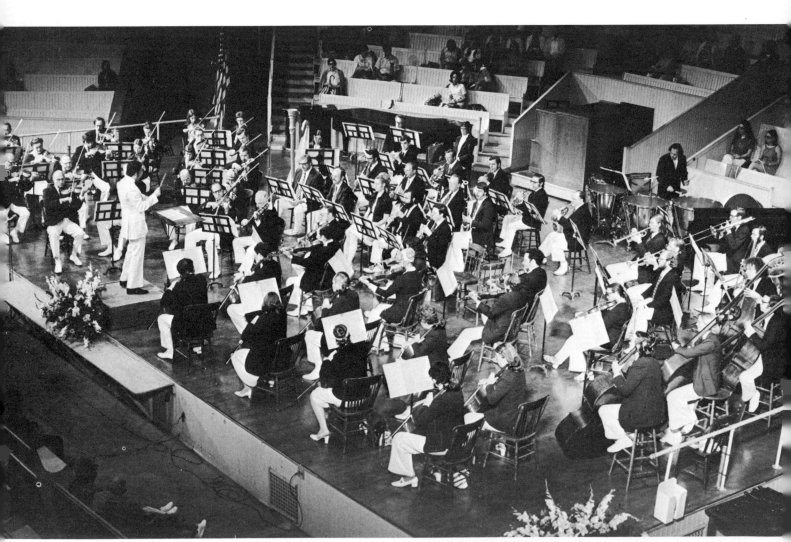

66. Students often find Chautauqua's natural resources an appealing practice area (1973).

64

65

66

67. Palestine Park (a most unusual visual aid in learning biblical history and geography) was a feature of the first assembly and is shown as it was rebuilt in 1888.

68. The 1889 CLSC class is photographed on Recognition Day with Kate Kimball (first row, center), flanked by Edward Hale (left) and Jesse Lyman Hurlbut (right).

69. Kate Kimball, executive secretary of Chautauqua reading circles for almost forty years, corresponded tirelessly with circles and individual readers. She also traveled and spoke throughout the country on behalf of the CLSC.

70. In 1885 chemistry classes were held in the College of Liberal Arts.

Education

68

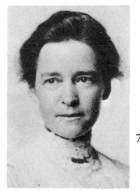

69

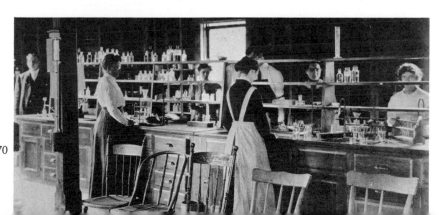

70

71. The first CLSC class graduated in 1882. Here the class is shown in 1895 in front of Pioneer Hall, built ten years earlier. This building, maintained by the alumni, houses a CLSC museum.

72. The CLSC Recognition Day was always a big occasion for many Chautauquans. This photo shows Chautauqua children serving as flower girls in the Recognition Day Parade of 1900.

73. 1901 saw the opening of a School of Library Science under the guidance of America's eminent librarian, Melville Dewey. Instruction in library science is still being offered today.

74. The vacation school was under the general supervision in the early 1900s of John Dewey of the University of Chicago. The use of audiovisual aids and student construction of projects are shown in this view of the children's school.

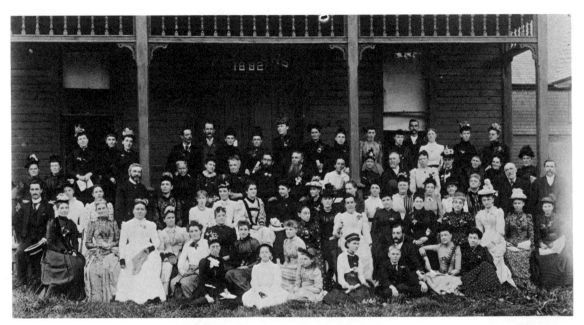

71

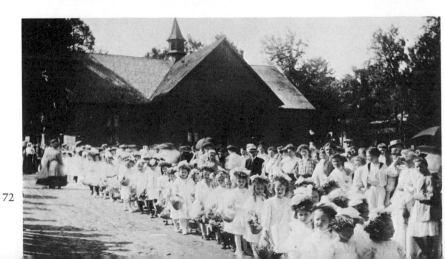

72

75. The Chautauqua School of Domestic Science prepared the elaborate breakfast for President Theodore Roosevelt, August 11, 1905. The first cooking school was held in a tent in 1889. In 1882 *The Chautauqua Cookbook,* by Kate Cook, was published.

76. A favorite activity of school groups, starting with kindergarten. In the background may be seen the CLSC building.

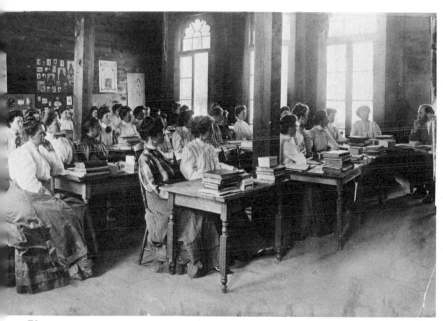

73

74

75

76

77. Chautauqua's summer schools have long included the practice of weaving. A blind woman here works at her loom.

78. Bishop Vincent stands with Jane Addams. The 1915 CLSC class was named for Miss Addams.

79. This procession entering the Hall of the Grove features the Arthurians, the CLSC class of 1918.

 "Live pure
 Speak true
 Right the wrong
 Follow the King"

reads this banner. They were met at the top of the steps by Dr. Jesse L. Hurlbut and Mrs. Ida B. Cole, CLSC leaders, and Bishop Francis J. McConnell, Recognition Day speaker.

77

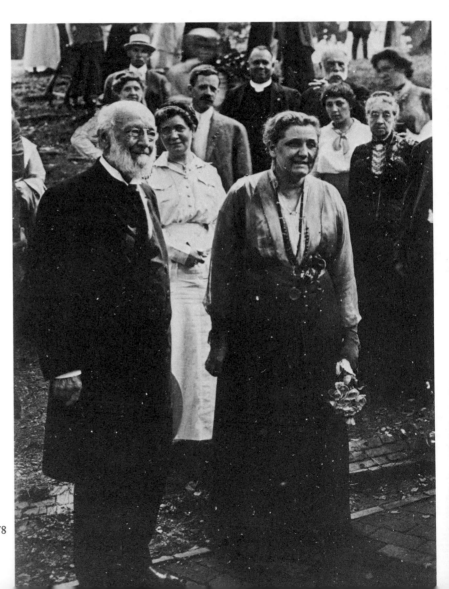

78

80. Chautauqua, acclaimed as typically American, never has lacked expressions of patriotism. This National Service School retreat shows the involvement of the women of Chautauqua in World War I. Such ceremonies were frequent during the war.

81. A class in telegraphy was offered during World War I. The Institution's facilities were used as a training place for women in the war effort. Chautauqua president Arthur E. Bestor was appointed by President Wilson to be director of the Speaking Division of the U. S. Committee on Public Information. The appointment was taken as a tribute to Chautauqua's platform leadership.

82. A women's service school was billeted in the south end of the grounds.

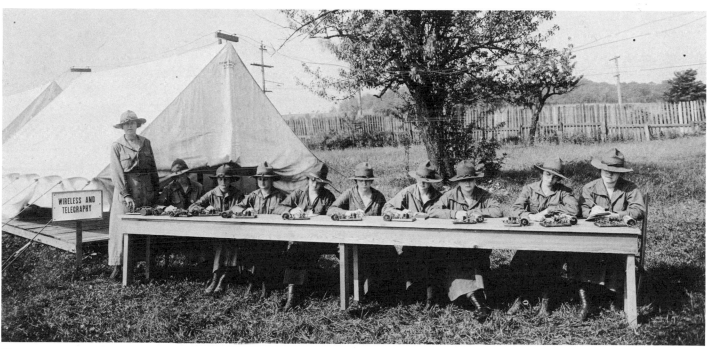

81

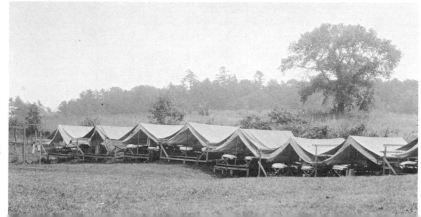

82

83. The elementary school erected on College Hill accommodates children between the ages of two and six. It serves as a work school, play school, and study school. This facility was expanded in 1969.

Kindergarten classes were started shortly after the Assembly's beginning, coordinated with kindergarten training.

84. Thomas A. Edison's certificate of membership in the CLSC class indicates that he graduated in 1930.

85. Field trips became a regular feature in the program of the Boys' Club (1930).

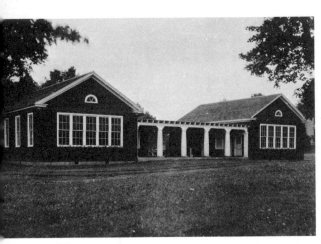

83

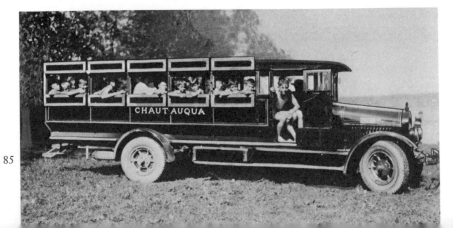

84

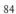

85

86. Three Bell Aircobras were displayed in Smith Memorial Library to celebrate Aviation Day, July 8, 1944.

87. Town Meeting of the Air contributes to Chautauqua's "Open Platform" (1945).

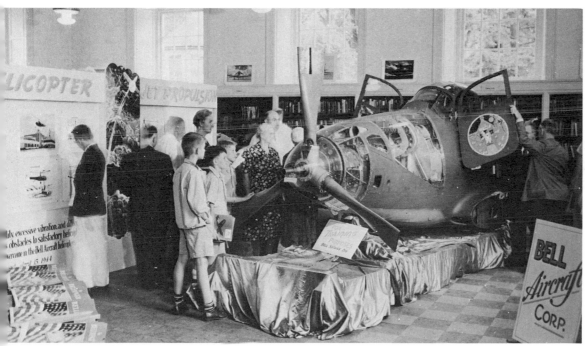

86

87

88. David McCord brings poetry and youth together (1972).

89. "Story Lady" holds attention at the Nursery School (1972).

90. In cooperation with the affiliate Artist Program of New York, Chautauqua makes an effort to reach out into the community. Here an opera performer becomes the teacher, to the delight of young people.

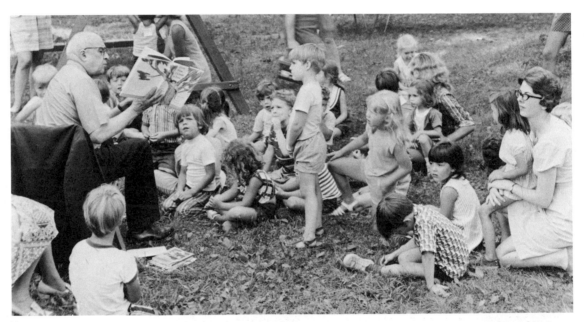

88

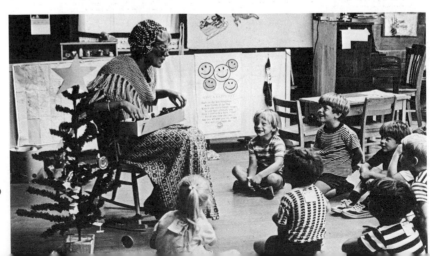

89

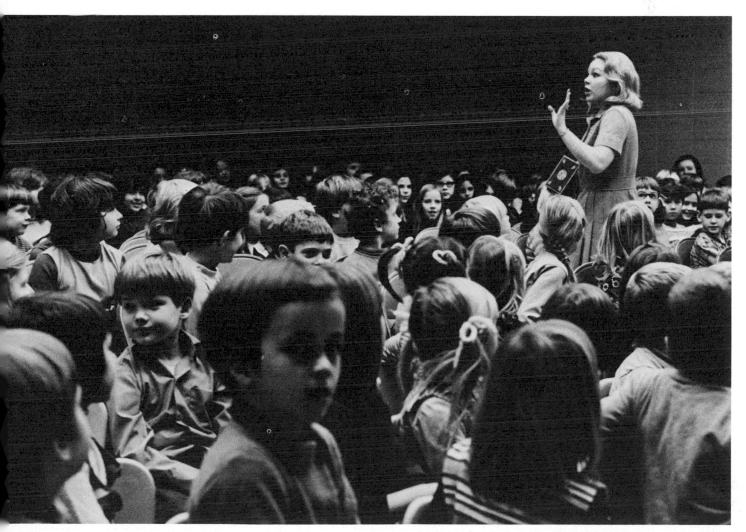

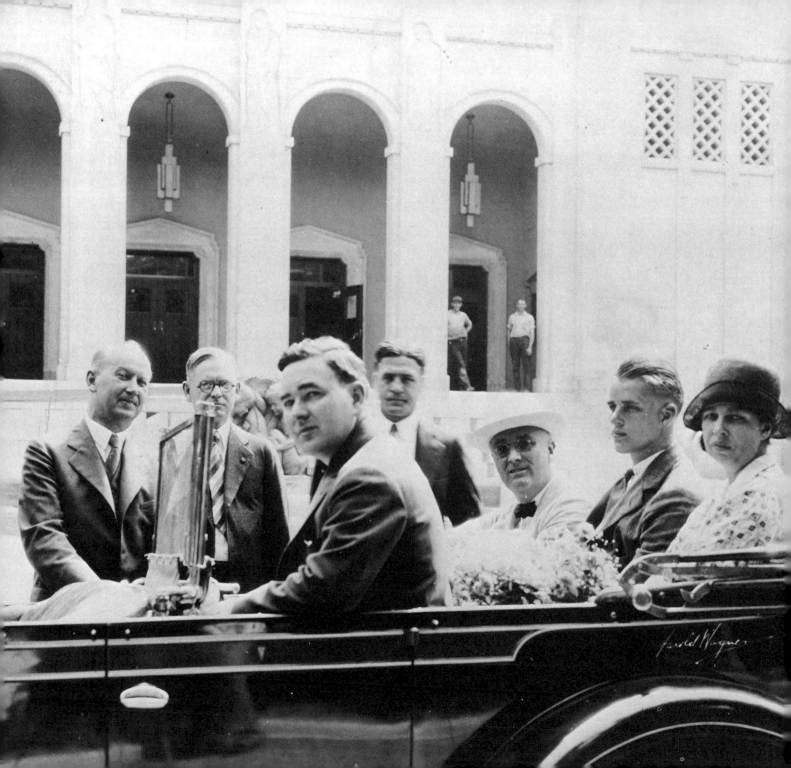

91. Franklin D. Roosevelt, then governor of New York, inspects the newly built Norton Hall on his way to deliver an Amphitheater address. With him, seated in the rear, are his son Elliott and Mrs. Roosevelt. In front sits his secretary, Gurnsey T. Cross. Standing, to greet the governor, are President Bestor and Ralph Norton.

92. Among the foreign visitors to Chautauqua was Chinese ambassador Lieng Cheng. He is shown here with Bishop Vincent in 1904.

93. Theodore Roosevelt visited Chautauqua for the fourth time in 1905.

94. Governor Charles Evans Hughes of New York spoke from the platform on August 24, 1907.

Personalities

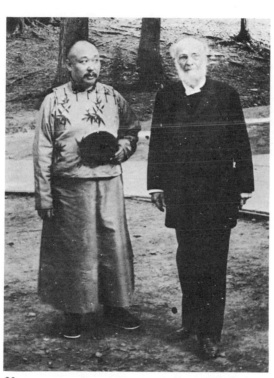

92

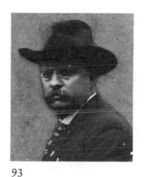

93

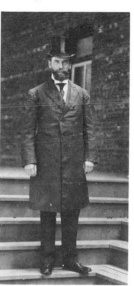

94

95. Ida M. Tarbell worked on the *Chautauquan*, assisting editor Theodore L. Flood, and wrote for the Chautauqua *Assembly Herald* in the summers.

96. Count Ilya Tolstoy spoke at Chautauqua on June 27, 1922, to the National Federation of Women's Clubs' sixteenth biennial meeting. The Athenaeum, Men's Club, and all facilities opened early to take care of the large convention.

97. President Bestor poses with John D. Rockefeller, Jr. (center), who gave a lecture on capital and labor in the Amphitheater on July 12, 1918.

98. Edison is shown here broadcasting from his garden at Chautauqua.

95

96

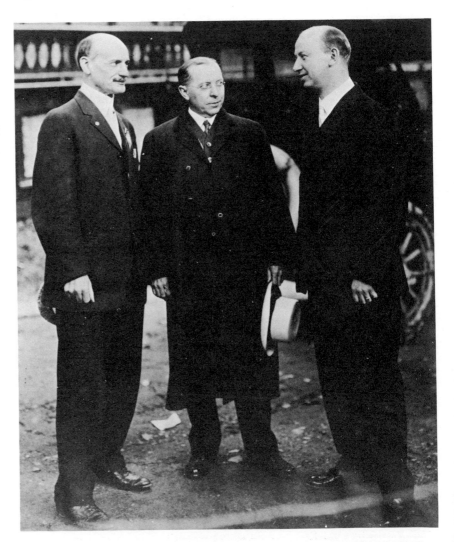

97

99. George Gershwin, shown here with Ernest Hutcheson, composed his Concerto in F in one of Chautauqua's practice shacks during the summer of 1925.

100. Mrs. O. W. Norton attended the groundbreaking for the edifice bearing the family name. It was the first monolithic concrete building east of the Mississippi River. Today Norton Hall is the opera and theater center of Chautauqua.

101. Co-explorers Captain George H. Wilkins and Lieutenant Carl Eielson are shown with President Bestor and their plane, which landed at Chautauqua in 1928.

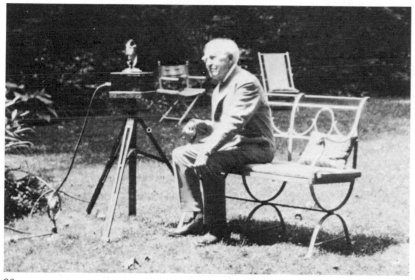

98

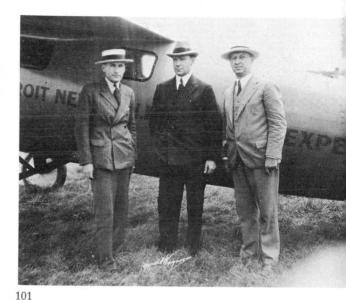

101

99

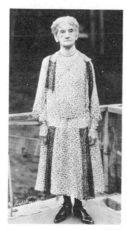

100

102. Thomas A. Edison is here followed by President Bestor (1929).

103. Henry Ford, Thomas A. Edison, and Adolph Ochs, publisher of the *New York Times,* were at Chautauqua in 1929 to celebrate the Centenary of Lewis Miller's birth (President Bestor is standing in rear).

104. President Bestor and Franklin D. Roosevelt on the Bestor porch (1929).

105. Amelia Earhart is welcomed on her arrival at Chautauqua by President Bestor (1929).

102

103

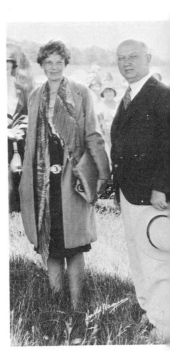

105

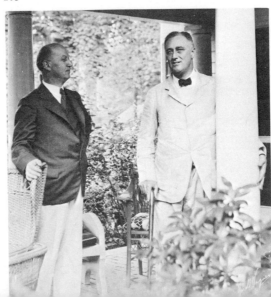

104

106. Vachel Lindsay, one of America's foremost poets, spoke at Chautauqua on August 21, 1930.

107. Admiral Richard E. Byrd, Antarctic explorer, poses with President Bestor. According to the *Daily,* Admiral Byrd's 1931 lecture on "Little America," accompanied by motion pictures, drew "the largest crowd ever . . . to hear a single man in the Amphitheater" and marked the first use of loudspeakers at Chautauqua.

108. Eleanor Roosevelt delivers an address at the Amphitheater in 1933.

106

107

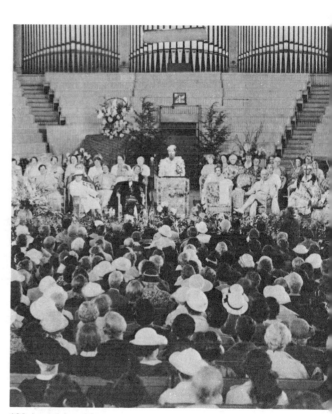

108

109. Upton Sinclair debated with Hamilton Fish about social betterment on June 24, 1935.

110. Franklin D. Roosevelt delivering his "I Hate War" speech, August 14, 1936.

111. An appearance was made in 1936 by the Republican candidate for president, Alfred Landon (left). His grandfather, the Reverend W. H. Mossman, built the cottage at 20 Miller Park in 1876.

112. WPA chief Harry Hopkins made one of his rare public appearances when he spoke on "What Is the American Way" in the Amphitheater in 1938.

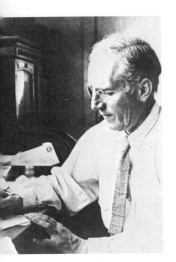

109

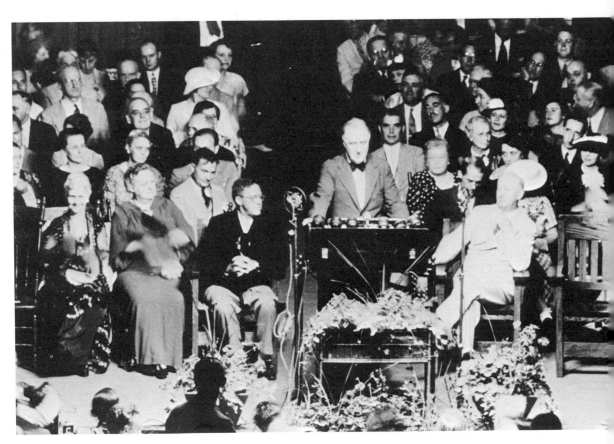

110

113. Karl Menninger, popular lecturer at Chautauqua, talks in Smith Wilkes Hall (1965).

114. The late Paul Dudley White, noted authority on care and diseases of the heart, lectured at Chautauqua in 1969.

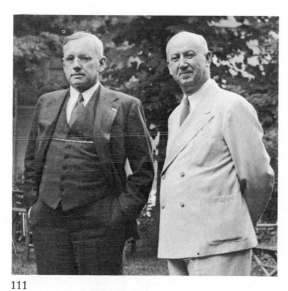

111

113

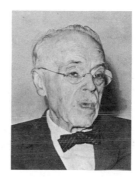

114

112

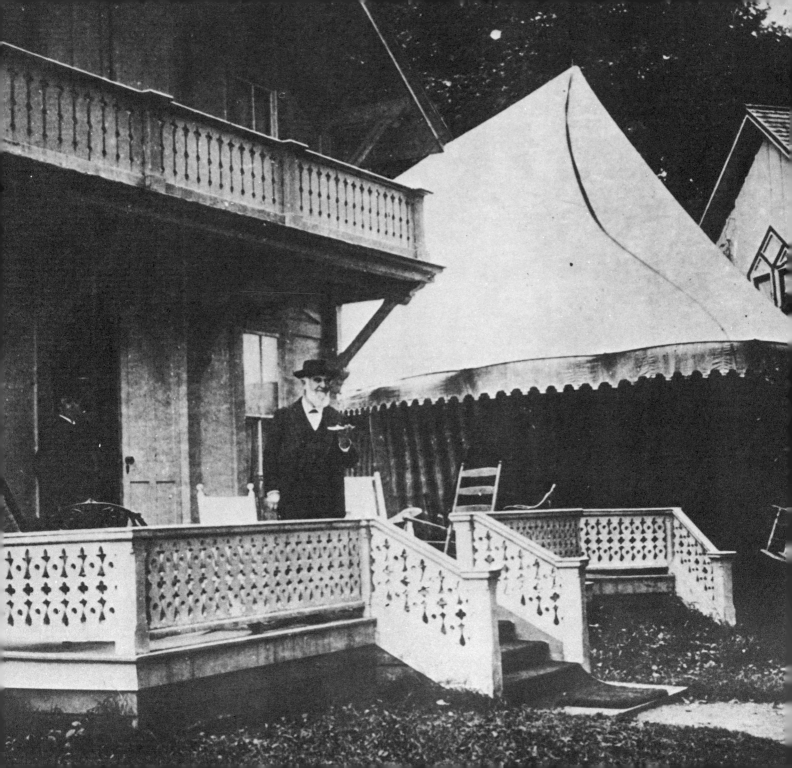

115. The Miller Cottage, home of Lewis Miller, and later of his son-in-law, Thomas A. Edison, with an adjoining tent. The original tent helped provide accommodations for Miller's large family and his many guests. Here, in 1875, Miller and Vincent acted as hosts to President Grant.

116. The Miller Cottage, flanked by its large tent-platform. The cottage, for which lumber was cut and brought from Akron, is an early example of at least partial prefabrication. In 1969 it was made a National Historical Landmark.

117. John Vincent first occupied a tent near the boat landing. This cottage, built a few years later, no longer stands. Its site is now a memorial, called the Bishop's Garden.

Architecture

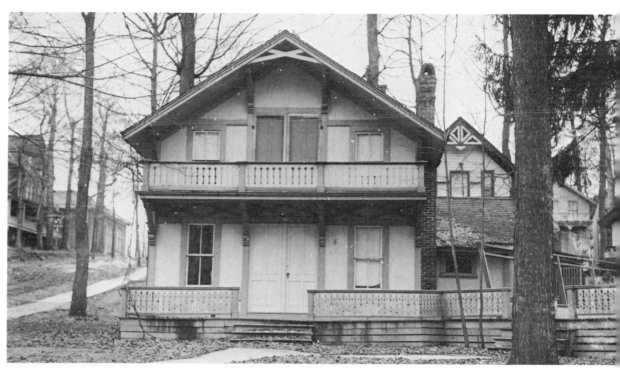

116

117

118. This edifice was built for the 1876 assembly. The speaker's stand was enlarged and backs were added to the hard wooden benches.

119. The first Hall of Philosophy, called "The Hall in the Grove," was erected in 1879 and replaced by the present structure in 1906.

120. The first Amphitheater, built in the Gorge in 1879 and replaced in 1893 by a structure with steel pillars and trusses. This project was directed by Lewis Miller.

121. The Athenaeum Hotel was so-named to impart a classical tone to a growing educational institution and to provide more suitable accommodations for visitors. This was the

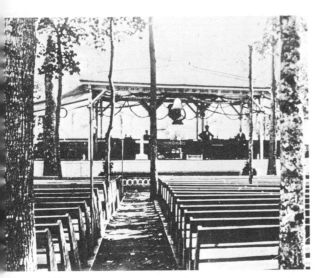

118

119

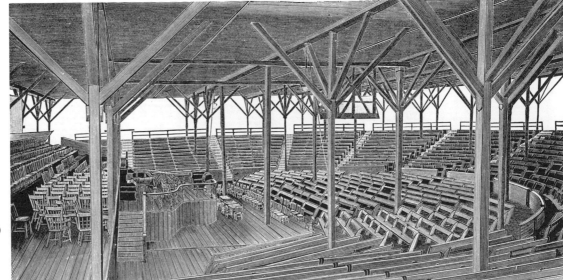

120

place where people could chat with platform personalities and the Institution's leaders. The Athenaeum is still in use as the premium Chautauqua hotel.

122. In 1913 the Athenaeum Hotel was admired for its wicker furniture, many pieces of which can still be seen there today.

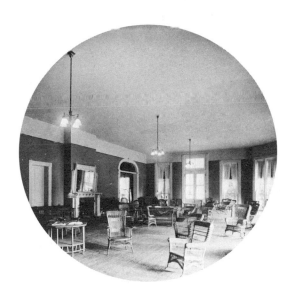

122

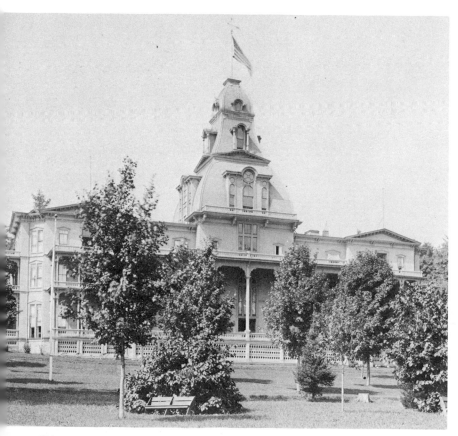

121

123. The business and editorial quarters in 1876 of the Chautauqua *Assembly Herald,* edited by Theodore L. Flood.

124. A roomy, gabled Victorian house was advertised for sale in the Chautauqua *Assembly Herald* of August 4, 1881. The house still stands.

125. In 1886 the old Pier Building was erected. Boats arrived every hour. Shops were housed on the second floor, and popcorn and candy pagoda was close by. Indians frequently sold sweet-grass baskets under the ramp. The Pier Building also contained the original Bell Tower.

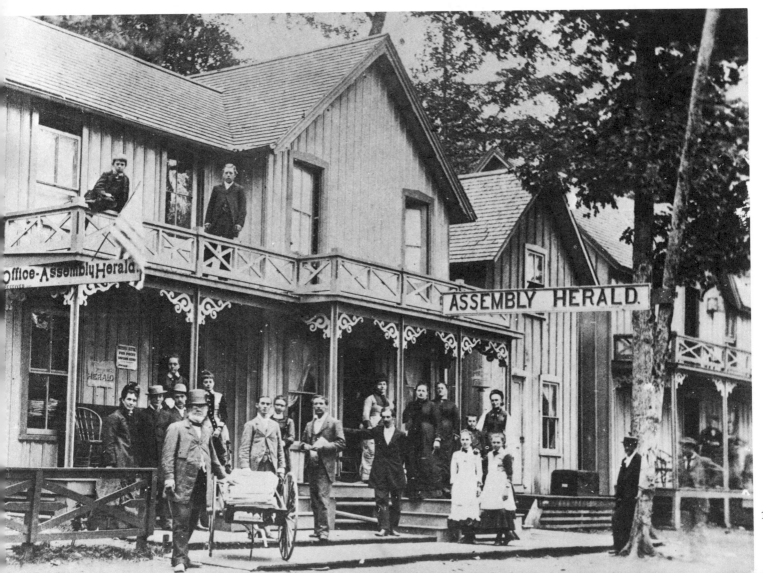

126. Students are shown in rainy weather leaving the College Building, known as the "Moorish Barn." It was built in 1887 while William Rainey Harper was heading the Chautauqua College of Liberal Arts.

127. This bell, shown in the Pier Building Tower, is said to be the Bryant Bell that was rung each season to signal the new CLSC reading year. It is one of the original ten bells which were transferred to the Miller Bell Tower in 1911.

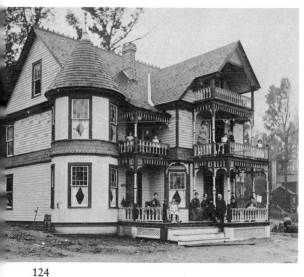

124

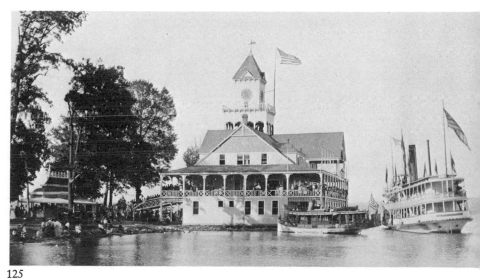

125

126

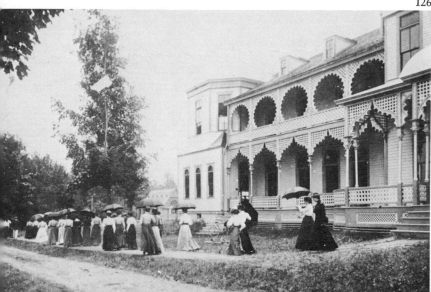

127

128. The original Jacob Miller House, owned by A. T. Scofield in 1895, was on the spot where the headquarters of the Chautauqua Women's Club was built in 1929. Jacob Miller was the brother of Lewis Miller.

129. Erected in 1889, this Administration Building housed the Chautauqua *Assembly Herald*. It has had many uses. A tearoom once occupied the second floor and balcony. The building now features a gift shop.

130. The charming Muncie Hotel was built in 1883. It became the North Shore Inn in 1944 and finally succumbed to time in 1970, when it was torn down to make room for private homes. Its cuisine was among Chautauqua's best.

131. The CLSC and museum buildings are shown on the site now occupied by the Smith Library.

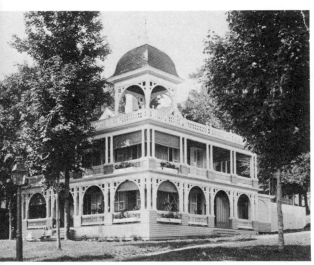

128

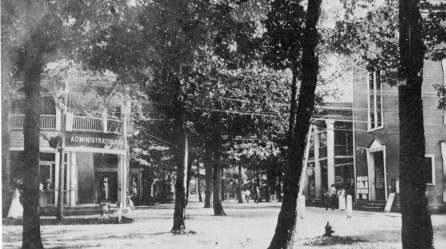

130

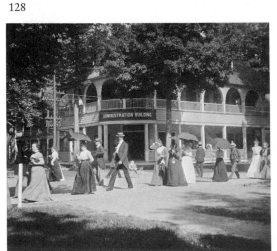

129

131

132. Pilot houses were constructed in various styles and naturally attracted the younger set.

133. The Anne M. Kellog Memorial Hall was moved to its present location in 1905 in order to provide more room for its kindergarten playground.

134. The present Amphitheater was erected in 1893, with a seating capacity of over seven thousand people. This picture was taken in 1907 when the Massey Organ, given by the Massey family, was being installed. Vincent Massey, first Canadian ambassador to the United States, represented the third generation of Masseys to be Chautauqua trustees. Raymond Massey (the actor) and Vincent came as children to visit grandfather H. A. Massey.

132

134

133

135. The Lebanon, at 14 Miller, now known as the Hotel William Baker, commands a beautiful view of the lake.

136. The open porches and doors of the Morey cottage exemplified Chautauqua's unique architectural characteristic of easy access to the out-of-doors. Lincoln Park now occupies the area on which the "Morey" was built.

137. Originally built in 1912 as Chautauqua's hospital, this building is now used to house forty summer school participants. It is now known as the Lodge.

138. The old wooden traction station was remodeled in 1916. The basic structure stands today as the gate, or main entrance, to the grounds.

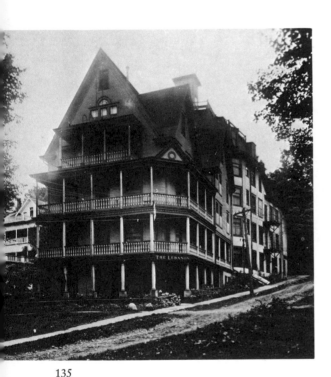

135

136

137

139. The house of the Chautauqua Art Association since 1957, this building, seen here c. 1924, served as a chapel when built in 1891. It was used as a summer-school commons from 1910 to 1933.

140. One of Chautauqua's most unusual and comfortable hotels is the Cary. George Gershwin stayed here in 1925 while writing his Concerto in F.

138

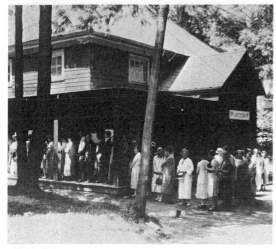

139

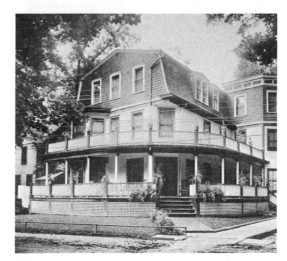

140

141. The Hall of Philosophy is classical in design. Nearby stands the Hall of Christ. The relationship between faith and reason was an important element in the Chautauqua idea (1930).

142. Architect for this Hall of Christ was Paul J. Pelz, who designed the Library of Congress. This building was one of Bishop Vincent's great dreams, symbolizing, as he intended, Chautauqua's basic commitment to the Christian faith.

143. The St. Elmo Hotel in 1930. It still accommodates visitors to Chautauqua, remaining open the year round.

144. Of stately Georgian architecture, the Smith Memorial Library stands today at the center of Chautauqua—an appropriate symbol of Chautauqua's basic purpose. It houses the

141

142

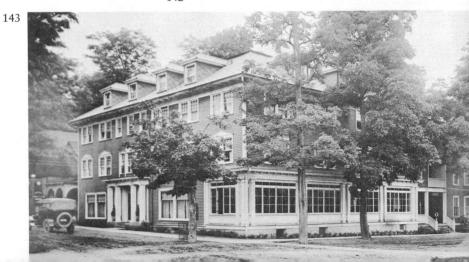

143

collection of the
Institution's publications
and historical
documents (1931).

145. Interior of the
Smith Library as it
appeared in 1930.

146. An aerial view of
the Miller Bell Tower
shows the College Club
(built 1916) in the
background. Many
college students work
and study on the
grounds in the summer.
The Club is their social
center.

144

145

146

147. The Gingerbread Cottage, built in 1891 on an old tent platform, is still standing and has become the most painted and photographed house on the grounds. It is now owned by Pauline Fancher.

148. The Athenaeum Hotel, viewed from the lakefront, remains an attractive and popular facility.

149. The present United Church of Christ Denominational House is located on the same site as that of the original.

150. Chapel of The Good Shepherd (Episcopal).

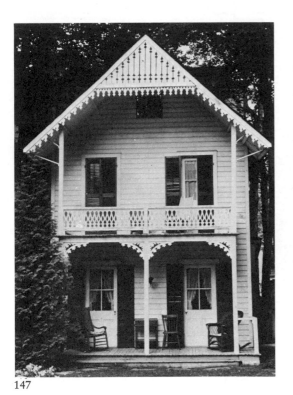

147

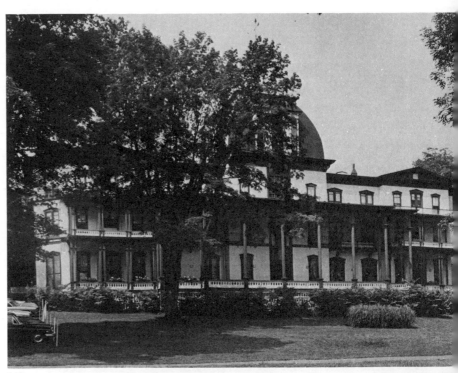

148

149

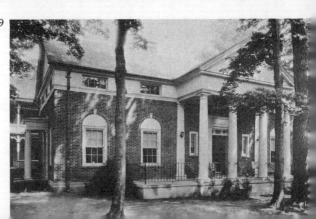

151. This type of
architecture, typical of
Chautauqua, helps create
the milieu for which the
Institution is noted.

152. This panorama of
architecture illustrates the
variety of Victorian
buildings which continue
to attract interest (1972).

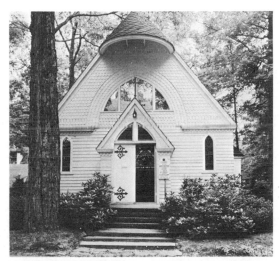

150

152

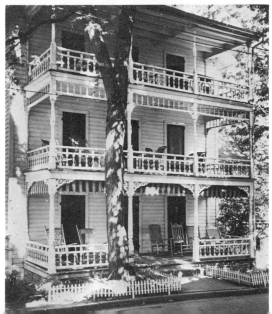

151

153. The Chautauqua Women's Club has its headquarters in this building which faces the lake.

154. The Frances Willard House was an early (1890) lakefront cottage. The Frances Willard Memorial Window was moved here in 1924 from its original site in Kellogg Hall, and the next year the house was bought for the WCTU. It is now a private residence.

155. The Octagon House was built in 1885 to furnish classroom space for the Chautauqua Literary and Scientific Circle. In recent years it has housed meetings of the Writers' Workshop, a

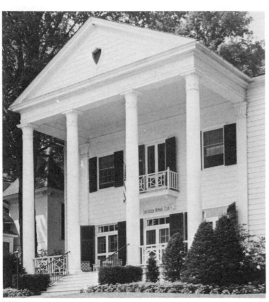

153

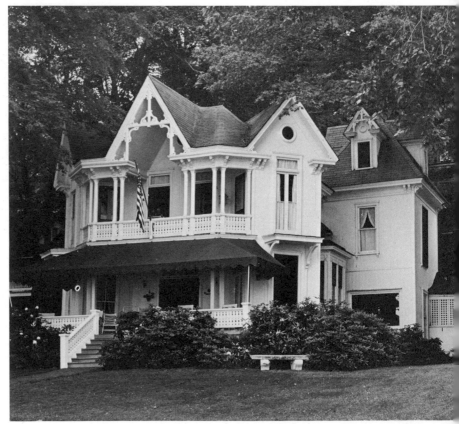

154

fact which explains the sign, "The Octagon Poets," over the door.

156. A North Lake Drive home. This modern home is in an area of Chautauqua known as the original Packard estate (1950).

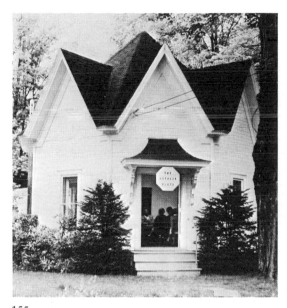

155

156

157. The Amphitheater and Norton Hall serve as the main program centers. The Amphitheater houses services of worship, major performances of the symphony orchestra, lectures, addresses, films, recitals, and popular entertainment.

158. Norton Hall is the site for operas, plays, and chamber music. Over the stage reads the motto: "All passes; art alone endures."

159. The Miller Bell Tower commemorates Lewis Miller, co-founder of Chautauqua.

160. The second Hall of Philosophy was completed in 1906 on the same spot as the original one. The hall, modeled after the Parthenon, is used for the Chautauqua Literary and Scientific Circle meetings, vespers, and lectures (1972).

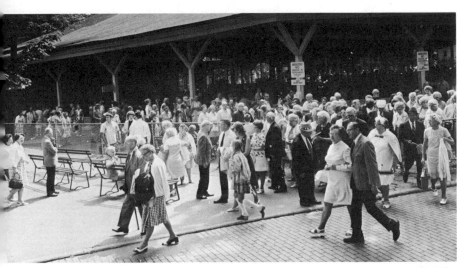

157

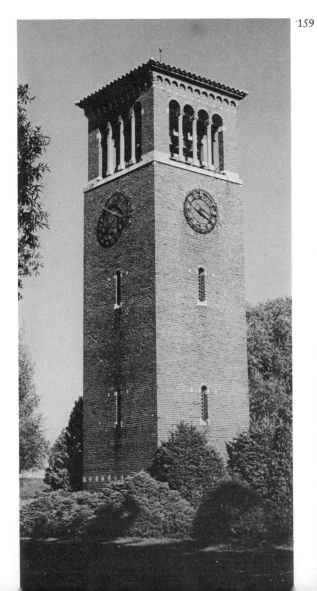

159

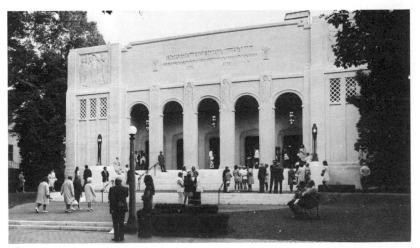

158

160

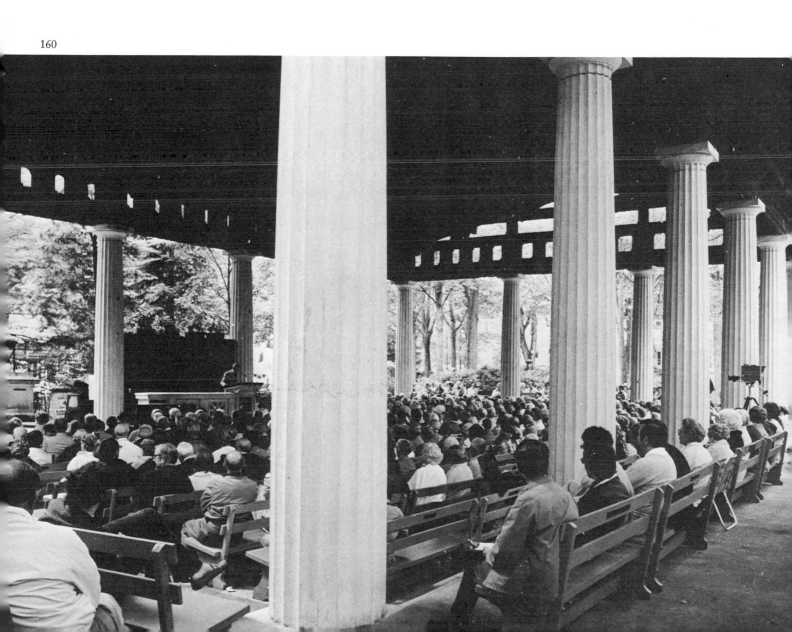

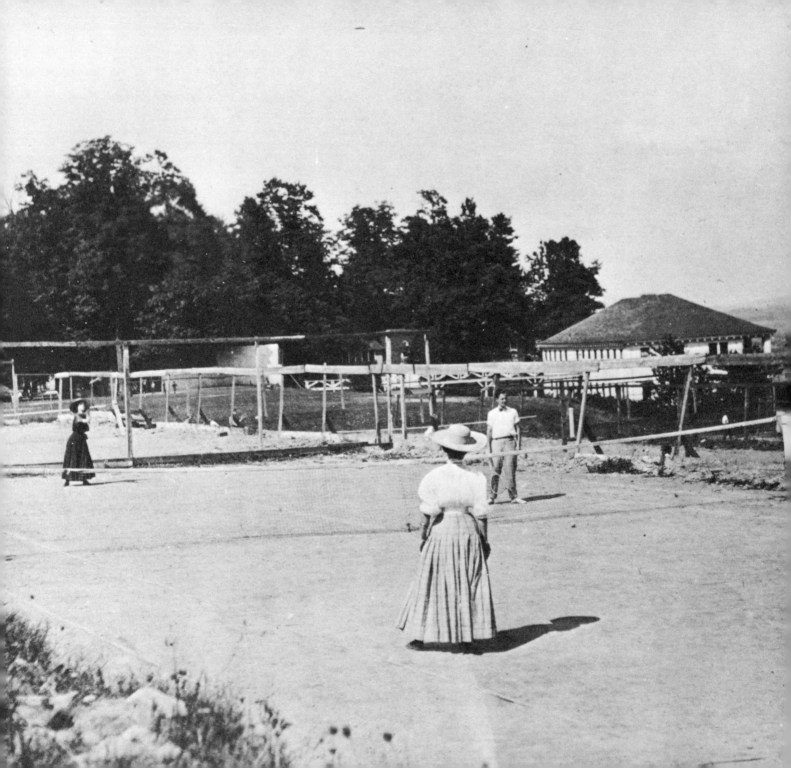

161. Co-founder John Vincent became acquainted with tennis during a visit to England and promptly had courts constructed on his return.

162. The first rather casual golf course was laid out in the 1890s at the rear of the main college building. A professionally designed course was put into use in 1914. By 1924 it was a full eighteen-hole golf course.

163. Writing home from Chautauqua during 1896, William James had a good word for the Delsartian calisthenic system, here illustrated by Elizabeth Bishop.

164. Various colleges were represented on the team in the early days of Chautauqua baseball. Alonzo A. Stagg, a gymnasium instructor at Chautauqua in 1888, attracted large crowds when he played baseball.

Leisure

162

163

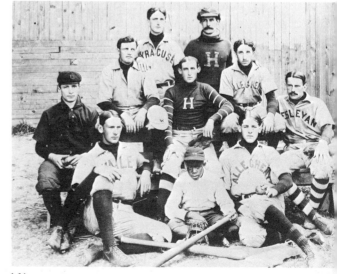

164

165. Some of the activities of the 1909 Boys' Club included archery, golf, baseball, tennis, shooting, weight lifting, and lacrosse. Such gear is pictured above, along with the boys who put it to use.

166. Theodore Miller, commemorated in George Vincent's edition of his Spanish War diary, brought home enthusiasm for crew from Yale in the 1890s and was instrumental in procuring two new shells. The sport continued to draw college athletes to Chautauqua, as this pre-World War I photograph attests.

167. Double-runners of an older time appear ready for a coast toward the lake.

165

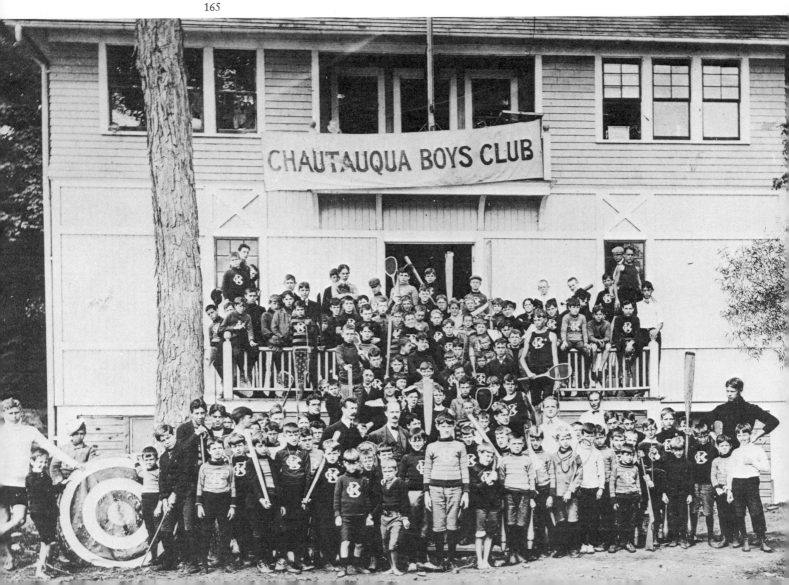

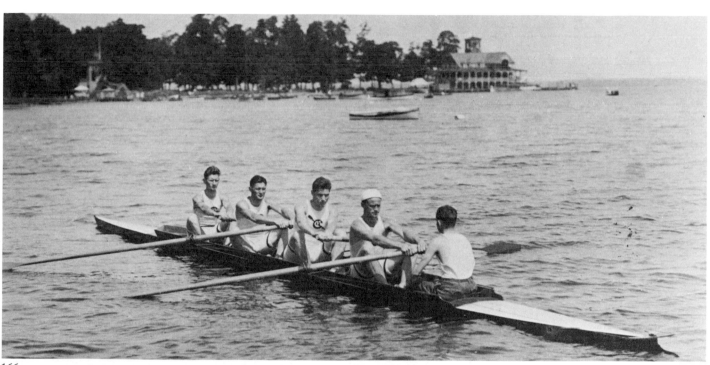

166

167

168. Roque is a form of croquet played on a court allowing banked shots. Chautauqua roque courts were considered the finest in the country in the first quarter of the twentieth century.

169. Bowling on the green (1935).

170. Shuffleboard has retained its popularity since being introduced at Chautauqua in 1934.

171. A beginner's swim class at the Boys' and Girls' Club is a major attraction to would-be swimmers (1971).

168

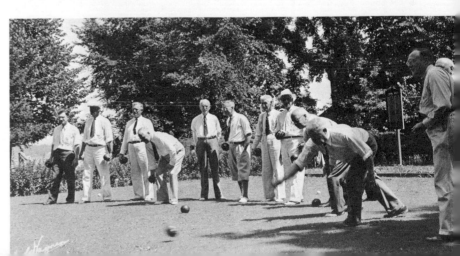

169

170

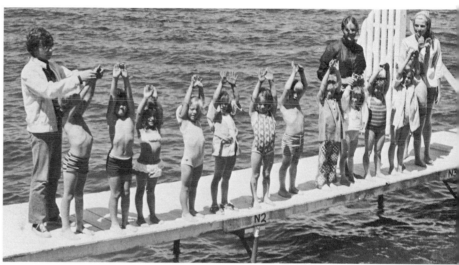

171

Acknowledgments and Sources

A formal apparatus of footnotes seemed inappropriate to this book, which is addressed to general readers. A number of special acknowledgments and a list of sources follow.

One source, indispensable for this book, has been *Chautauqua—Adventure in Popular Education,* by Harrison John Thornton, late professor of history at the University of Iowa. This is a two-volume, unpublished work, in typescript, running to well over 1,100 pages, tracing in detail the history of Chautauqua from its beginning through 1948. The typescript, the property of the Institution, was entrusted to me by Chautauqua authorities, with the consent of Professor Thornton's widow, for use in preparing the present volume. I gratefully acknowledge my very extensive debt to Thornton's text, with the observation that in the time at my disposal since the beginning of 1972, it would not only have been impossible for me to repeat his exhaustive research, but it would also have been a work of supererogation.

Earl J. Johnson, now of Tucson, Arizona, sent me lively reminiscences in correspondence and happily put me in touch with Roland M. Mueller, of Winfield, Kansas. Mr. Mueller has been extraordinarily generous in providing me with extensive materials from his own research, bearing principally on "permanent" and "circuit" Chautauquas. These, I trust, are sufficiently acknowledged in place in the text. Mr. Mueller is not to be held responsible for deficiencies of statement or emphasis in my chapter "Tents and Tabernacles." Whatever his reservations, I am grateful to him for his patience in correspondence and for criticizing a draft of the chapter mentioned.

Mrs. Darlene Roth White, of Atlanta, Georgia, referred me in correspondence to Franklin M. Garrett, director, Atlanta Historical Society, who kindly supplied me with material concerning the Piedmont Chautauqua and checked my pages dealing with it. Mrs. White also referred me to Mrs. Lee G. Alexander, archivist of the Trevor Arnett Library of Atlanta University, who generously sent me documentation concerning the Chautauqua Circle of Atlanta.

Elizabeth Vincent Foster (Mrs. Maxwell Foster) shared with me in conversation ingratiating reminiscences of her father, George Edgar Vincent, and her mother, Louise Palmer Vincent, and lent me the originals of the letters by Andrew Carnegie and Henry George quoted in chapter 5.

L. Jeanette Wells and Robert Cowden have not only allowed me to make extensive use of their valuable studies of music at Chautauqua, but have also read my chapter on the subject. I owe special thanks to Dr. Wells and Dr. Cowden, whatever deficiencies of my own remain in the text.

The photographs in Part 4 of this book are from the archives of the Chautauqua Institution. The captions for the photographs were also supplied by the Institution, and the final selection and arrangement of the photographs was made by the publisher in collaboration with the Institution. The photographs for chapter 10 are from the extensive Chautauqua collections of the University of Iowa and were made available to the author by Robert A. McCown, manuscripts librarian of the university. The photograph of William Rainey Harper in Part 4 was furnished by the Regenstein Library of the University of Chicago. The photograph of George Gershwin and Ernest Hutcheson in Part 4 was taken by Edward Jablonski.

For certain information about the recovery of Chautauqua from receivership, I am indebted to "Notes from the Scrapbook of Mrs. Norman Jacobs," a typed document made available to me at Chautauqua.

I owe cordial thanks to Mrs. Kathryn Nuttall for reviewing my typescript, and to Mrs. Alfreda Irwin for the same service as also for illuminating conversations and helpful research tips from her extensive knowledge of Chautauqua history.

The librarian of the Smith Library at Chautauqua, Miss Pauline Fancher, together with her staff, have provided generous help. Edward Connery Lathem, dean of libraries and librarian of Dartmouth College, kindly put the resources of the Baker Library at my disposal during summer work in neighboring Vermont.

Official and unofficial Chautauquans have supplied me with memories and anecdotes. Oscar E. Remick, president of the Institution since 1971, has been both personally and institutionally hospitable, and has encouraged this book with a cordiality I can only hope will be at least partly rewarded.

The commission to write this book came to me through the good offices of Edward Weeks, Jr., formerly editor, now consulting editor of the *Atlantic Monthly,* and a frequent lecturer at Chautauqua. My

association with him goes back to the early 1920s at Harvard College and I am happy to have this new occasion for gratitude.

All-important sources for the history of Chautauqua are its publications, notably *The Chautauquan,* a monthly magazine, the organ of the Chautauqua Literary and Scientific Circle, issued, before it underwent changes and mergers, from 1880 to 1913, and even more notably *The Chautauquan Daily* (originally *The Assembly Herald*). The *Herald* and the *Daily* contain the continuous record of the activities and news of the Institution during its annual sessions from 1876 through the present. For the years up to World War I, I have relied extensively on Thornton's painstaking inspection of the *Daily,* or on reports and quotations from it in the work of other investigators. For selected seasons from World War I through World War II, and for the twenty-odd years thereafter, I have made my own inspection. I have also used the following sources:

Ahlstrom, Harold J., ed. *Chautauqua Lake Steamboats.* Pamphlet. Jamestown, New York: The Fenton Historical Society.

Alden, Mrs. Isabella Macdonald ("Pansy"). *Four Girls at Chautauqua.* Boston: D. Lothrop, 1876.

————. *The Chautauqua Girls at Home.* Lothrop, 1877.

Angell, James R. "The Chicago Period." In *Addresses* commemorating George Edgar Vincent. Stamford, Connecticut: The Overbrook Press, 1941.

Bestor, Arthur Eugene, Jr. *Chautauqua Publications: An Historical and Bibliographical Guide.* Chautauqua, New York: Chautauqua Press, 1934.

Bliven, Bruce. "Mother, Home and Heaven." *New Republic,* January 9, 1924.

Case, Victoria and Robert Ormond. *We Called it Culture.* New York: Doubleday, 1948.

Cowden, Robert H. "The Chautauqua Opera Association 1929–1968. An Interpretative History." Typescript monograph. Smith Library, Chautauqua.

Downs, John P., and Hedley, Fenwick Y. *History of Chautauqua County, New York, and Its People.* Vol. 1. Boston, New York, Chicago: American Historical Society, 1921.

Earhart, Mary. *Frances Willard. From Prayers to Politics.* Chicago: University of Chicago Press, 1944.

Edson, Obed, and Merrill, Georgia Drew. *History of Chautauqua County*. Boston: W. A. Ferguson and Company, 1894.

Frank, Glenn. "The Parliament of the People." *Century Magazine*, July, 1919.

Gale, Zona. "Katytown in the Eighties." *Harper's*, August, 1928.

Goodspeed, Thomas Wakefield. *William Rainey Harper*. Chicago: University of Chicago Press, 1928.

Gould, Joseph E. *The Chautauqua Movement*. State University of New York, 1961.

Gray, James. *The University of Minnesota, 1851–1951*. Minneapolis: The University of Minnesota Press, 1951.

Harrison, Harry P., as told to Karl Detzer. *Culture under Canvas. The Story of Tent Chautauqua*. New York: Hastings House, 1958.

Hendrick, Ellwood. *Lewis Miller*. New York: G. P. Putnam's Sons, 1925.

Horner, Charles F. *Strike the Tents*. Philadelphia: Dorrance, 1954.

———. *The Life of James Redpath and the Development of the Modern Lyceum*. New York, Newark, N.J.: Barse and Hopkins, 1926.

Hurlbut, Jesse Lyman. *The Story of Chautauqua*. New York and London: G. P. Putnam's Sons, 1921.

Irwin, Alfreda L. *Three Taps of the Gavel: The Chautauqua Story*. Westfield, New York: The Westfield Republican, 1970.

James, William. *Talks to Teachers*. New York: Henry Holt, 1899.

———. *The Letters of William James*. Boston: Little, Brown and Company, 1926.

Kipling, Rudyard. "Chautauquaed," in *Abaft the Funnel*. B. W. Dodge, 1909.

Levine, Lawrence W. *Defender of the Faith—William Jennings Bryan: The Last Decade, 1915–1925*. New York: Oxford University Press, 1965.

MacLaren, Gay. *Morally We Roll Along*. Boston: Little, Brown, 1938.

McMahon, Helen G. *Chautauqua County, A History*. Buffalo, New York: Henry Stewart, 1958.

Mott, Frank Luther. "Chautauqua," in *Time Enough. Essays in Autobiography*. Chapel Hill: The University of North Carolina Press, 1962.

Nixon, Raymond B. *Henry W. Grady, Spokesman of the New South*. New York: Alfred A. Knopf, 1943.

Noffsinger, John F. *Correspondence Schools, Lyceums, Chautauquas*. New York: Macmillan, 1926.

Orchard, Hugh A. *Fifty Years of Chautauqua*. Cedar Rapids, Iowa: The Torch Press, 1923.

Price, Lucien. "Orpheus in Zion." *Yale Review,* December, 1929.

Richmond, Rebecca. *Chautauqua, An American Place.* New York: Duell, Sloane and Pearce, 1943.

———. *A Woman of Texas: Mrs. Percy V. Pennybacker.* San Antonio, Texas: The Naylor Company, 1941.

Scott, Marian. *Chautauqua Caravan.* New York: D. Appleton-Century, 1939.

Tarbell, Ida. *All in the Day's Work.* New York: Macmillan, 1939.

Thompson, Carl D. "Is the Chautauqua a Free Platform?" *New Republic,* December, 1924.

Vincent, George E., editor. *Theodore W. Miller, Rough Rider.* Akron, Ohio: privately printed, 1899.

Vincent, John Heyl. *The Chautauqua Movement.* Boston: Chautauqua Press, 1886.

Vincent, Leon H. *John Heyl Vincent, A Biographical Sketch.* New York: Macmillan, 1925.

Wells, L. Jeanette. *A History of the Music Festival at Chautauqua Institution, 1874–1957.* Washington, D. C.: The Catholic University of America Press, 1958.

Index

Abbot, Lyman, 54
Accomplishment, tangible badges of, 58
Addams, Jane, 60, 296
Administration Building, 318
Advertising, 62–63
"Akron Plan," 260
Alden, Isabella MacDonald, 50
Alexander, Mary Valinda, 24
Allen, Elisha, 10
Allen, Florence, 113
Alumni Association, formation of, 41
American Federation of Labor, 13
American Indians, 7, 100, 115, 202
Amherst Glee Club, 122
Amphitheater (first), 4, 87, 89, 91, 92, 94, 98, 101, 103, 107, 110, 116, 122
Amphitheater (present), 123, 141, 150, 212, 224, 228, 238, 279, 288, 309; photographs of, 306, 314, 319
Anne M. Kellog Memorial Hall, 319
Antiwar movements, 113, 222, 226–27
Apollo Club of New York, 120, 121
Appleby, D. F., 24
Apprentice Artist Program, 145
Art Association, 150–51, 321
Art classes, 149–51
Arthur, Revington, 286
Arthurians, The, 296
Artist Program of New York, 302
Artists at Chautauqua: Arthur, Revington, 150; Lee, Doris, 151; Shoa, Fang Sheng, 151; Smedly, Will Lattimore, 150; Wright, Frank Lloyd, 151
Arts, status of, 251
Arts and Crafts Quadrangle, 101
Ashman, Gregory, 136

Assembly Herald, 36, 149, 264, 268, 306, 316, 318
Athenaeum Hotel, 4, 150, 151, 227, 267, 279, 284, 306, 314, 315, 324
Atlanta Chautauqua Circle, 164–66
Atomic Commission, 197
Aultman, Cornelius, 23
Aultman, Elizabeth, 21
Aultman, Miller, and Company, 24
Autori, Franko, 139–42
Aviation Day, 301

Bampton, Rose, 283
Band, 279. See also Orchestra
Barnum, P. T., 139
Barrere, George, bust of, 284
Baruch Report, 197
Bat population, 6, 210
Bay View Assembly, 162
Beard, Frank, 37, 67, 163; photograph of, 262
Belk, William, 170
Beloit District Campmeeting Association. See Lincoln Park Chautauqua
Bemis, P. W., 268
Bemus Point Hotel, 267
Benét, Stephen Vincent, 137
Bestor, Arthur E., 49, 53, 69, 92, 93, 99, 100, 102, 103, 112, 113, 114, 116, 138, 162, 239, 298; death of, 115, 212; photographs of, 305, 306, 309
Bestor, Arthur E., Jr., 114
Bestor, Orson Porter, 87
Bestor Plaza, 3, 4, 116, 151, 210, 275
"Betty," letters from, 94–96
Billings, Josh, 177
Bimboni, Alberto, 136, 142, 153
Bimboni, Winona, 153

Bird, Tree, and Garden Club, 101, 107, 110

Birth control, discussion of, 219–20

Bishop, Elizabeth, 331

Bishop's Garden, 313

Blacks: problems of, 215–17; receptiveness to, 213; as speakers and performers, 96, 143, 217, 220, 224

Blainville, Céleron de, 8

Bliss, P. P., 120

Bliven, Bruce, 181, 184

Bolling, Landrum, 225–26

Bomb scare, 227

Book of the Month Club, 62, 69

Boston Lyceum Bureau, 177, 178

Bowling, 334

Boxer Indemnity scholarship, 204

Boys' and Girls' Clubs, 114, 220, 300, 332, 334

Braham, W. Walter, 208, 212

Bray, Frank Chapin, 64, 65

Brown, Hine, 282

Brown, John, 176

Brown v. Schoolboard of Topeka, 208

Bruce, Wallace, 172

Brulé, Étienne, 7

Bryan, William Jennings, 186–88

Bryant, Donald, 143

Bryant, William Cullen, 56

Buckeye Mower and Reaper, 24

Bugbee, L. H., 57

Byrd, Richard E., 309

Cadmean Circuit, 180–81

"Cannonade," 168

Carmichael, Stokely, 216

Carnegie, Andrew, 12, 54–55

Carnegie Institute of Technology, 157

Cape Colony, Africa, 162

Carothers, J. William, 212

Cary Hotel, 321

Cawker City, Kansas. See Lincoln Park Chautauqua

Celoron, 268, 272

Centennial Exhibition (Philadelphia), 42

Ceremony, importance of at CLSC, 58–59

"Certificate of Sentimental Ownership," 107

Chadakoin, 7. See also Name (of Chautauqua)

Chamber Music Society, 131, 135

Chapel of the Good Shepherd, 324

Charm course, 198

Chautauqua: affiliation of with outside establishments, 122; architectural style of, 5, 255; concepts of, 246; diversity of program, 99–101; early years, 11–14; as expression of faith, 244; fear for safety of, 112; forerunners of, 174–77; future of, 247–52; grounds of, 3–7; map of, 276; open platform at, 14; present comprehensiveness of, 246; receivership of, 105; region of, today, 11; symbolic sale of property of, 107

Chautauqua College of Liberal Arts, 76, 260

Chautauqua Cook Book, The, 295

Chautauqua Dance Company, 154

Chautauqua Foundation, 108, 274

Chautauqua Lake Camp Meeting Association, 262

Chautauqua (lake steamer), 261

Chautauqua Literary and Scientific Circle (CLSC): benefits of, 67–70; books used by, 61; building of, 53, 294; certificate of membership of, 300; decline of, 69–71; graduating class of, 296; growth of, 65–70; local circles of, 65; map of Chautauqua, 267

Chautauquan, 62–63, 306. See also Publications

Chautauqua Opera Association, 133, 134, 135, 143, 288

Chautauqua Press, 79

Chautauqua Reorganization Corporation, 105–8

Chautauqua Repertory Theater, 157

Chautauqua Society of Fine Arts, 149

"Chautauqua Salute," 58, 108

Chautauqua Summer Schools, 93

Chautauqua System of Education, 49, 50, 76, 78

"Chautauqua through Time," 256

Chautauqua Traction Company, 93, 270

Chautauqua Utility District, 108

Chautauqua University. See Chautauqua System of Education

Chautauqua War Chest, 114

Chautauqua Women's Club. See Women's Club

Chiang Kai-shek, government of, 202

Chicago, University of, 87, 260, 294

Chicago Women's Christian Temperance Union, 43

Chickasaw Circle (Indian Territory), 67

"Children's Day" at Chautauqua, 35

Choir, 121, 130, 136, 143, 279. See also Music

Christian Youth Movement, 199

Church of the Heavenly Rest, 125

Circuits, 120, 161, 171–94

City of Cincinnati (lake steamer), 271

Cleveland Play House, 156, 157

Clinger, William, 200–201

Clog dancing, 152–53

CLSC. See Chautauqua Literary and Scientific Circle

Cold war, discussion of, 199–202, 210

Cole, Ida E., 296

College Building, 317

College Club, 323

College Hill, 300

College of Liberal Arts, 49, 292, 317

Colonnade Building: facilities at, 112, 275; fire at, 212; theft from, 233

Communications Workers of America, 211

Communism, discussion of, 199–203

Comprehensive Plan, 99

Comstock, Anthony, 45

Consolidation of activities, 49

Coolidge, Calvin, 100

Cooperative Christianity Week, 100

Correspondence teaching, 49

Cottages, building of, 34–35

Cowden, Robert, 135, 138, 141, 143, 144

Credit Mobilier, exposure of, 12

Cross, Charlotte Elton. See Elton, Charlotte

Cross, Gurnsey T., 305

Culture, theology of, 245

Curtis Institute of Music, 126–27, 142

Dachau, 203

Damrosch, Frank, 125

Dance, 152–56

"Dear Mabel," letters to, 94–96
Death penalty, discussion of, 213
Delsartian calisthenic system, 331
de Mille, Agnes, 154
Denison University, 74, 75
Department of Comparative Literature, 202
Department of Microscopy, 44
Department of Public School Music, 122
Department of Religion, 101, 222
Department of Violin, 124
Detroit Symphony, 129
Dewey, John, 204, 294
Dewey, Melville, 294
Dien Bien Phu, 226
Douglas, William O., 224
Downs, John P., 7, 11
Dramatic Club, 156
Dusenbury, Elizabeth, 19

Earhart, Amelia, 101, 308
Eastman School of Music, 132, 142, 144, 145
Eckerberg, Sixten, 142
Ecology Week, 220, 275
Eddy, Nelson, 136
Edison, Mina, 103, 274
Edison, Thomas A., 26, 65, 98, 123, 134, 268, 274, 300; photographs of, 306, 308, 311
Edison Week, 197
Edson, Obed, 7, 9, 11
Education, future of at Chautauqua, 247–49
Eielson, Carl, 101, 307
Eisenhower, Dwight, 195, 204
Eisenstat, Max, 156, 157–58
Ellington, Duke, 119, 288
Ellison, J. R., 181
Elton, Charlotte, 153, 154
Emigh, Tula Draher, 169
Erskine, John, 282
Expansion, territorial, 47–48
Experimental Discussion Project of the Fund for Adult Education, 205
Extension program, 49

Fairbanks, Douglas, 93
Fair Point, 32, 38, 46, 73, 260, 262, 276

Fair Point Camp Meeting, 32
Fair Point Sunday School Assembly, 31–32
Fancher, Pauline, 324
Fay, Elijah, 11
Federal Council of Churches of Christ, 100
Festival Opera Theatre, 144
Financial difficulties, 98–99, 102–9
Fish, Hamilton, 310
Fisher, Edgar J., 114, 198, 201, 203, 204
Flagler, Isaac V., 122, 126
Flood, Theodore, 41, 62, 64, 156, 306, 316
Fokine's Russian Ballet, 153
Folk dancing, 152–53
Follansbee, George L., 213
Ford, Henry, 24, 98, 134, 308
Ford Foundation, 144, 204, 205
Forest Park Assembly, 167
Foster, Elizabeth Vincent, 79, 81, 94
Founders of Chautauqua, 26–28
Francis, Robert, 152
Francis Willard House, 326
Francis Willard Memorial Window, 326
Franklin, J. Benjamin, 180
Franklin College, 87
Fredonia Academy, 11
Friskin, James, 285
Frost, Robert, 69, 146, 152
Fund for Adult Education (Ford Foundation), 204, 205
Funk, Diane, 151

Gale, Zona, 68
Games, 331–34. See also Physical Education
Garchery, Eugenie Marie, 207
Garrick, Yvonne, 207
General audience, financial motive for, 46
General Federation of Women's Clubs, 69, 94, 205
George, Henry, letter from, 55
Georgia Pacific Railroad, 164
German Literary Chautauqua Society, 66
Gershwin, George, 130, 135, 143, 307
Gingerbread Cottage, 324
Gold Coast, 5

Golf Club, 105, 107
Goodwin, Etta Ramsdell, 93
Gough, John B., 45
Gould, Joseph E., 76
Grady, Henry, 163–66
Graham, Martha, 153
Grange, cooperative movement of, 13
Grant, Ulysses S., 10, 19, 21, 41–42, 231
Grape industry, 11
Gray, James, 80, 81
Green, John Richard, 61
Greenback Party, 13
Griffith, Benjamin W., 165
Griffith (lake steamer), 267
Grounds (of Chautauqua), 3–7
Guild of the Seven Seals, 59

Hale, Edward, 293
Hall, Donald, 152
Hallam, Alfred, 92, 124, 126, 128
Hall in the Grove. See Hall of Philosophy
Hall of Christ, 237, 238, 322
Hall of Missions, 101
Hall of Philosophy (original), 296, 314
Hall of Philosophy (present), 88, 150, 163, 168, 220, 228, 322, 328
Handel and Haydn Society of Boston, 121
Hanson, Howard, 131–32, 135, 138, 140, 144, 221, 286
Harper, Clare, 282
Harper, William Rainey, 75, 78, 87, 317; background, 25, 73–76; death, 84; intellectual precocity, 74–75; photograph of, 260; talents of, 57, 75
Harrison, Harry P., 161, 180, 183, 185, 187
Hart, William S., 93
Haug, Curtis, 144, 212, 213, 238
Hayes–Tilden campaign, 42
Haymarket Square Riot, 13
Hazlett, Samuel M., 106, 107, 108, 114, 116, 208, 274
Hedley, Fenwick Y., 7, 11
Hendl, Susan, 155
Hendl, Walter, 142–43
Henning, Edward B., 151
Higgins Hall, 93, 149

Hill, James J., 12
Hinkley, Solomon, 12
Hiroshima, 196
Hiss, Alger, 204
"History of the World," 62
Hitler, Adolph, 201
Holbrook, Josiah, 174–76
Holland Land Company, 7
Holmes, John, 152
Hoover, Herbert, 92
Hopkins, Harry, 310
Horner, Charles F., 178, 180, 181
Hotel William Baker, 320
Howe, Walter, 111, 136
Howell, John Daggett, 143
Hudkins, Mae, 172
Hughes, Charles Evans, 305
Hulbert, Eri, 75
Hurlbut, Jesse Lyman, 20, 33, 37, 41, 56,
 66, 67, 73, 78, 88–89, 120, 162, 163,
 293, 296
Hurlbut Memorial Church, 102
Hutcheson, Ernest, 282, 307
Hymn, Chautauqua, 36

Independent Chautauquas, 161–92
Indians, 7, 100, 115, 202
Institute of Religion in the Age of
 Science, 209, 215
Institute of World Missions, 203
International Correspondence Schools,
 49
International Federation of Business and
 Professional Women, 104
International Order of Good Templars,
 203
International Order of the King's
 Daughters and Sons, 104
International Women's Conference, 199
Interstate Sunday School Assembly, 162
Iroquois Federation, 7
Irwin, Alfreda L., 46
Island Park. See Winfield Chautauqua
 Assembly
Israeli situation, discussion of, 199

Jack and the Beanstalk, 284
Jackson, Robert H., 197
Jackson Memorial Library, 206

Jacob Miller House, 318
James, William, 80–81, 231, 331
Jamestown (lake steamer), 264, 267
Jepson, Helen, 283
Jesse L. Hurlbut Adult Bible Class, 208
Jo Daviess Guards, 42
John XXIII (pope), 215
Johnson, Earl J., 167, 168
Johnson, Samuel, 158
Jordon Hall, 158
Jose Greco Ballet, 154
Josie Bell (lake steamer), 42
Juilliard School of Music, 126, 133, 138,
 145
Junior Girls, 180

Kahn, Otto, 207
Kansas Women's Temperance Union, 172
"Katytown in the Eighties," 68
Kellog Memorial Hall, 319
Kelly, Edgar S., 122
Kennedy, Charles Rann, 182
Kennedy, John F., 195
Kimball, Kate Fisher, 64–65, 67, 79, 89,
 293
King, Julius, 70, 107, 137
King, Rose, 97
Kipling, Rudyard, 234–35
Kiser, Marian C., 165
"Klantauqua," 161
Kochanski, Paul, 282
Korean War, 199–202
Koussevitsky, Serge, 142
Koussevitsky Foundation, 140, 142
Ku Klux Klan, 12, 161

Labor, problems of, 13, 114–15, 209,
 210–11
Lake Chautauqua: contamination of,
 220; description of, 5–7; fishing in, 6;
 history of, 6–8, 9–11; horse-boat on,
 10; old road to, 8–9; steamboats on,
 10–11, 33, 42, 109, 261, 264, 271
Lakeside Encampment (Lakeside, Ohio),
 162
Landon, Alfred, 310
Language study, 46, 48, 93, 267
"Last $100,000 Club," 107

Lathbury, Mary A., 36, 41, 50, 119
Layman's Commission, 103
Layman's Mission Conference and
 Forum, 103
Leach, Henry Goddard, 152
League of Nations, 97, 99
League of the Round Table, 58
Learning, hunger for, 54
Lebanon, The. See Hotel William Baker
Letters, about home study, 54–55
"Letters from N.S.S. Camp," 94–96
Levine, Lawrence W., 186
Lien Cheng, 305
Lincoln, Abraham, 21, 63
Lincoln Center, 155
Lincoln Park Chautauqua, 169–72, 173
Lindbergh, Charles, 101
Lindsay, Vachel, 309
Linley, Margaret, 133
Living conditions, during early years,
 34–35
Local circles, 66, 67–69
Lodge, The, 320
Look Forward Circle, 67
Lowe, K. Elmo, 157
Lyceums, 174–77

MacArthur, Douglas, 195
McCallister, Ralph, 139, 140, 144, 212
McCarthy, Eugene, 221
McCarthy, Joseph, 203
McConnell, Francis J., 296
McConnell, Frederic, 157
McCord, David, 302
MacLaren, Gay, 161, 177, 182, 186, 188,
 189
McMahon, Helen G., 7, 10, 11
McMaster, James B., 62
McNeal, Thomas A., 170
Mammoth Supply Store, 270
Mann, Horace, 175
Mara, interview with, 155
Marcosson, Sol, 124
Martha Baird Rockefeller Fund for
 Music, 144, 145
Mason, Walt, 172
Massey, Chester D., 126
Massey, Hart A., 126, 319
Massey, Raymond, 319

Massey, Vincent, 126, 319
Massey Memorial Organ, 126, 319
Mayville (lake steamer), 109
Mencken, H. L., 100, 110
Menninger, Karl, 311
Menninger Foundation, 203
Men's Club, 110, 306
Mercyhurst College, 221
Messiah, 130
Methodist Sunday School Union, 32
Methodology, Sunday school, 41
Metropolitan Opera Company, 135, 142
Midsummer Night's Dream, A, 288
Miller, Doug, 226
Miller, Jacob, 101, 318
Miller, John, 21, 274
Miller, Lewis, 37, 38, 41, 78, 93, 120, 123,
 162, 262, 311, 314, 318, 328; antipathy
 to farming, 23; architectural talents,
 25; boyhood, 22–23; candidacy for
 Congress, 13, 23; children, 268; death,
 29; interest in Sunday schools, 25, 26,
 260; inventive talents, 23; marriage,
 24; move to Akron, 24–25; passion
 for education, 25; photographs of, 259,
 274; powers of persuasion, 27
Miller, Milton, 274
Miller, Mrs. Cotta, 274
Miller, Mrs. Jacob, 101
Miller, Mrs. Robert, 274
Miller, Theodore, 28, 332
Miller Bell Tower, 4, 316, 317, 323, 328
Miller Cottage, 311
Miller Park, 268
Milner, Duncan C., 167
Mincer, Richard, 142
Minnesota, University of, 80, 81, 83, 219
Minnesota State Prison. *See* Pierian
 Circle
Mischakoff, Mischa, 131
Mischakoff String Quartet, 131, 134, 282
Mockel, Jessie, 142
Modernity, history of, 244
Monteagle Assembly (Tennessee), 173,
 174
Monona Lake, Chautauqua Assembly at,
 162
"Moorish Barn." *See* College Building
Morey Cottage, 320

Morgan Park, 75, 76
Mormon Tabernacle Choir, 121, 288
Morrison, Samuel Eliot, 88, 90, 187
Morrison, Theodore, 243
Morton, David, 152
Mossman, W. H., 310
Mott, Frank Luther, 182, 189
Mountain Park Chautauqua, 174
Mount Herman (in Palestine Park), 279
Müller, Abraham (Lewis Miller's
 grandfather), 21
Muncie Hotel. *See* North Shore Inn
Murphy, Edward, 285
Music: band, 279; beginning of at
 Chautauqua, 119; choral, 121, 129–30,
 136, 142–43, 279; compositions heard,
 61, 92, 93, 98, 111, 120–47, 182, 210,
 283; orchestral, 128, 132, 139–47, 155;
 under Albert Stoessel, 132, 139; under
 Alfred Hallam, 124–29, under H.
 Augustine Smith, 129–32; under H. R.
 Palmer, 123–24; under W. F. Sherwin,
 119–23; variety of, 119–34. *See also*
 Performers at Chautauqua
Music Festival Week, 127
Muskingum College, 73–74

Naismith, James, 168
Name (of Chautauqua), 8; profanation
 of, 161–63
Narcotics education, course in, 218
National Army Day, 42
National Education Association, 48
National Federation of Women's Clubs,
 306
National League for Woman's Service, 94
National Liberation Front, 223
National Normal School of Music
 (Boston), 122
National Service School, 94, 97, 298
Nearing, Scott, 90
Negro Chaplains of the Week, 217
Nettie Fox (lake steamer), 264
New Deal, 103, 105, 109
New England Assembly, 162
New Nations of Europe Week, 99
New York City Ballet, 155
New York Philharmonic Society, 132,
 137

New York State Commission on the
 Arts, 221
New York State Council of the Arts, 145
New York Times, 63, 109, 137, 197, 199,
 221, 308
New York University, 131, 152, 198
Nixon, Richard, 195
Noffsinger, John, 175, 176, 191
Nordell, Carl J., 150
Norman Hall, 126, 157, 163
North Carolina, University of, 152, 208
Northern Illinois Chautauqua Union, 60
North Lake Drive, 327
North Shore Inn, 318
Norton, Mrs. O. W., 133, 307
Norton, Mrs. Ralph, 107, 116, 305
Norton, Ralph, 107, 116, 305
Norton Hall, 101, 103, 133, 135, 138, 141,
 143, 153, 202, 228, 307, 328
Nursery School, 302

Ochs, Adolph, 98, 308
Octagon House, 326
Ohio State Camp Meeting, 31
"Old First Night," 36, 93, 102, 107, 108,
 114, 126, 140, 198, 204, 274
Old Salem Chautauqua, 162
Opera Association, 133, 134, 135, 143,
 288
Orchard, Hugh, 162, 177
Orchestra, 128, 132, 142–43.
 See also Symphony
Order of the Knights of Labor, 13
Order of the White Seal, 58
Organizations, proliferation of, 47–51
Osborne, Lloyd, 156

Packard Estate, 327
Painting, 149–51
Pakistani problem, discussion of, 197–98
Palestine Classes, 18
Palestine Park, 5, 35, 109, 238, 279, 293
Palmer, Albert W., 114
Palmer, Alice Freeman, 60
Palmer, H. R., 120, 122, 123
Palmer, Louise, 80, 81
"Pansy." *See* Alden, Isabella MacDonald

Parnova, Lisa, 153
Paul, Ella, 75
Pearl Harbor, 84, 112, 113, 137, 138
Pearson, Paul, 180
Peebles, Brownie, 283
Pennybacker, Mrs. Percy V., 92, 103, 108
Performers at Chautauqua: Adair, Tom,
 155; Altschuler, Modest, 127, 129;
 Anderson, Marian, 143, 220, 224;
 Antoine, Josephine, 134, 135; Autori,
 Franko, 139–42; Bampton, Rose, 134,
 135, 136; Barrere, Georges, 128, 131,
 135, 136; Ben Greet Players, 182;
 Bible, Francis, 134; Bimboni, Alberto,
 136, 142, 153; Bond, Carrie Jacobs,
 127; Boynton, F., 120, 122; Britton,
 George, 116; Buckley, Emerson, 144;
 Case, C. C., 121, 122; Columbus
 Boychoir, 139, 142, 143; Connell,
 Horatio, 136; Conradi, Austin, 137;
 Crooks, Richard, 137; Dame, Donald,
 116, 134; Damrosch, Walter, 127, 128,
 130; Dickey, Annamary, 115, 134;
 Dickson, Donald, 134; Ellington,
 Duke, 119, 228; Erskine, John, 131,
 134–35, 147; Fiske Jubilee Singers,
 119; French Military Band, 127;
 Gallagher, Gil, 145; Goodwin, F. A.,
 37, 119; Grainger, Percy, 140;
 Greenwell, Gean, 141; Green Willow
 Dancers, 154; Hempel, Frieda, 139;
 Hendl, Walter, 142, 144, 147; Huehn,
 Julius, 134, 142, 144; Hutcheson,
 Ernest, 126, 137, 139, 140; Jepson,
 Helen, 134; Kingston Trio, 212;
 Kullman, Charles, 134, 135; Libling,
 Max, 122; Lind, Jenny, 139;
 Listemann, Bernhard, 124; Lombardo,
 Guy, 225; McClintock, Belle, 122;
 MacLaren, Gay, 119; Mendelssohn
 Choir of Pittsburgh, 143; Mischakoff
 String Quartet, 131, 134; Mormon
 Tabernacle Choir, 121, 288; Murphy,
 Edward, 141; Neway, Patricia, 141;
 New York Symphony, 129, 130, 132;
 Nielsen, Alice, 182, 189; "The North
 Carolinians," 119; Peebles, Joan, 135;
 Porter, Hugh, 131, 136; Richardson,
 Naomi, 155; Rochester Opera
 Company, 133; Royal Hand Bell
 Ringers and Gleemen of London, 120;
 Russian Symphony, 127, 129; Sankey,
 Ira D., 120; Schubert Male Quartet,
 122, 127; Schumann-Heink, Madame,
 182; Sherwood, William H., 123, 124,
 126; Southern Plantation Singers, 133;
 Stellman, Maxine, 134; Swarthout,
 Gladys, 137; Templeton, Alec, 137;
 "The Tennesseeans," 119; Thomas,
 Michael Tilson, 147; United States
 Army Field Band, 119; Vitale, Joseph,
 122; Volkel, George, 111, 136, 137,
 143; Welleke, William, 138; "White
 Hussars," 189; Wittgenstein, Paul, 140;
 Yale Glee Club, 122. See also Speakers
 heard at Chautauqua
Philadelphia, Academy of Music, 186
Physical Education, 152–53.
 See also Sports
Pickford, Mary, 93
Piedmont Chautauqua, 163–66
Pier Building, 316
Pier Building Tower, 317
Pierce, Pauline, 115–16, 141
Pierian Circle, 67
Pioneer Hall, 294
Pioneers, 9
"Pioneers" (CLSC class), 150
Point Chautauqua, 73
Population (of Chautauqua), three
 strands of, 236
Potter, Harrison, 136, 137
Price, Lucien, 158–59
Price, The (play), 158, 288
Porter, Mrs. James R., 166
Prisons, CLSC circles in, 67–68
Publications: Assembly Daily (See
 Publications, Daily); Assembly Herald,
 36, 149, 264, 268, 306, 316, 318;
 Atlanta Constitution, 163–64; Atlanta
 Constitution Magazine, 165; Atlanta
 Herald, 164; Atlanta Historical
 Bulletin, 164; Boston Post, 126;
 Chautauqua Assembly Daily Herald
 (See Publications, Chautauquan
 Daily); Chautauquan Daily, 3, 6, 11,
 62–65, 89, 93, 156, 195, 200, 201, 204;
 Cawker City Ledger, 172; Century
 Magazine, 181, 184; Chautauquan
 (monthly), 62–63, 306; Chautauquan
 Quarterly, 98; Chautauquan Weekly,
 149; Chautauqua Publications, 53;
 Daily, 47, 89–91, 93, 96, 97, 98, 104, 105,
 106, 109, 110, 111, 112, 115, 127, 131,
 136, 142, 143, 145, 146, 150, 151, 155,
 158, 173, 204, 205, 208, 209, 212, 214,
 216; Daily Herald, 45, 46; Emporia
 Gazette, 172; Harper's Magazine, 68;
 Herald, 123, 124, 149; Independent,
 64; New Republic, 181, 183, 184; New
 York Times, 63, 109, 137, 197, 199,
 221, 308; New York Tribune Monthly,
 47, 176; Police Gazette, 45; The Story
 of Lincoln Park, 172; Sunday School
 Journal, 32; Winfield Daily Courier,
 168
Public Ownership League of America,
 183

Race, discussion of, 96, 100, 198, 208,
 215–17
Radical ideas, desire for, 47
Ralph Norton Garden, 282
Rawlinson, George, 62
"Recognition Day," 59, 63, 66, 199, 220,
 293, 294, 296
Red Oak, Iowa, Chautauqua Pavilion in,
 174
Redpath, James, 176–77
Redpath Bureau, 177, 178
Redpath-Horner Circuit, 131, 169
Reiner, Fritz, 142
Religion, future of at Chautauqua,
 249–51
Remick, Oscar E., 238
Richmond, Rebecca, 33, 36, 108, 151,
 162, 284
Riis, Jacob, 183
Rockefeller, John D., 12, 177
Rockefeller, John D., Jr., 108, 306
Roosevelt, Eleanor, 305, 309
Roosevelt, Elliot, 305
Roosevelt, Franklin D., 305, 308, 310
Roosevelt, Theodore, 62, 111, 235, 237,
 270, 295, 305
Roque (game), 332
Ross, Lyman, 12

349

Rudel, Julius, 143
Rusk, Dean, 225
Russian Symphony, 129

St. Denis, Ruth, 153
St. Elmo Hotel, 212, 322
Salt Lake Mormon Tabernacle Choir, 288
"Sandwich Poets," 152
Sanford, Marian, 284
Schoenberg, Arnold, 136, 284
School integration, 208
School of Aeronautics, 196
School of Domestic Science, 295
School of the English Bible, 77
School of Languages, 46, 48, 93, 267
School of Library Science, 294
School of Music, 121, 142, 144
School of Political Education, 100
School of Theology, 48
Schuchari, 282
Science, prominence of, 42–45
Scientific Congress, 42–43
Scott, Marian, 184, 188, 189
Senior Citizen's Day, 211
Shawn, Ted, 153
Sherman, William, 36, 119, 120, 122, 162
Sinclair, Upton, 310
Singer, Jaques, 282
"Singing Geography," 18, 20
Sloane, William, 152
Smedley, Will Larymore, 150
S. M. Hazlett Honorary Endowment, 274
Smith, A. W., 171
Smith, Alfred A., 101
Smith, Grace Hallam, 97
Smith, H. Augustine, 129–30, 136
Smith Memorial Library, 102, 116, 301, 318, 322
Smith-Wilkes Hall, 101, 102, 210, 311
Social problems, discussion of, 215–19
Society of Fine Arts, 149
Spalding, Albert, 137
Speakers heard at Chautauqua: Adebo, S. O., 214, Ames, Sir Herbert, 109; Anthony, Susan B., 167; Asirvatham, Eddy, 197; Baldwin, Hanson, 197; Bannow, Rudolph F., 211; Barr,

Stringfellow, 198; Bauer, Marion, 131, 136, 137; Beale, Oliver H., 206, 210; Beecher, Henry Ward, 41; Beirne, Joseph A., 211; Ben-Dor, Immanuel, 207; Bethune, Mary McCloud, 109; Beveridge, Albert, 183; Bishop, Donald, 222; Bolling, Landrum, 219; Booth, Edwin P., 215, 222; Brogan, D. W., 211; Brown, Rollo Walter, 152; Bryan, William Jennings, 65, 67, 68, 88, 163, 167, 186, 187; Buckley, J. M., 125; Bunche, Ralph, 205; Burgess, John W., 217; Cannon, "Uncle Joe," 168; Catt, Carrie Chapman, 94, 167; Chun Ming Chang, 213; Ciardi, John, 152, 215, 220; Clark, Walter H., 215; Clark, Champ, 168, 183; Cleveland, Grover, 164; Cleveland, Harlan, 215; Colvin, D. Leigh, 110; Commager, Henry Steele, 202, 203; Comstock, Anthony, 45; Conwell, Russell H., 185–86; Cousins, Norman, 207; Crittendon, William E., 225; Currier, Raymond P., 225; Darrow, Clarence, 167; Dean, Vera Micheles, 213; Dickens, Charles, 176; Dietz, David, 198, 201, 204; Doremus, R. Ogden, 43–44; Downes, Olin, 126; Dugmore, J. Radcliffe, 91; Earhart, Mary, 43; Eastman, Charles A., 100; Eliot, Charles W., 60; Empey, Arthur Guy, 182; Engle, Paul, 204; Eversull, Frank L., 199; Fallon, Carlos, 204, 206; Field, Eugene, 156; Fine, Benjamin, 199; Finley, John H., 63, 109, 136; Fishbein, Morris, 104; Fleishman, Joel H., 217; Ford, Gerald R., 223; Frank, Glen, 181, 184; Friedrich, Carl J., 199; 203; Friskin, James, 140; Gompers, Samuel, 13, 183; Goodell, Charles E., 218; Gordis, Robert, 220; Gough, John B., 45–47; Greeley, Horace, 176; Greene, S. L., 58; Grewe, Wilhelm, 213; Gunsaulus, Frank W., 167; Hale, Edward Everett, 59–60, 176; Harbord, James G., 100; Hatton, Bill, 226; Havea, John A., 206; Hay, Ian (Major John Beith), 182; Hayes, Rutherford, B., 12, 167; Heath,

Douglas H., 218; Higgins, Lois, 218; Holmes, Oliver Wendell, 176; Huh Shih, 203; Imes, William, 115; Jefferson, Joe, 156; Jensen, Robert E., 219; Jones, Sam, 167; Jordan, Clarence, 215, 222; Jordan, David Starr, 89; Kang, Younghill, 201–2; Kennedy, Robert, 195, 224; Keyser, William, 222; Kirshaw, A. L., 209; Knowland, William F., 201, 202; Koo, T. Z., 199; La Follette, Robert, 167, 168; Laking, George R., 214; Lalande, M., 156; Landon, Governor Alfred, 107, 109, 111; Lapp, Ralph, 205; Lattimore, S. A., 44–45; Lew, Hyunhki, 200; Lewis, Fulton, 205; Ley, Willy, 204; Lindsay, John, 195; Little, Clarence Cook, 206; Lowell, James Russell, 176; Luger, Milton, 218; McCarthy, Joseph, 203; McClure, S. S., 89; McCord, David, 220; McDonald, James G., 103, 111, 203; McKinley, William, 165, 167; Marshall, Thurgood, 208; Matsumoto, Takuo, 199; Melby, Ernest O., 198; Menninger, Karl, 150, 203, 205, 206, 212, 213, 218; Meyer, Mrs. Eugene, 109; Mills, Roger Q., 165; Mitchell, James P., 211; Mondlane, Eduardo C., 210; Montagu, Ashley, 205; Morton, Thruston, 225; Moton, Robert B., 96; Muskie, Edmund, 225; Musmanno, Michael A., 201; Nason, John W., 207; Niebuhr, Reinhold, 114; Niemoeller, Martin, 202; Ojike, Mbonu, 197; Page, Thomas Nelson, 165; Pahk, Induk, 199; Parlette, Ralph, 185; Pearson, Drew, 221; Perkins, Dexter, 204; Phelps, William Lyon, 109; Phillips, Wendell, 176; Powers, Leland, 156; Procter, Samuel D., 216; Ransom, William I., 83; Reischauer, Edwin O., 211; Reuther, Victor, 209; Revercomb, Senator, 197; Rhode, Mrs. Owen, 198; Rodeheaver, Homer, 115; Romney, George, 216; Roosevelt, Eleanor, 103, 105; Roosevelt, Franklin D., 92–93, 100, 107; 111, 195, 231; Rowan, Carl T., 217; Ruttenberg, Stanley, 211; Sergio, Lisa, 214; Seversky, Alexander

Speakers—*Cont.*
 de, 113; Shapley, Harlow, 209, 215;
 Shaw, Anna Howard, 94, 167; Shelton,
 Turner, 222; Silliman, Benjamin, 174;
 Simmons, Leo W., 211; Smith, Kelly
 Miller, 217; Soyeshima, Michimasa,
 100; Spearman, Walter S., 152, 208;
 Steffens, Lincoln, 183; Stoessinger,
 John G., 216, 222; Subhan, John A.,
 197; Suthers, Mrs. W. Glenn, 204;
 Talmadge, DeWitt, 34, 36, 165, 167;
 Taylor, Maxwell D., 210; Taylor,
 Robert, 185; Thai Vu Van, 225;
 Thomas, Norman, 105, 110, 198;
 Totah, Kahlil, 199; Tsiang, Tingfu,
 202; Van Slyck, Philip, 221, 222;
 Vickery, Oliver, 206; Viereck, Peter,
 206; Washington, Booker T., 167, 171;
 Washington, Walter, 216; Watterson,
 Henry, 163; Weeks, Edward, 206;
 White, Paul Dudley, 221; Wicker,
 Tom, 221; Wieczoredk, Judith, 221;
 Wiley, Harvey, 183; Wilkins, Captain,
 101; Williams, Talcott, 93; Wilson,
 Charles E., 207; Win, U, 210
Speaker's Training Camp, 97
Spencer, Herbert, 13
Sports, 331–34. *See also* Physical
 Education
Stagg, Alonzo, 331
Stainer, Sir John, 125
Stanford, Leland, 12
Steamboats, 10–11, 33, 42, 109, 261, 264,
 271
Stegner, Wallace, 239
Stevenson, Adlai, 195, 204
Stoessel, Albert, 135, 136, 137, 141, 145;
 background, 130–31; photographs,
 283, 284
Strawbridge, Edwin, 153
Strong, Oscar, 156
Sublette, Statia, 154–56
Sunday School Assembly, 4, 14, 34
Sunday School Camp Meeting, 31
Sunday School Teacher's Assembly,
 32–38
Sunday School Union, 21, 260
Swartzkopensky, Vladimir, 96–97
Swarthmore Circuit, 180, 221

Symphony (Chautauqua), 132, 155;
 directorship of, 139–47
Symphony Society of New York, gift
 from, 129

Tarbell, Harlan, 202
Tarbell, Ida, 34, 35, 44, *55*, *56*, 63, 187,
 191, 233, 305
Teacher's Retreat, 48
Teaching the Activities of Little
 Children, course in, 153
Temperance, 45–47. *See also* Women's
 Christian Temperance Union
Tent Chautauquas. *See* Circuits
Texas-Colorado Chautauqua
 Association, 174
Texas School Teachers' Association, 174
Theater, 156–59
Thompson, Carl D., 183–84
Thomson, James, 18
Thornton, H. J., 36, 62, 66, 102, 149, 156
"Tight Booking," 179
Tilden, Samuel, 12
Tolstoy, Ilya, 306
Tourjee, Eben, 120
Town Meetings of the Air, broadcast of,
 114, 196, 197, 301
Treash, Leonard, 145, 147
Trees, 9–10
Tremont Temple, 176
Truman, Harry S., 201
Tuilovoni, Setareki, 203
Twain, Mark, 12, 150, 177

Un-American Activities Committee, 198
United Church of Christ Denominational
 House, 324
United Nations Week, 197
Universality, challenge to, 252

Valenti, Alfredo, 133, 138, 141, 142, 143,
 283
Van Laer, R. T., 280
Vawter, Keith, 178–80, 183, 190
Vietnam Teach-In, 222
Vietnam War, discussion of, 221–28
Villella, Edward, 155
Vincent, George Edgar, 59, 63–64, 73–77,
 156, 177, 196, 201, 261, 332;

background, 78–84; boyhood, 20, 32;
 character, 79, 81; death, 84; father's
 love for, 80
Vincent, Henry, 78, 126, 131, 279
Vincent, John Heyl, 33, 41, 48–98 passim,
 120, 123, 156–75 passim, 313, 322,
 331; birth and childhood, 17–18;
 character of, 18–20, 53; early career,
 18–21; as editor of *Sunday School
 Journal*, 21; educational ideas, 20;
 marriage, 19; photographs of, 259,
 296, 305; as secretary of Sunday School
 Union, 260; thoughts on CLSC, 57
Vincent, Leon H., 18, 48, 78
Vincent, Louise Palmer, 81, 94
Vincent, Mrs. B. T., 94
Virginia, University of, 75, 165

Wagnsson, Ruben, 203
Ward, Artemus, 62, 177
War Department, inspection of grounds
 by, 112
Warner, Charles Dudley, 12
Warren, J. H., 173
Wayland Academy, 87
Webb, Bunyan, 290
Webster, Daniel, 175
Weidman, Charles, 153
Welch, Thomas B., 11
Whallon, Evan, 147
White, Paul Dudley, 311
White Citizens' Councils, 208
Whitney Bay, 261
Widdemer, Margaret, 152
Wilkes, Addie May Smith, 101
Wilkins, George H., 307
Willamette Valley Chautauqua, 163
Willard, Francis E., 43
Williams, Oscar, 152
Wilson, Woodrow, 62
Winfield Chautauqua Assembly, 167–69
Women: participation in war effort,
 93–95, 97; role of, 104
Women's Christian Temperance Union
 (WCTU), 43, 115, 168, 172, 326
Women's Club, 101, 103, 104, 107, 108,
 152, 318, 326
Woman's Committee, National Council
 of Defense, 94

351 Woman's Service Week, 94
Woodside, Robert, 172
World affairs, discussion of, 198–220
World Missions Institute, 109
World Missions Week, 197
World War I, 88–96, 112–13, 152, 167, 181
World War II, 112–15, 146, 197
Wrench, Sue, 171
Writers' Workshop, 152, 208, 326

Xerxes (William Dodd Chenery), 280

Youth, problems of, 217–19